WITNESS
IRAQ

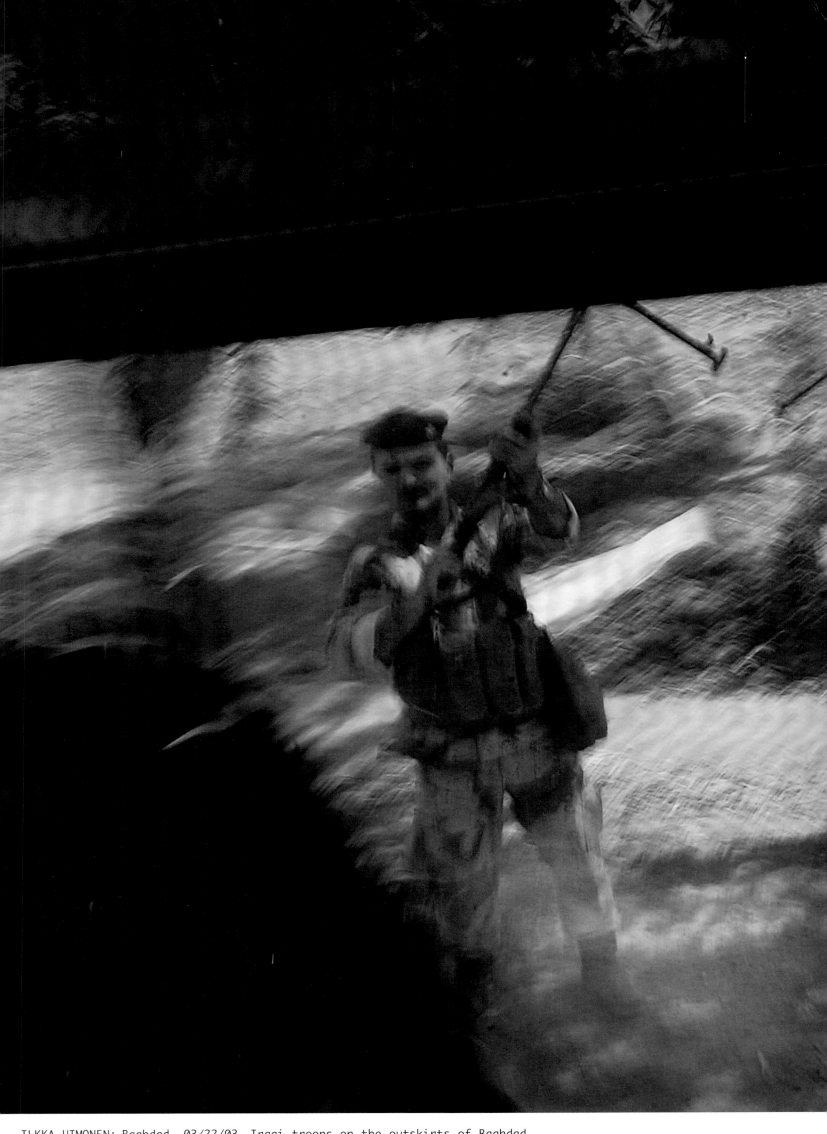

ILKKA UIMONEN: Baghdad, 03/22/03. Iraqi troops on the outskirts of Baghdad.

JULIE JACOBSON: Iraq, 03/31/03. A CH-46E Sea Knight helicopter with the 3rd Marine Air Wing's HMM 268th helicopter

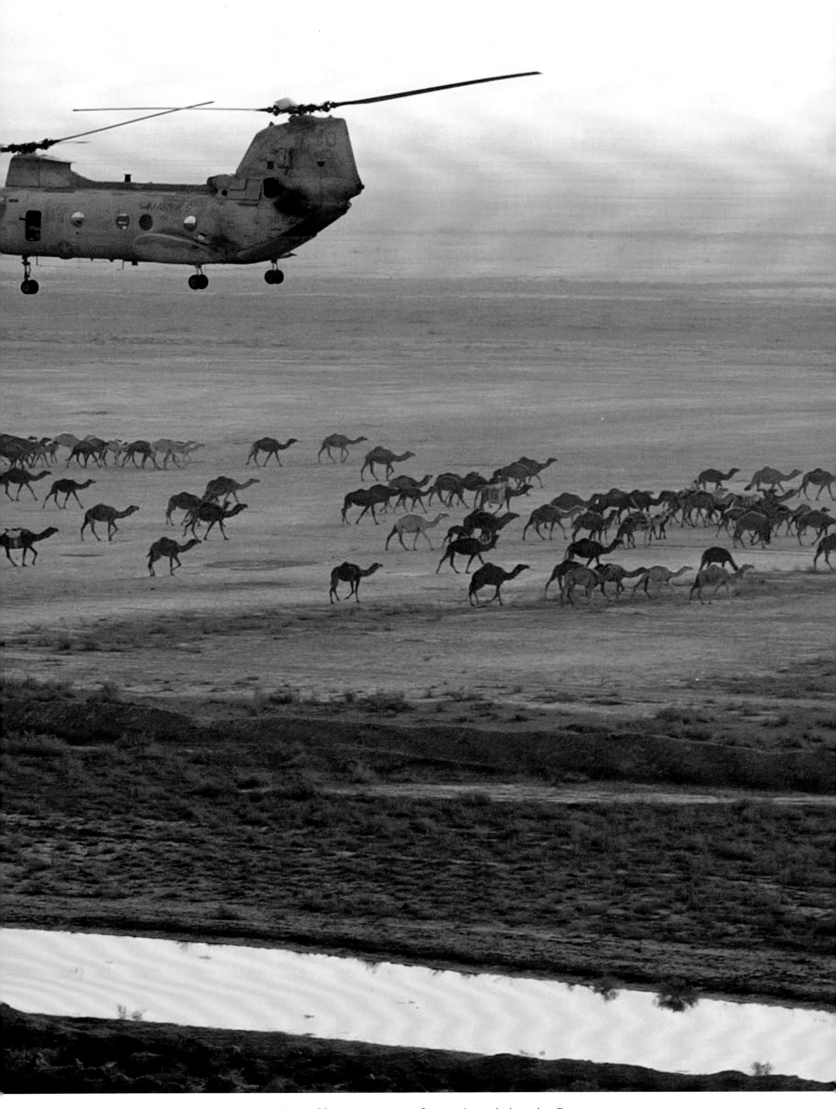

unit heads back to base after dropping off troops at a forward position in Iraq.

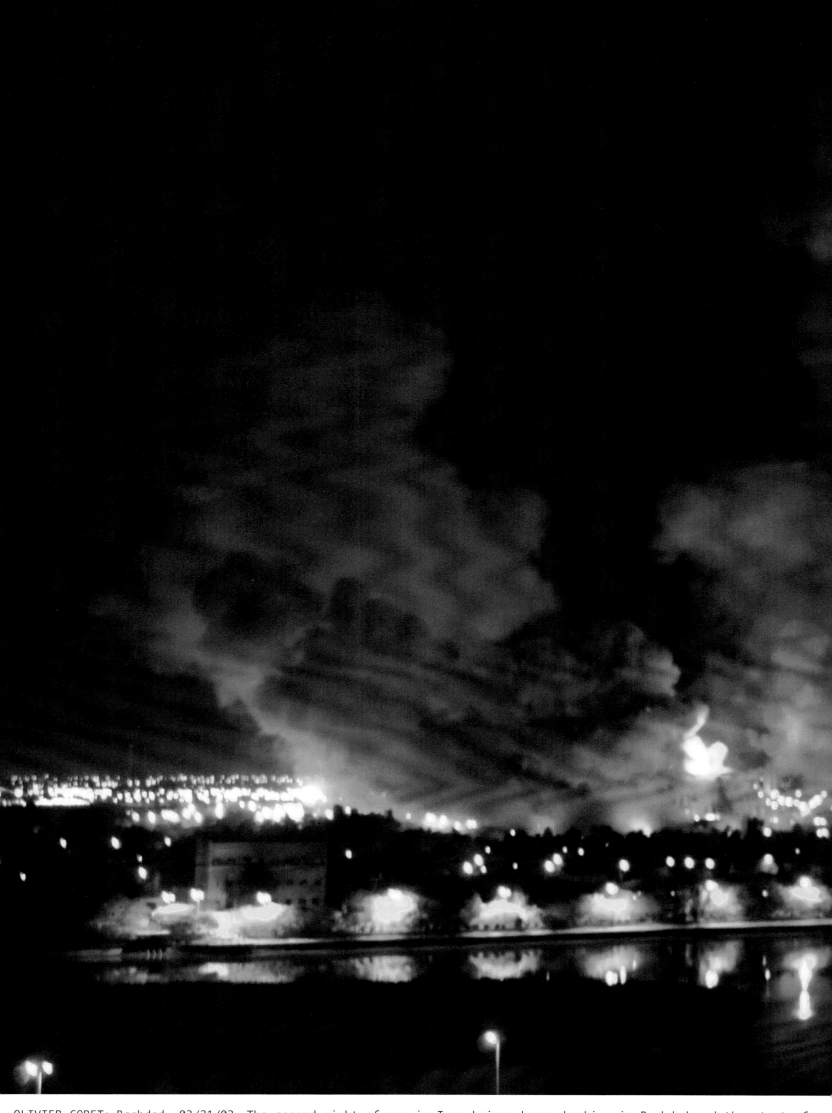

OLIVIER CORET: Baghdad, 03/21/03. The second night of war in Iraq brings heavy bombing in Baghdad and the start of

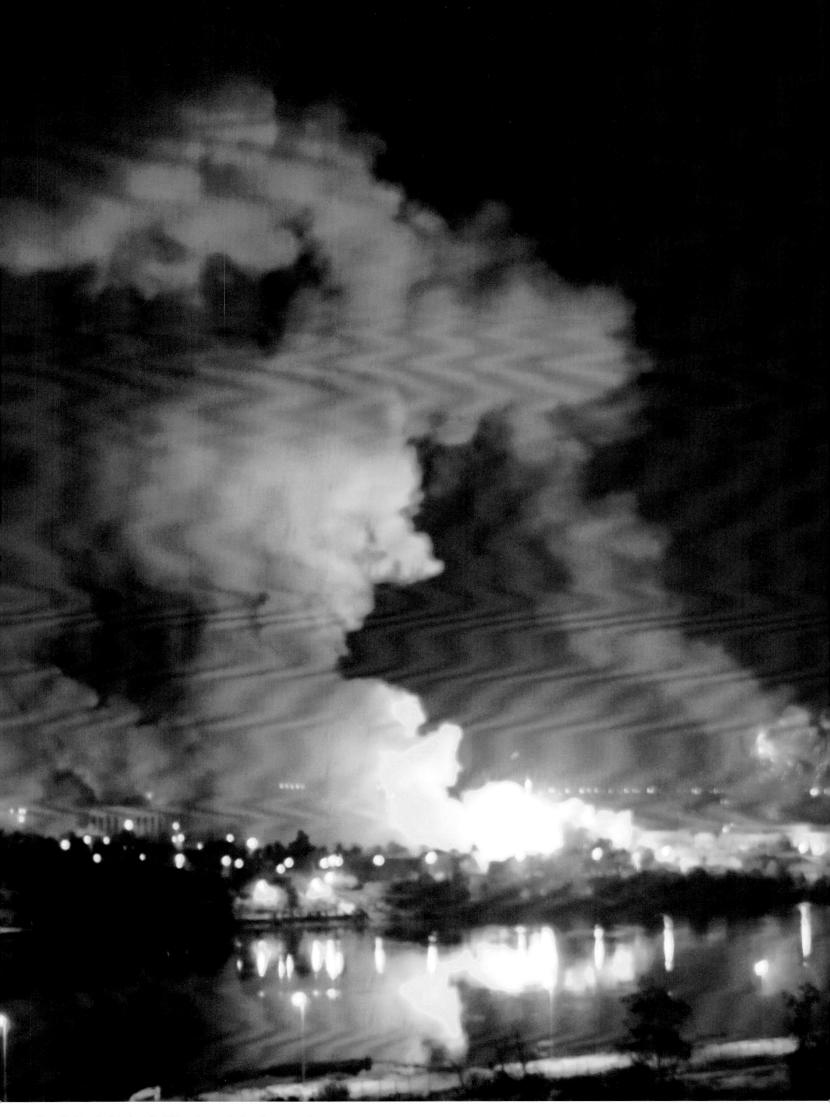

the United States' "Shock and Awe" campaign.

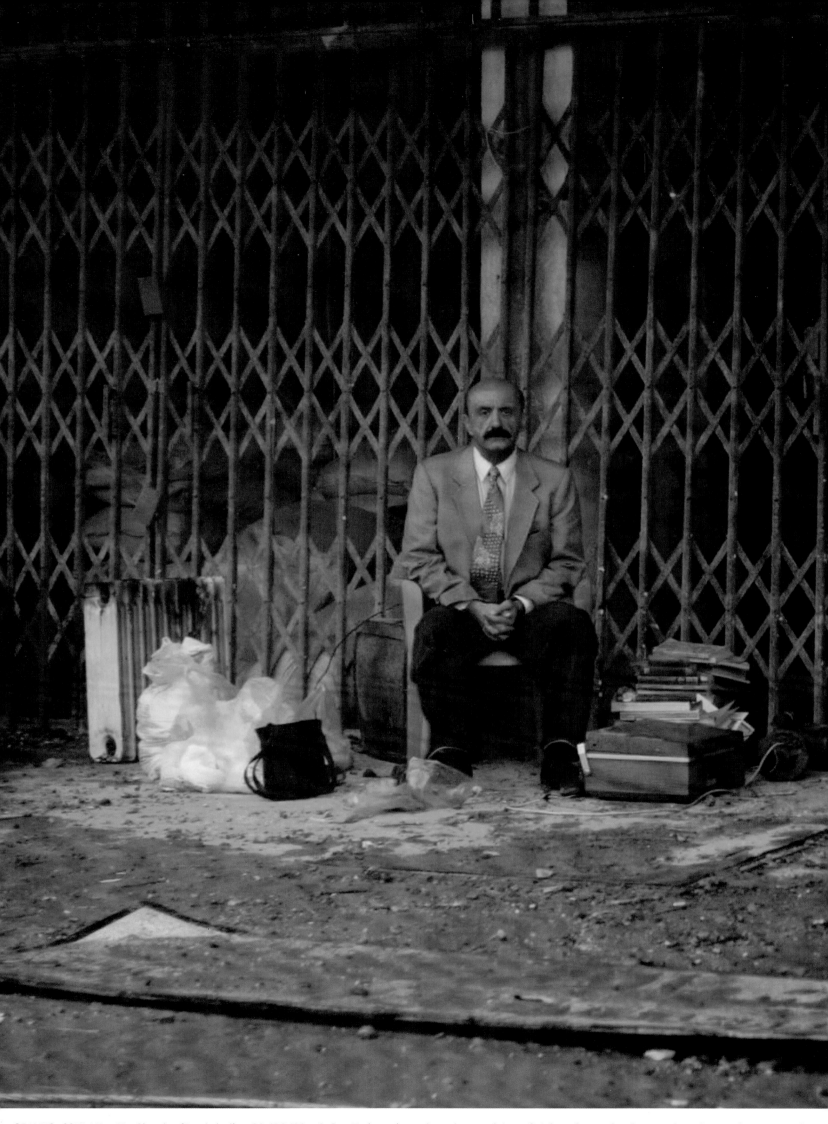

SEAMUS CONLAN: AL-Shaab (Baghdad), 03/26/03. Sala Izit sits dazed outside of his electrical repair shop after a U.S.

bombing raid kills 14 civilians and injures 30 in this northern residential area.

PREFACE

Throughout my career, I have always been in the fortunate and enviable position of being able to look at and edit pictures from some of the finest photojournalists working in the field. I have spent countless hours as the director of a photo agency editing film from photographers covering conflict in far-flung places. Most of the images I was looking at had not yet been seen by anyone, including the photographers in the field who took the pictures.

Now the digital age in upon us, and nowhere in photography is it more omnipresent than it is in photojournalism. The processing and shipping of film has given way to the uploading and transmission of the digital image. Digital cameras and computers have replaced processing labs. Images are sent all across the world via satellite phones. This is all happening in the field, all done by the photographer. The results are instantaneous, allowing us to see glimpses of war in "real" time.

This book gave me a new perspective on editing pictures. I had the challenging task of going through thousands and thousands of images, most of which were shot digitally, all of which were transmitted to various digital libraries. I accessed these libraries and edited the pictures from my computer. The journalists who made these images had already seen them in the field, and no doubt had done a first edit themselves.

The way in which war is covered has also changed. This book presents images taken by both independent and embedded photojournalists. Whether based in Baghdad, or with the Kurds in the North, independent journalists were free to move about, on their own, as their particular circumstances—and their willingness to take risks—allowed. Embedded journalists, on the other hand, were closely integrated and moved with the coalition forces. This, depending on circumstances, could provide either unprecedented access to remarkable images of the war, or sheer boredom, depending on the luck of the embedded. Both scenarios came with great personal risk. All of these journalists have my deepest admiration, gratitude, and respect.

There is no doubt that the still camera remains a powerful tool, and this book is a tribute to that. Through the eyes of some of the world's most renowned photojournalists working today, you will see the realities of war. You will witness courage, tragedy, heroism, fear, humor, and compassion. Through these powerful images of conflict, you will see not only the horrors of war, but humanity at its best.

—Marcel Saba
New York City, May 2003

TIMOTHY FADEK: Baghdad, 04/18/03. Families gather outside a former Baath Party office to check a list of those executed; more than 300 people on this list had been missing since 1998. Similar lists are being printed and posted throughout the city.

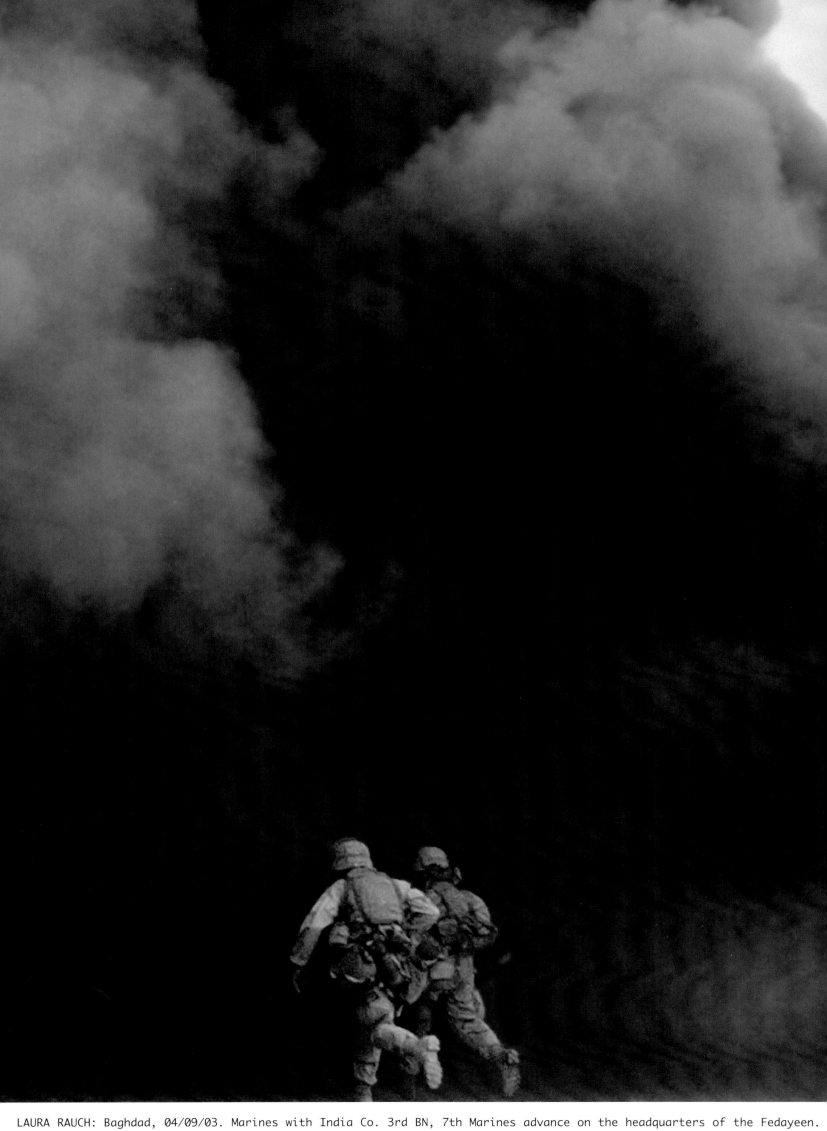

LAURA RAUCH: Baghdad, 04/09/03. Marines with India Co. 3rd BN, 7th Marines advance on the headquarters of the Fedayeen.

WITNESS IRAQ

A WAR JOURNAL

FEBRUARY–APRIL 2003

EDITED BY
MARCEL SABA

DESIGNED BY YOLANDA CUOMO

pH powerHouse Books New York, NY

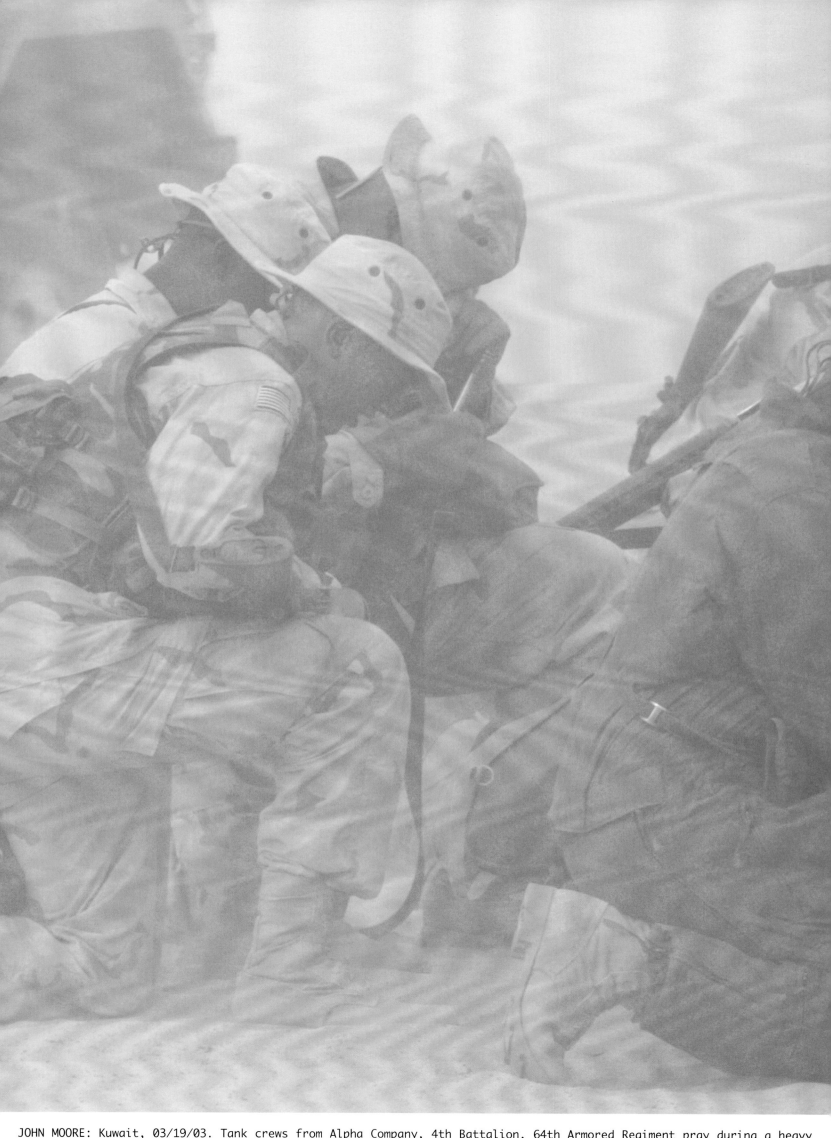

JOHN MOORE: Kuwait, 03/19/03. Tank crews from Alpha Company, 4th Battalion, 64th Armored Regiment pray during a heavy

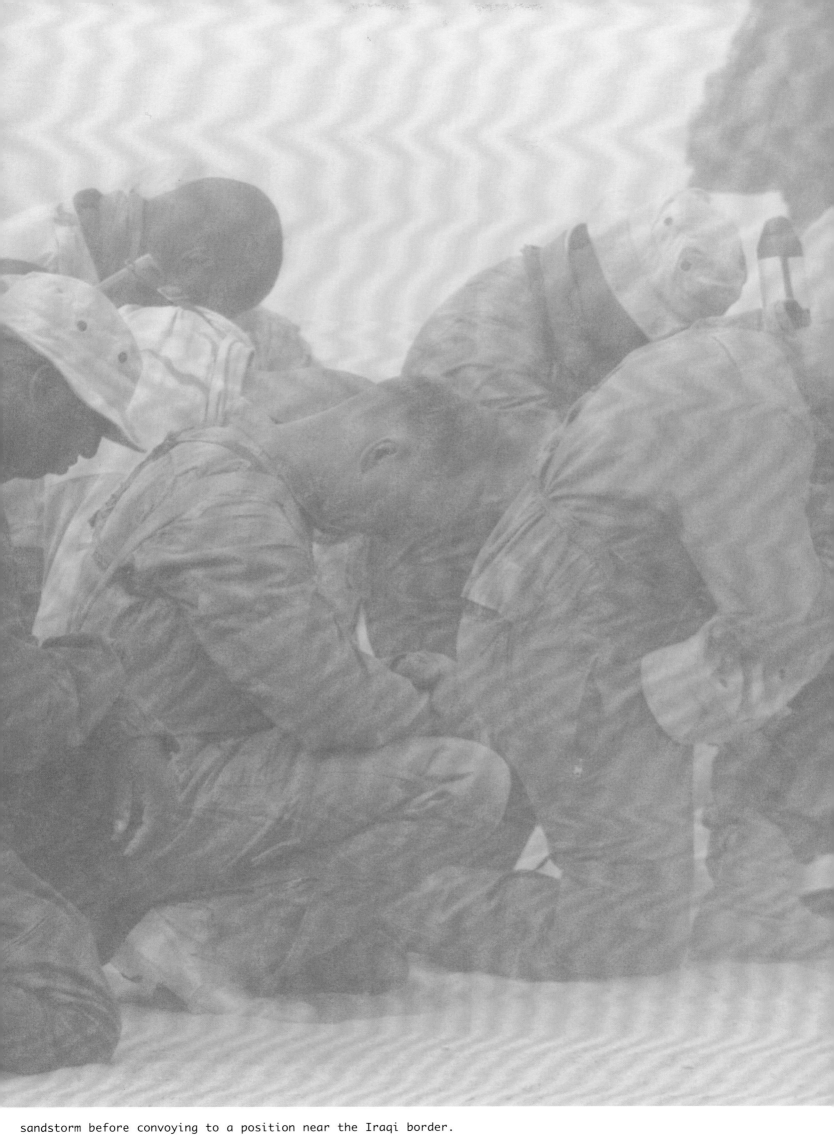

sandstorm before convoying to a position near the Iraqi border.

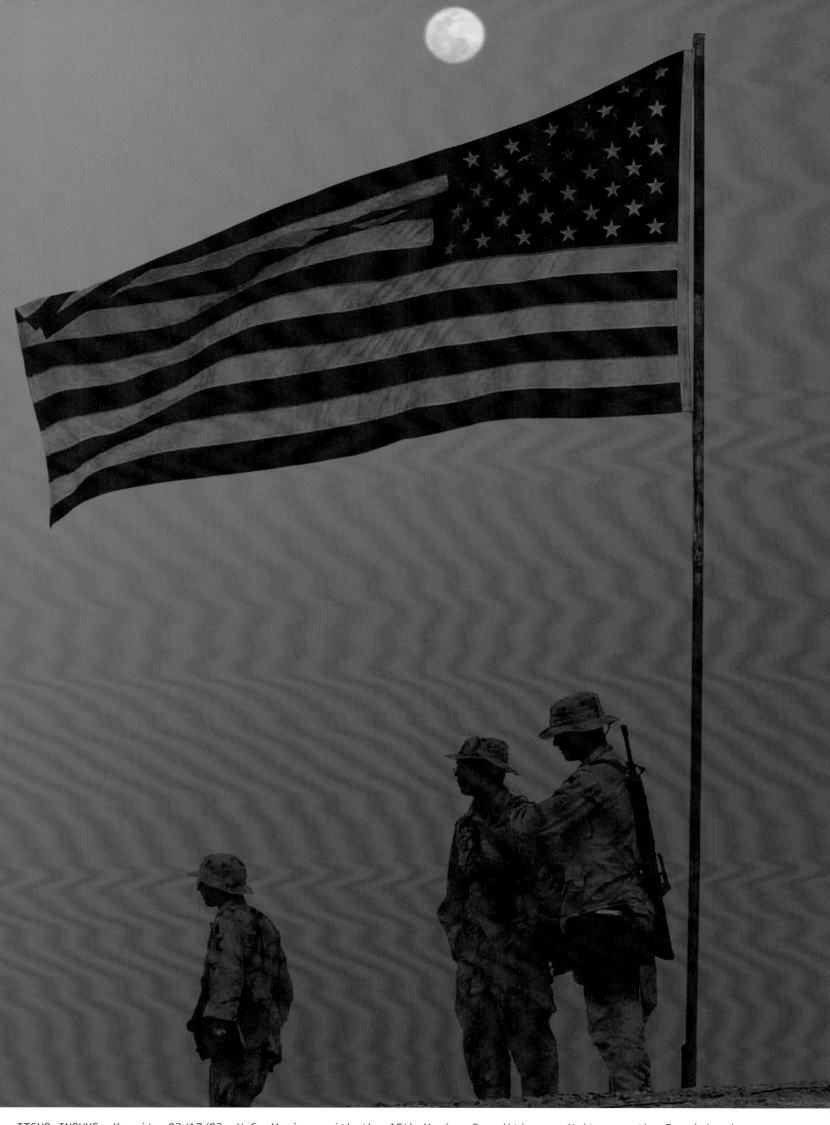

ITSUO INOUYE: Kuwait, 03/17/03. U.S. Marines with the 15th Marine Expeditionary Unit near the Iraqi border.

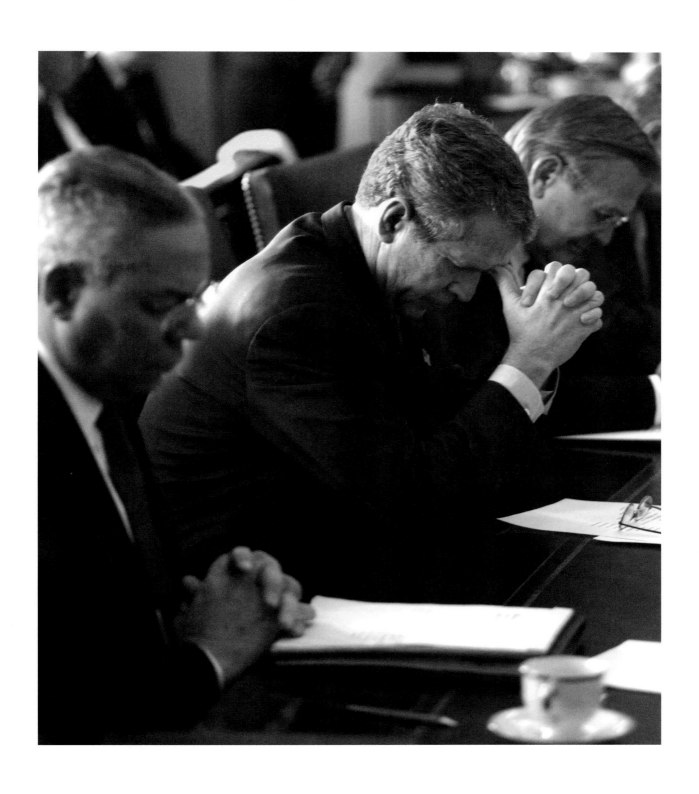

BROOKS KRAFT: Washington, 02/28/03. President Bush starts a cabinet meeting the morning of his State of the Union Address.

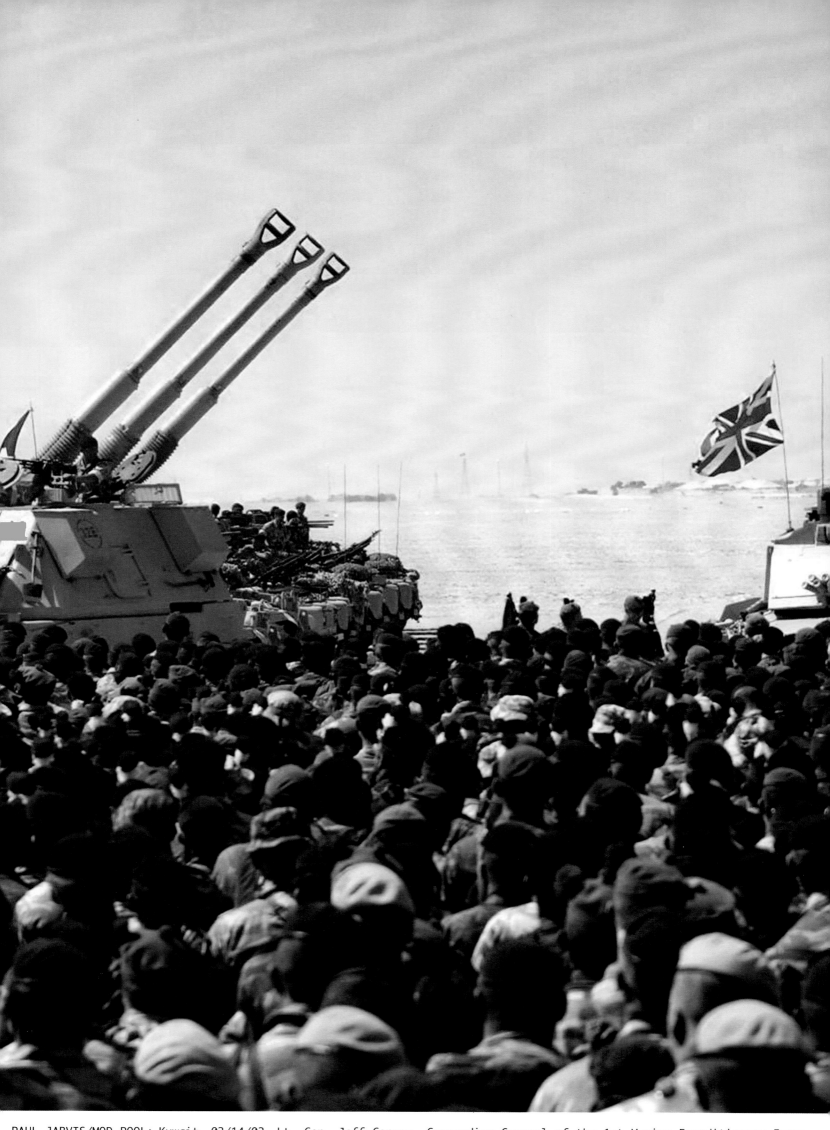

PAUL JARVIS/MOD POOL: Kuwait, 03/14/03. Lt. Gen. Jeff Conway, Commanding General of the 1st Marine Expeditionary Force,

addresses the British troops in Kuwait taking part in Operation Telic, the UK's preparation for the conflict with Iraq.

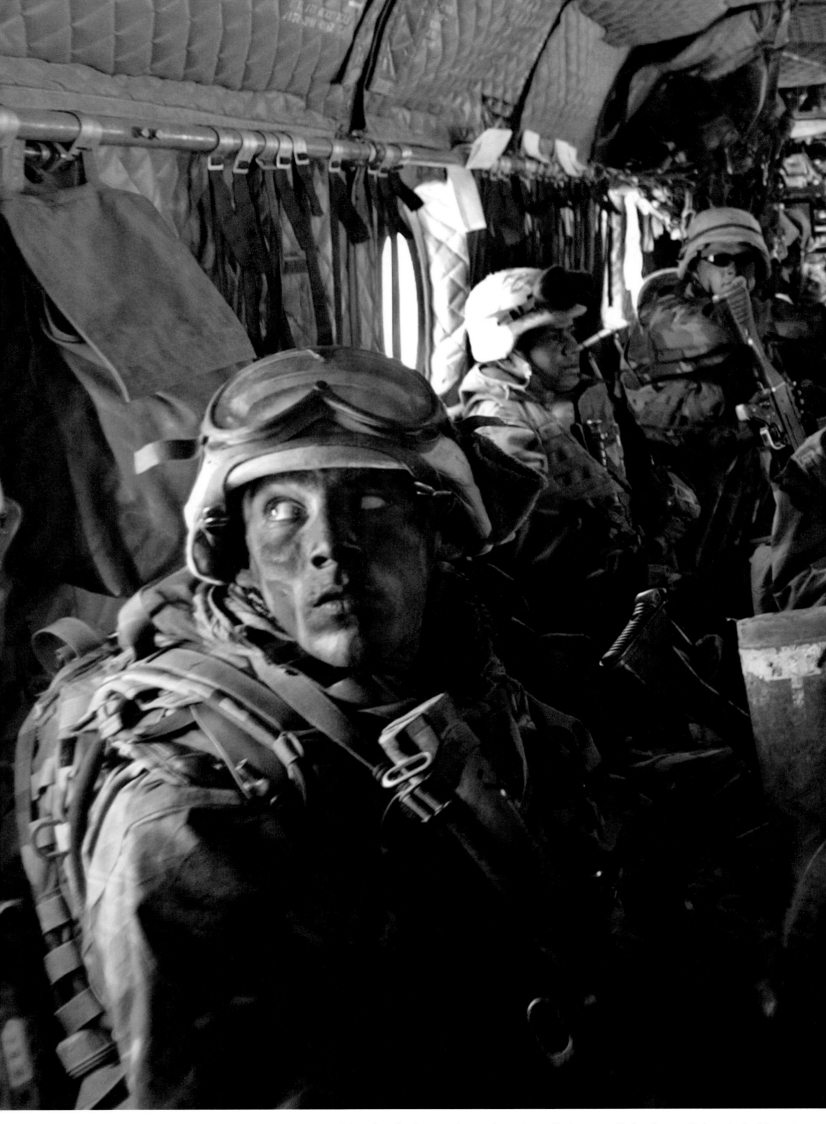

DESMOND BOYLAN: Iraq, 03/28/03. Fox Company "Raiders" of the 15th Marine Expeditionary Unit in a Chinook helicopter

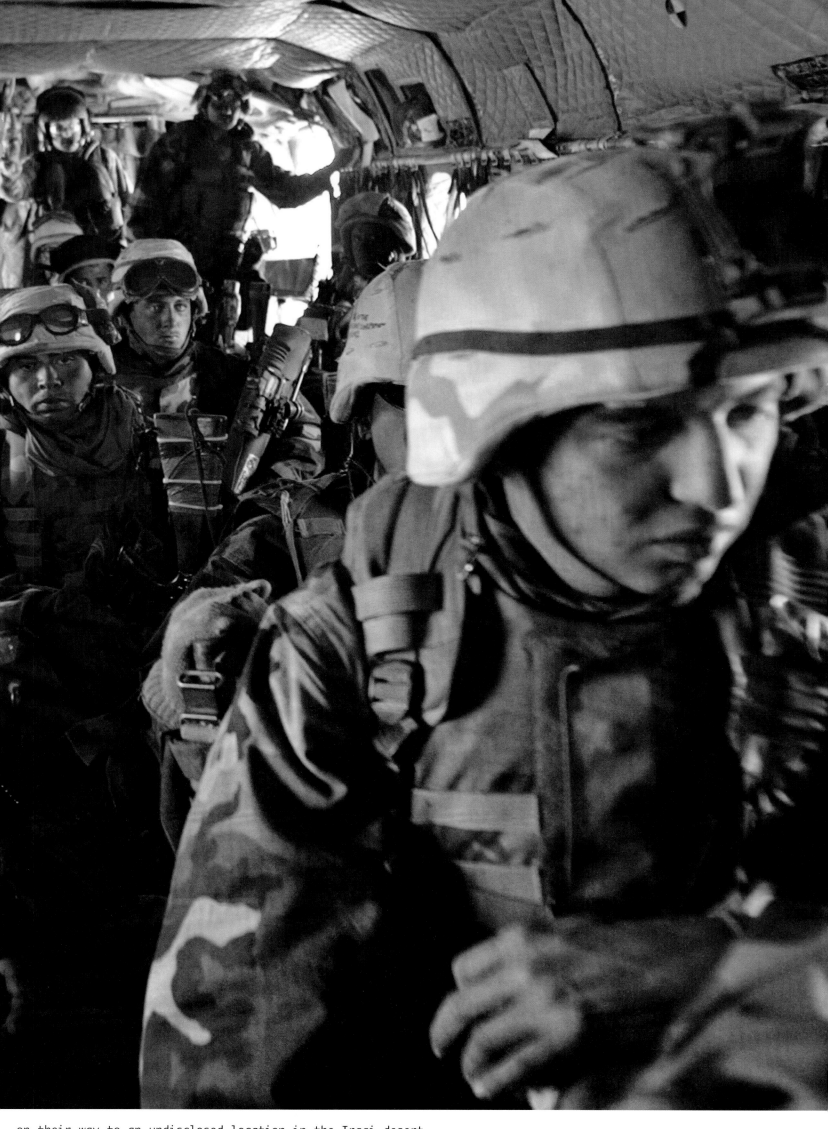

on their way to an undisclosed location in the Iraqi desert.

BETWEEN IRAQ & A HARD DRIVE
March 2, 2003 Jordan-Iraq border

Our passage into Iraq was relatively smooth this time, compared to the trip last year, when it took eight hours to cross the border. This time the uniformed border guards kept us waiting just several hours. They searched our car and temporarily confiscated our satellite phones and computers. At least they didn't take the good stuff, the stash of Stoli that I hid down the back seat.

Driving across the desert from Jordan on this superhighway (built during the last twenty years by the French), I pass oil tanker after oil tanker, coming and going into Jordan. I can't help but think what the future of this whole region will be like in the coming weeks.

On my last visit on assignment, the Iraqis were surprisingly warm and charming. Their openness was something I hadn't anticipated in the least, given what has been hanging over them and what they have gone through over the last twelve years. My story on everyday citizens—some of the 36 million men, women and children of Iraq—revealed some surprising insights. I'm surprised to hear that even MTV crews are now roaming around the region in hope of educating their young audience on the effects the looming war will have on typical Iraqis. Good to know that MTV kids are going to be dished up some reality. That can only be a good thing, considering the teenagers of Gaza know more about world politics than most journalists I know.

The coming hours—when I reach Baghdad—will tell me how things have changed there. I cannot be naive enough to think that these last, tense days and weeks have not affected the population in some tangible ways. Unable to receive much information outside the Iraqi media, the Iraqis rely on government channels. I wonder what Saddam has been serving up instead. After all, his people know little or nothing of the systematic executions that take place in their country, and the gassing of the Kurds. They don't fully realize that their jails are full of political prisoners whose only crime has been to speak out, as in a normal society.

At one point on my last visit, I was asked how I felt about the Iraqi people themselves. I answered by saying, "The only difference between us is that I was born in a different country." After all, each of us is a product of our own circumstances—sometimes this makes for a sad reality, but it's the one basic true condition. If I had been born in Gaza, I would be throwing stones at the Israelis; if I had been born in Israel, I would be shooting Palestinians throwing stones at me. So why am I heading towards Baghdad on this desert highway?

"What's the news?" I'm asked as I'm greeted in the main media haunt, the Al Rasheed Hotel. Good question. What will this war be like and how will I, honestly, handle this situation once the 2,000-lb bombs begin to drop outside my hotel bedroom? Taking the necessary precautions has always been my forte to surviving a war zone. Earlier during this whirlwind month, I had the bizarre experience of rolling up to the MOD (Ministry of Defence) in England with my great mate, photographer Seamus Murphy, to learn about chemical, biological, and radioactive weapons of war—and, most importantly, to learn how to survive them in an attack. We were put through drills in gas chambers with CS gas to learn to use respirators and chemical suits. I couldn't help but think how easy this might be in the heat of the Iraqi desert, without the body armor and hardhat on. Learning how to drink water—while still encased in a gas mask—I really began to pay attention. I soon realized that in case of an emergency, sleeping in the bathtub with a mattress covering me might be an actual survival option. So would having a portable shower bag filled with antibacterial soap hanging at the ready above the bath. And what about the industrial earmuffs and safety glasses to make life easier once the canisters and warheads began to drop? I quickly understood: I'd look like a fool, but a 2,000-lb bomb dropped on the presidential palace, only a few hundred yards away from my hotel room, would otherwise make my ears bleed, and the flying glass would catch me by surprise. I thought to myself: securing the windows with duct tape will be my first job upon hitting the ground at the Al Rasheed.

Although the hotel staff may be alarmed to see this sort of activity, I guess it wouldn't be surprising, given that a few hundred journalists would be staying there. Not in a hotel known for its Gestapo-esque attendants and a wiretap or two in every room.

Thinking about the situation that I'm going to have to deal with, both mentally and physically, is very daunting. Putting aside what average Iraqis will have to cope with, I selfishly think about my beautiful daughter and her lovely mother. What will I miss? I have already missed her first day at "big school" and my wife's 31st birthday. In fact, I felt guilty having been unable to join them on that first leg of our new life together in New York.

So now we high-tail it along our desert highway. Tara and the gang mind the agency, for the moment, and we rumble on to meet our destiny with the Iraqi people, and with a war neither we nor the Iraqis really want.

—Seamus Conlan

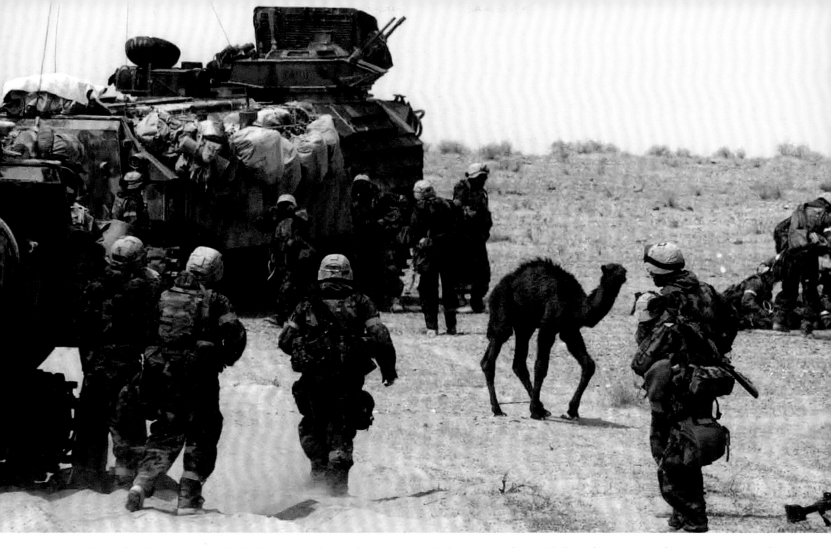

HAYNE PALMOUR: Southern Iraq, 03/21/03. A Marine column in amphibious assault vehicles first day of the invasion of Iraq.

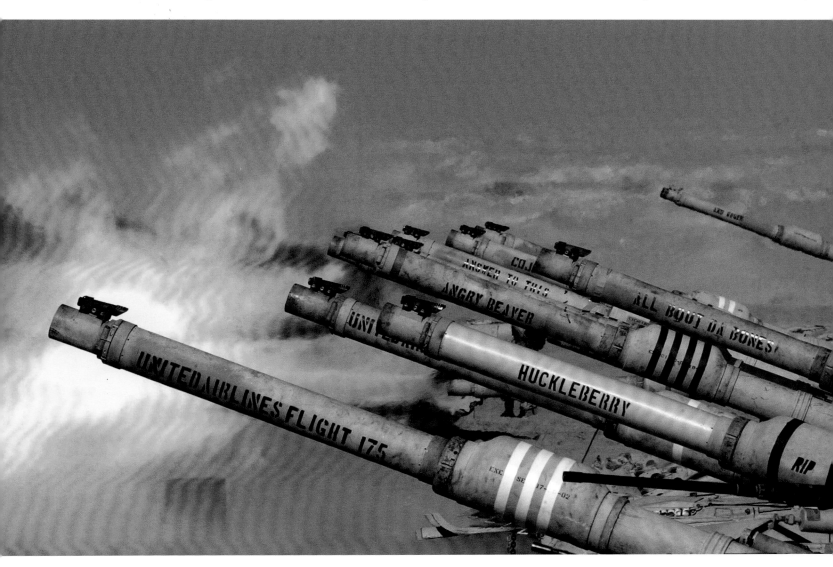

SCOTT NELSON: Kuwait, 02/06/03. U.S. Army M1A1 Abrams tanks from Task Force 1-64 fire live rounds during a training session.

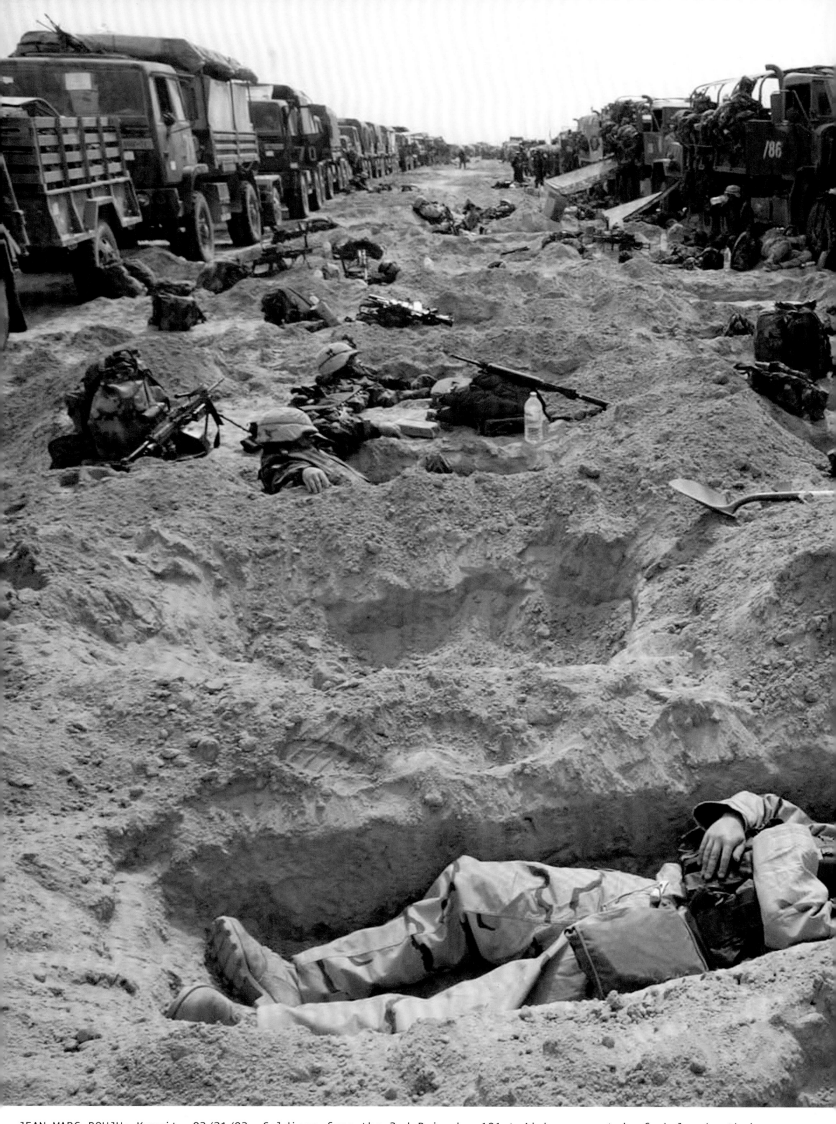

JEAN-MARC BOUJU: Kuwait, 03/21/03. Soldiers from the 3rd Brigade, 101st Airborne rest in foxholes by their convoy

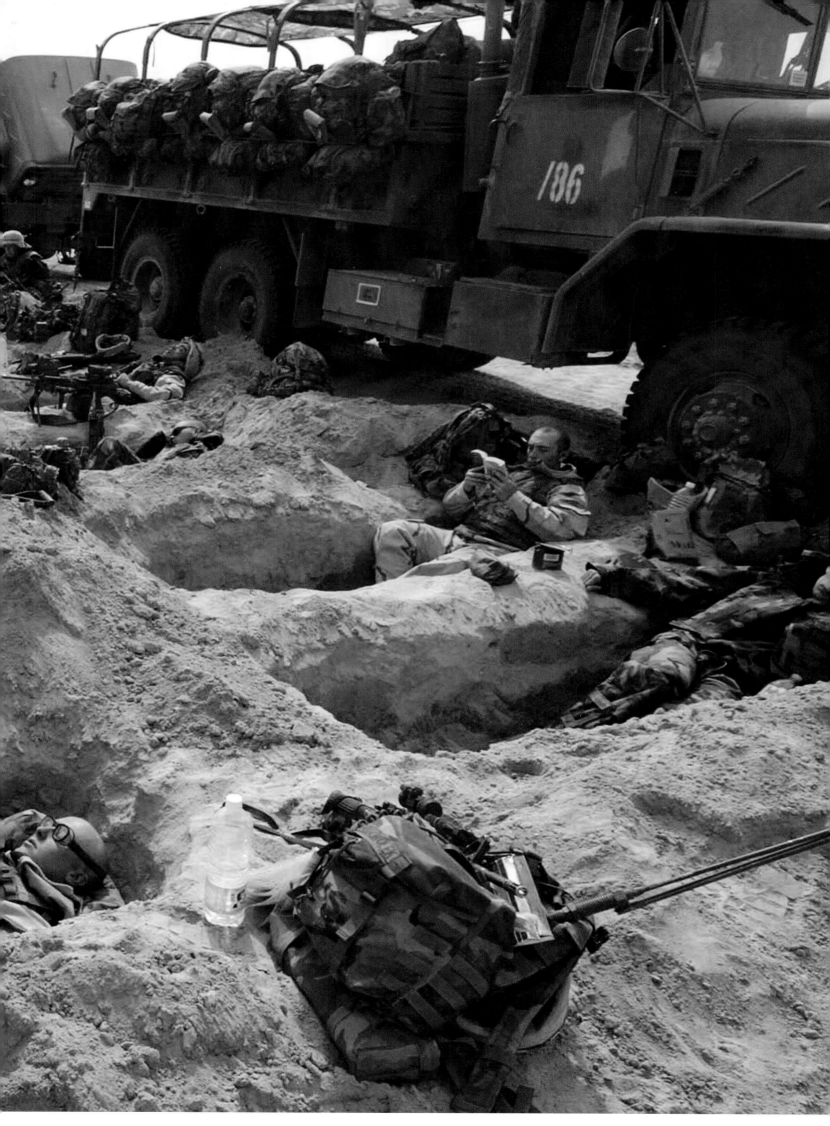

in a staging area.

>>The dictator who is assembling the world's most dangerous weapons has already used them on whole villages—leaving thousands of his own citizens dead, blind, or disfigured. Iraqi refugees tell us how forced confessions are obtained—by torturing children while their parents are made to watch. International human rights groups have catalogued other methods used in the torture chambers of Iraq: electric shock, burning with hot irons, dripping acid on the skin, mutilation with electric drills, cutting out tongues, and rape. If this is not evil, then evil has no meaning. >>Applause<< And tonight I have a message for the brave and oppressed people of Iraq: Your enemy is not surrounding your country—your enemy is ruling your country. >>Applause<< And the day he and his regime are removed from power will be the day of your liberation. >>Applause<<

–President Bush, State of the Union Address,
January 2003

>>Tomorrow is the day we determine whether or not diplomacy can work…Tomorrow is a moment of truth for the world…Many nations have voiced a commitment to peace and security, and now they must demonstrate that commitment in the only effective way, by supporting the immediate and unconditional disarmament of Saddam Hussein.<<

–President Bush, Azores Summit,
March 16, 2003

>>All the decades of deceit and cruelty have now reached an end. Saddam Hussein and his sons must leave Iraq within forty-eight hours. Their refusal to do so will result in military conflict, commenced at a time of our choosing. For their own safety, all foreign nationals—including journalists and inspectors—should leave Iraq immediately.<<

–President Bush, March 17, 2003

>>Removing Saddam will be a blessing to the Iraqi people. Four million Iraqis are in exile. Sixty percent of the population dependent on food aid. Thousands of children die every year through malnutrition and disease. Hundreds of thousands have been driven from their homes or murdered. I hope the Iraqi people hear this message. We are with you. Our enemy is not you, but your barbarous rulers.<<

–Prime Minister Blair, March 20, 2003

>>The enemy should be in no doubt that we are his nemesis and that we are bringing about his rightful destruction. There are many regional commanders who have stains on their souls, and they are stoking the fires of Hell for Saddam. As they die they will know their deeds have brought them to this place. Show them no pity. But those who do not wish to go on that journey, we will not send. As for the others, I expect you to rock their world.<<

>>We go to liberate, not to conquer. We will not fly our flags in their country. We are entering Iraq to free a people, and the only flag that will be flown in that ancient land is their own. Don't treat them as refugees, for they are in their own country.<<

>>I know men who have taken life needlessly in other conflicts. They live with the mark of Cain upon them. If someone surrenders to you, then remember they have that right in international law, and ensure that one day they go home to their family. The ones who wish to fight, well, we aim to please. If there are casualties of war, then remember, when they woke up and got dressed in the morning, they did not plan to die this day. Allow them dignity in death. Bury them properly, and mark their graves.<<

>>You will be shunned unless your conduct is of the highest, for your deeds will follow you down history. Iraq is steeped in history. It is the site of the Garden of Eden, of the Great Flood, and the birth of Abraham. Tread lightly there. You will have to go a long way to find a more decent, generous, and upright people than the Iraqis. You will be embarrassed by their hospitality, even though they have nothing...<<

>>There may be people among us who will not see the end of this campaign. We will put them in their sleeping bags and send them back. There will be no time for sorrow. Let's leave Iraq a better place for us having been there. Our business now, is north.<<

–Lieutenant Colonel Tim Collins,
Commander of the Royal Irish Battle Group,
speaking to the coalition forces
massed at the Kuwait-Iraq border

>>Read the President's speech today. The clock is ticking.<<

>>It took almost forty minutes to download all of my email this morning. Breakfast was a packet of MRE peanut butter as I browsed through the messages.<<

>>Got some great photos of my nephews. They're growing up so fast.<<

>>>Thanks again for all of your kind messages. Don't have time to read them all, but I do appreciate them.<<

>>One letter in particular made my eyes tear up:
 >Hi-
 My daughter gave me your email address…I've been reading your journal and love your sense of humor, rationale, and reasoning. My husband was on Flt. 175, the 2nd plane to hit the WTC. Of course we're all missing him so much and sometimes can't believe what happened that day. You have my prayers every day. And I'm grateful for your incredible sacrifices, just living in the desert, anticipating this war, being away from home for so long, etc. etc. is more than I can imagine doing.<<
 May God be with you!<<
 >Cathie Jalbert
 >Wife of Robert A. Jalbert
 >United Flt. 175

>>We will not forget.

>>And we will not rest as long as our freedom and safety is threatened.

>>I've got to go to work now.

>>I'll post again when I can.

>>>>>Posted by LT Smash at 06:50 AM
>>>>>U.S. Serviceman stationed in Kuwait
>>>>>March 19, 2003

JOE RAEDLE: Nasiriyah, 04/02/03. U.S. Marine Lance Corporal Jacob Noack from Houston, Texas of Task Force Tarawa.

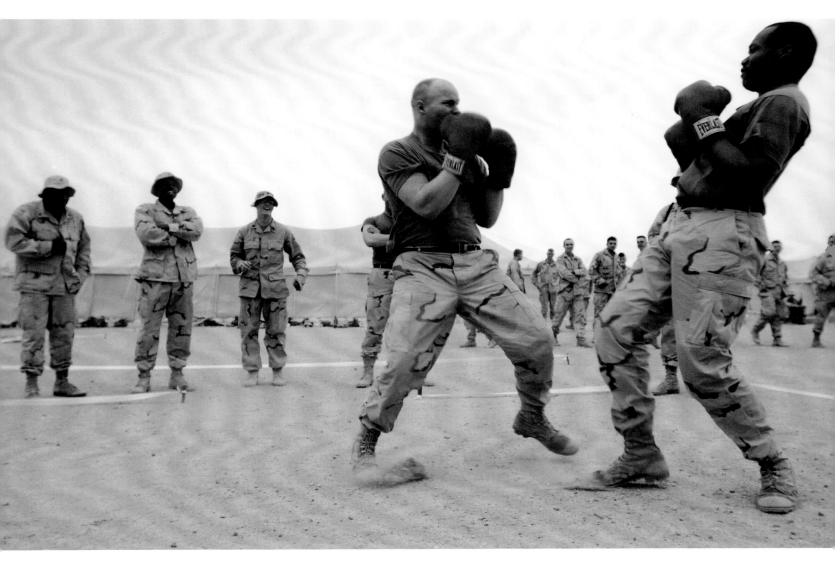

JAMES HILL: Camp Virginia, Kuwait, 03/11/03. Soldiers from the 41st Infantry Regiment box for amusement after training.

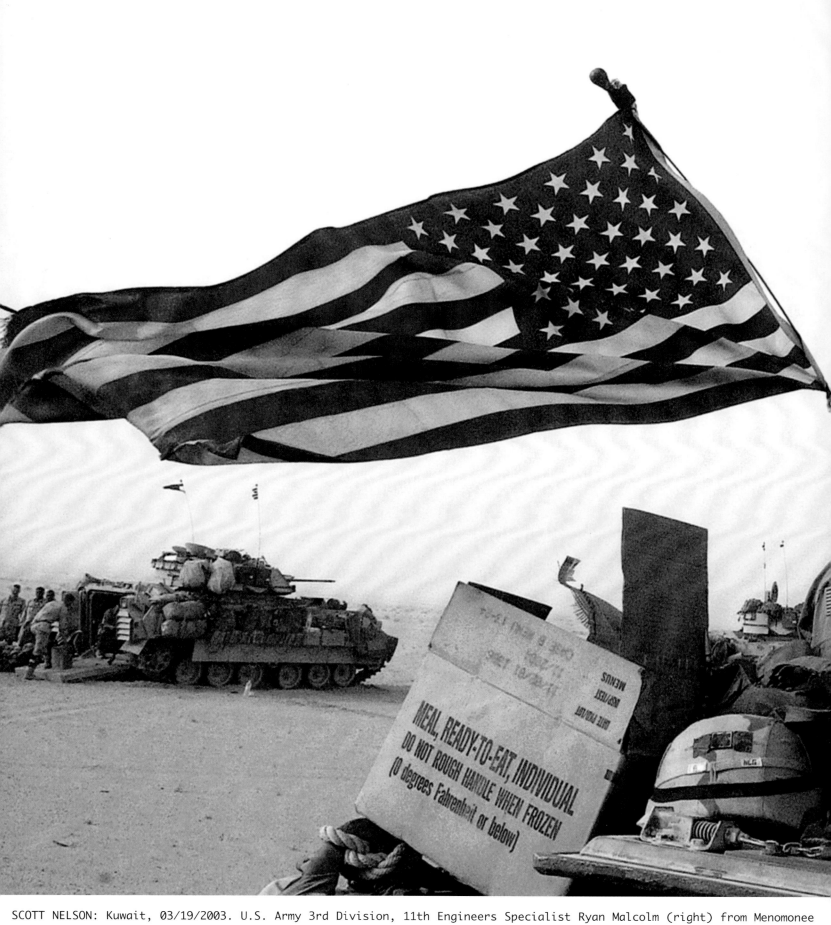

SCOTT NELSON: Kuwait, 03/19/2003. U.S. Army 3rd Division, 11th Engineers Specialist Ryan Malcolm (right) from Menomonee

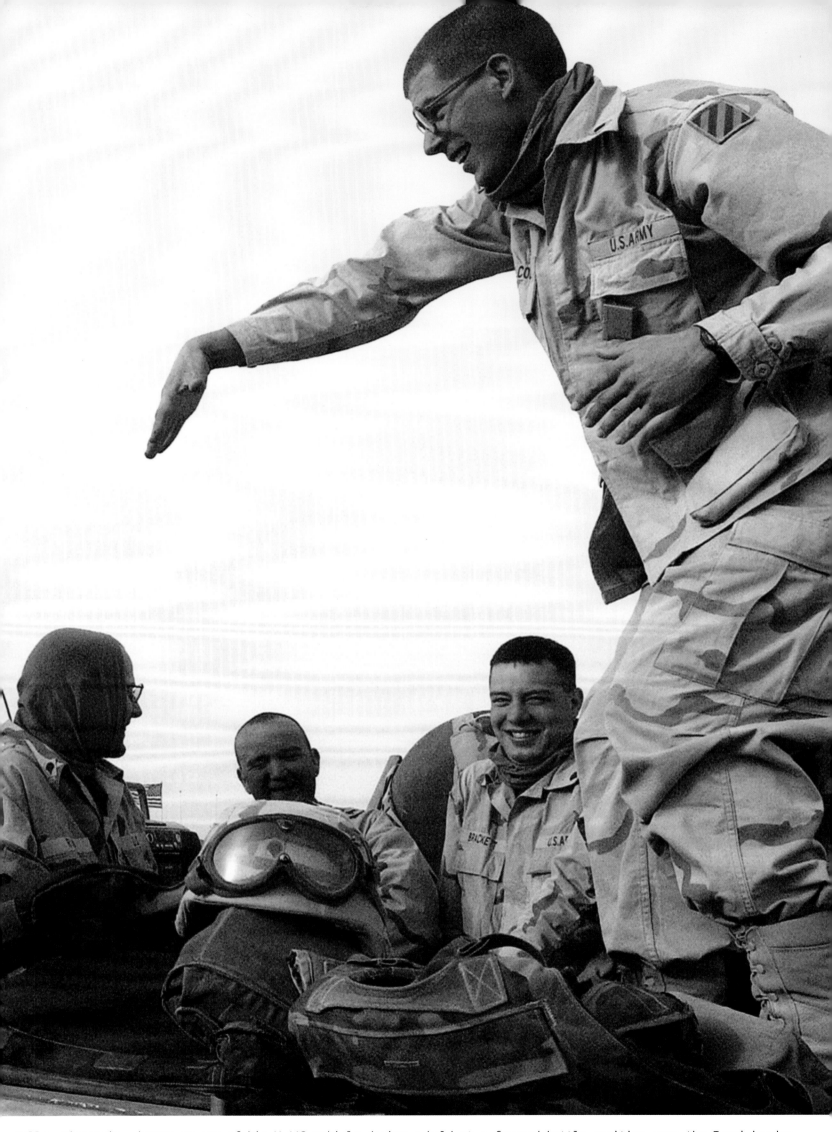

Falls, Wisconsin, dances on top of his M-113 vehicle during a hold at a forward battle position near the Iraqi border.

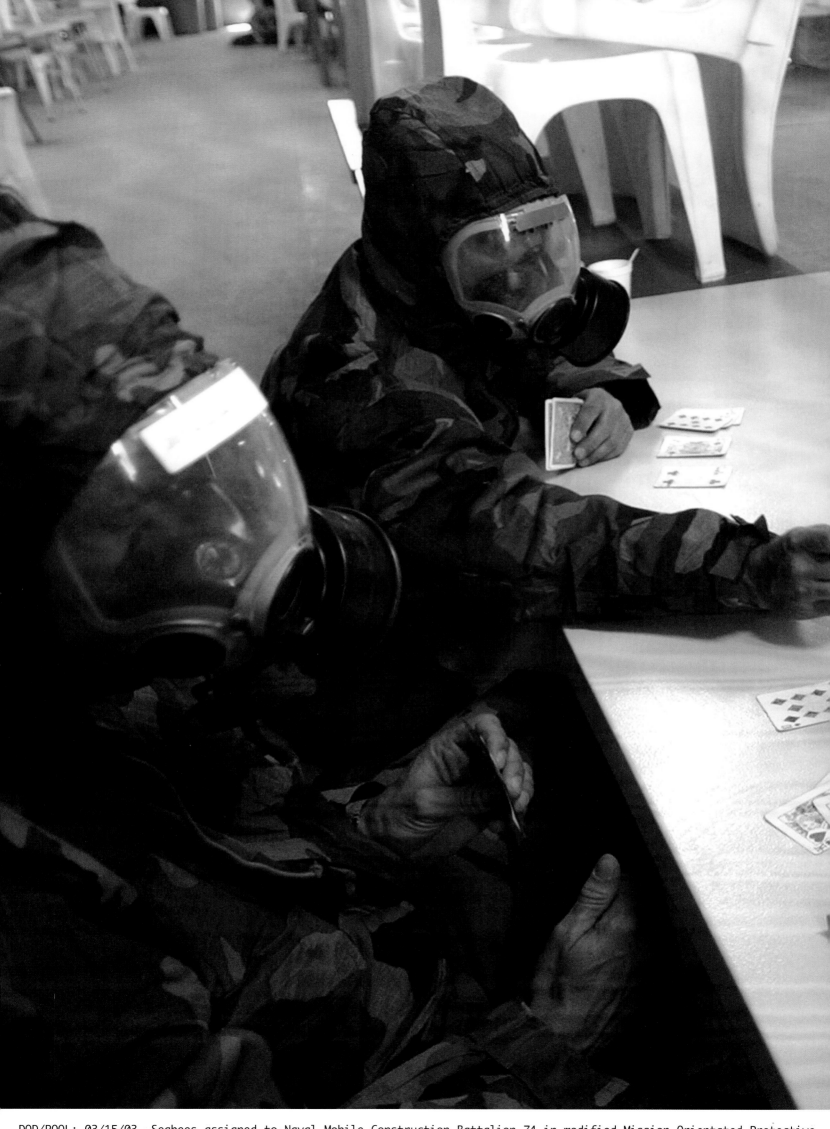

DOD/POOL: 03/15/03. Seabees assigned to Naval Mobile Construction Battalion 74 in modified Mission Orientated Protective

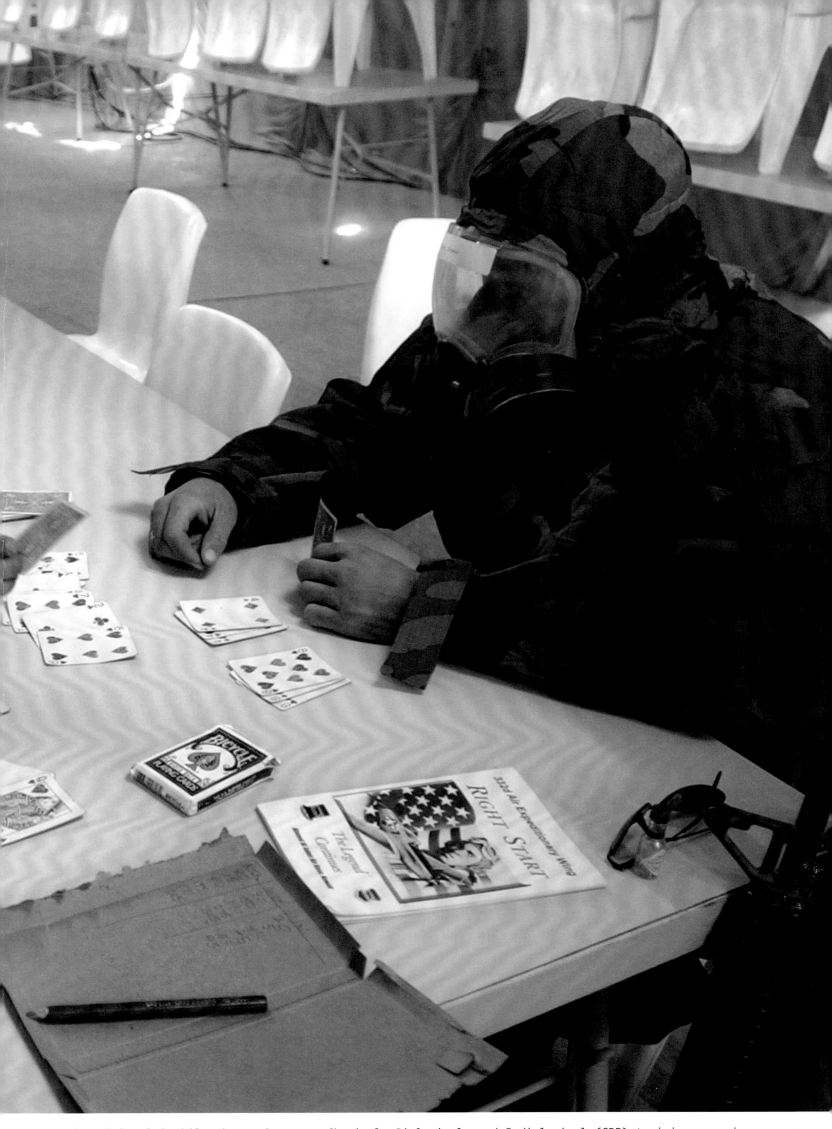

Posture (MOPP) level-3 while they wait out a Chemical, Biological, and Radiological (CBR) training exercise.

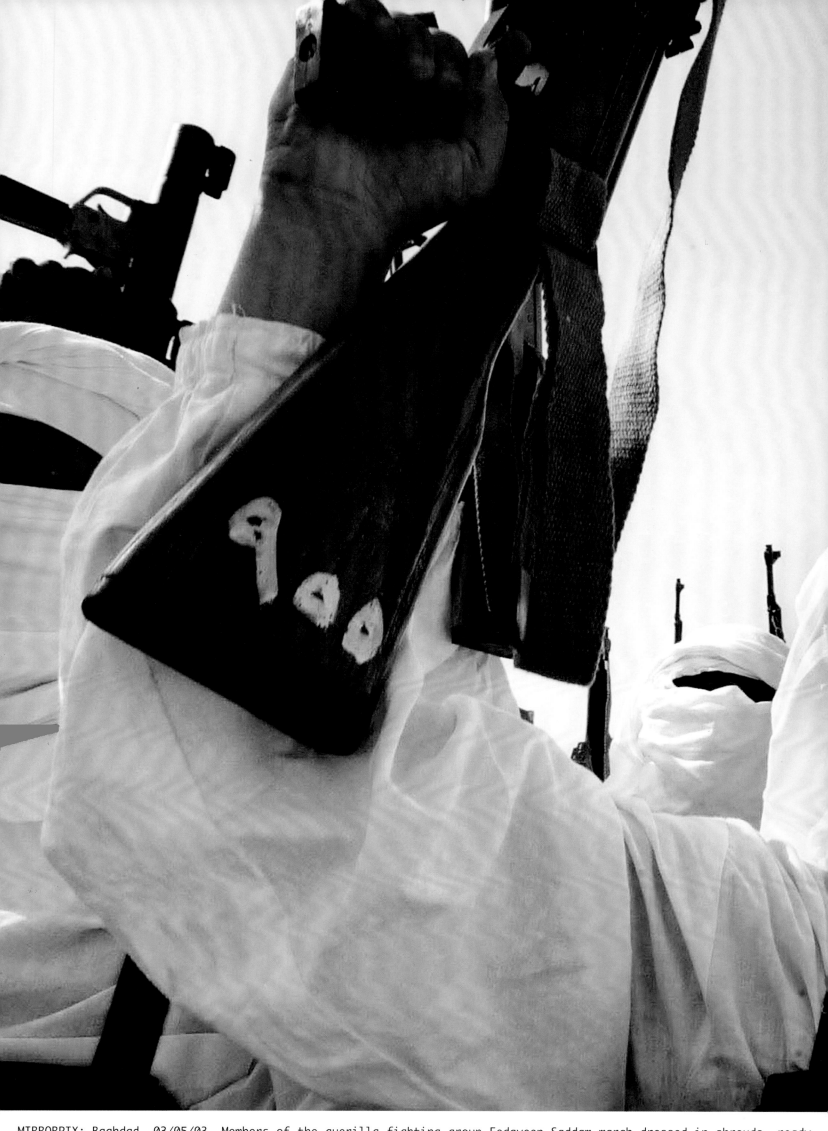

MIRRORPIX: Baghdad, 03/05/03. Members of the guerilla fighting group Fedayeen Saddam march dressed in shrouds, ready

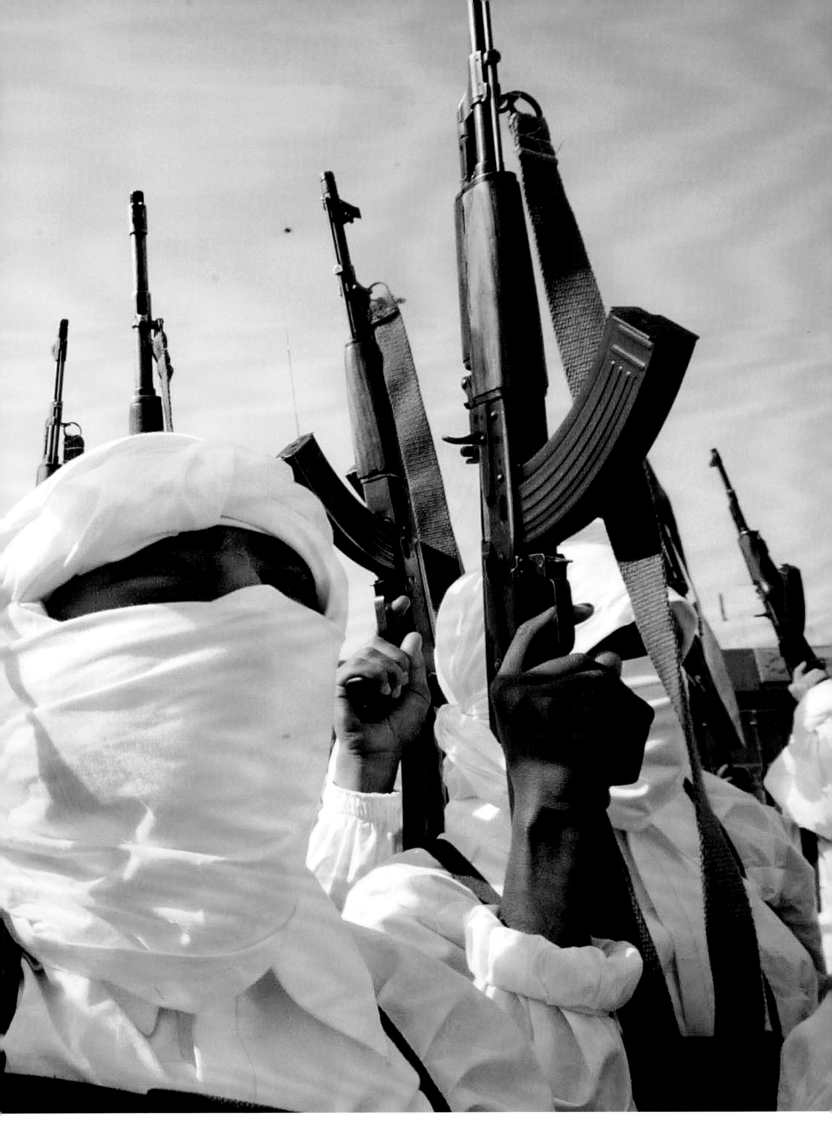
to die in battle.

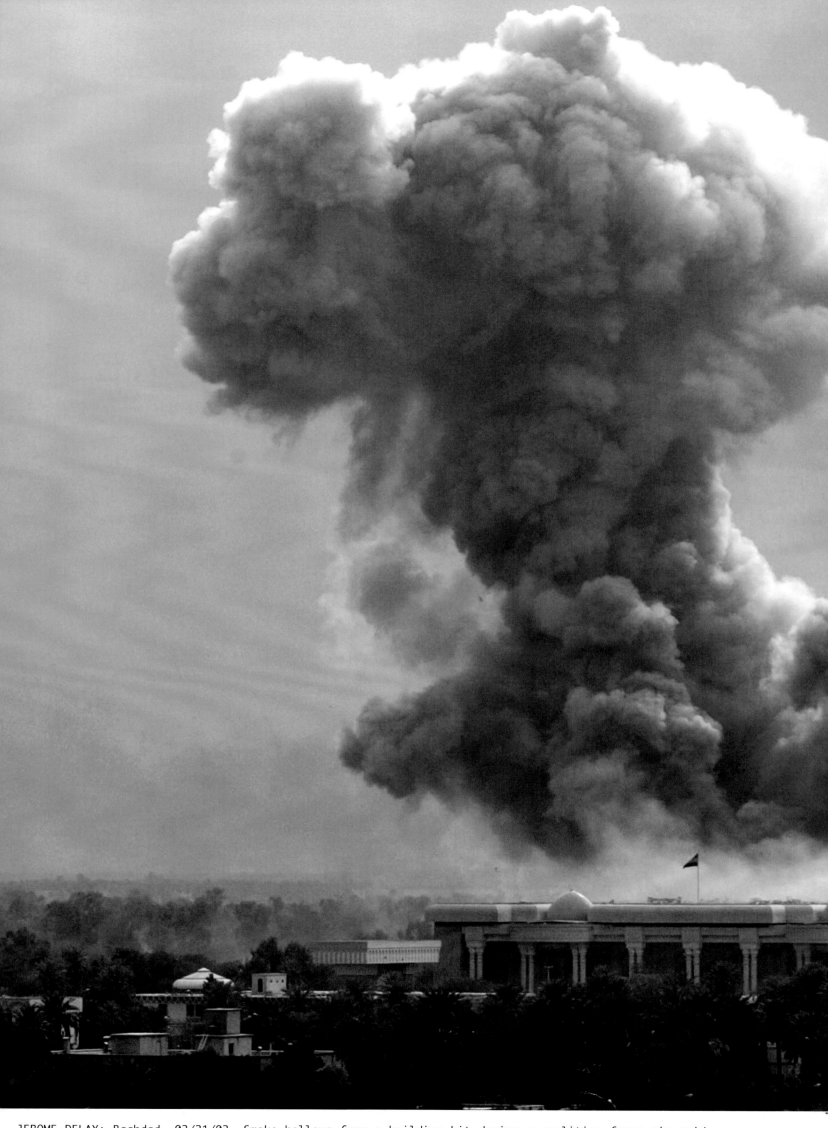

JEROME DELAY: Baghdad, 03/31/03. Smoke bellows from a building hit during a coalition force air raid.

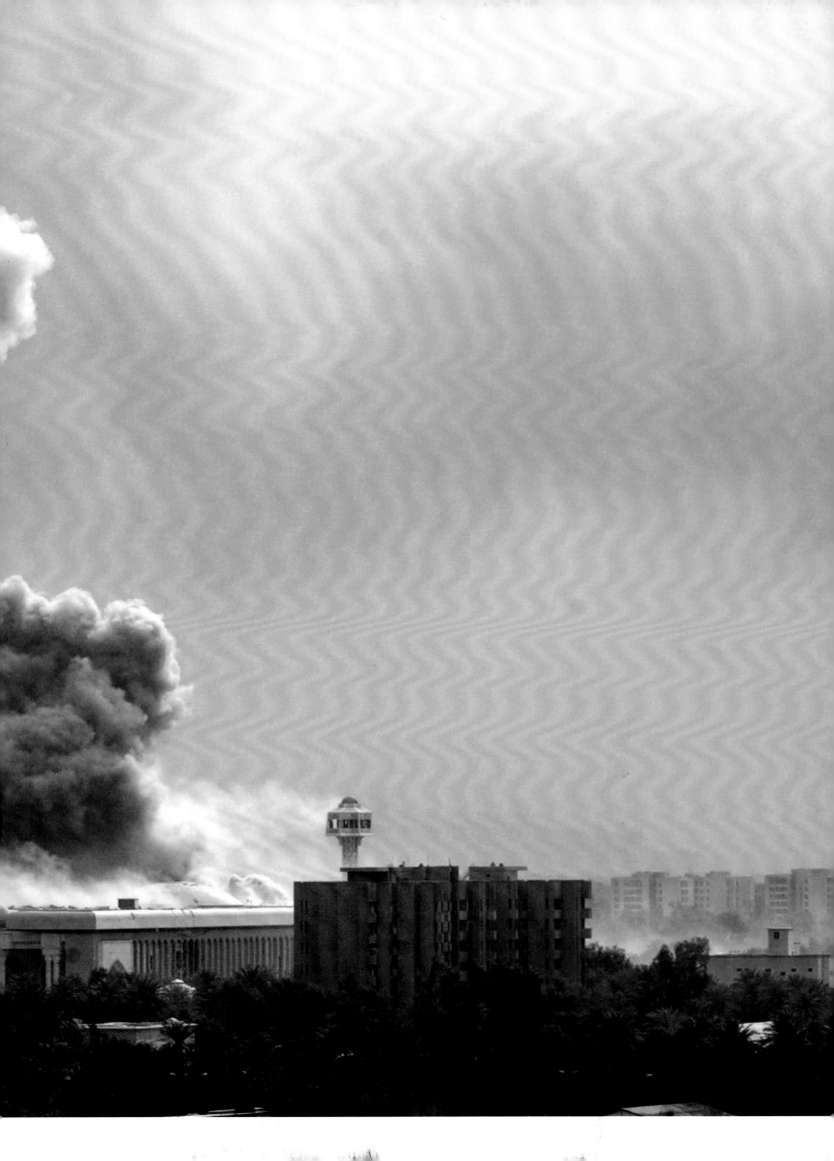

March 20, 2003 Al Rasheed balcony, Baghdad

Just before the Pentagon gave warning to all journalists to leave Iraq in the next 48 hours, more than half had already made their minds up. "Have you heard?" "What if they take us as human shields?" "What are you going to do if they come room to room?" After a few heart-to-hearts with friends at the bureaus back home, word begins to spread quickly that doubt has set in among the press. This is a hardcore group that I tend to see from one conflict to another—an extended family on the move, growing over the years. Fear begins to take hold among some of the commissioning editors who've sent us here. No one wants blood on their hands. A few journalists clearly want to leave, but don't want to be the first to do so. Some are clearly spreading alarm. "Are you leaving, are you leaving?"

Many things run through your mind quickly. Rumors spread like the oil fires outside my window: They will round us up to use as human shields; the street fighting will be too dangerous to cover; chemical weapons will be unleashed—such talk flies around the press center. Fear will kill you, my mother always said. Over the last week, this has preoccupied me.

The next day, pullout is in the air. Supposedly the Pentagon has been contacting news organizations, and before long the ministry building that houses the press is being emptied. Only a few empty tents, which only a few hours earlier had been the live-feed point for the networks, are left. What is happening here? Is the U.S. government legitimately concerned about our safety? Or do the allied commanders know that the press corps is on its own? We are out of their control, unlike the embeds traveling with them. We are free to express what we see and say.

We get the order to go quickly. Some have no choice in the matter; they could lose their jobs. I, on the other hand, am a freelancer. Nonetheless, I have my wife and our daughter to think about. But also my career and what I feel is right are important. I know deep down that I came here to do a job, and I haven't even begun yet. How could I abandon the Iraqi people I've covered these past weeks and months? The women and children who live here have nowhere else to go. So why should I? I would love to see my loved ones; it hurts me to say it, but I have to stay.

Pete leaves at 5:00 A.M. the day before the deadline. James (Nachtwey) awakens me to help fix his equipment. I'd been up until after two in the morning loading drivers for his computer. We all help one another as we can. We're journalists. TV teams, in contrast, come with military advisers, technicians, producers, dozens of staff to pack up equipment.

Photojournalists, instead, have to go it alone. The digital age has not reduced the time-load saved by processing. All it has done is create more work in those hours during which others are waiting for our processed film. We shot thirty-six frames per roll in the old days, compared to two hundred on a flash card now. We provide a bigger edit; more choice for the editors. We now have ISDN satellite phones that transmit at one megabyte per minute. (A year ago, in Afghanistan, it was ninety minutes a picture.) Even so, this requires extra flash cards, computers, power supplies, batteries, generators, cables.

A long night is ahead of us, with the deadline running out at 4:00 A.M. We all wait in our rooms watching from the balconies with baited breath. What will this be like? We've heard so many stories now from the Americans, and from one another, that everyone is wound up pretty tight. Hour after hour passes. Long—very long—stretches of not knowing. How do the people of Iraq feel if we feel like this? We can go home, eventually, but this is their home, a land awaiting its destiny. Is this going to be the war among wars, the final hour?

It's midnight now and it begins to sink in that maybe they won't be coming tonight. A knock at the door, "I'll take you with me on my bus at four or maybe five to see the sites after the attack." "Do you think we will be able to go out tonight?" "Oh yes, they will attack and we will see what they have done." It appears that Sadune is thinking this is going to be like all the other wars Iraq has had in the last twenty years. Somehow I don't share his optimism. "You come, we'll see." I think he knows they will come on the deadline. I wait till 1:00 A.M. to tune into the BBC World Service before going to bed, just to hear what they say about all this craziness. "The hours are closing in on Baghdad," comes the voice, crackling over the radio. Only three hours left until 4:00 A.M.

At 4:00 A.M., I awaken instantly, still fully clothed. The BBC reports that the deadline has passed. I sit and wait, peering into the sky, watching small quick flickers off to twelve o'clock on the horizon. 5:22 A.M. The ground shakes and tracer fire shoots up into the air over my balcony. I can almost touch it. Baghdad is under attack. The sky is lit up and the echoing trails of tracers fill the night as far as the eye can see. I run into the bedroom and look out the balcony. The sky is filled in every direction. Turning around, I go into the bedroom, and two loud thuds shake the building. I run back to the living room to watch the oil refinery go up in smoke. I'm slow, and it's too dark to get a good picture of it. But it will be the first of many, and I feel a lot better for its having begun this way.

—Seamus Conlan

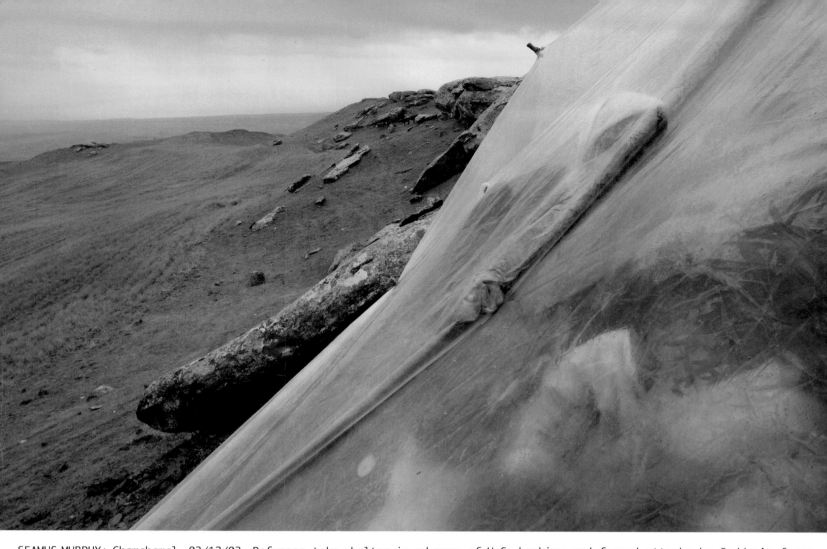

SEAMUS MURPHY: Chamchamal, 03/12/03. Refugees take shelter in advance of U.S. bombing and feared attacks by Saddam's forces.

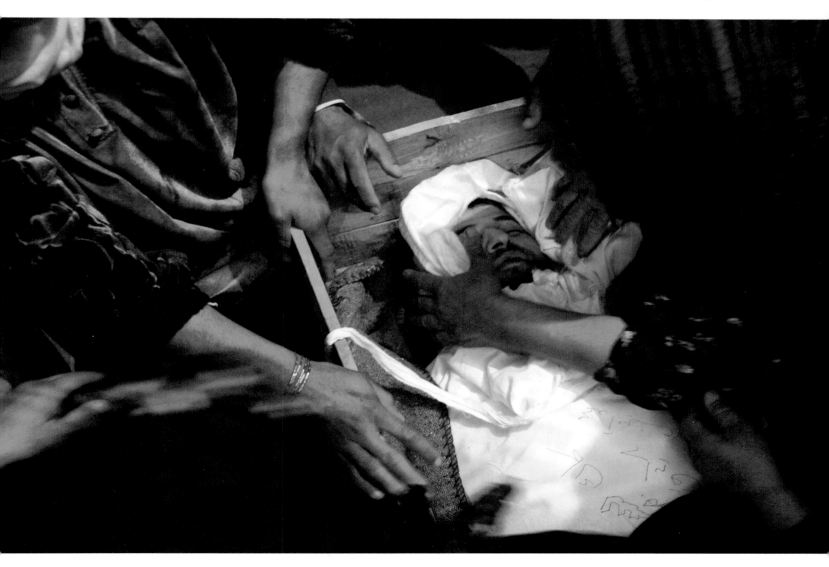

SEAMUS MURPHY: Sulaimaniya, N. Iraq, 03/04/03. Women grieve over a Komal soldier killed at a Kurdish checkpoint.

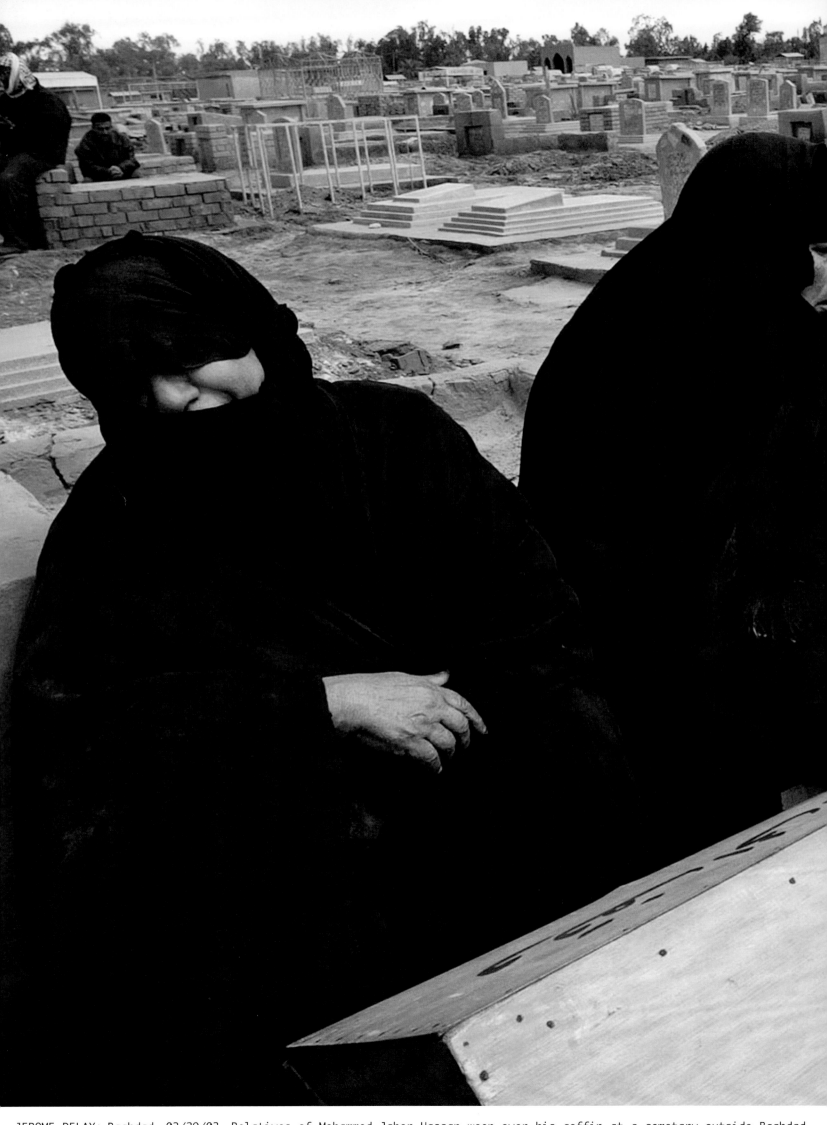

JEROME DELAY: Baghdad, 03/29/03. Relatives of Mohammed Jaber Hassan weep over his coffin at a cemetary outside Baghdad.

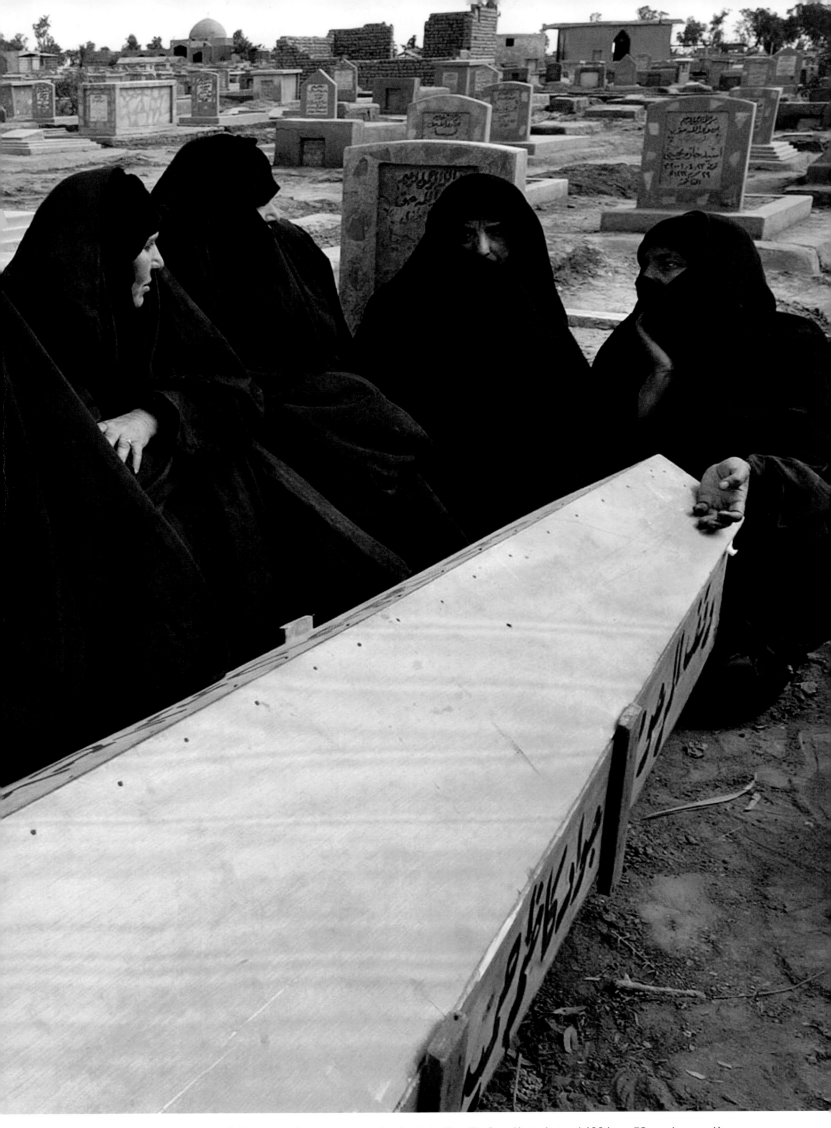

Hassan, 22, died when a bomb fell on a busy market in Baghdad's Shula district, killing 52 and wounding scores.

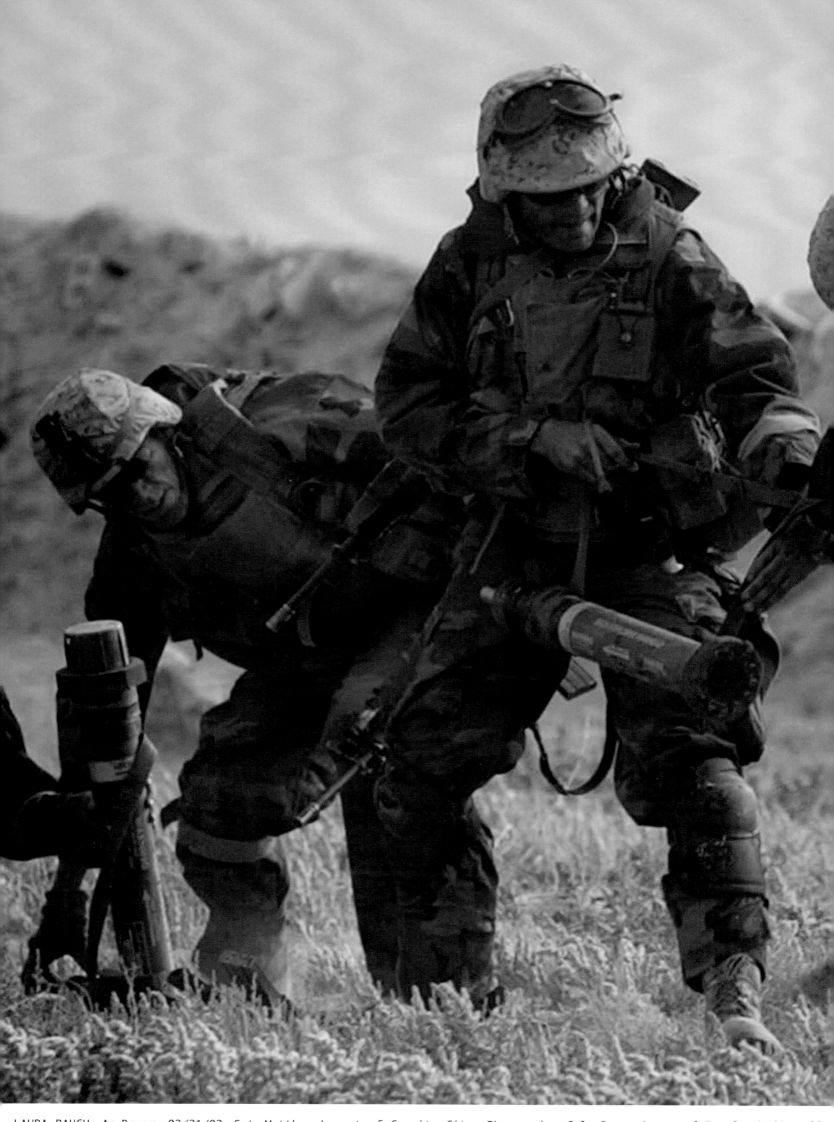

LAURA RAUCH: Az Bayer, 03/21/03. Sgt. Matthew Levart of Granite City, IL, carries Cpl. Barry Lange of Portland, OR, off

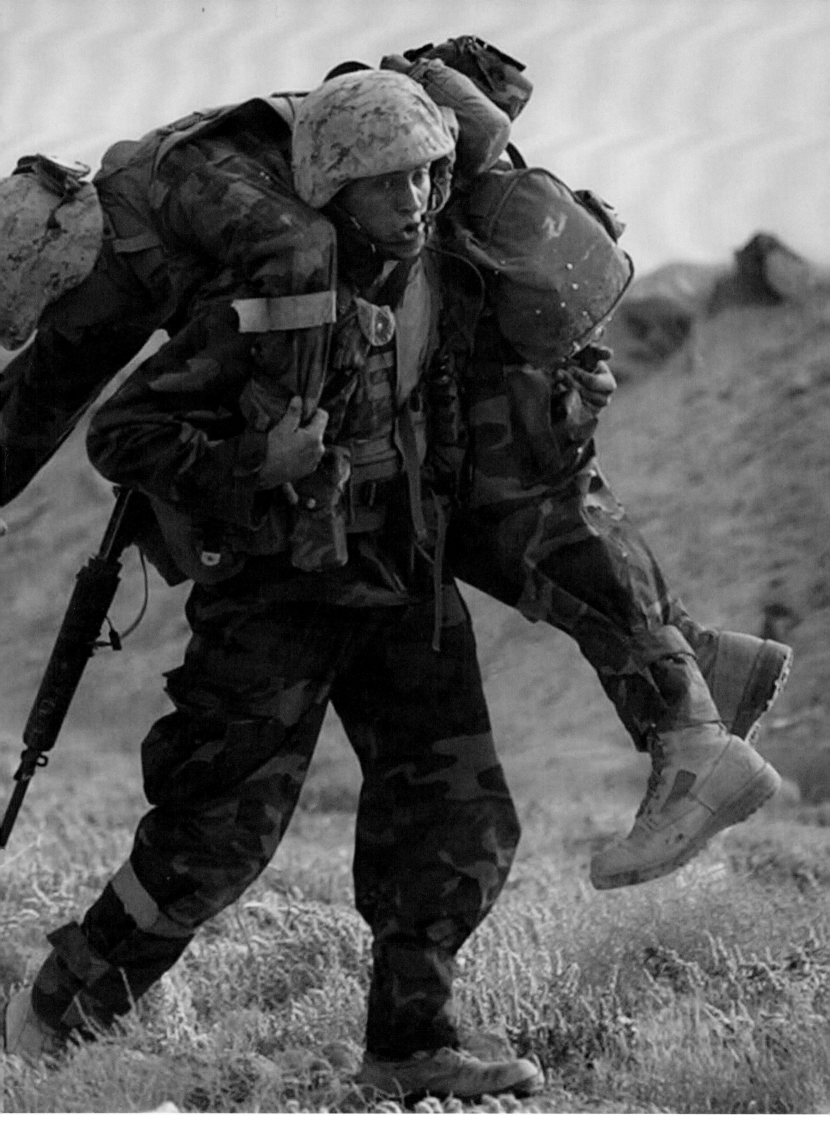

the battlefield as India Co., 3rd BN, 7th Marines engages Saddams's 51st and 32nd mech division.

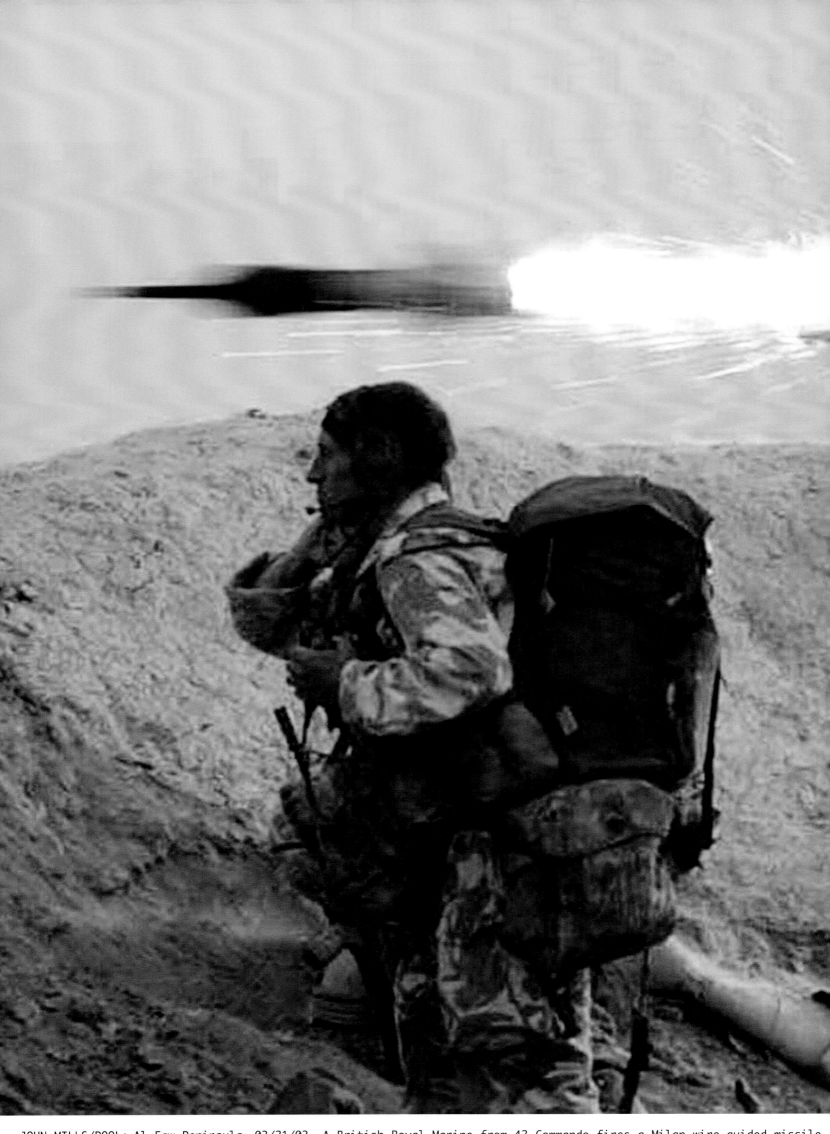

JOHN MILLS/POOL: Al Faw Peninsula, 03/21/03. A British Royal Marine from 42 Commando fires a Milan wire-guided missile

at an Iraqi frontline position.

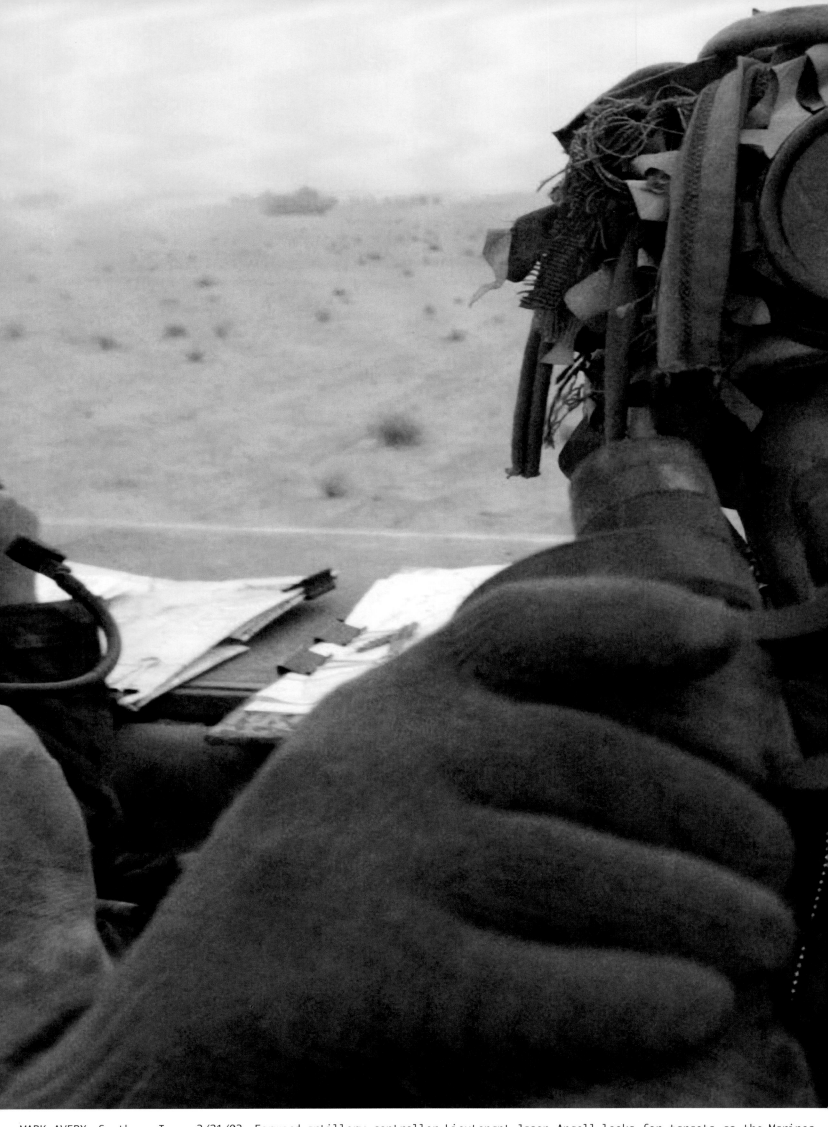

MARK AVERY: Southern Iraq, 3/21/03. Forward artillery controller Lieutenant Jason Angell looks for targets as the Marines

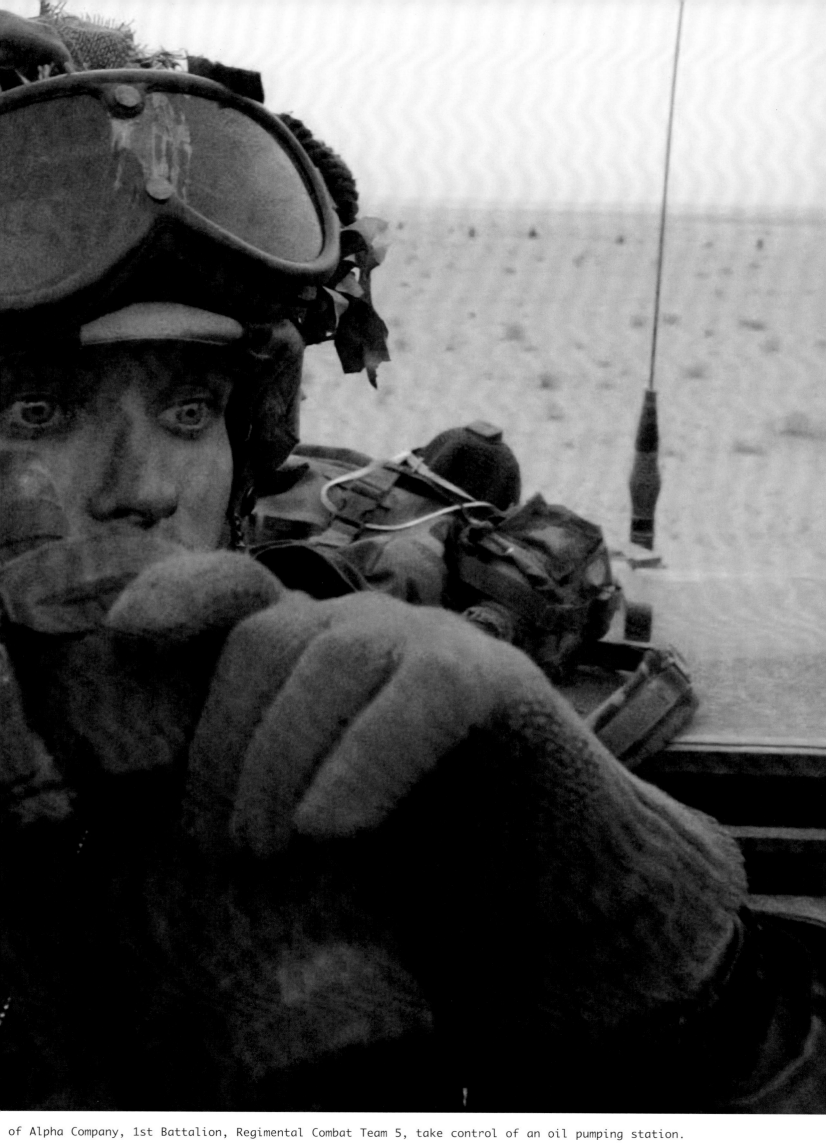

of Alpha Company, 1st Battalion, Regimental Combat Team 5, take control of an oil pumping station.

>I have never seen Baghdad like this. Today the Ba'ath Party people started taking their places in the trenches and main squares and intersections, fully armed and freshly shaven. They looked too clean and well groomed to defend anything. And the most shocking thing was the number of kids. They couldn't be older than 20, sitting in trenches sipping Miranda fizzy drinks and eating chocolate.... other places you would see them sitting bored in the sun, more cars with loads of Kalashnikovs everywhere....
>>The ultimatum ends at 4 in the morning here in Baghdad, and the big question is will the attack be on the same night or not. Stories about the first gulf war are being told for the 100th time.
>>the Syrian border is now closed to Iraqis. They are being turned back. what is worse is that people wanting to go to Deyala which is in Iraq are being told to drive back to Baghdad. There was a rumor going around that Baghdad will be closed—no one goes in or out.... there are rumors that many people have taken the path thru Deyala to go to the Iranian border. Maybe, maybe not. :: salam 10:13 PM [+] :: 03/19/03 [Salam Pax, aka Blogger from Baghdad]

>Ari Fleisher just said the attack is underway. We see anti-aircraft fire over Baghdad on TV. The president will speak at 10:15.—Jeff Jarvis

>The CNN people in Kuwait just can't get over the air-raid sirens they heard. It was nuts! They had to put on gas masks and shout at the camera! - Ken Layne, 03/20/2003 02:32:56 AM

>"In 1424 of the Hijra (Muslim) calendar, the reckless criminal little Bush and his accomplices committed his crime, with which he had threatened Iraq and humanity."-Saddam Hussein, speech to Iraqis.(AP)

>IS THAT IT? Saddam fired a couple of those Scuds that he doesn't have at me this afternoon. He missed. Posted by LT Smash at 01:34 PM

>The AP is reporting that "some 200 Iraqi soldiers surrendered to the U.S. 15th Marine Expeditionary Unit just over an hour after it crossed the border into Iraq from northern Kuwait." This is one of the first reports I've seen of specific units surrendering. Certainly a good sign. Posted By Steven Kruczek at 03:32 AM (TCP)

>U.S. has launched an assault into two key airfields in the West, and controls both. Also, two of the four burning oil wells are out, one is on the way, and the fourth is still burning. Posted By Alan at 07:17 AM (TCP)

>>U.S. forces bombard Baghdad—as well as Kirkuk and Mosul—with laser-guided explosives in an attempt at "decapitating" the regime. Shock and awe is based on a 1996 strategy paper which reads, in part: "The key objective of Rapid Dominance is to impose [an] overwhelming level of Shock and Awe against an adversary on an immediate or sufficiently timely basis to paralyze its will to carry on. In crude terms, Rapid Dominance would seize control of the environment and paralyze or so overload an adversary's perceptions and understanding of events that the enemy would be incapable of resistance at tactical and strategic levels."

>Man, there are a lot of cars out on the street considering all the "shock and awe" that's been going on. Who's going to work on a day like today in Baghdad? (Fox and MSNBC feeds of the Iraqi "webcam") Posted By bryan at 12:03 AM(TCP)

>If the first Gulf War was the "CNN War," then this war is the "Blogger War." Consider that this Blog has been updated over a hundred times in the past eight hours…Drudge only once. Posted By PoliticaObscura at 08:39 AM(TCP)

>MSNBC reporting that, although the 11th and 51st Divisions have surrendered to Marines now surrounding Basra, the Iraqi 3rd Brigade (of what I don't know) remains hostile and is inside Basra. Posted By SunDevilDog at 01:24 AM(TCP)

>Fox News: Can't you see some Green Beret 2nd Lt. taking the surrender of a Guard division? Posted By at 08:08 PM(TCP)

>The American flag has been taken down from the occupied port of Umm Qasr, Skynews reports. "No reason was given for the decision, but Washington has consistently stressed that invading forces want to liberate Iraq, not occupy it."-Jeff Jarvis

>CNN's Brent Sadler, embedded reporter, is with the troops who dropped into N. Iraq earlier today (a 1:00 a.m. night drop, BTW). They are digging in and setting up a perimeter around the airfield they have occupied. According to Brent there are no hostiles in the immediate area. Posted By Alan at 11:19 PM (TCP)

>"Oooooo, peace be upon you, peace be upon you, peace you, oooooo…I'm not afraid of Saddam anymore."-Zahra Khafi to Americans and British. (NYT)

>Met with some of the locals again today. They were excited. They are anticipating the end of Saddam's evil regime even more than we are. They were glued to their satellite TV set, switching between Al-Jazeera, FOX News, BBC, the local station, and Iraqi TV. They especially enjoyed the female anchor on FOX, with her short skirt. "What city?" one asked, pointing at the woman on the TV.
>>"New York," I said. >>"I must go there!" They all laughed. >>Posted by LT Smash at 1310Z

>I watched Al Sahaf on Al-Jazeera. He said that the U.S. has bombed the Iraqi sattelite channel, but while he was saying that the ISC was broadcasting and if it really did hit the ISC headquarters it would have been right in the middle of baghdad.... all TV stations are still working.
:: salam 4:28 PM [+] ::

>"They have no foothold in Iraq…We will welcome them with bullets and shoes." Minister of Information Mohammed Saeed al-Sahaf

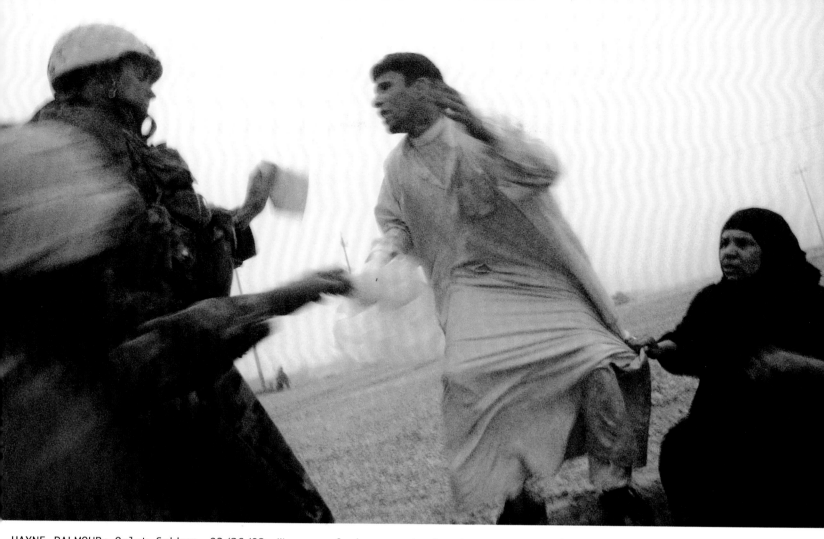

HAYNE PALMOUR: Qalat Sukkar, 03/26/03. Woman refrains man trying to prevent Marines from shooting at his apt.

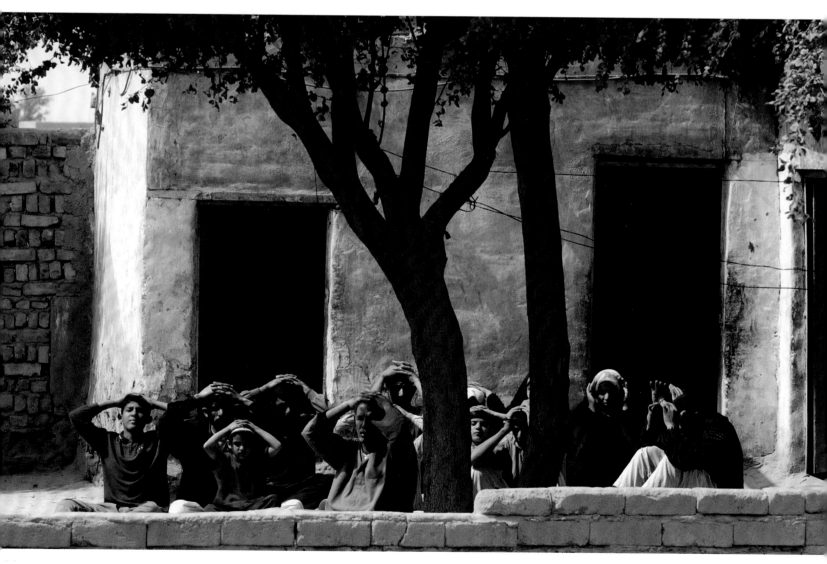

HAYNE PALMOUR: Al-Shatra, 03/31/03. An Iraqi family holds their hands over their heads as Marines search the house.

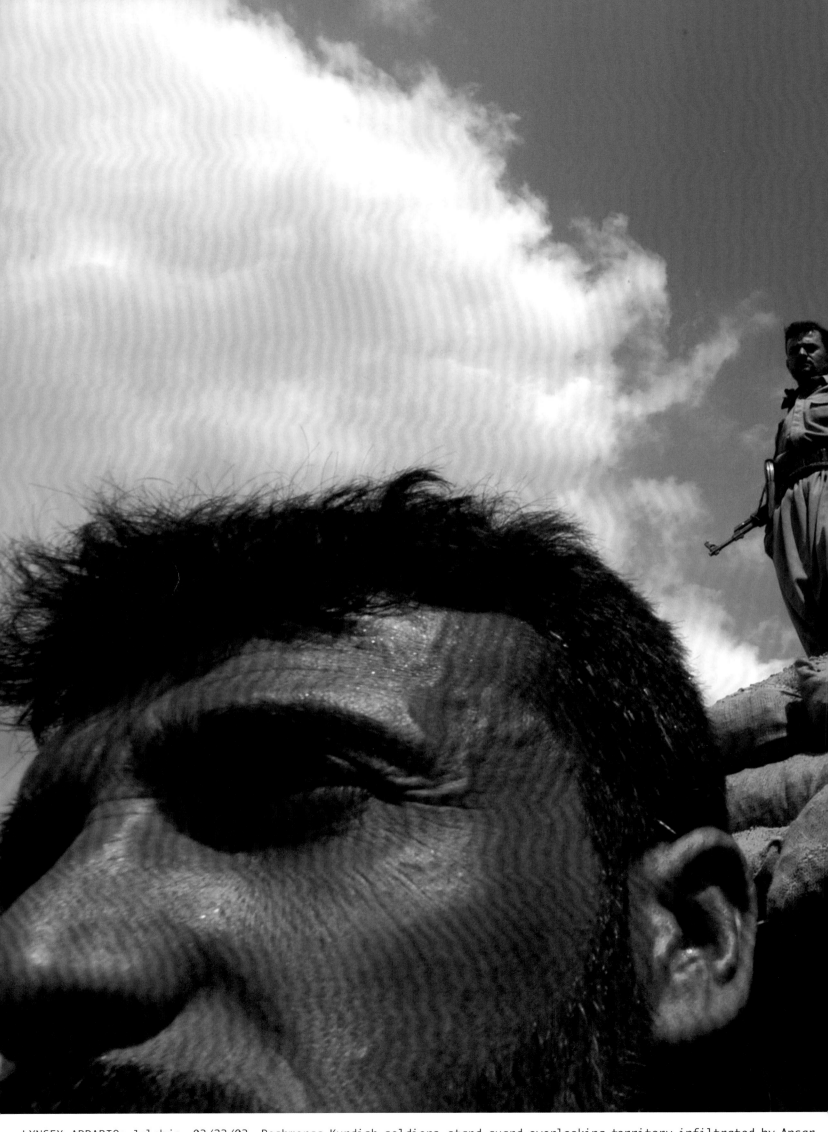

LYNSEY ADDARIO: Jalabja, 03/23/03. Peshmerga Kurdish soldiers stand guard overlooking territory infiltrated by Ansar

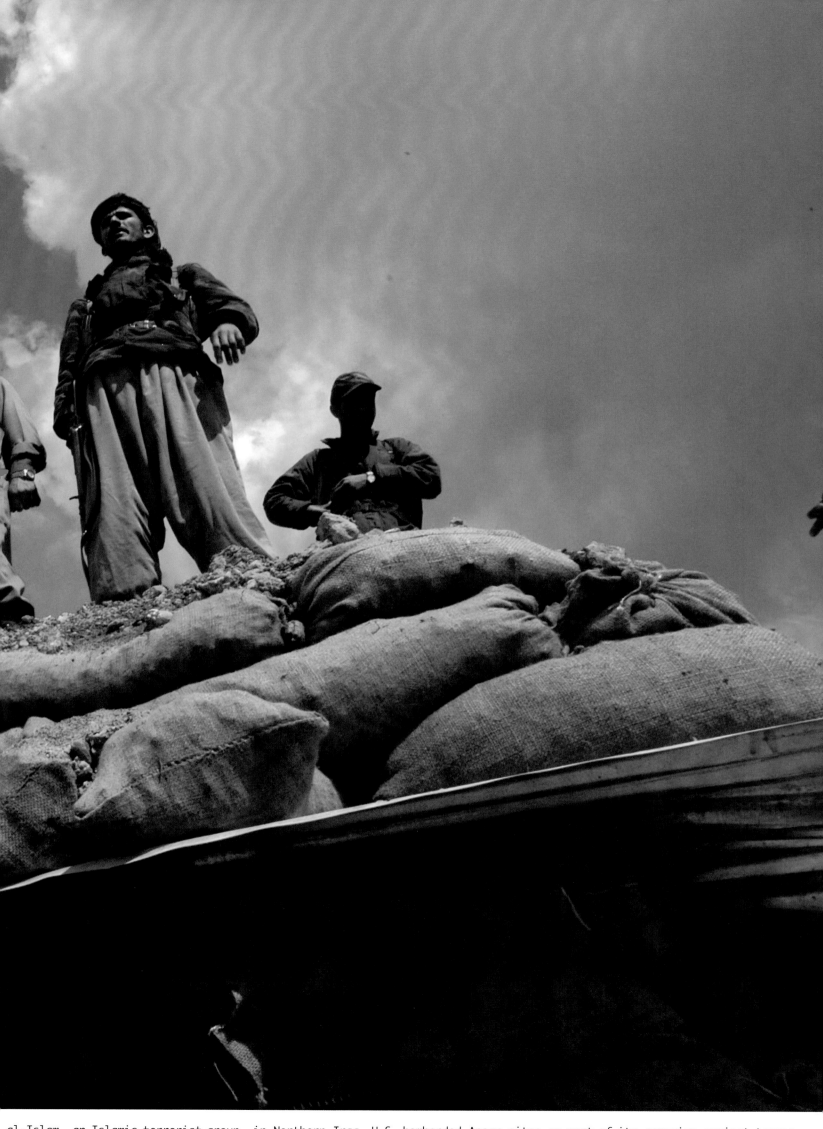

al-Islam, an Islamic terrorist group, in Northern Iraq. U.S. bombarded Ansar sites as part of its campaign against terror.

ITSUO INOUYE: Az Zubayar, 03/23/03. A U.S. Marine from the 15th Marine Expeditionary Unit checks the kitchen in a

command office at the Iraqi Naval base in the southern Iraqi desert.

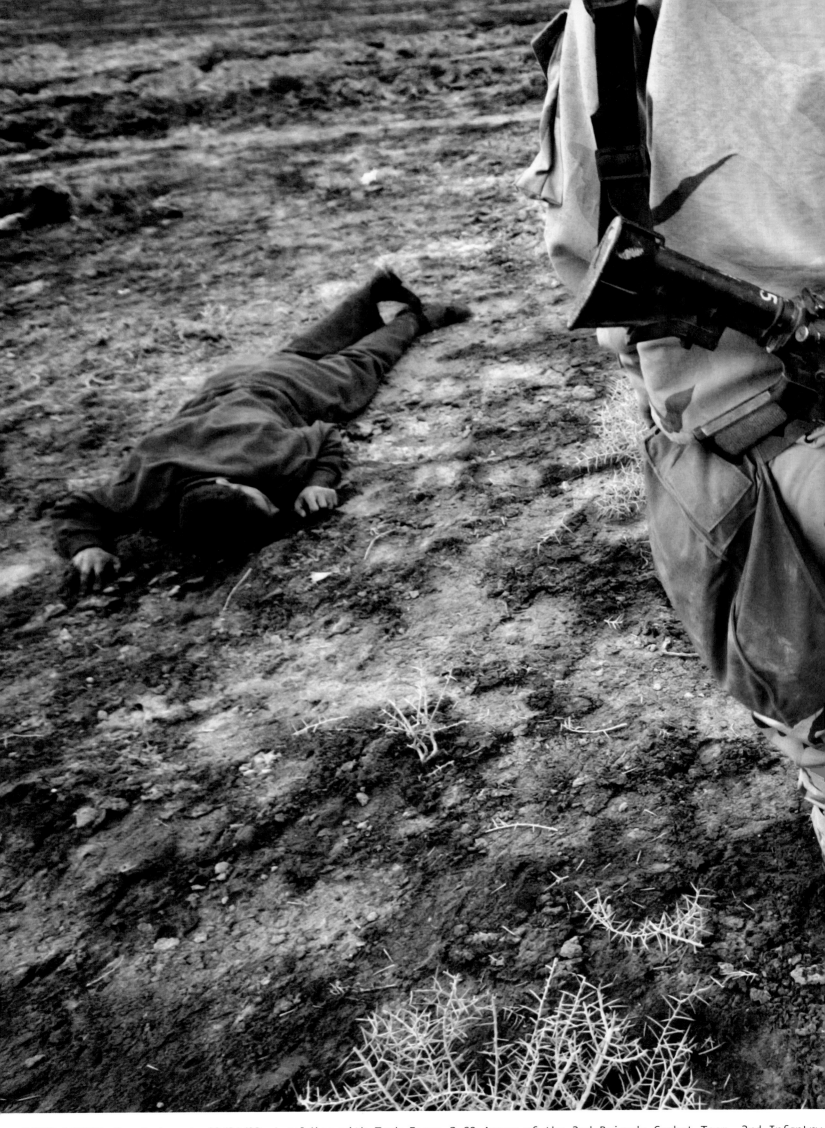

DAVID LEESON: Iraqi desert, 03/24/03. A soldier with Task Force 2-69 Armor of the 3rd Brigade Combat Team, 3rd Infantry

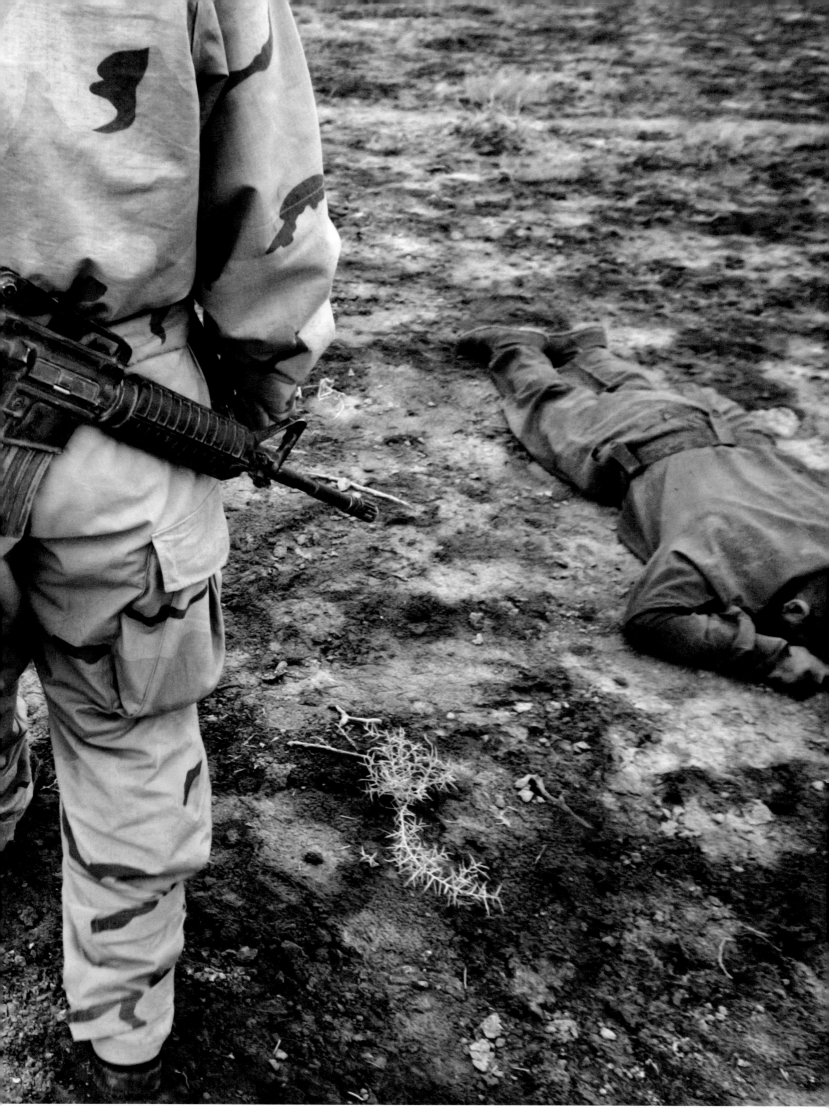

from Fort Benning, Georgia, walks slowly past the bodies of Iraqi soldiers.

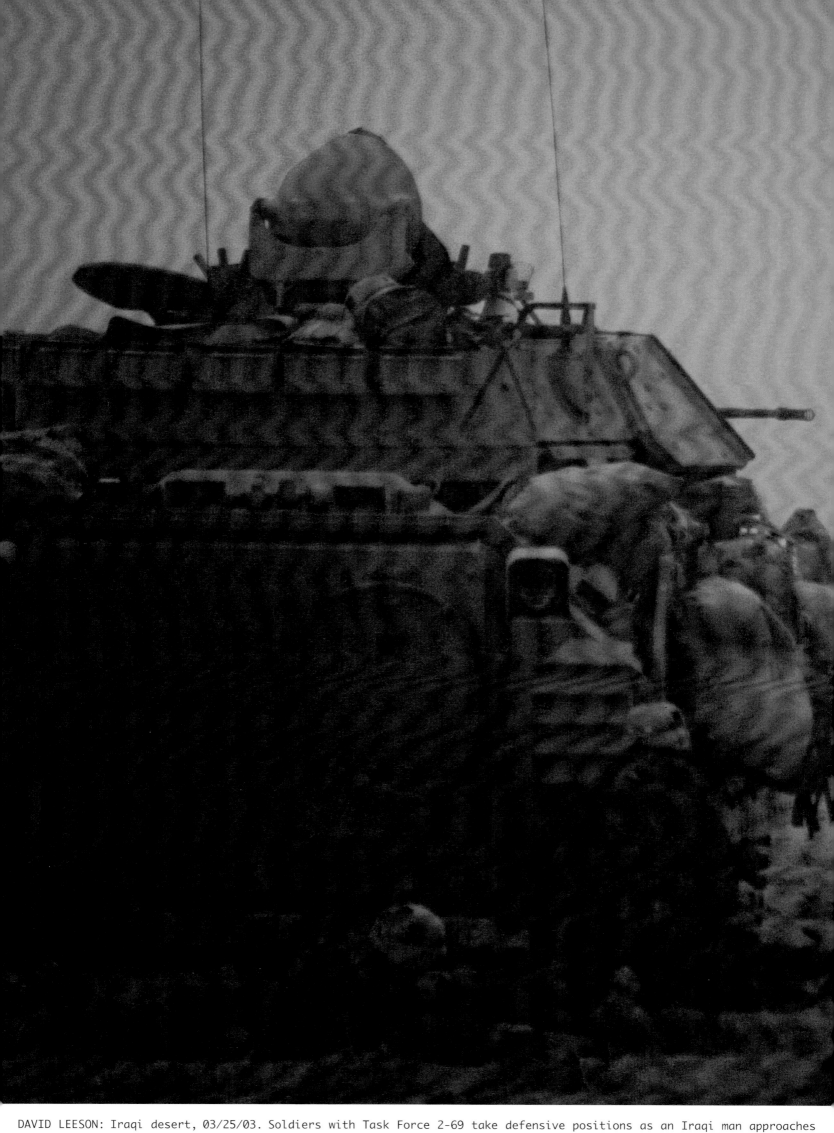

DAVID LEESON: Iraqi desert, 03/25/03. Soldiers with Task Force 2-69 take defensive positions as an Iraqi man approaches

their Bradley Fighting Vehicle; the raging dust storm reduced visibility to less than 20 yards.

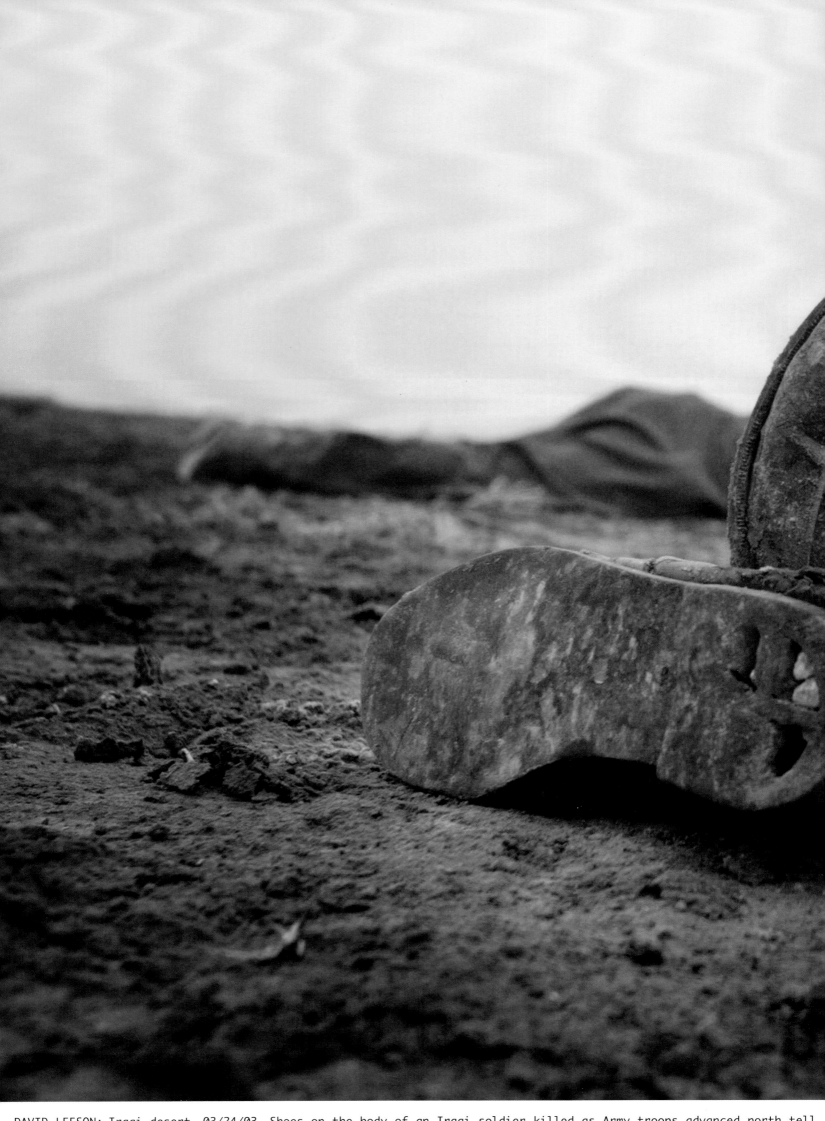

DAVID LEESON: Iraqi desert, 03/24/03. Shoes on the body of an Iraqi soldier killed as Army troops advanced north tell

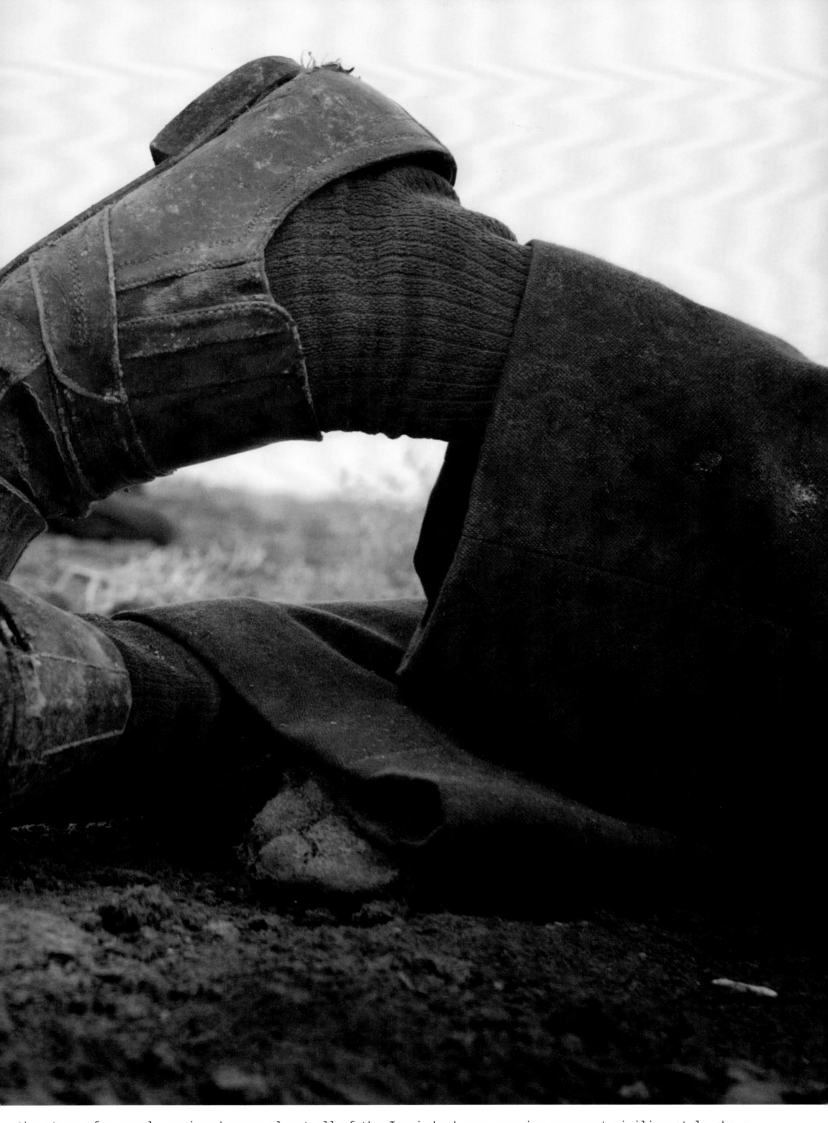

the story of a poorly equipped army; almost all of the Iraqi dead were wearing worn-out civilian-style shoes.

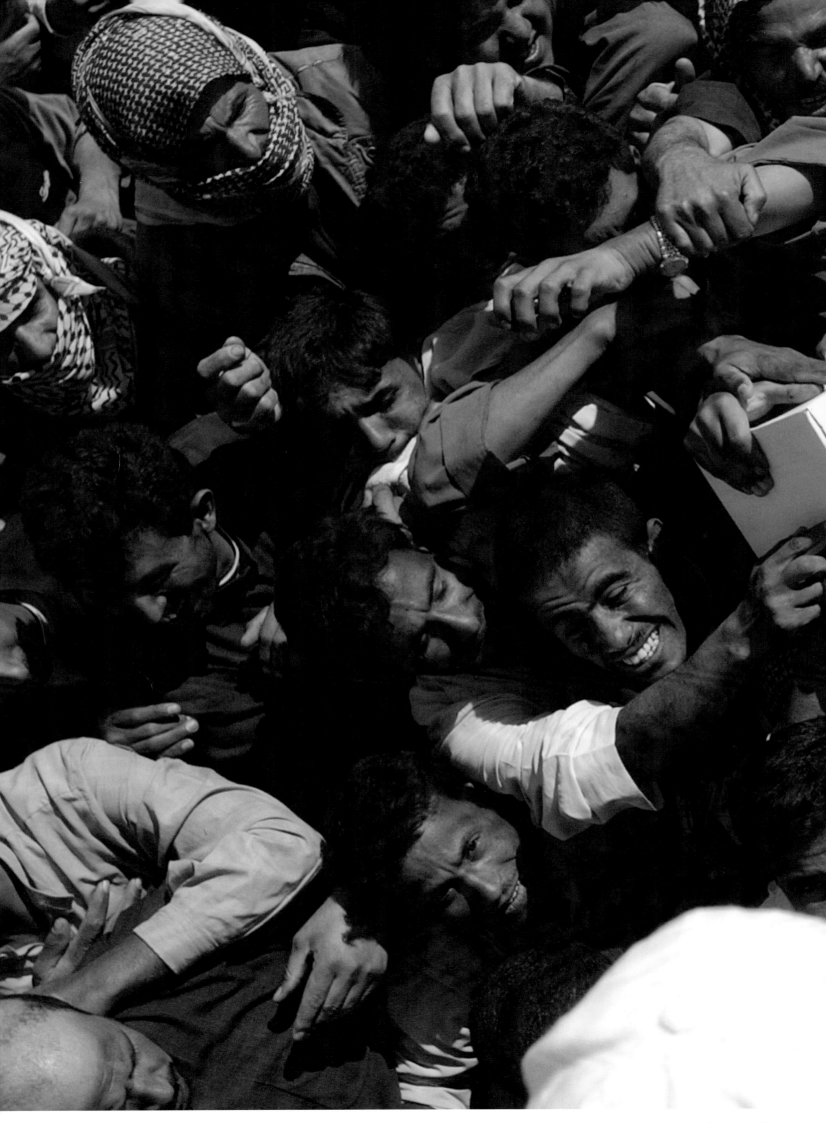

HYOUNG CHANG: Safwan, 03/28/03. Iraqi citizens rush into the crowd to get a box of donations from the Red Crescent

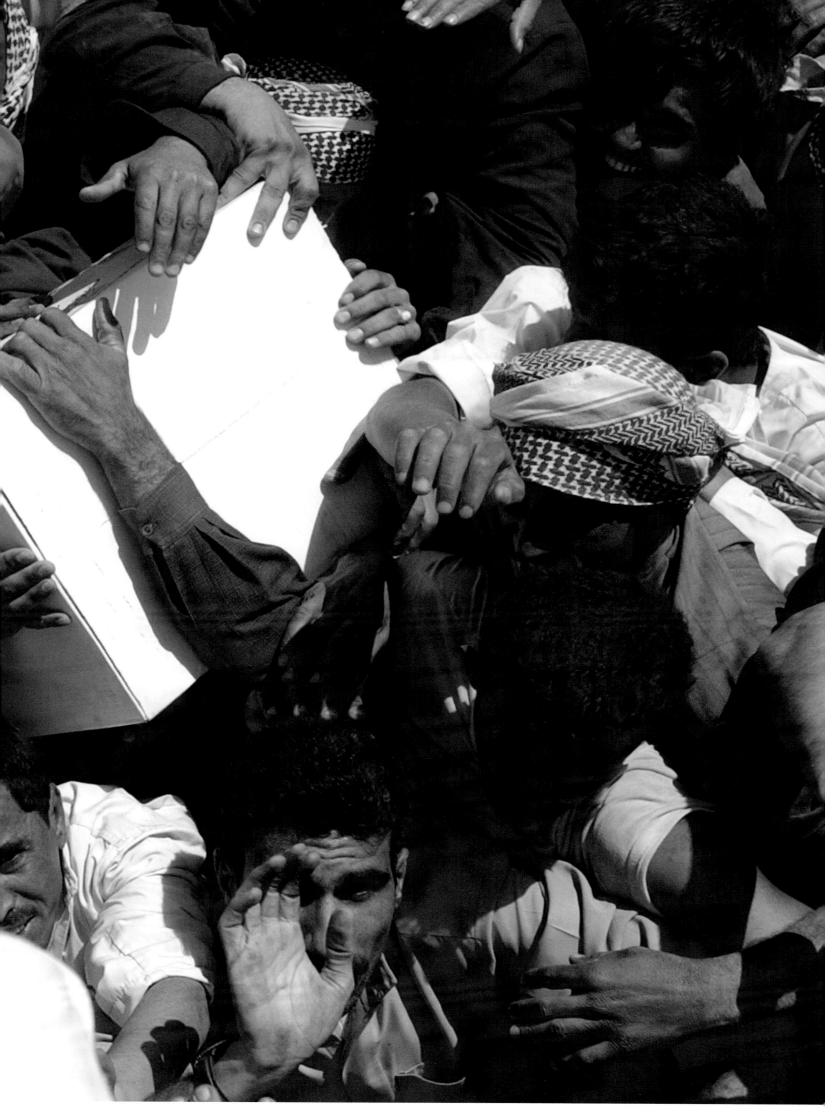

Society of Kuwait at a farm area 10 km north of Safwan.

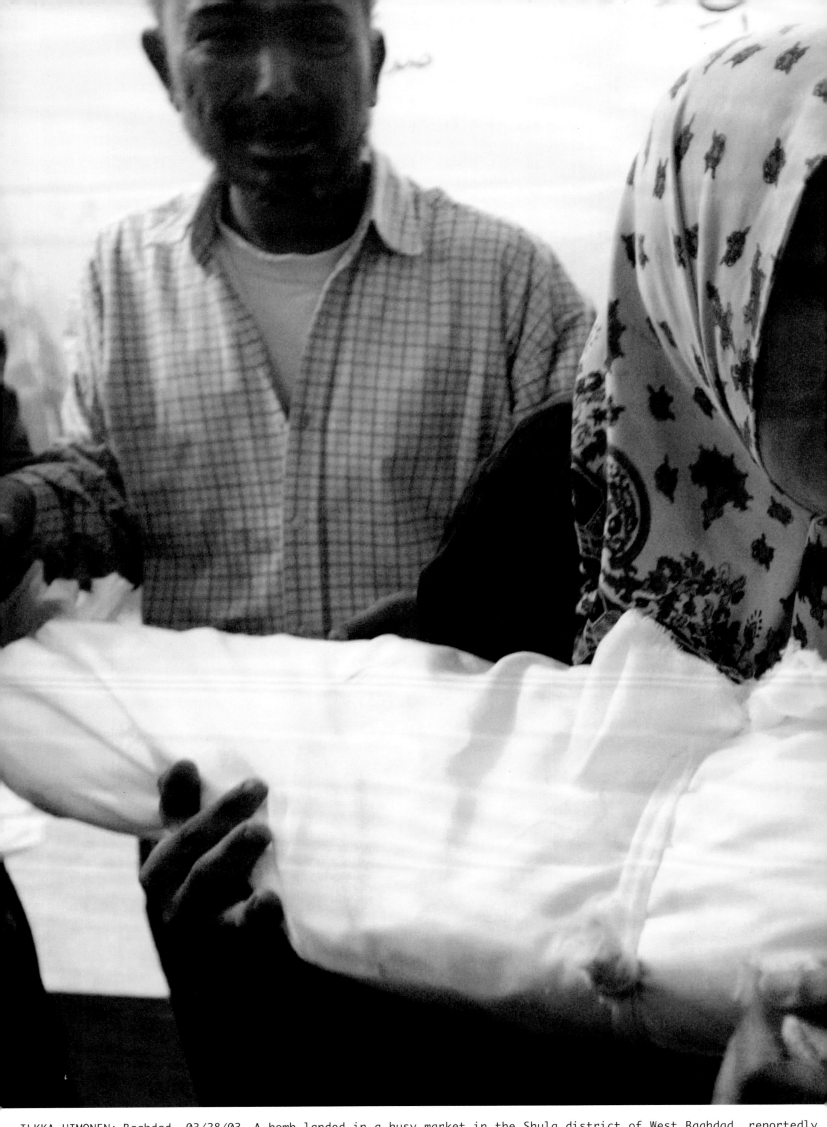

ILKKA UIMONEN: Baghdad, 03/28/03. A bomb landed in a busy market in the Shula district of West Baghdad, reportedly

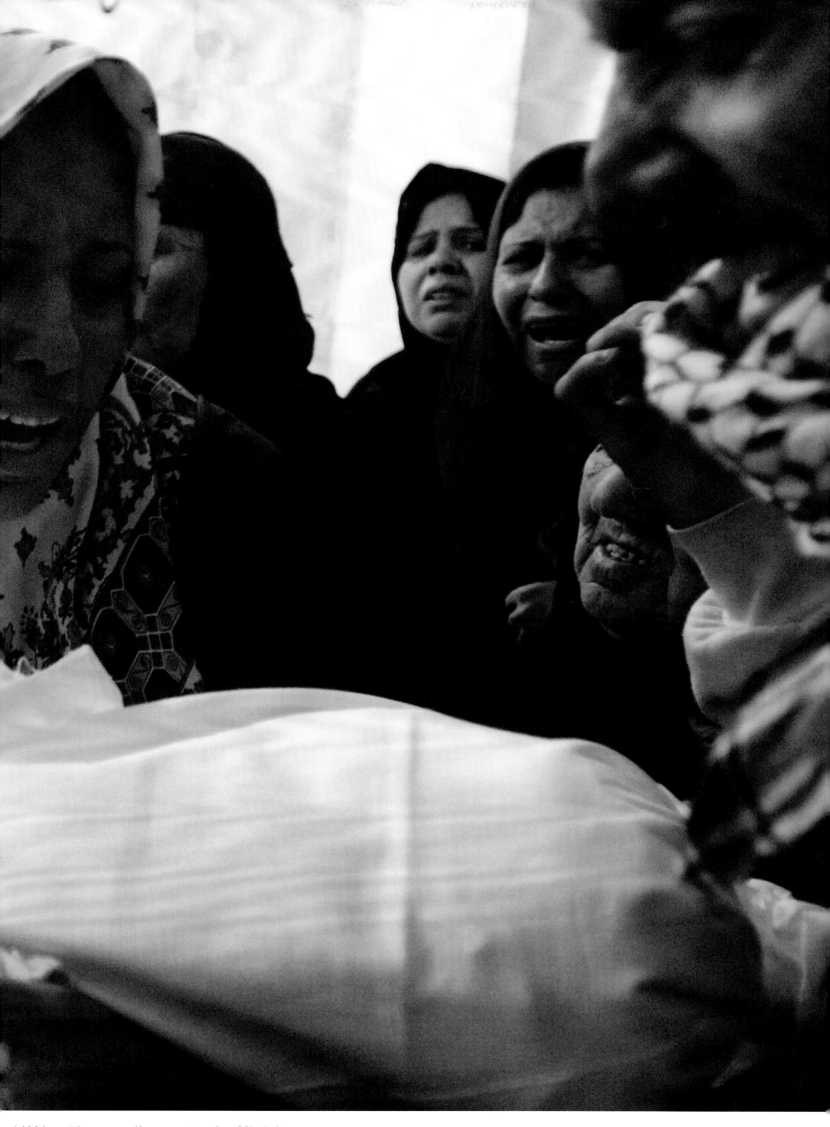

killing 53, according to Iraqi officials.

DAMIR SAGOLJ: Central Iraq, 03/29/03. A U.S. Marine doctor holds an Iraqi girl after frontline cross fire ripped

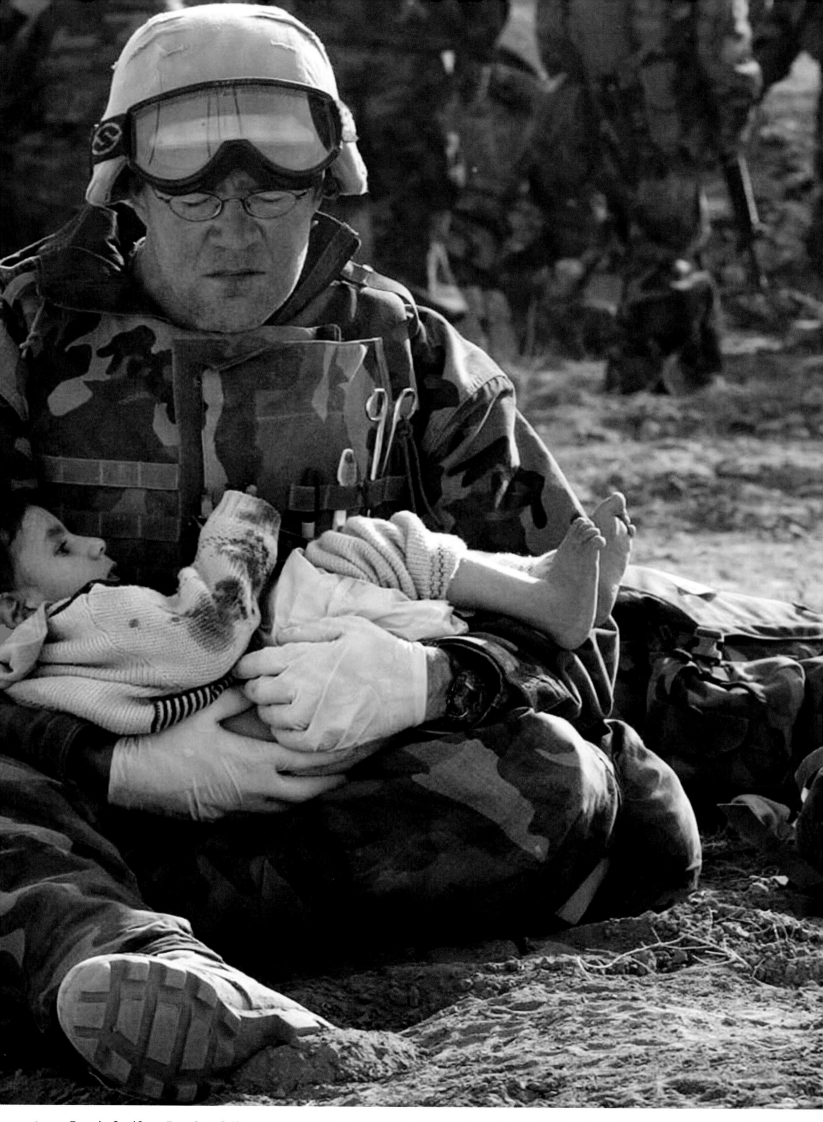

apart an Iraqi family; Iraqi soldiers appeared to force civilians toward the Marines' positions.

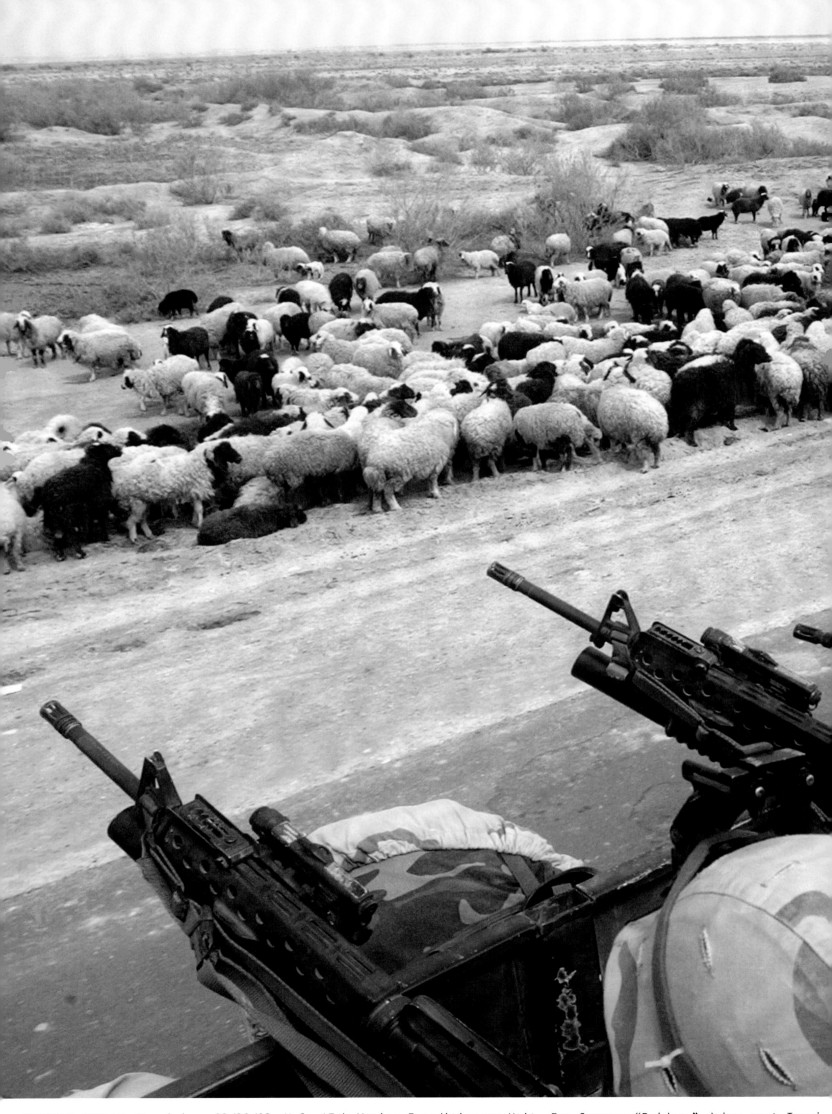

DESMOND BOYLAN: Nassiriya, 03/30/03. U.S. 15th Marine Expeditionary Unit, Fox Company "Raiders" drive past Iraqi

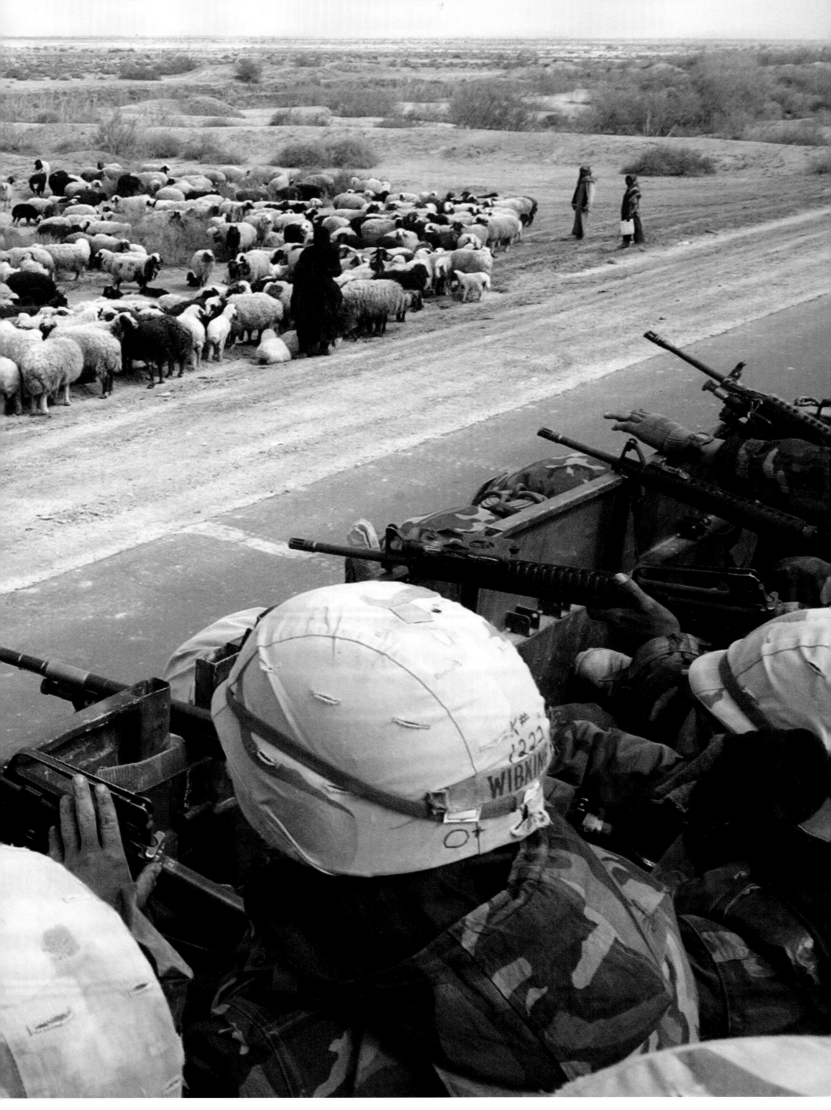

Bedouins herding sheep south of the town.

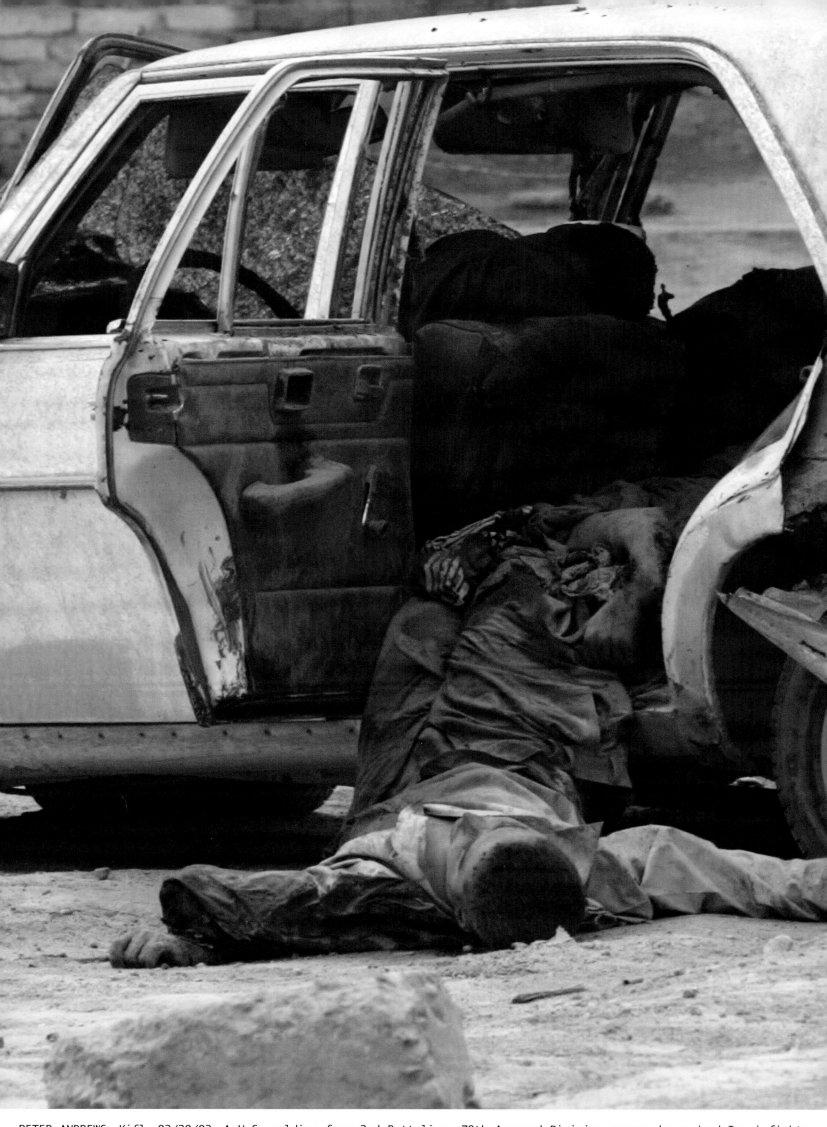

PETER ANDREWS: Kifl, 03/30/03. A U.S. soldier from 2nd Battalion, 70th Armored Division passes by a dead Iraqi fighter

south of Baghdad as U.S. troops dig in, preparing for the advance on the reportedly heavily defended capital city.

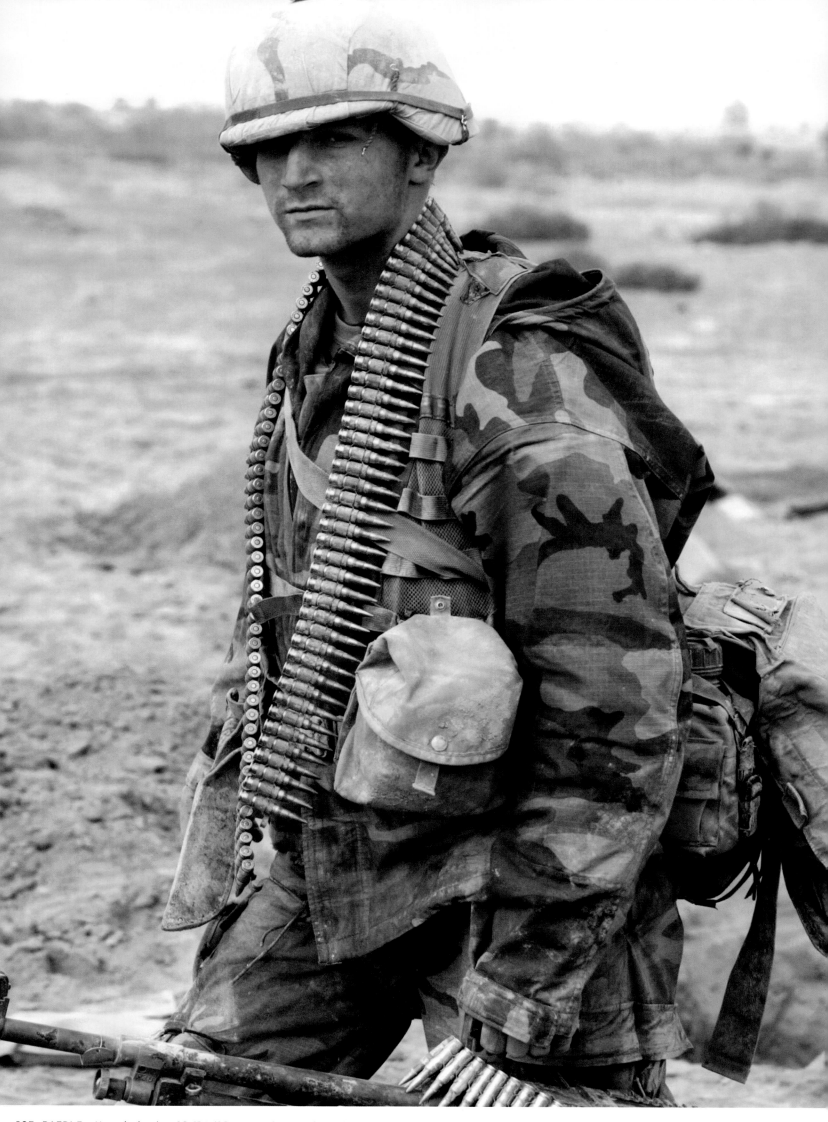

JOE RAEDLE: Nassiriyah, 03/24/03. A U.S. Marine from Task Force Tarawa repositioning with his ammunition and weapon.

WOMAN ON A BRIDGE
March 31, 2003 Hindiyah

We learned of the mission during a briefing the night before: to secure and hold a strategic bridge in Hindiyah less than a hundred miles south of Baghdad. I was embedded with "Attack" Company A 3-7, part of the U.S. Army's enormous Third Infantry. We had crossed into southern Iraq ten days earlier, and made a rapid advance towards Baghdad until brutal sandstorms the last few days slowed us down. After the briefing, soldiers compared the possibility of the next day's urban fighting to a battle in Mogadishu, Somalia, a decade before. Too many of them had seen *Black Hawk Down* and kept saying, "This could get hairy."

Wake up was 0430, and by 0500 our convoy of Bradley Fighting Vehicles and tanks was rolling out of the desert towards Hindiyah. The planned dawn attack never happened; we got bogged down in the desert, meaning the fighting would take place in full daylight, losing the element of surprise. In my military-issue camouflaged chemical suit, bullet-proof vest, and helmet, I looked disconcertingly like a soldier. Few Iraqis would notice there were cameras, not weapons, hanging around my neck, nor would they be able to read the word "PRESS," printed in English, not Arabic, across my vest.

I rode in the back of the Bradley in its heavily-armored hold, hearing only the ping-ping-ping against the vehicle as we came under fire. Outside, the world was exploding around us. The gunners in the turrets later said entering Hindiyah was like driving through a gauntlet of fire, with rocket-propelled grenades and heavy machine-gun fire coming at us from all directions. Tucked up in the hold, I obviously couldn't shoot any pictures.

The drive through town took fifteen minutes but seemed much longer, with the thud of the 25mm Bradley gun pounding away above our heads. When we arrived at the bridge, the vehicle commander let me out, and I stayed close to the rear hatch, using it as cover in the crossfire. The tanks in our convoy were firing rounds across the river, and the Iraqi forces were firing back. The Bradleys were blasting at the banks and back down the street we had just come up.

Suddenly, U.S. artillery shells exploded in the river in front of us, throwing up huge splashes of water and spraying my camera lenses with a muddy mist. A U.S. artillery company was positioned behind us, firing rounds over our heads towards the far bank. The arching artillery shells are often less precise than tank and Bradley fire, and that day many of the 155mm shells fell short, unnerving all of us.

I went to the roof of a building secured by U.S. soldiers across the street. From that height I could see the ring of Bradleys blasting away at the Iraqi troops, and the artillery rounds exploding on the far side. A car trying to cross the bridge was stopped with a single shot from a U.S. tank. It exploded in flames.

I heard another explosion below and saw my colleague, AP reporter Chris Tomlinson, feeling his legs and torso, checking for shrapnel wounds. A rocket-propelled grenade (RPG) round had landed too close for comfort, maybe just ten feet from where he was crouched. Incredibly, he was uninjured. An Army captain taking cover inside the Bradley wasn't so lucky. A piece of shrapnel pierced his leg. The medics rushed in and treated him there, just behind the vehicle, while the battle continued around them. Under the embed agreement, we couldn't file pictures of injured soldiers that showed their faces, at least not until their families could be informed. I shot the scene from far away, the injured soldier on the stretcher, his face unrecognizable.

Later I went back down to the street and spotted a woman in black slumped on the edge of the bridge. She was waving her arms and appeared to be screaming. There was another body lying nearby. I called to Captain Carter, the commanding officer, and told him there was a civilian alive on the bridge. He immediately decided to evacuate her, even though he and his men were embroiled in an intense firefight. His decision would later be described by Defense Secretary Donald Rumsfeld as one of the most selfless acts of heroism of the war.

Cpt. Carter called over a Bradley and took a squad of men, including Chris Tomlinson and myself, out onto the bridge. We walked behind the vehicle, using its bulk as cover. Once the Bradley reached the bleeding woman, who had been shot in the hip, Cpt. Carter tossed out a smoke grenade to provide cover. The man lying on the ground nearby was dead. Cpt. Carter gave the woman a bottle of water, and motioned for her to stay still while he radioed for an armored ambulance to come forward to evacuate her.

Chris and I took cover behind a steel arch on the bridge, giving me a good angle to shoot the scene, but little room to move around. I don't know if the Iraqis were shooting at us. The constant thunder from the American side drowned out everything else. But no American soldiers on the bridge were injured during the evacuation. The medics rolled the injured woman onto a stretcher and into the ambulance, which pulled back off the bridge. We pulled out with it, again using the vehicle as cover.

As the fighting began to slow, I crept into an adjacent police station where a large canvas of Saddam Hussein dominated the entrance. The soldiers later cut it down and took it as a souvenir. I spent the next hour in that lobby, transferring photos from my camera to my laptop and preparing to file the pictures to the AP office in New York. I had set up my satellite phone, the antenna pointing out the front window, when we suddenly got orders to leave the area. I had a hard drive full of photos from the battle, and no time to transmit them.

Later in the afternoon, once we arrived back at our previous patch of desert outside Hindiyah, I set up my satellite phone again and started to file. Just then, a dust storm rolled in, blowing down the antenna and knocking me briefly off-line. As the soldiers congratulated each other and swapped war stories from the battle, I too was reviewing the day's events. I draped a jacket over my laptop and myself as a shield from the blowing sand, and sent pictures late into the night, twenty-seven of them in all. By the time I finished, the soldiers had been asleep for hours, exhausted from a day of combat that would begin the all-out push to Baghdad, eventually landing them in the comfortable chairs of Saddam's palace.

—John Moore

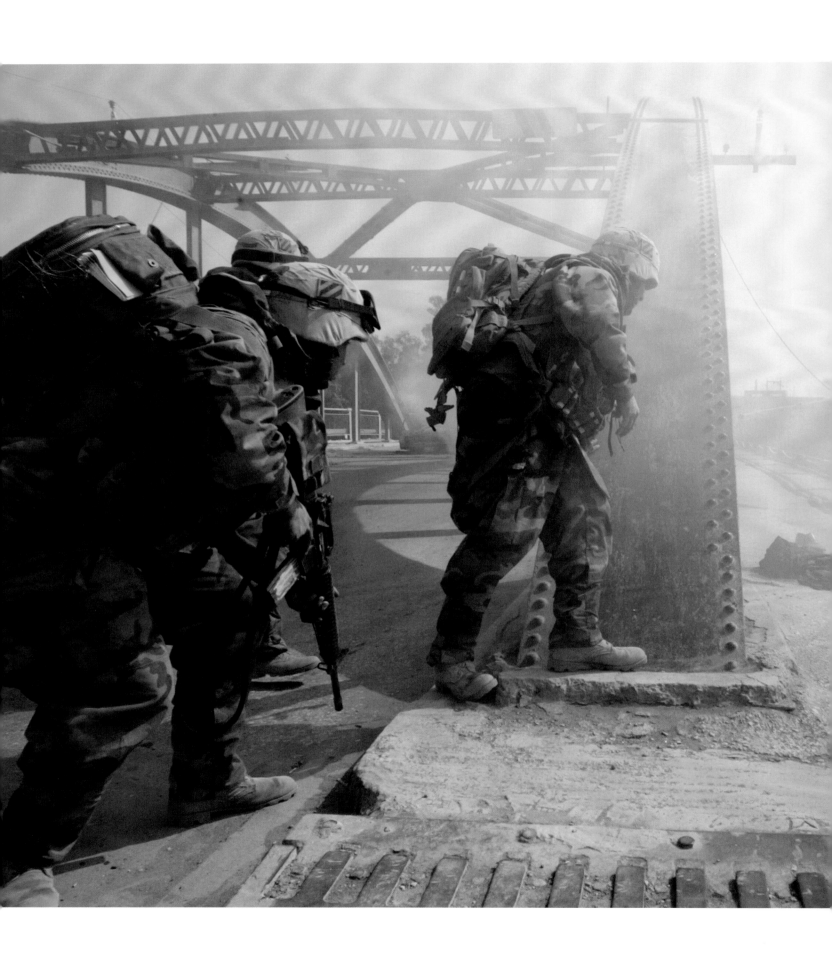

JOHN MOORE: Hindiyah, 03/31/03. Captain Chris Carter, commander of A Company, 3rd Battalion, 7th Infantry Regiment
River. The Army's Task Force 4-64, part of the 3rd Infantry Division, took the strategic bridge in its move north

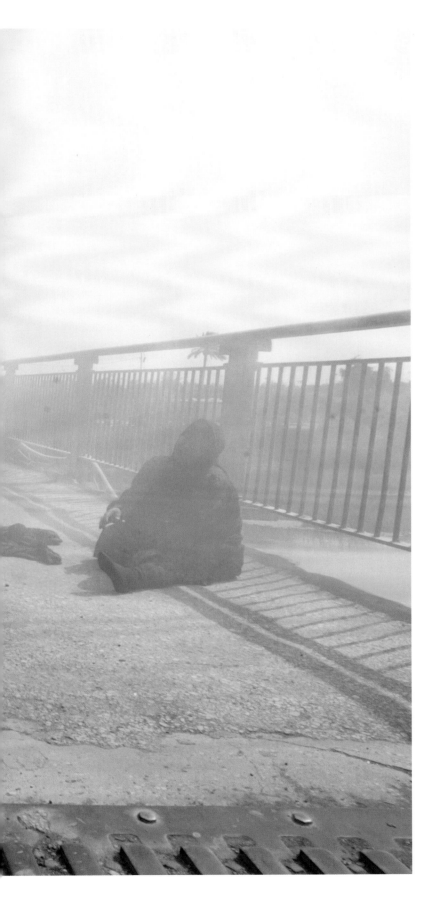

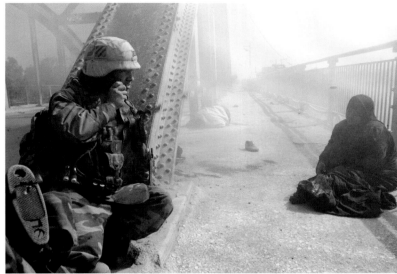

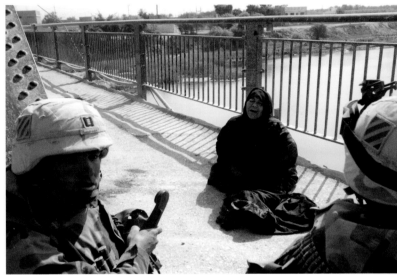

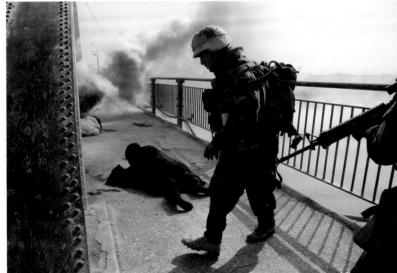

approaches an injured woman who was caught in crossfire when the U.S. Army seized the bridge over the Euphrates towards Baghdad. The woman, near a dead civilian man, was bleeding, apparently shot in the buttocks.

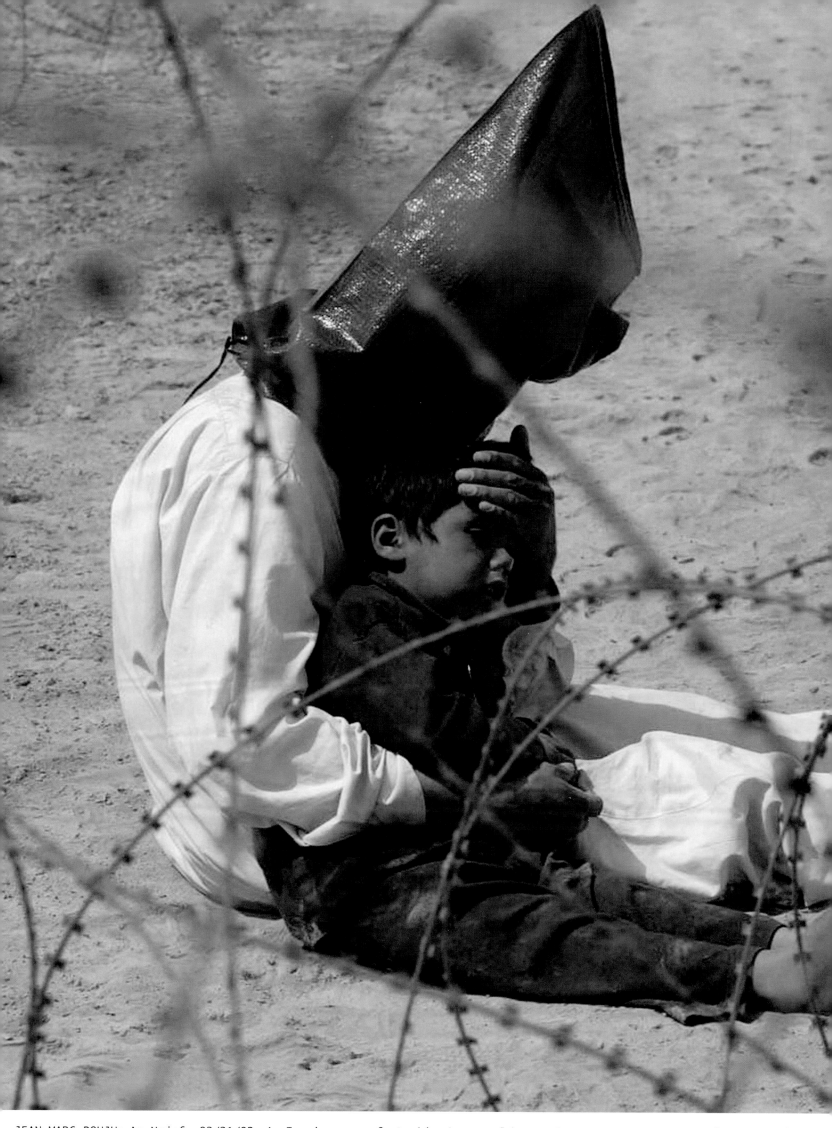

JEAN-MARC BOUJU: An Najaf, 03/31/03. An Iraqi man comforts his 4-year-old son at a regroupment center for POWs of

the 101st Airborne Division. The man was seized with his son, and the U.S. military did not want to separate them.

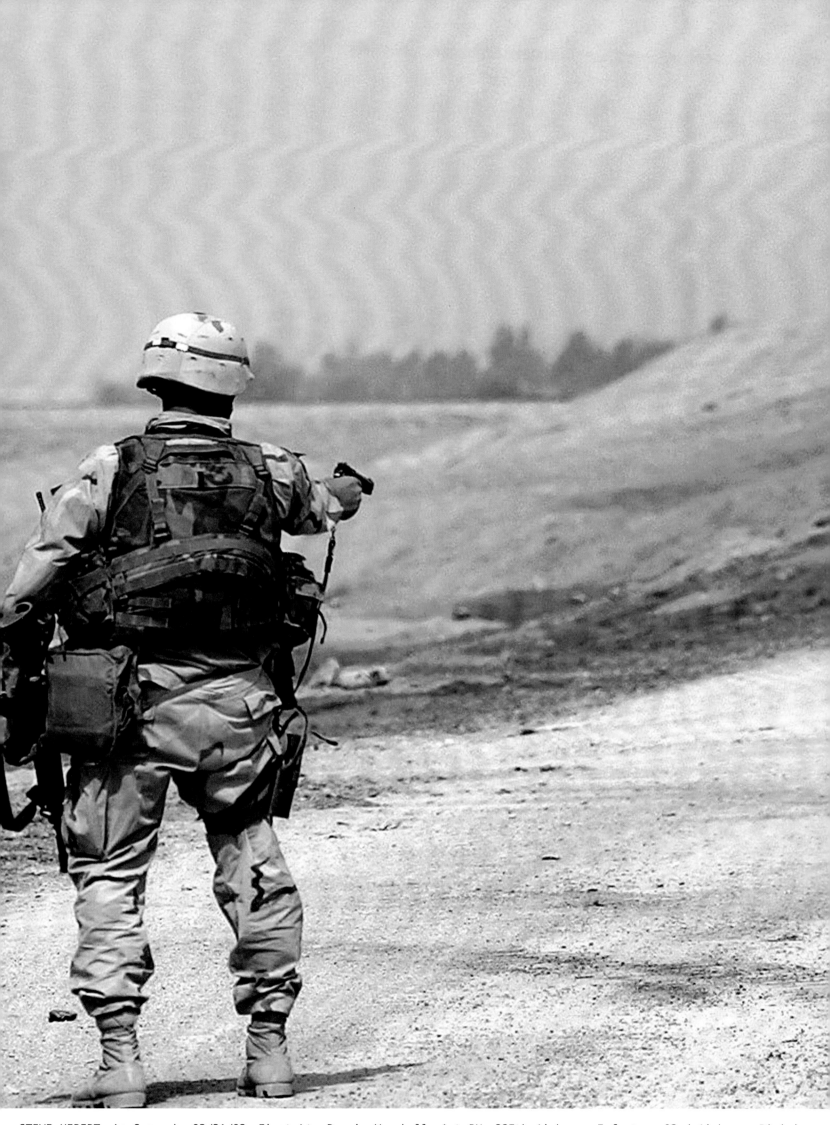

STEVE HEBERT: As Samawah, 03/31/03. First Lt. Dennis Marshall, 1st BN, 325th Airborne Infantry, 82nd Airborne Division

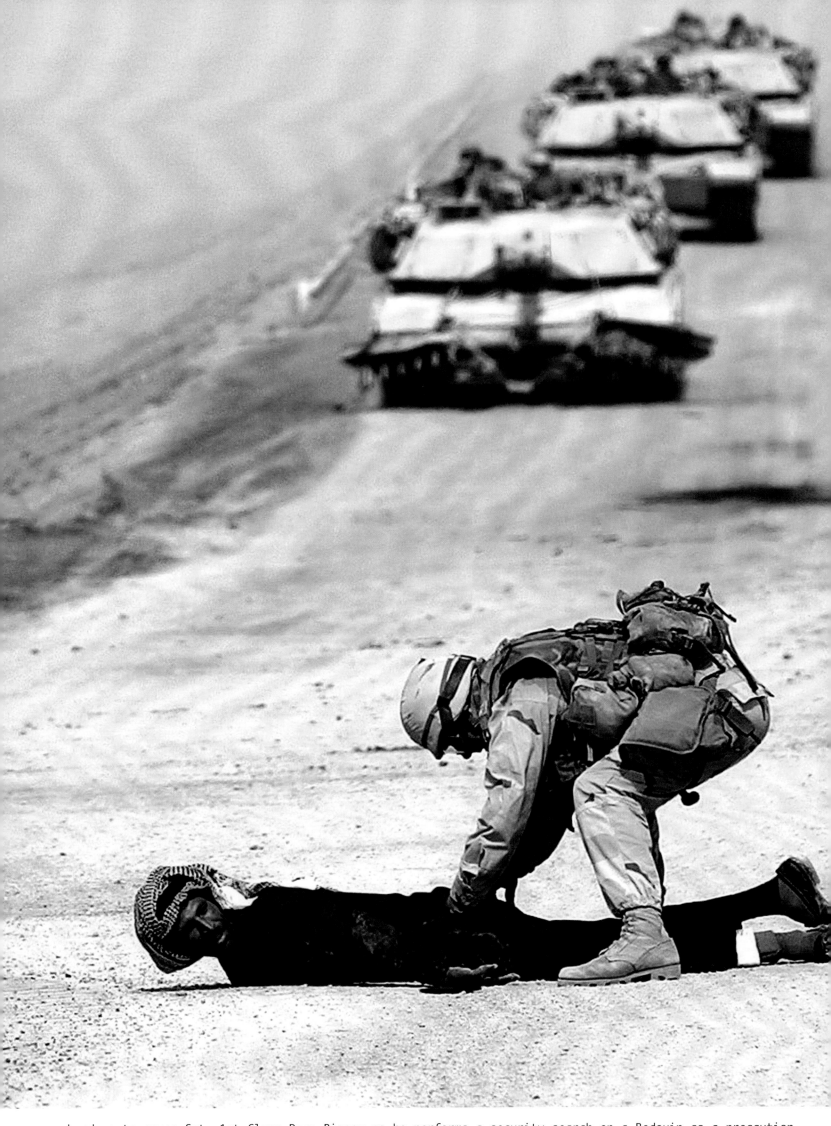

uses a handgun to cover Sgt. 1st Class Dean Bissey as he performs a security search on a Bedouin as a precaution.

CHRIS HONDROS: Safwan, 03/21/03. U.S. Marine Major Bull Gurfein pulls down a poster of Iraqi President Saddam Hussein.

Chaos reigns in southern Iraq as coalition troops continued their offensive to remove Iraq's leader from power.

JULIE JACOBSON: South of Baghdad, 04/05/03. U.S. Marine Corpsman Joe Clairmont (L) of Jacksonville, FL, of the HMH 364

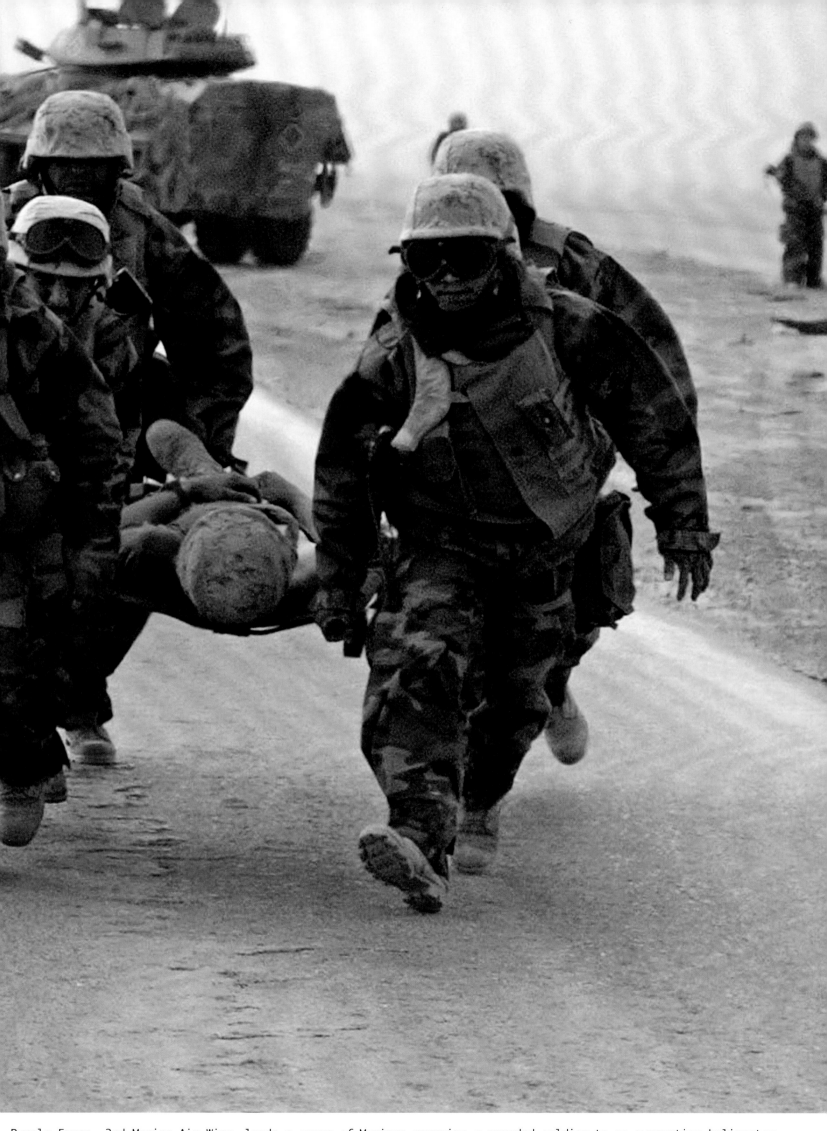

Purple Foxes, 3rd Marine Air Wing, leads a group of Marines carrying a wounded soldier to an evacuation helicopter.

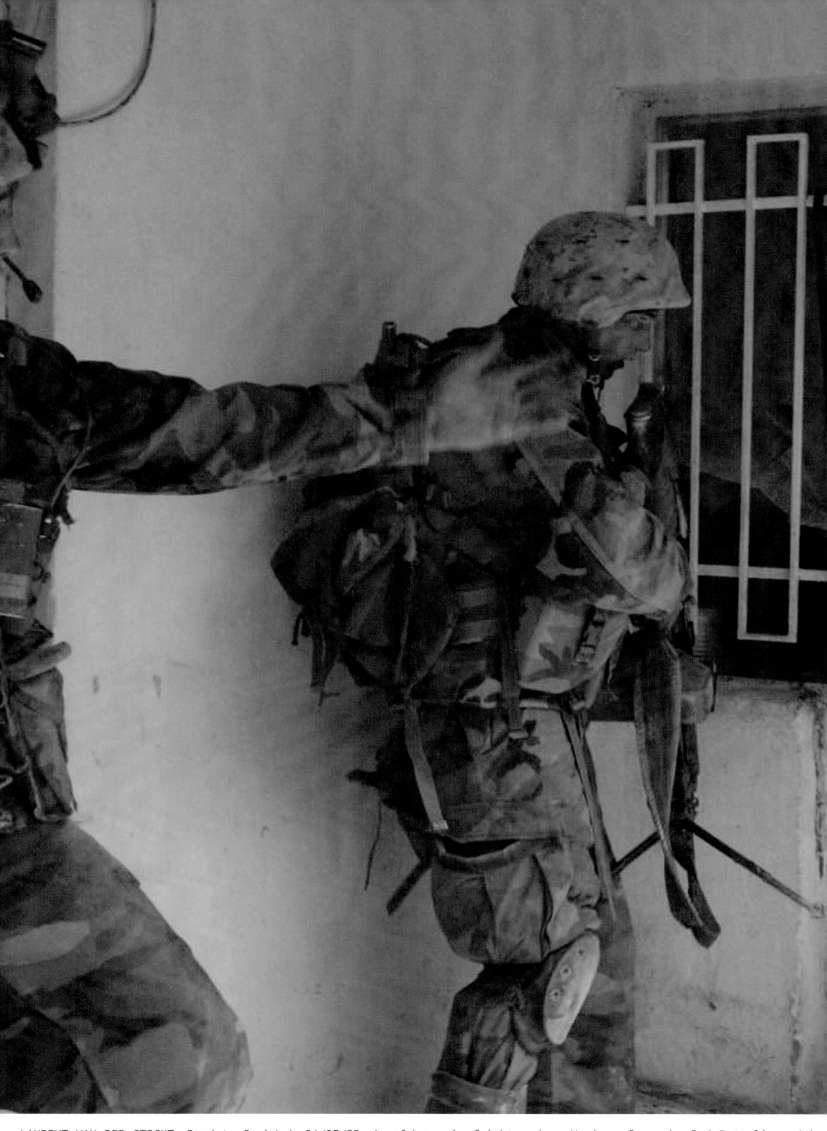

LAURENT VAN DER STOCKT: Road to Baghdad, 04/05/03. An old man is frightened as Marines from the 3rd Battalion, 4th

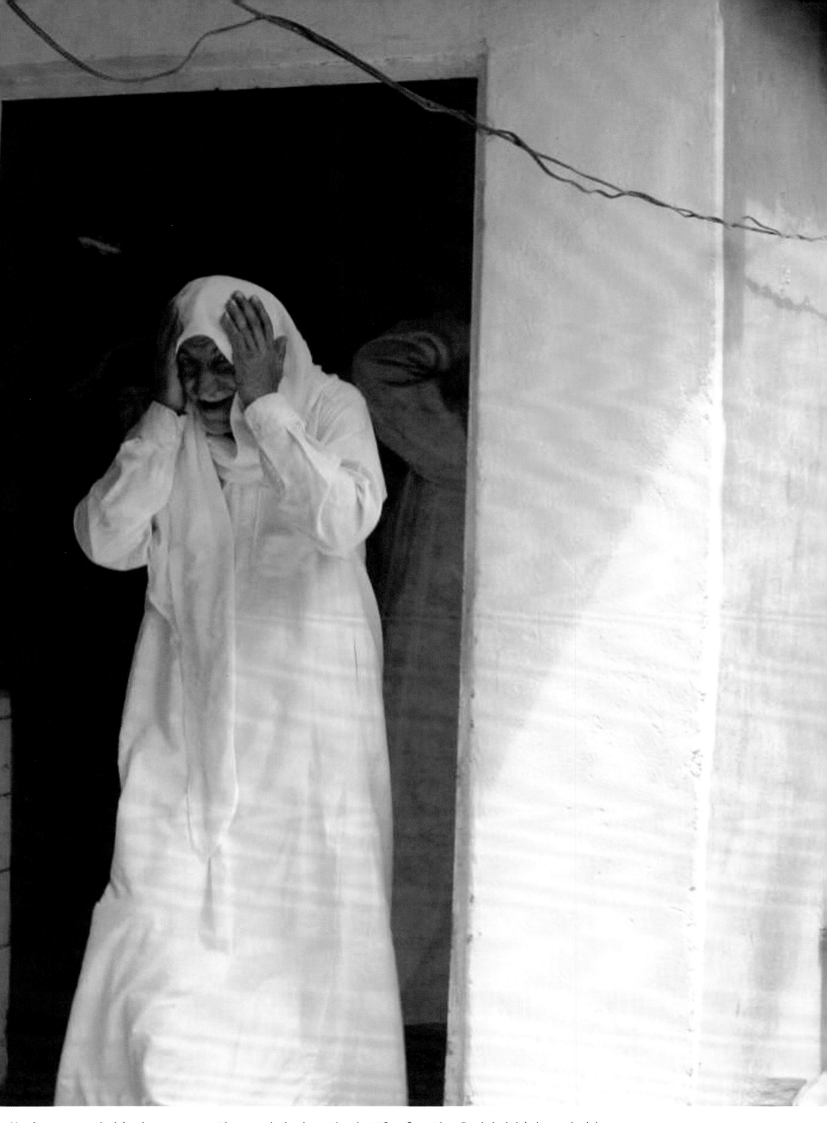

Marines search his house near the road during the battle for the Baghdad highway bridge.

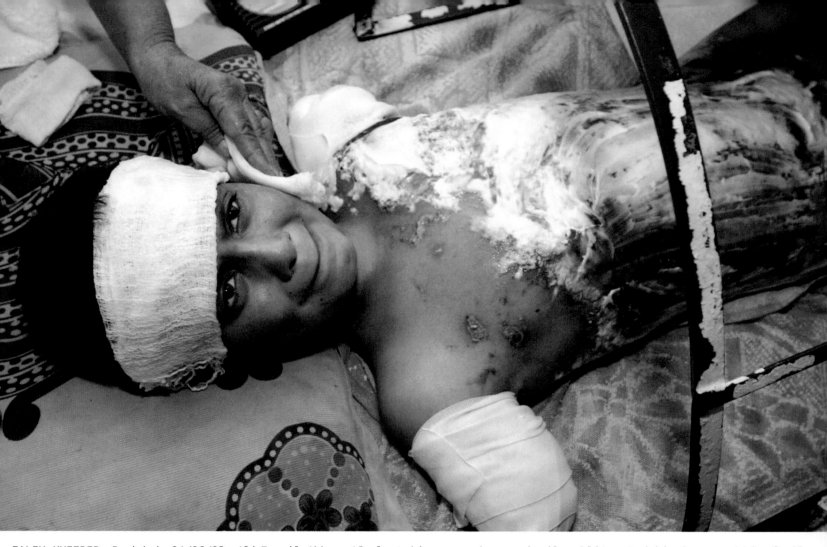

FALEH KHEIBER: Baghdad, 04/06/03. Ali Ismail Abbas, 12, lost his arms when a missile obliterated his home and his family.

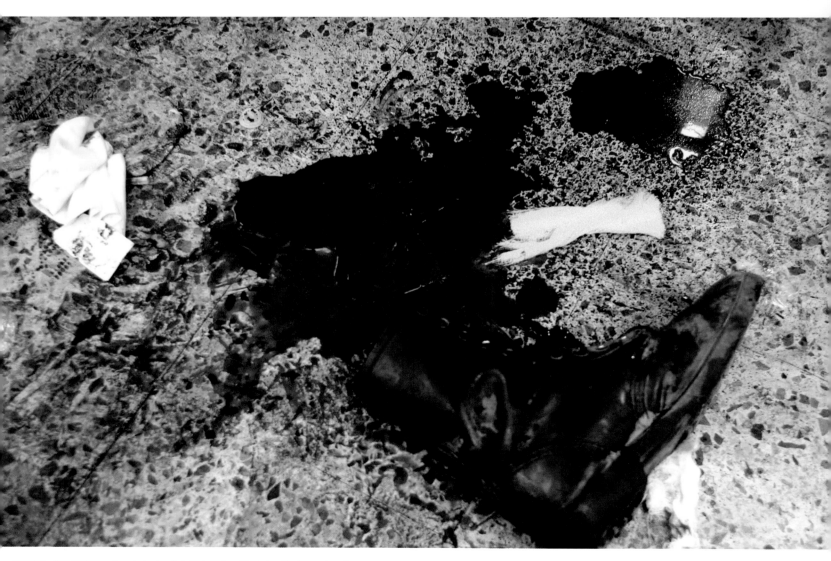

BRUNO STEVENS: Baghdad, 04/05/03. Al Kindi hospital admitted 70 bombardment victims in 2 hours; one-fifth were military.

>The British are dispensing food, juice, milk, and other staples to residents of outside of Basra. The locals are cautious, but open with the allied servicemen. Posted By Dean Esmay at 01:16 AM (TCP)

>As Allison reported earlier on The Command Post, more details are emerging of the shooting of Iraqi civilians trying to flee Basra. SkyNews reporter Emma Hurd with the Black Watch battle-group of 7 Armoured Brigade (UK) says that 1-2,000 civilians were crossing a bridge when Iraqi forces fired on them shooting many in the back and causing them to retreat towards Basra. British troops watching, opened fire on the Iraqi troops responsible but said they could not engage them as heavily as they would have liked due to the mass of civilians scattering in front of their positions. Posted By Perry de Havilland (Samizdata) at 03:31 AM (TCP)

>Kurdish Peshmerger guerillas and U.S. Special Forces capture the area held by the Ansar al-Islam (an extremist Muslim group accused of having links with al-Qaeda) in mountainous north-east Iraq. Posted By Judith (Kesher Talk) at 01:09 PM(TCP)

>Four U.S. soldiers from the Army's 3rd Infantry died about 15 minutes ago when a car bomb exploded at a checkpoint they were manning near the southern city of Najaf, on the road to Baghdad. The Jerusalem Post

>"They were wearing civilian clothes, but when I ripped them off they were wearing Iraqi uniforms underneath." Staff Sergeant Jamie Villafane

>Last night the 101st attacked the Republican Guard, and lost two helicopters due to rollover crashes on landing. Their former base camp in Northern Kuwait is being occupied by the 4th Infantry Division; two 4th ID cargo ships are already in Kuwait harbor. This is one reason they have more units en route to their location—there is no place left for them in Kuwait. They are not talking about a pause but the consolidation of forces. There will be no pause in the aerial campaign, including the attacks by the 101st choppers. Posted By John (Useful Fools) at 01:18 AM

>THOMAS MULLEN ADAMS 1975-2003 Adams, a Lieutenant in the US Navy, was killed early Sunday morning when two British Sea King helicopters collided shortly after takeoff from a ship in the Persian Gulf. A descendant of two presidents and a graduate of the US Naval Academy, Adams was a Naval Flight Officer participating in an exchange program with the Royal Navy. He was 27 years old.
>>Among many other things, he was a good friend to my brother.
>>The Navy Hymn:
>>Eternal Father, strong to save
>>Whose Arm hath bound the restless wave
>>Who bids the mighty Ocean deep
>>Its own appointed limits keep
>>Oh, hear us when we cry to Thee
>>For those in peril on the sea!
>>My thoughts and prayers go out to his family and friends. Posted by LT Smash at 12:21 PM

>Jim Axelrod of CBS TV is reporting that after the car bomb that killed four US soldiers overnight, three other taxis attempted to run U.S. check-points. In all three cases the drivers were shot and killed. Posted By Alan at 05:49 PM

>"Now even the American command is under siege. We are hitting it from the north, east, south and west. We chase them here and they chase us there. But at the end we are the people who are laying siege to them. And it is not them who are besieging us." Mohammed Saeed Al-Sahaf

>Through Israeli channel 2: Al Jazeera video shows 4 soldiers, man 31 y/o from New Jersey, woman 30, from Texas and another man from Texas. 2 of them are from 507 maintenance unit. Some of them are injured. The captured soldiers told their names, age, state, army number and unit. Posted By Gil Shterzer (Israel) at 11:08 AM 03/23/03

>ABC: "liberated" Iraqis turning doubtful and bitter the next day. Promised supplies aren't there, etc. This is going to be the real war soon; seems we'd better start doing a better job at it before too much longer. Posted By Gary at 09:35 AM

>MSNBC now reporting word from CENTCOM that the missing RAF aircraft was bagged by a US Patriot battery on the Kuwait border. Two dead. This is awful. Posted By Billy Beck at 02:53 AM

>We've heard about soldier posing as civilians to ambush Americans troops, but according to Reuters, some civilians are posing as soldiers so they can surrender. The humanitarian situation is bad enough that civilians want to be 'captured' by Americans in the hopes of getting a decent meal. Posted By Sean Kirby at 11:53 03/24/03

>CNN scrolling that the Pentagon reports the downed Apache has been destroyed. No word on the dancers with rifles alongside. Posted By Chuck at 09:27 PM

>Switched to the Iraqi station. An Iraqi general was giving a briefing. He was looking around the room as if he was frightened for his life. The locals translated some of his statements. The general was making outrageous claims of victory on all fronts, which were met with cries of "Bulls-t!" from my hosts. They mocked him.
>>Switched to BBC; anchor announced that the port city of Umm Qasr had been secured, and would be receiving humanitarian supplies within days.
>"Sir, is it true," they asked me, "is Umm Qasr secured?"
>"That's what he said."
>"Can we go there?" they asked; this puzzled me.
>"Why would you want to go there?"
>"Dancing girls! Beer!"
>Then it hit me; Umm Qasr is a border town; it holds memories of a different time for these men, a time before war when they could travel freely to Iraq, and do all the things not allowed in their own country. Umm Qasr is their Tijuana. Posted by LT Smash at 01:10 PM 03/26/03.

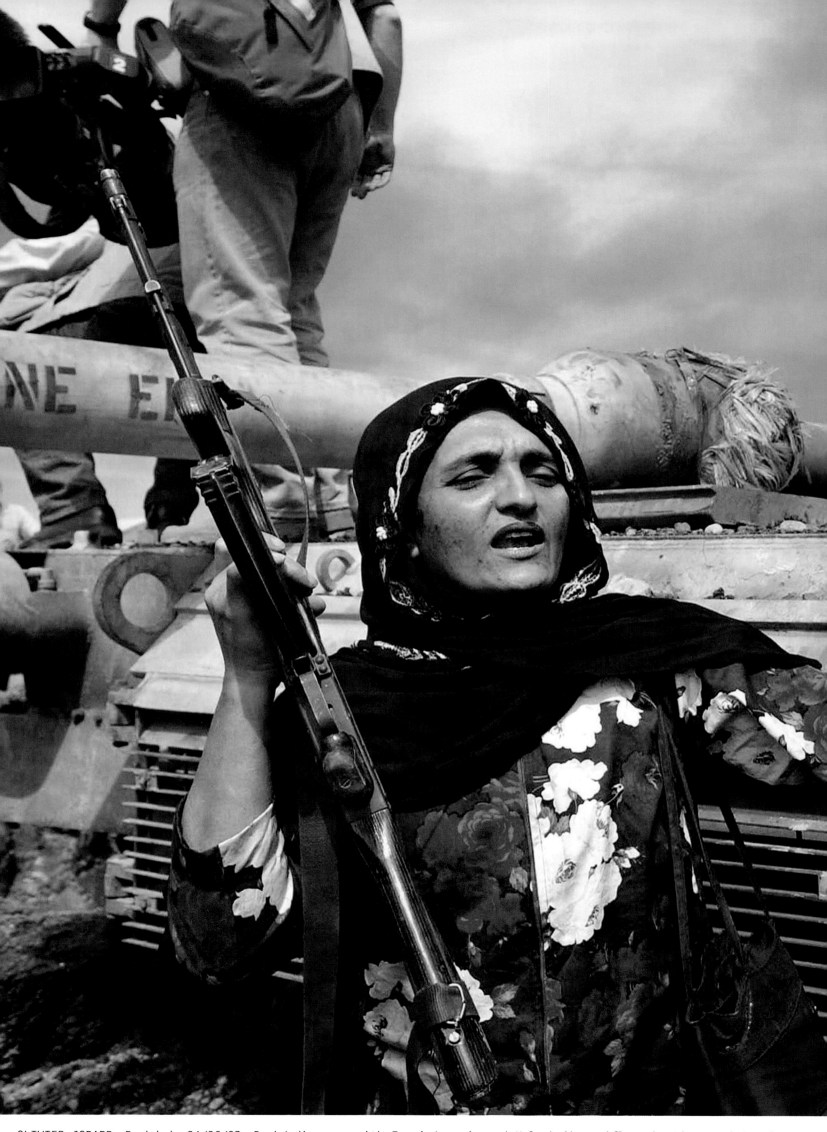

OLIVIER JOBARD: Baghdad, 04/06/03. Baghdadi women with Iraqi Army-issued Kalashnikov rifles chanting anti-American

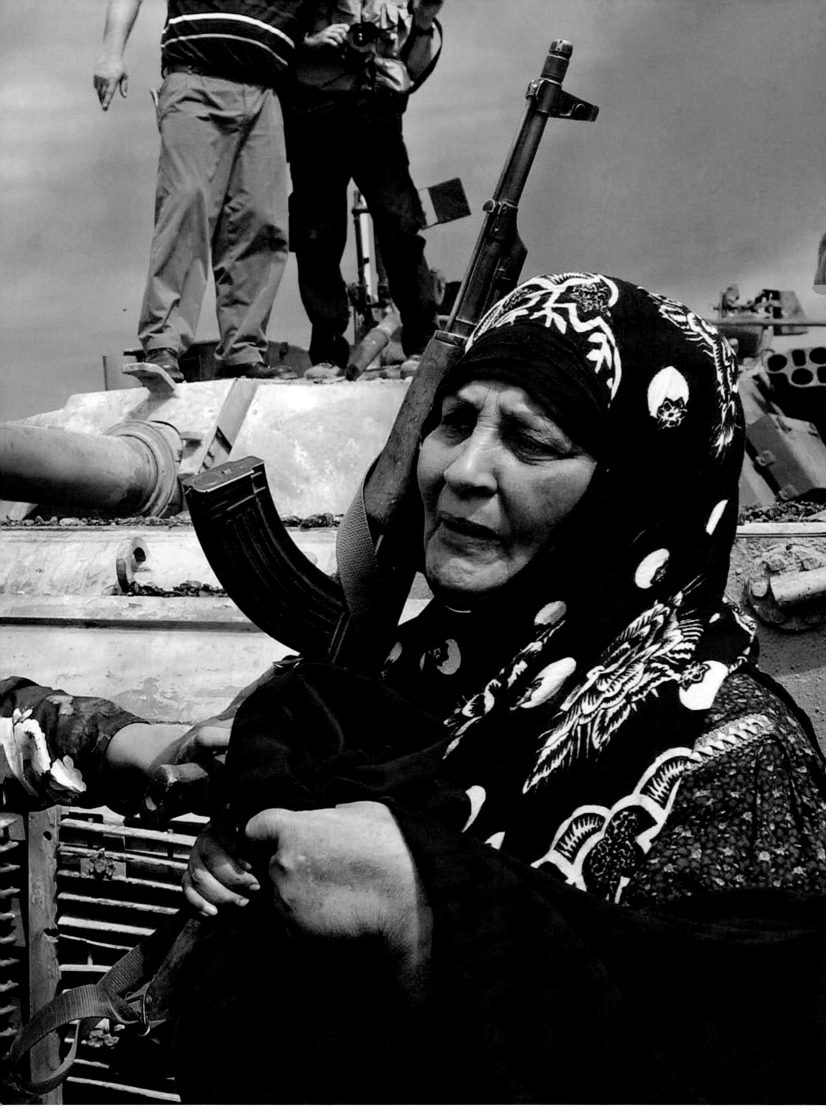

slogans next to a destroyed American tank in the Dora district of southern Baghdad.

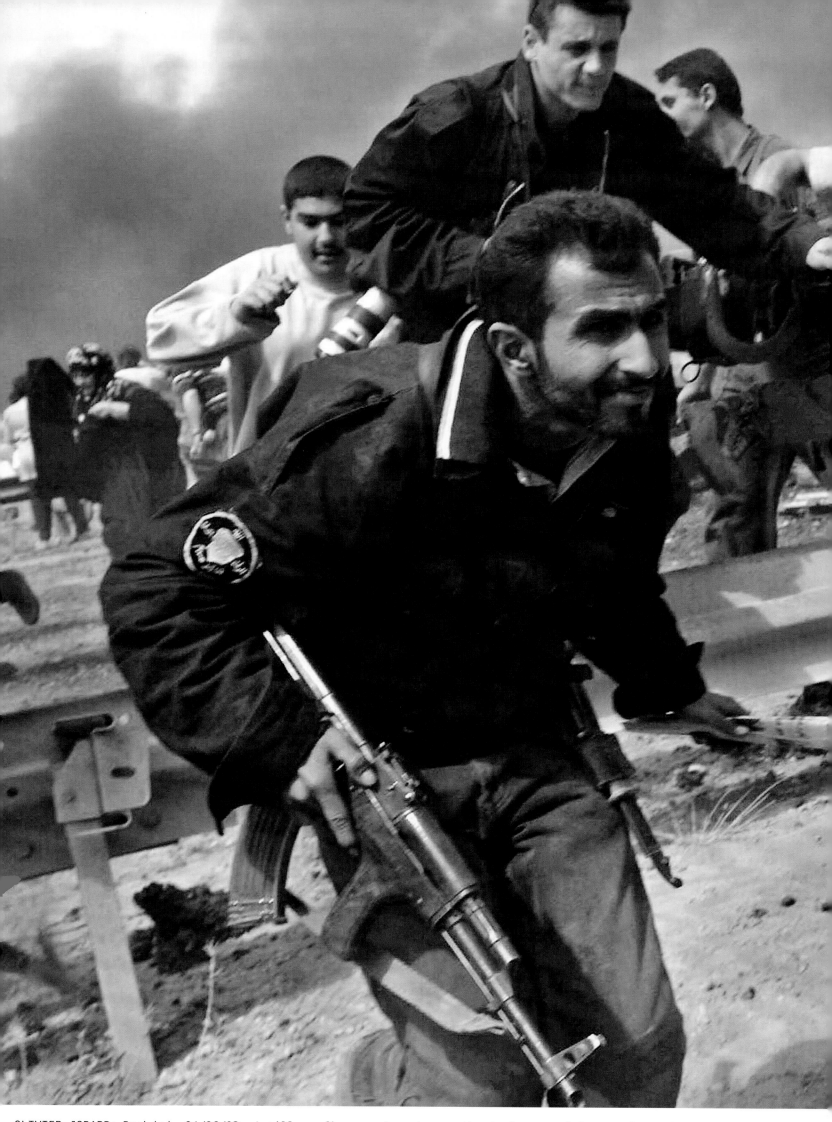

OLIVIER JOBARD: Baghdad, 04/06/03. Artillery fire was heard near the tank several hours after the engagement on the

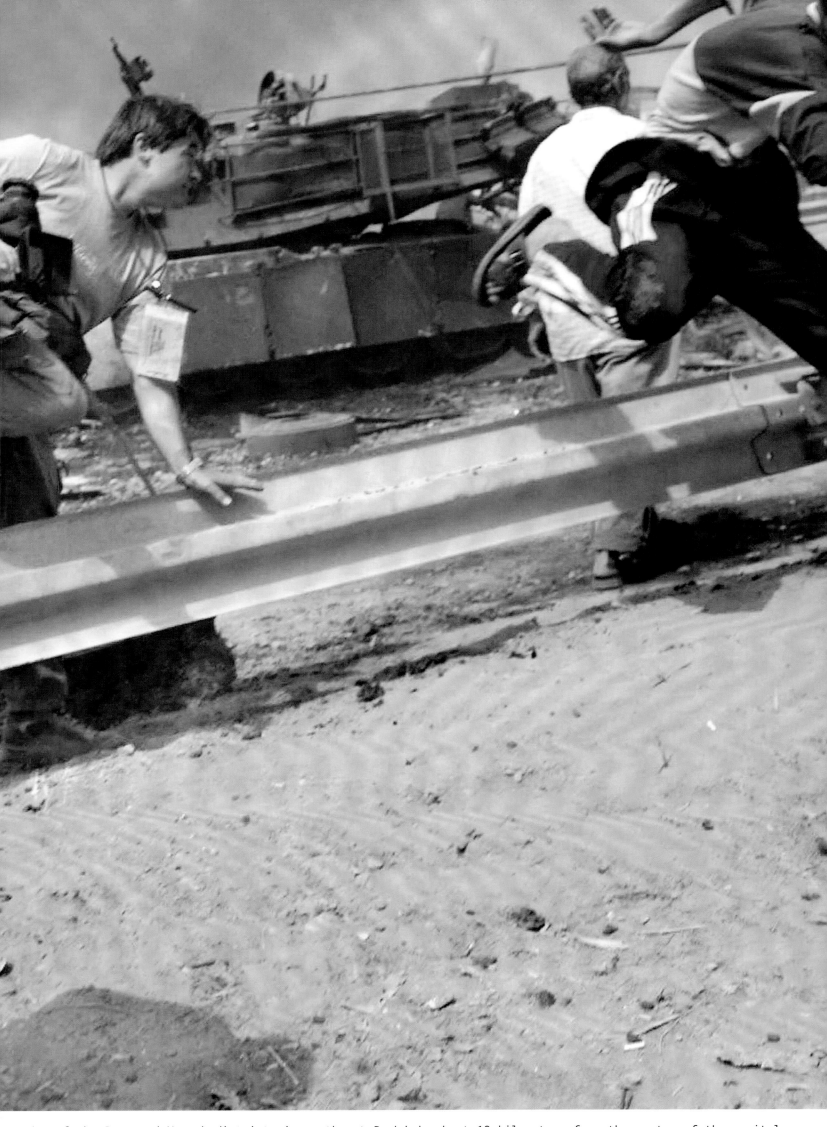

edge of the Dora and Yarmuk districts in southwest Baghdad, about 10 kilometers from the center of the capital.

March 22, 2003 The hand of God

The following morning we are shown wounded civilians in the hospital. These are not the victims of heavy shelling, but people who have literally been caught in the crossfire. Tracer bullets, shot by Iraqi gunners, have landed on the Baghdad population. The Iraqis we interview live in areas too far away from one another, and their wounds are too minor, to be accounted for by any other explanation. Do these poor people really know that the allied forces want to liberate them? I don't think so. They have had twelve years of hardship and suppression, from what they can only see as having come at the hands of the Americans. I wonder what they will think or do when the troops march on Baghdad.

Later that night the ministry building across the river is hit with an almighty thud. Tracers continue to fill the sky. I'm calm now, compared to the way I felt at this point the evening before. I fire off a few frames before the flames go out. Strike after strike hit targets on the horizon. It is very dark, and happening too quickly to really shoot anything. All I can do is watch in disbelief, realizing that it has finally come to this.

After gaining access to the roof of the hotel, through a broken door, I find that I'm not the only one trying to get a bird's-eye view. But things are quieting down. We experience hour after hour of nothing. Some photographers sleep on top of their equipment. Suddenly, the door to the roof swings open, and a dozen or so men from the Ministry of Information rush at us. One TV camera after another is thrown to the ground. James Nachtwey's camera is taken from him and thrown off the roof. A quick push and shove, and I make a run for it, scrambling to the stairs before anything else happens. I ditch the stairwell and hop on the lift at the seventeenth floor.

Later that day, after managing to catch a nap, I was awakened with an offer of a bus tour of Baghdad—an attempt by Iraqi authorities to show that all is still well. I realize I can do without the bus trip, especially one on which you can't take pictures or get off the bus.

Later, we find that there is no food in the hotel. Not even a cup of Turkish coffee, the local delight. "Hanid, can you change a twenty to Iraqi dinar?" "Quickly, Mr. Shams, but be quick, ha? The B52s are coming in fifteen minutes," he looks white with fear. Hanid, working at the hotel reception desk, has asked me, day after day, "Is it today? Should I bring my family here now?" Rumors have been flying around, prompting photographers and correspondents to get into position for the beginning of the big strikes.

The chief targets, we all think, will be the main palaces and, once more, the military headquarters on the far riverbank of the Tigris, literally across from our windows. Only a week ago every journalist stayed on that side of the river. But, one by one, we moved to the "safe side," and took up residence in the Palestine Hotel, abandoning our rooms at the Al Rasheed, made famous during the Gulf War in 1991. It's more recently become known for its military command center in the basement. Not the safest place in Baghdad.

Just at nine o'clock I hear a loud missile coming my way. It flies right overhead in a screaming whistle. I run to the bedroom balcony to find the heavens opening with a thunder such as I have never heard in my life. If I had been in the Al Rasheed this instant, I would have been blown to the other side of the room. For about a minute, the ground shakes, continually, from the bombing that has sent hot flames of cloud racing into the air. My first few exposures are shaky, the result of the trembling building, and my attempts to catch my breath and get a grip on what is going on. Focus. Deafening thunder rains out only a few hundred yards away. Last night did not prepare me for this. No flying debris, though, which is a good thing. Tracers everywhere light up the sky as they hit, one after another, along the riverbank.

I race up to a colleague's room, which had a better view. My stunned and mixed emotions are sickening. It isn't easy to witness and record attacks of aggression for a living. Maybe in my misspent youth I might have had a different approach to life and enjoyed the fireworks. But this has been a display of unleashed terror the likes of which I didn't think existed. The hand of God couldn't have done it any more effectively.

—Seamus Conlan

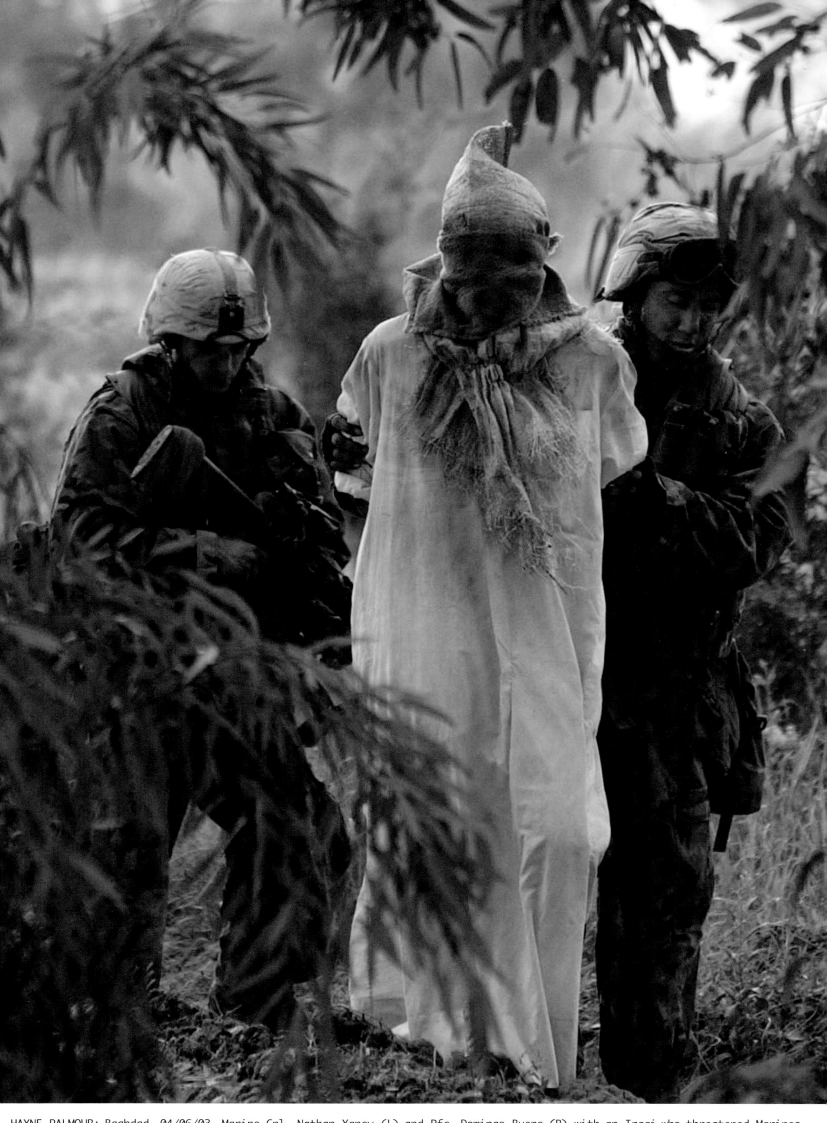

HAYNE PALMOUR: Baghdad, 04/06/03. Marine Cpl. Nathan Yancy (L) and Pfc. Domingo Bueno (R) with an Iraqi who threatened Marines.

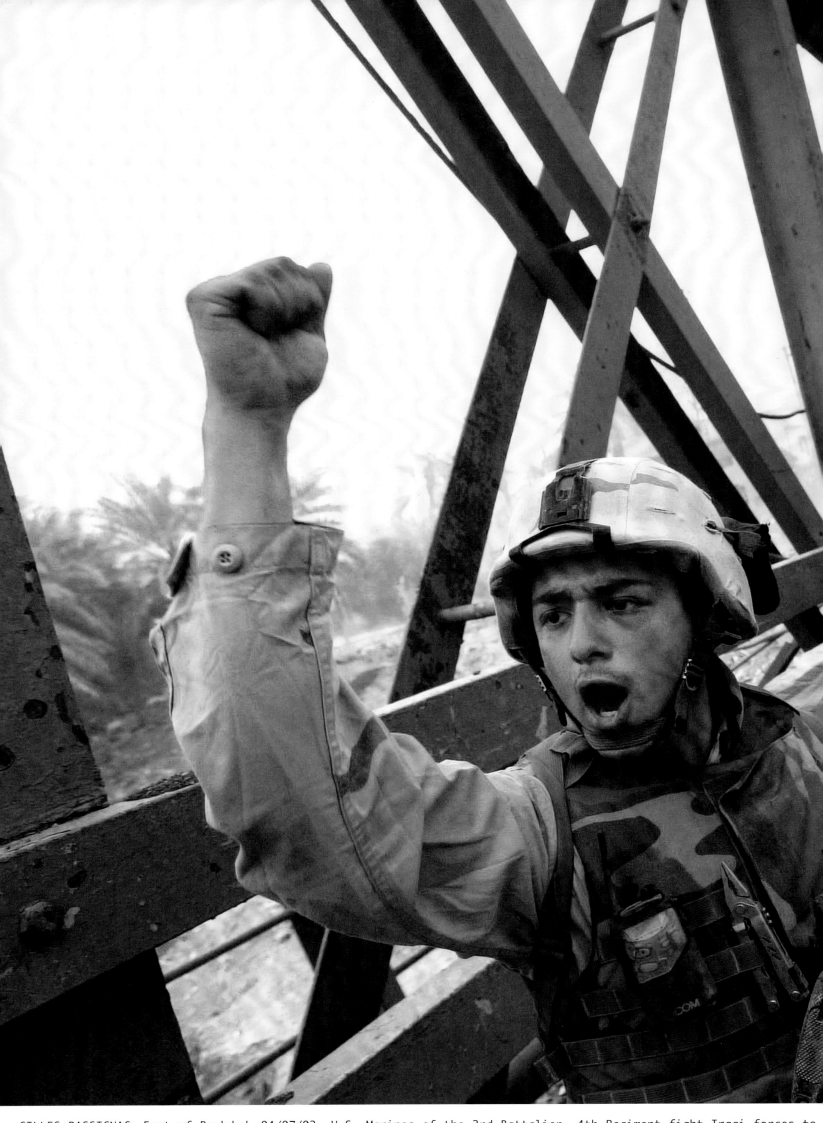

GILLES BASSIGNAC: East of Baghdad, 04/07/03. U.S. Marines of the 3rd Battalion, 4th Regiment fight Iraqi forces to

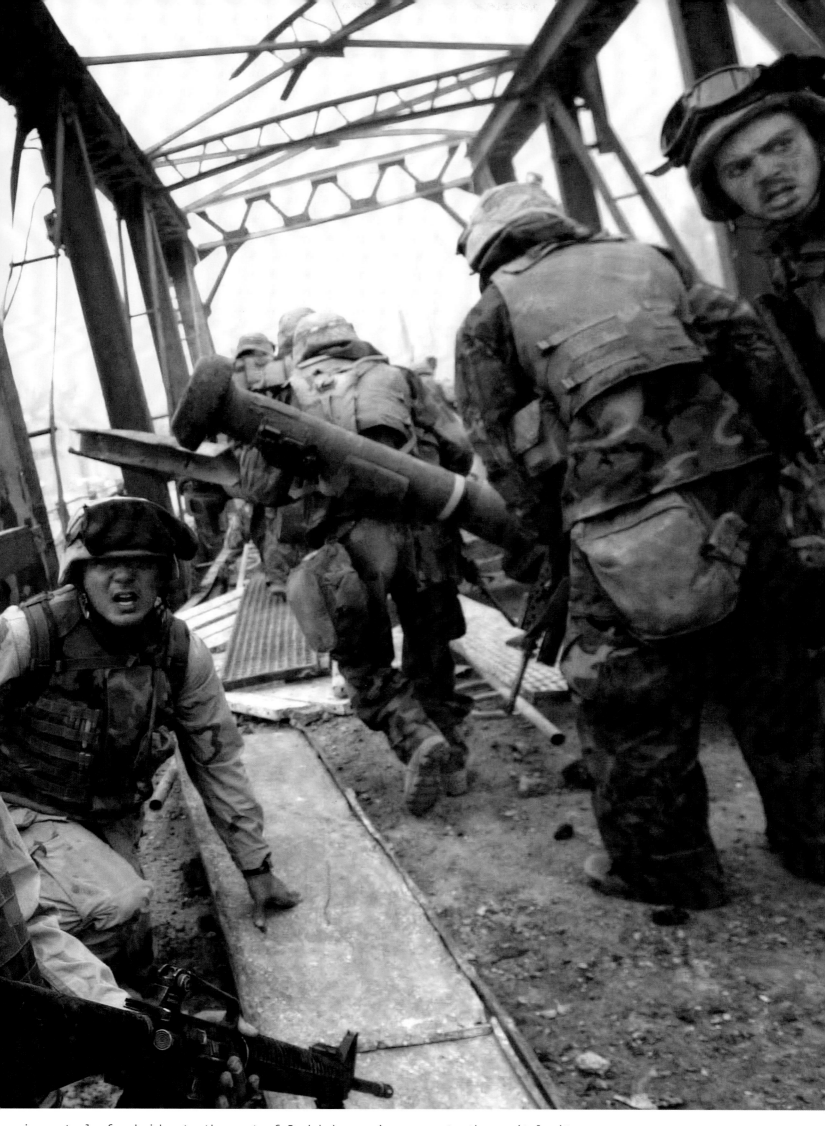

gain control of a bridge to the east of Baghdad, a main access to the capital city.

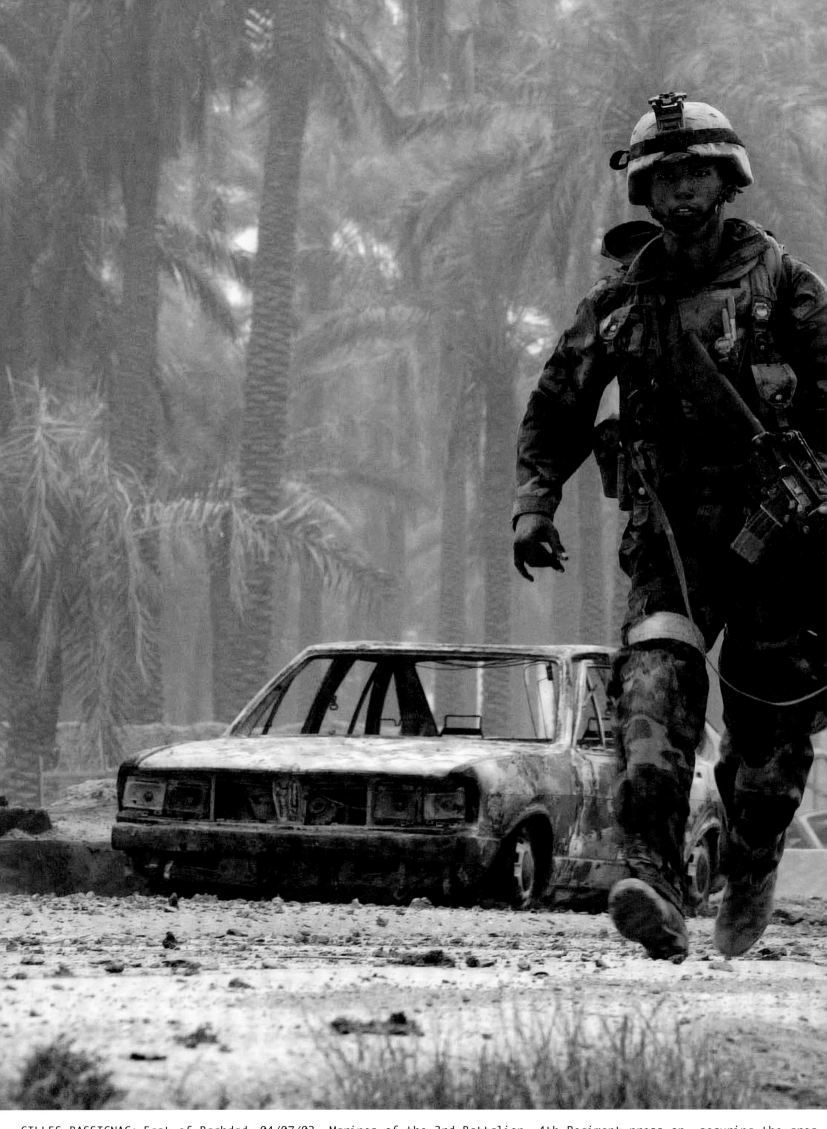

GILLES BASSIGNAC: East of Baghdad, 04/07/03. Marines of the 3rd Battalion, 4th Regiment press on, securing the area

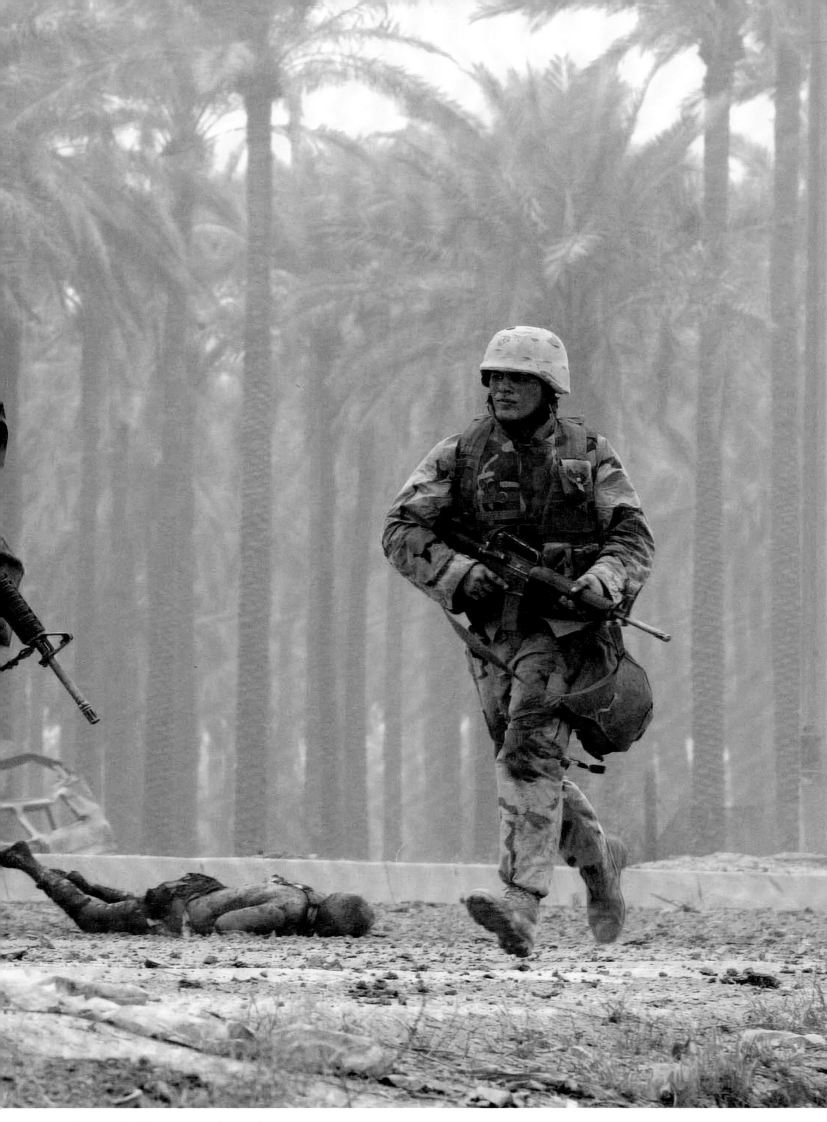

surrounding the bridge east of Baghdad.

PAOLO PELLEGRIN: Basra, 04/07/03. Bodies of Feyadeen, pro-Saddam militia fighters, at a hospital's morgue before burial;

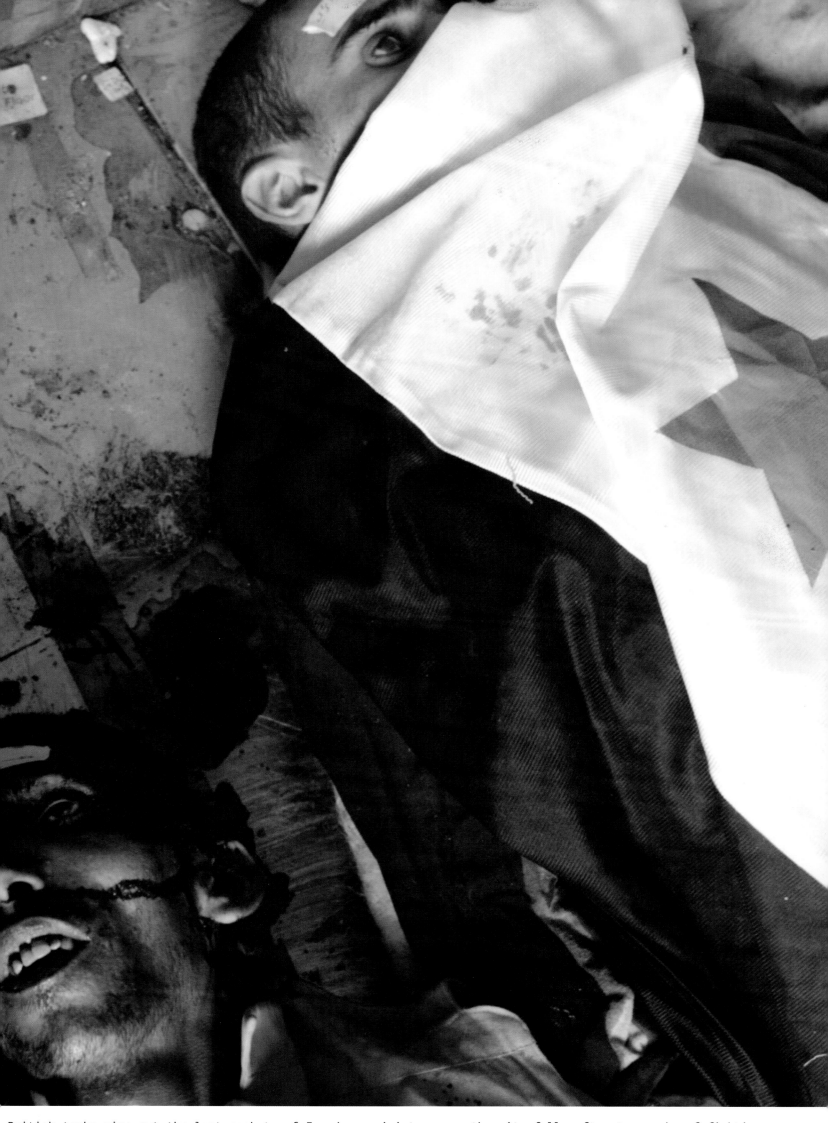

British tanks wipe out the last pockets of Feyadeen reisistance as the city falls after two weeks of fighting.

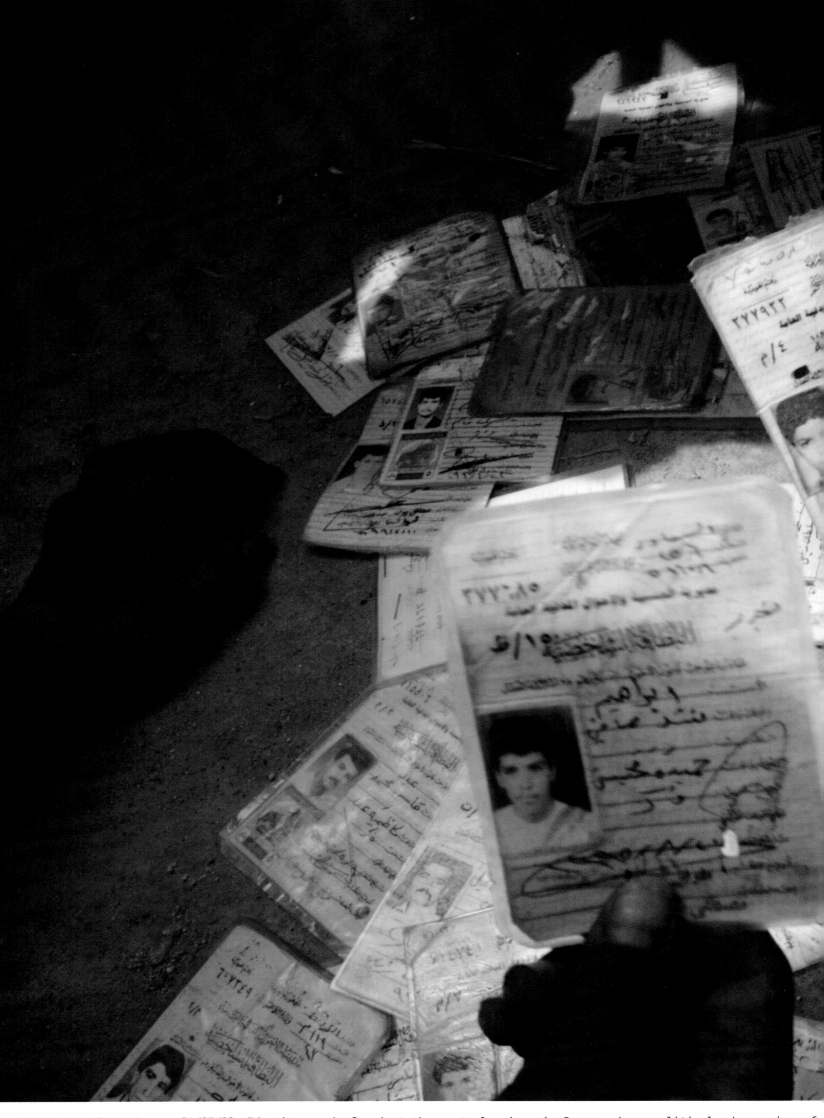

PAOLO PELLEGRIN: Basra, 04/07/03. Identity cards found at the central prison in Basra, where political adversaries of

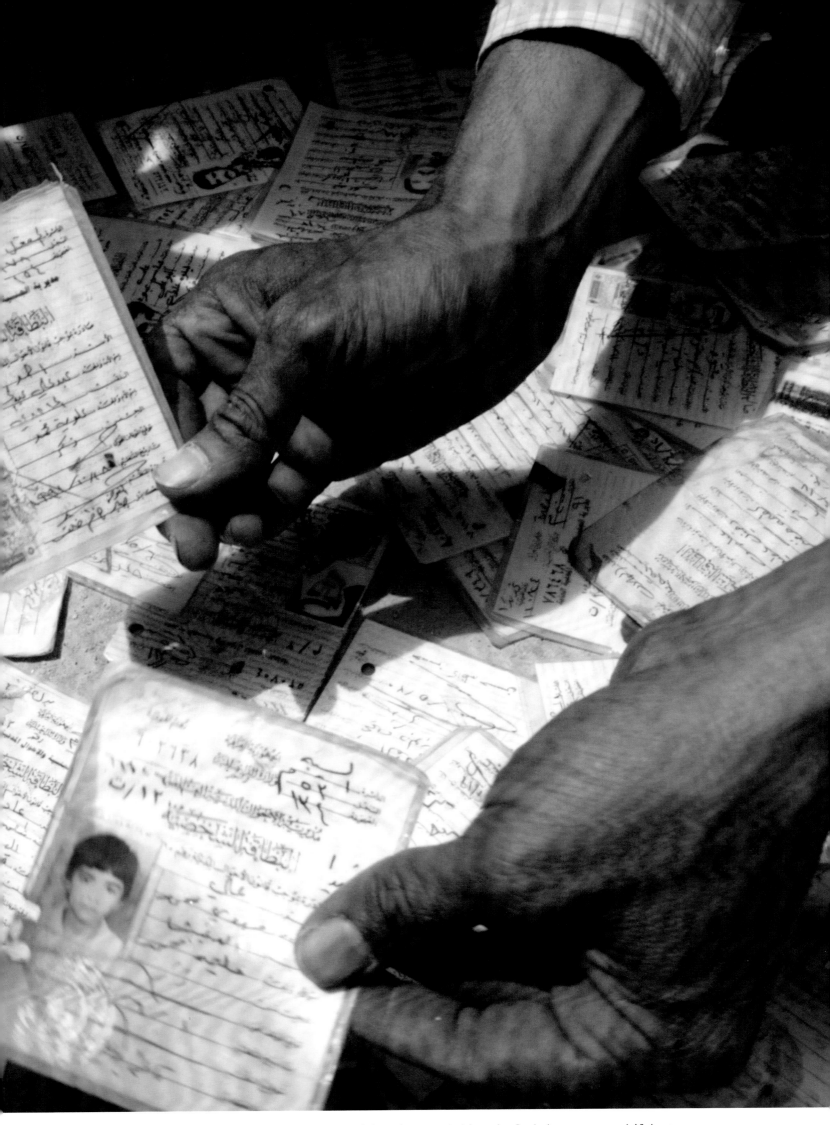
Saddam's regime were reeducated, using torture and beatings; victims included numerous children.

أم الربيعين

JEROME DELAY: Baghdad, 04/07/03. Iraqi men chat at a normally busy café across the river from one of Saddam Hussein's

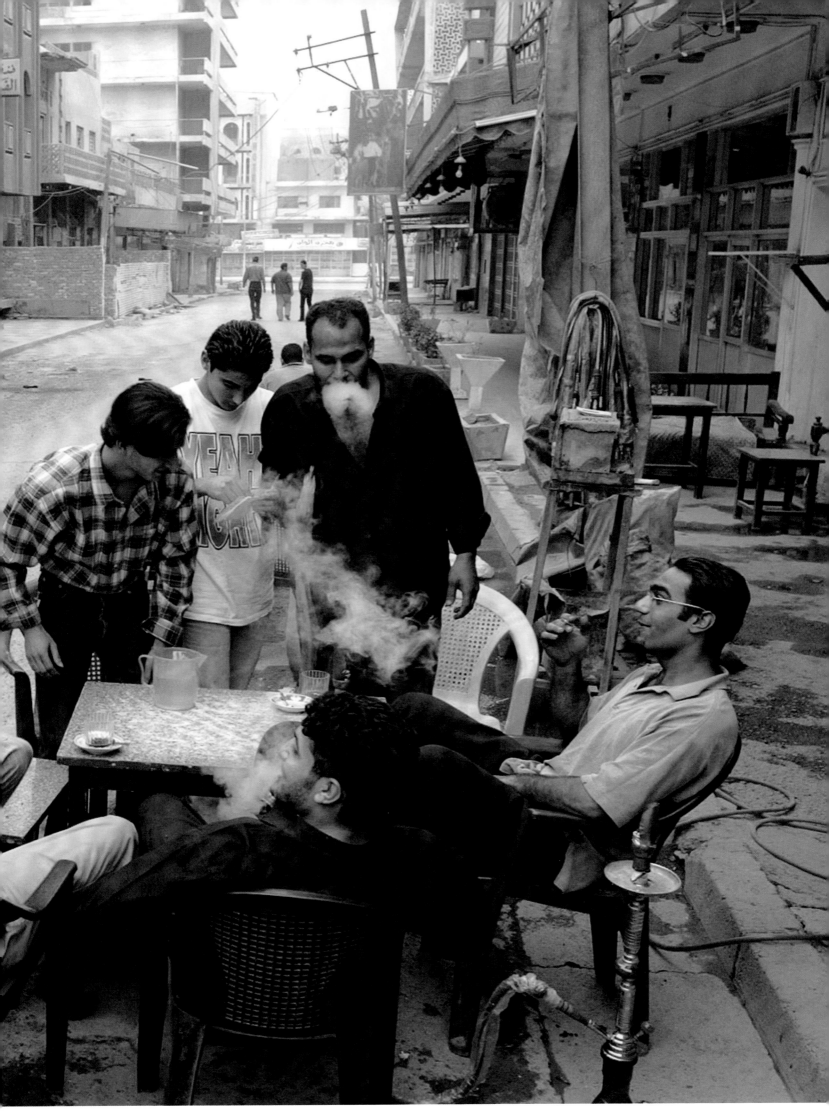

presidential palaces.

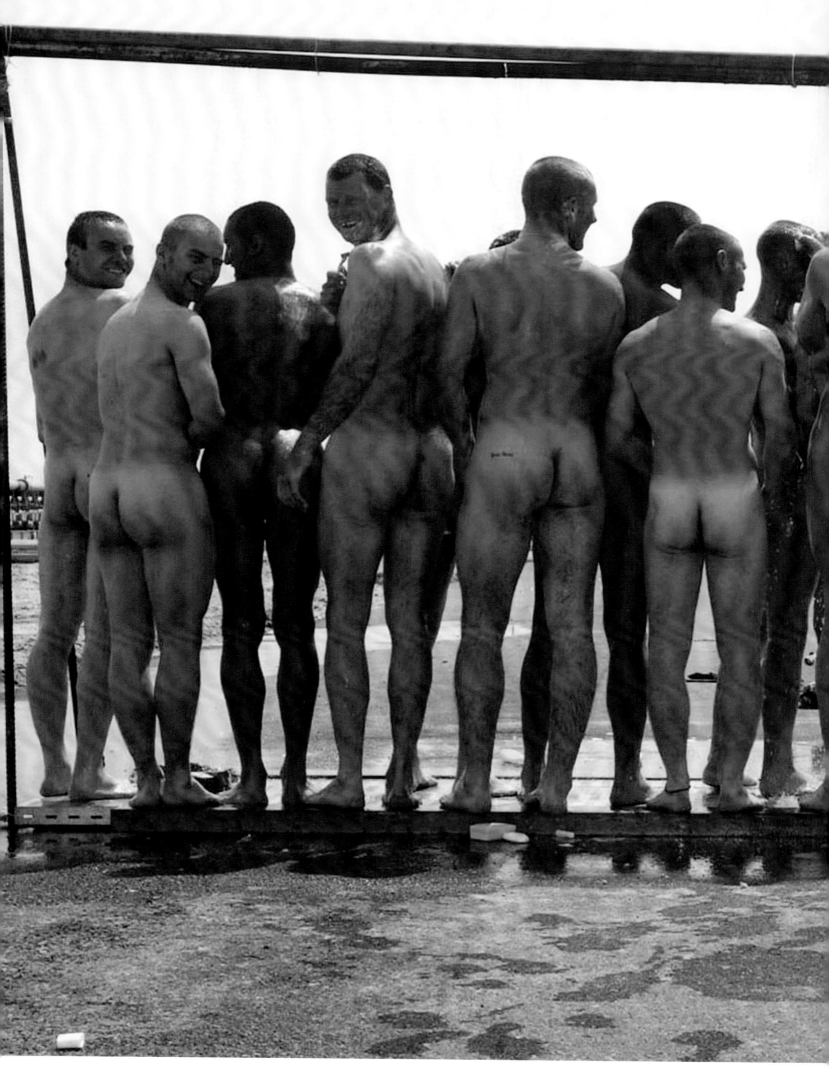

GILES PENFOLD/POOL: Basra, 04/07/03. British troops from 2 Platoon, 1 Parachute Regiment, 16 Air Assault Brigade take

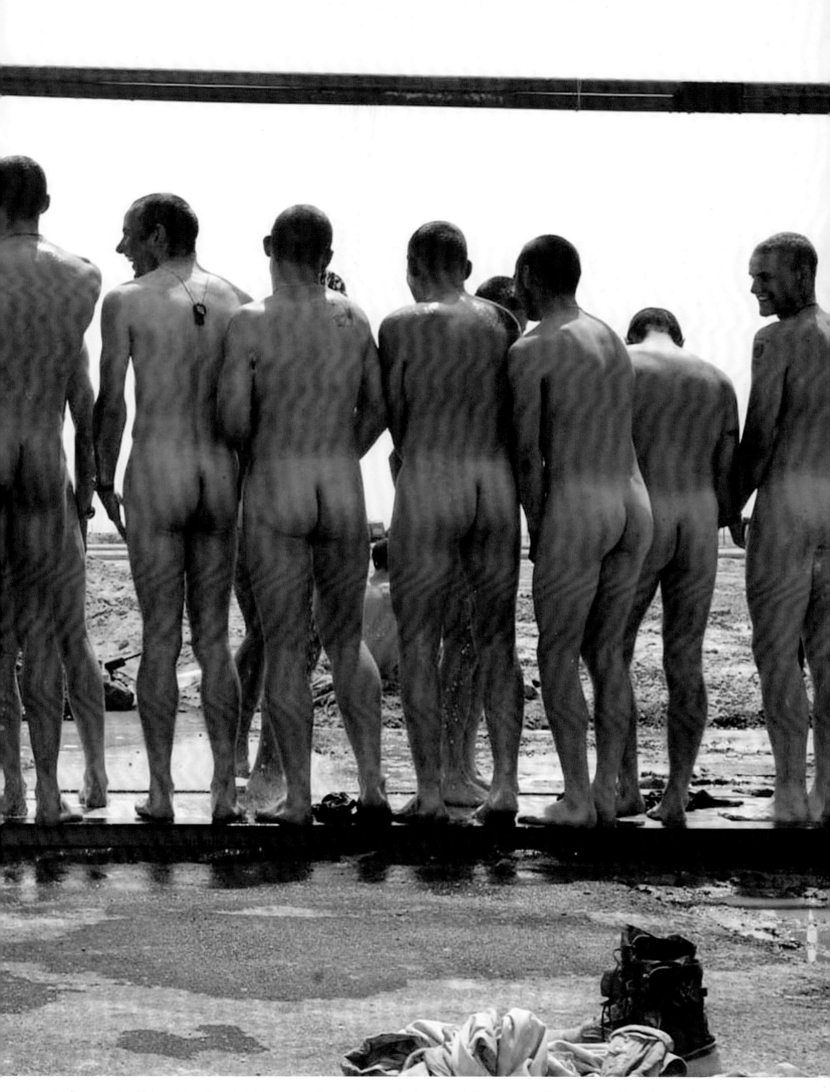

a break from patrolling the front line near Basra to cool down and freshen up by means of an improvised shower unit.

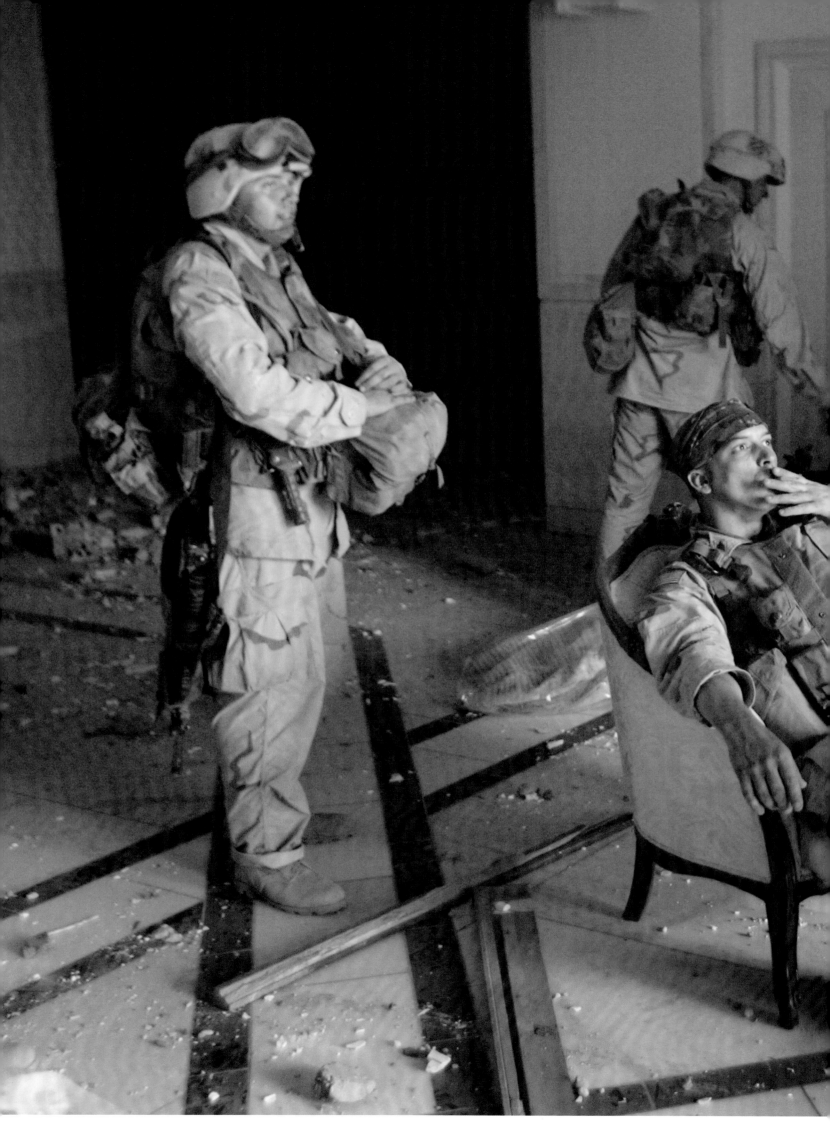

JOHN MOORE: Baghdad, 04/07/03. U.S. Army Staff Sgt. Chad Touchett, center, relaxes with fellow soldiers from A Co.,

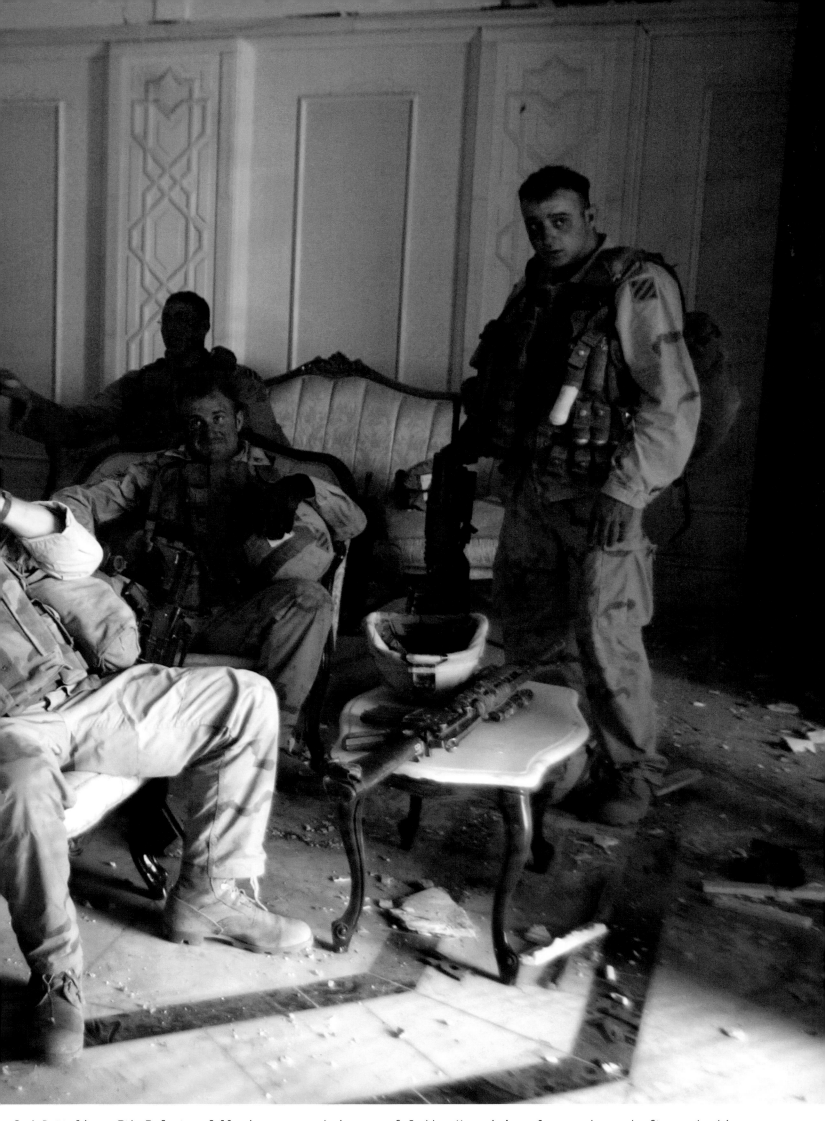

3rd Battalion, 7th Infantry following a search in one of Saddam Hussein's palaces, damaged after a bombing.

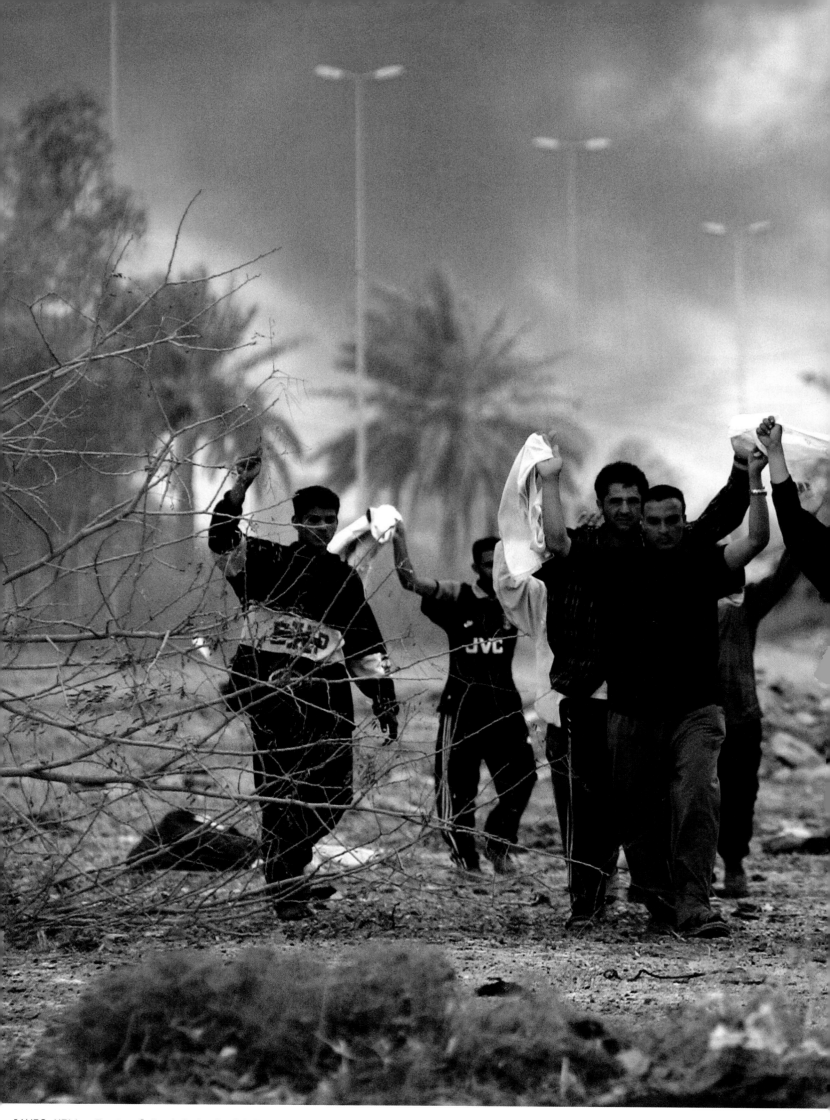

JAMES HILL: East of Baghdad, 04/08/03. Iraqi men pass an abandoned Iraqi rocket to approach a U.S. Marine position

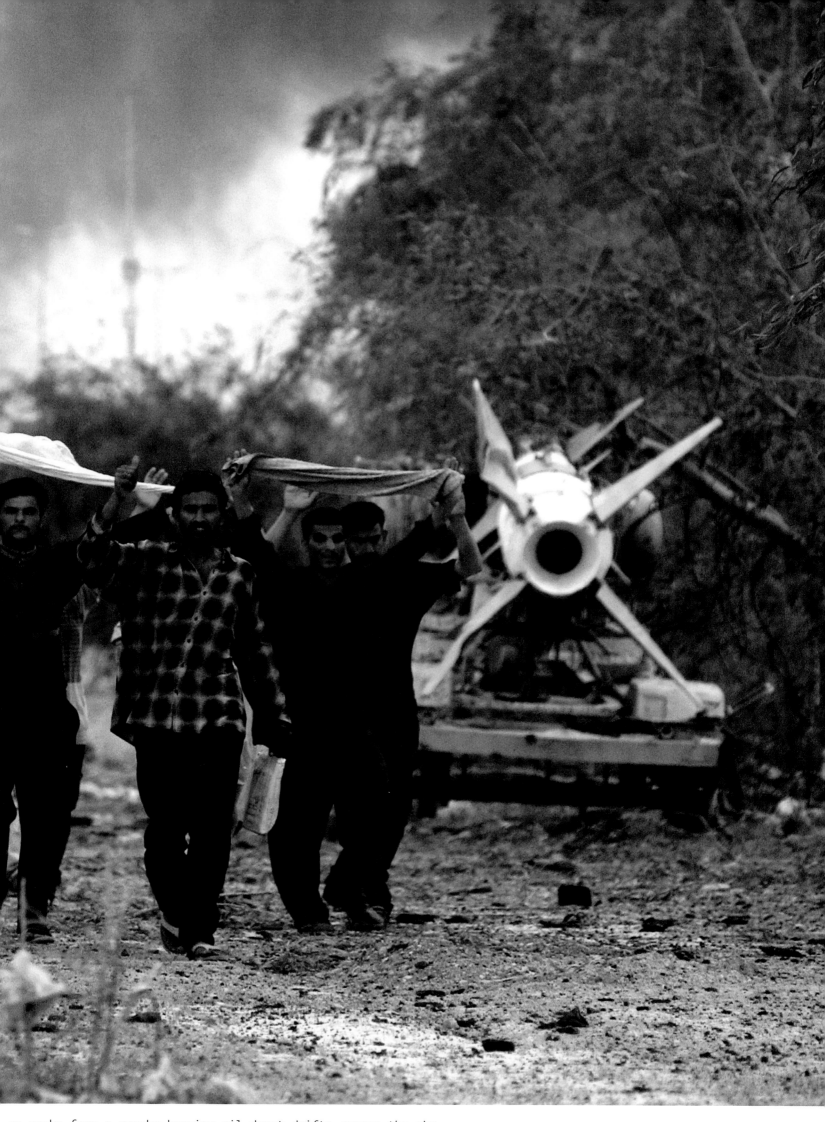

as smoke from a nearby burning oil depot drifts across the sky.

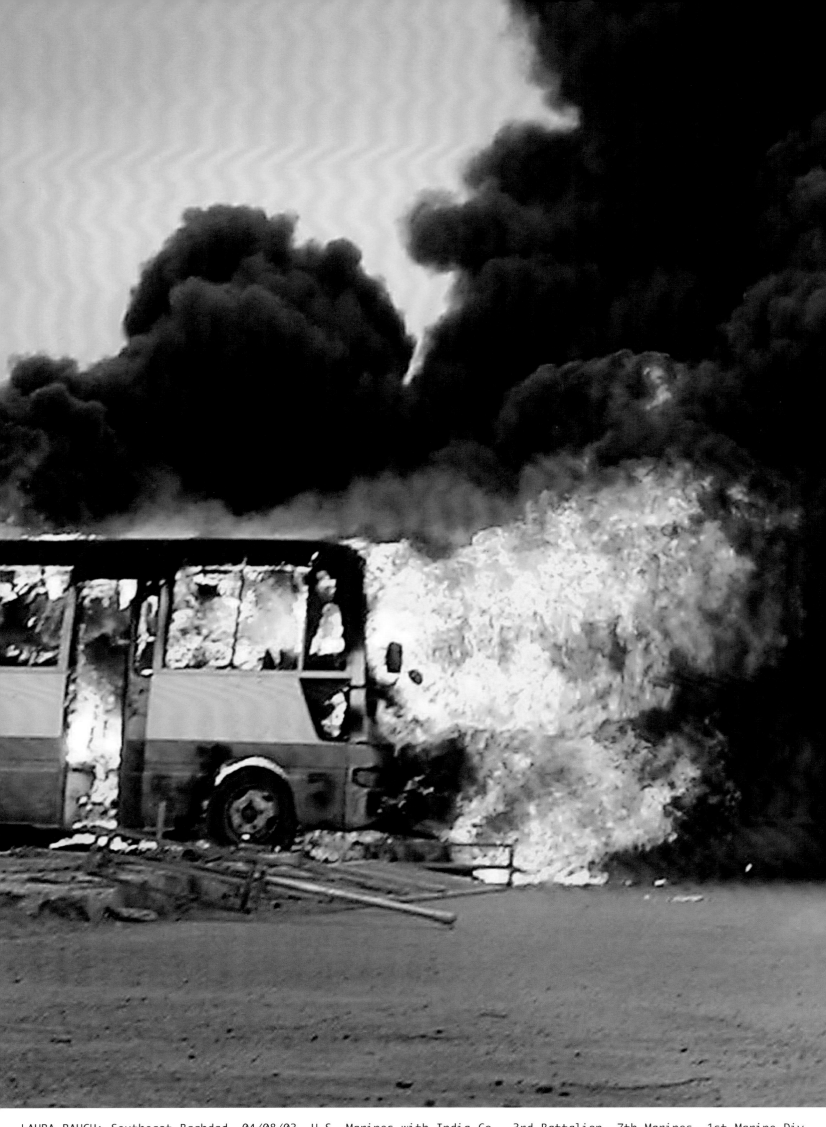

LAURA RAUCH: Southeast Baghdad, 04/08/03. U.S. Marines with India Co., 3rd Battalion, 7th Marines, 1st Marine Div.

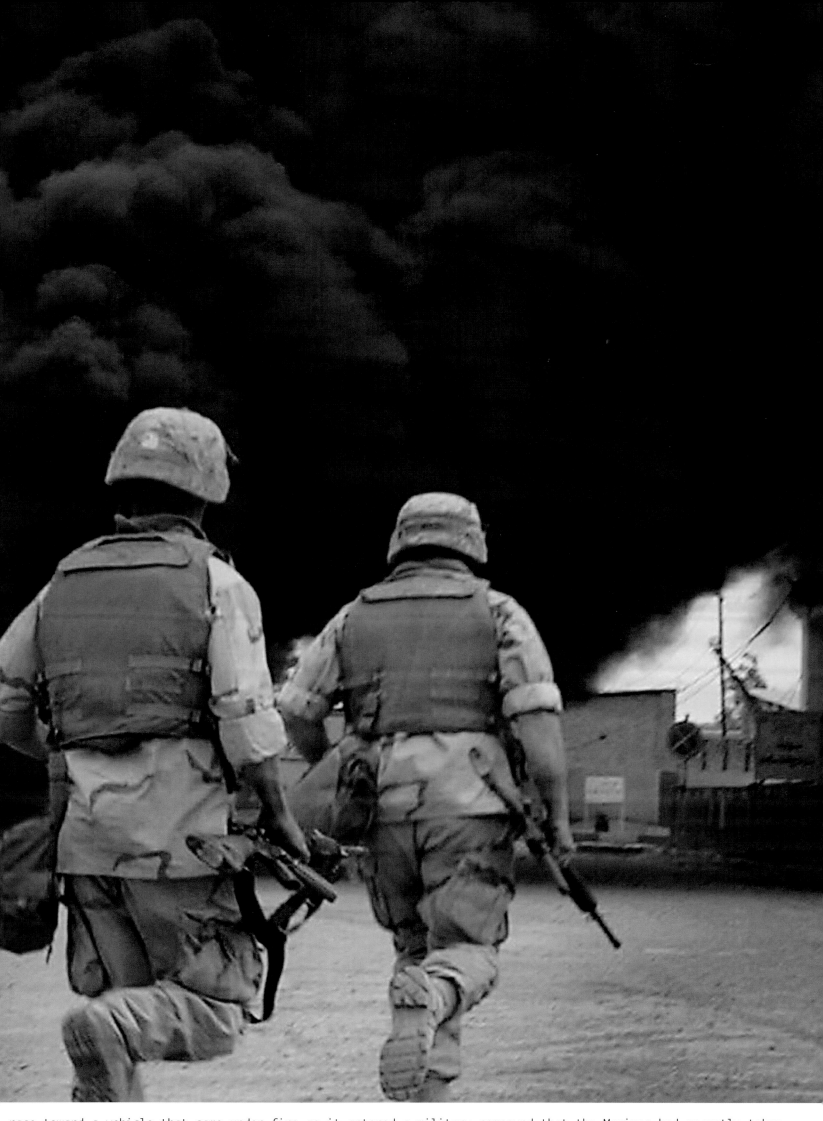

race toward a vehicle that came under fire as it entered a military compound that the Marines had recently taken.

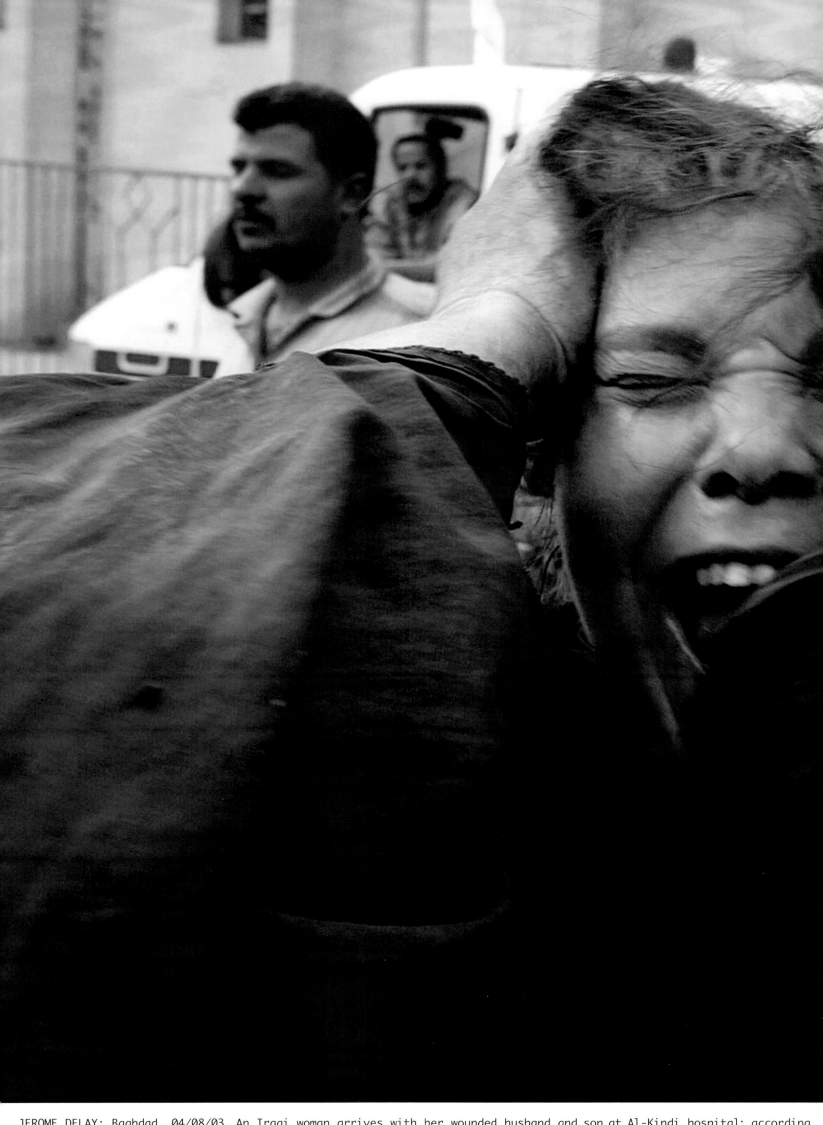

JEROME DELAY: Baghdad, 04/08/03. An Iraqi woman arrives with her wounded husband and son at Al-Kindi hospital; according

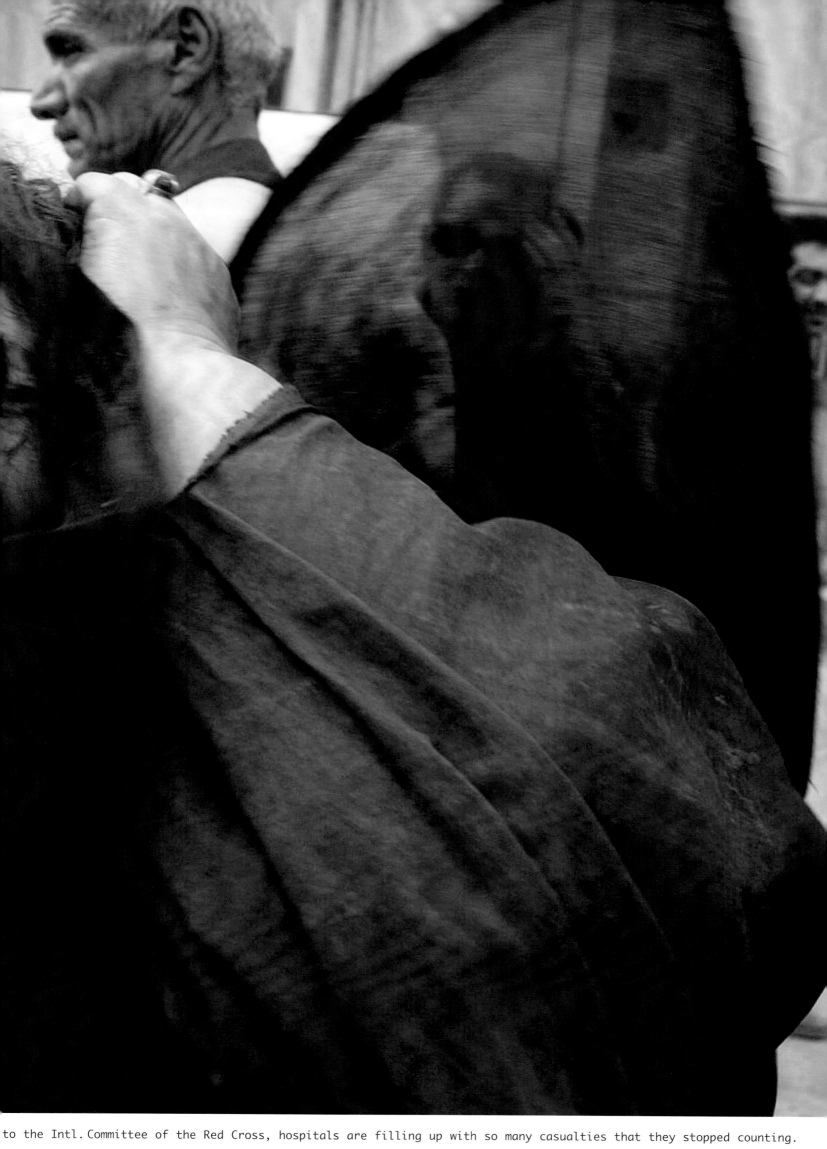

to the Intl. Committee of the Red Cross, hospitals are filling up with so many casualties that they stopped counting.

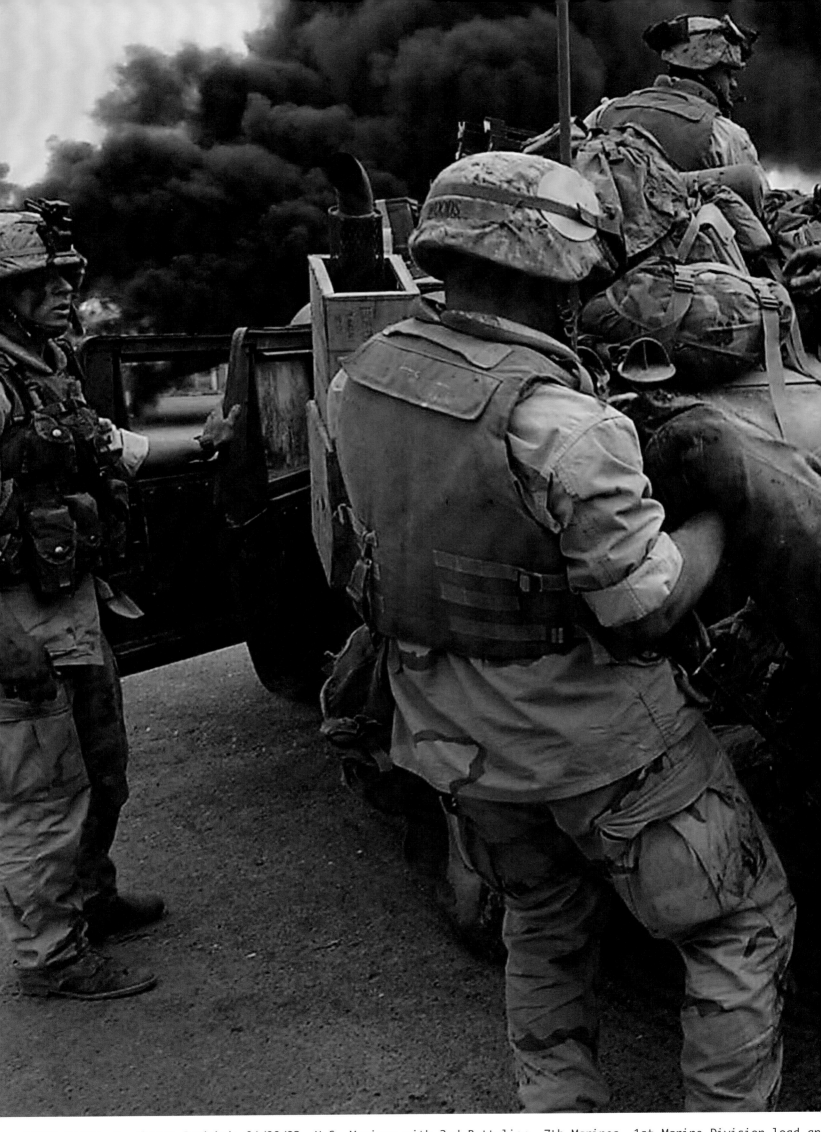

LAURA RAUCH: Southeast Baghdad, 04/08/03. U.S. Marines with 3rd Battalion, 7th Marines, 1st Marine Division load an

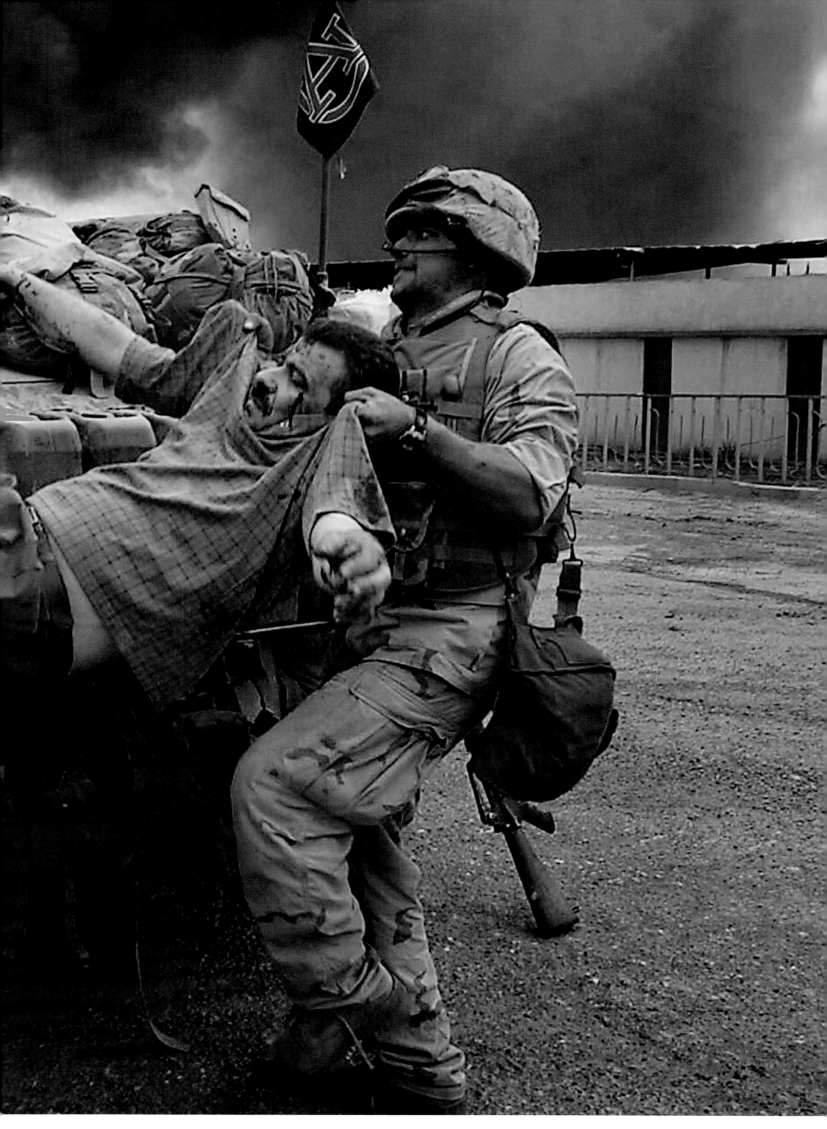

injured Iraqi man onto their vehicle after his bus came under fire as it entered an area Marines had taken.

>4:30pm (day3) Half an hour ago the oil filled trenches were put on fire. Al-Jazeera said these were the places that got hit by bombs from an air raid a few minutes earlier, but when I went up to the roof to take a look I saw that there were too many of them, and we heard only three explosions. My cousin came and told me he saw police cars standing by one and setting it on fire. Now you can see the columns of smoke all over the city.

>>8:30pm (day4) We start counting the hours from the moment one of the news channels report that the B52s have left their airfield. It takes them around 6 hours to get to Iraq. On the first day of the bombing it worked precisely. We were surprised yesterday when after 6 hours bombs didn't start falling. We found out today in the news that the city of Tikrit got the hell bombed out of it. Karbala was also hit last night. Today the B52s took off at 3pm. In half an hour we will know whether it is Baghdad tonight or another city.

>>Today's (and last night's) shock attacks didn't come from airplanes but rather from the airwaves. The images Al-Jazeera is broadcasting are beyond any description. First was the attack on (Ansar al-Islam) camp in the north of Iraq. Then the images of civilian casualties in Basra city. What was most disturbing are the images from the hospitals. They are simply not prepared to deal with these things. People were lying on the floor with bandages and blood all over. If this is what "urban warfare" is going to look like, we're in for disaster. And just now we saw the images of U.S./UK prisoners and the dead on Iraqi TV. This war is starting to show its ugly ugly face to the world. :: salam 4:41 PM [+] :: 03/23/03.

>"Did you hear about the bus?" One of the local men is talking to me.

>>He's referring to an incident in Iraq, where a large van attempted to run a Coalition checkpoint. The soldiers at the checkpoint opened fire, killing several women and children aboard. It's been all over the news here.

>>"Yes. It is very sad."

>>"Do you know what happened?" He's going to tell me. "Saddam's men kidnapped their husbands. They said they would kill them if the women did not drive through the checkpoint."

>>"That's horrible."

>>"Yes. Saddam is a very bad man. You must kill him." He is angry.

>>"We will get him," I promise.

>>"Yes, *inshallah* (if Allah wills it)."

>>I don't know if what this man told me is what really happened. Rumors about atrocities in Iraq spread like wildfire amongst the local population. But I wouldn't be surprised if it were true. Posted by LT Smash at 09:42 AM 04/03/03.

>This is one of the emails we got, subject line "critical info" (loosely translated into English):

>>"The world has united in a common cause. These countries have formed an alliance to remove the father of Qusay and his brutal regime. Qusay's father has tyrannized the sons of the Euphrates and exploited them for years, and he has to be removed from power.

>"The coalition forces are not here to hurt you, but they are here to help you. For your safety the coalition forces have prepared a list of instructions to keep you and your families safe. We want you to realize that these instructions are to keep you safe, even if they are, maybe, not (appropriate) [this is a bit difficult because even in Arabic I don't get exactly what they mean, but it sure got my attention; are they going to ask me to stand naked in the garden or something?]. We add that we don't want to hurt innocent people.

>>"Please and for your safety stay away from potential targets, like TV and Radio stations. Avoid travel or work near oil fields. Don't drive your cars at night. Stay away from military buildings or areas used for storage of weapons. All the mentioned are possible targets. For your safety don't be near these buildings and areas.

>>"For your safety stay away from coalition forces. Although they are here for not your harm [sic] they are trained to defend themselves and their equipment. Don't try to interfere in the operations of coalition forces. If you do these forces will not see you as civilians but as a threat and targets too.

>>"Please for your safety stay away from the mentioned areas. Don't let your children play there. Please inform your family and neighbors of our message. Our aim is to remove the father of Qusay and his brutal regime."

>>Then they list the frequencies for "Information Radio." What caught my attention is the use of "father of Qusay." We don't say "walid Qusay" in Iraqi-Arabic, but use "abu Qusay," and he is usually referred to as "abu Uday", but then again Uday is obviously out of the game. No one sees him in meetings. Four of the emails came from a hot-pop account, one from a Lycos and another from a yahoo accounts. I don't think they expect anyone to answer. :: salam 9:29 PM [+] :: 03/24/03.

>Since the day the airport was seized, we have no electricity and water is not reliable. We turn on the generator for 4 hours during the day and 4 at night, mainly to watch the news. Today my father wanted to turn on the generator at 8 in the morning because of news of an attack on the center of Baghdad. We sat for hours watching the same images until Kuwait TV showed footage taken from Fox News of American soldiers in Al-Sijood Palace. Totally dumbstruck. Right after that we saw Al-Sahaf denying once again what we have just seen minutes ago.

>>OK, having moved around a bit and met people from different parts of Baghdad, all running away to other parts, this is what it looks like. The push did not come from the west where the airport is, but from other parts of the city, more from an east direction. Al-Saydia district was bedlam. It did become a front line. Which means Mahmudia in the suburbs if Baghdad and Latifiyah have also had it bad. There is a highway we call the "airport road" which goes from Saydia to the airport in one big sweep around the city, and all the areas adjacent to it have seen fighting. I guess the Iraqi government will self-destruct in humiliation. Excuse me, but where are you, friggin' republican guards? :: salam 11:30 AM [+] :: 04/07/03.

HAYNE PALMOUR: Baghdad, 04/08/03. Marine Lance Cpl. Michael Redding, 22, of Lima Co., 3rd BN, 1st Marines from Versailles, KY, urinates on a mural of Saddam before being recalled by his superior during a power plant sweep.

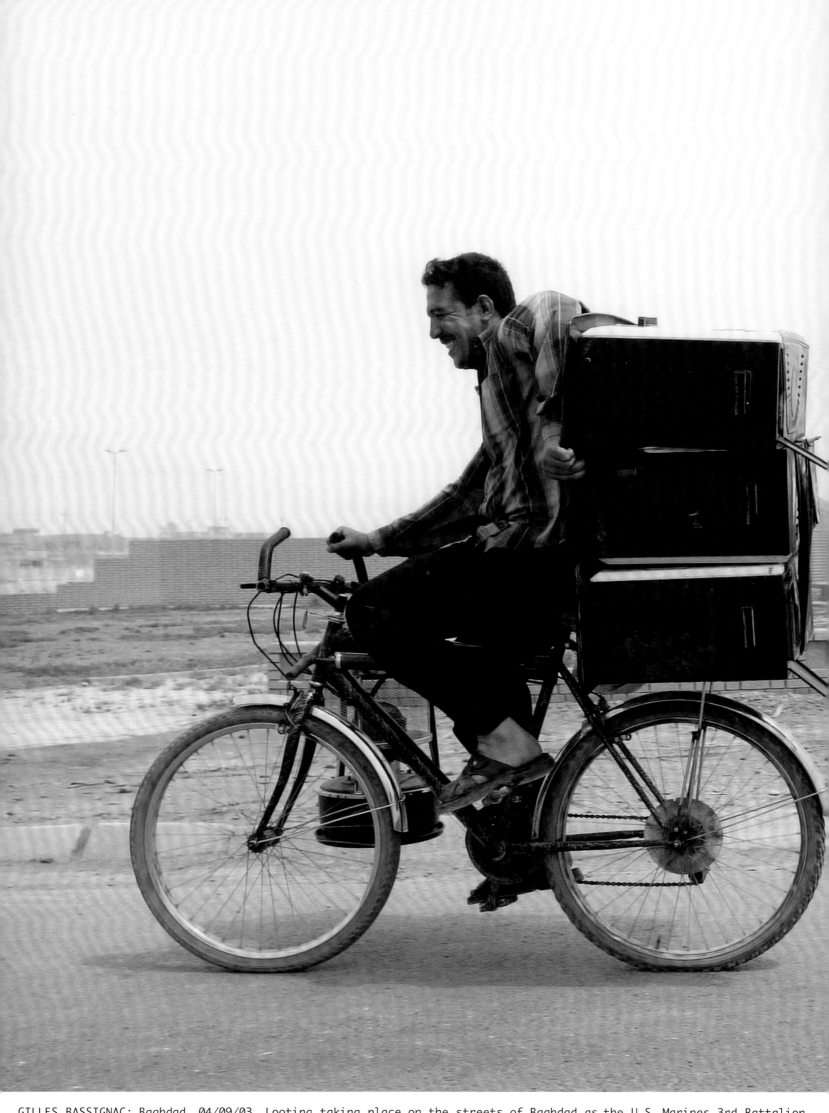

GILLES BASSIGNAC: Baghdad, 04/09/03. Looting taking place on the streets of Baghdad as the U.S. Marines 3rd Battalion,

4th Regiment rolls tanks in through the city with little resistance.

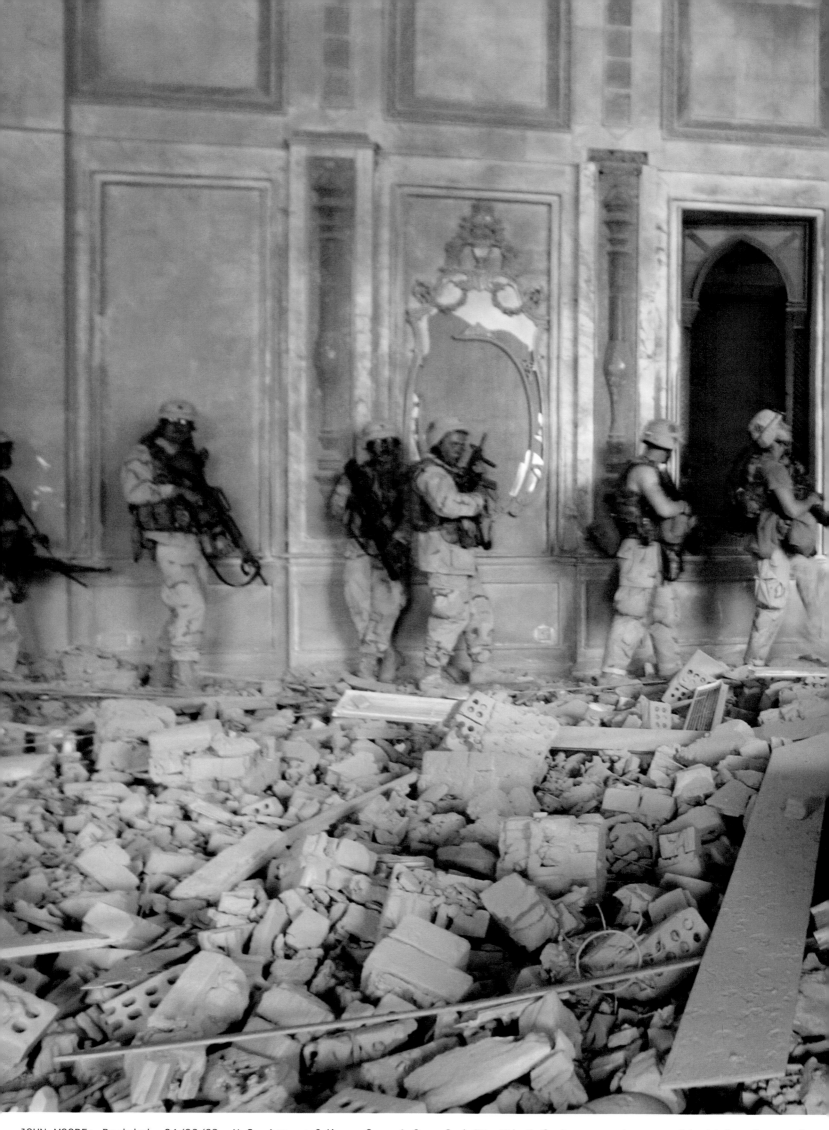

JOHN MOORE: Baghdad, 04/08/03. U.S. Army soldiers from A Co., 3rd BN, 7th Infantry search a presidential palace, the

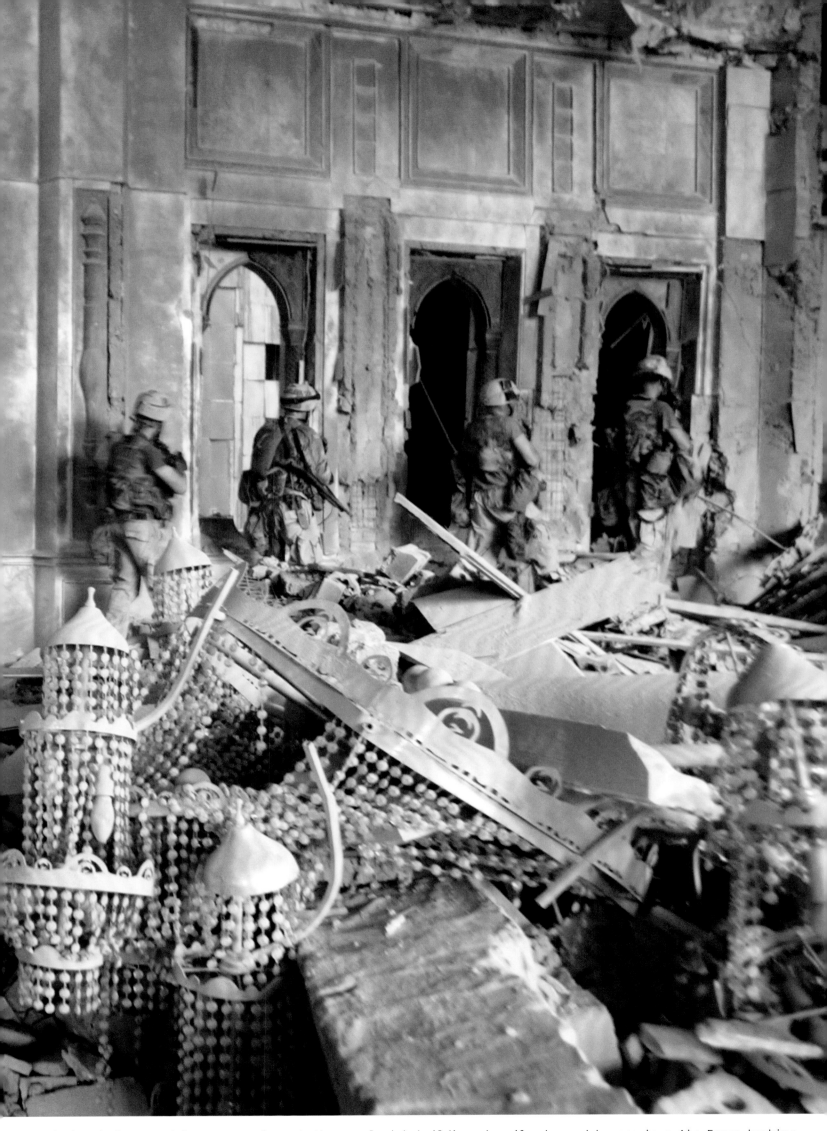

second they had secured in as many days; both were lavish buildings heavily damaged by previous Air Force bombing.

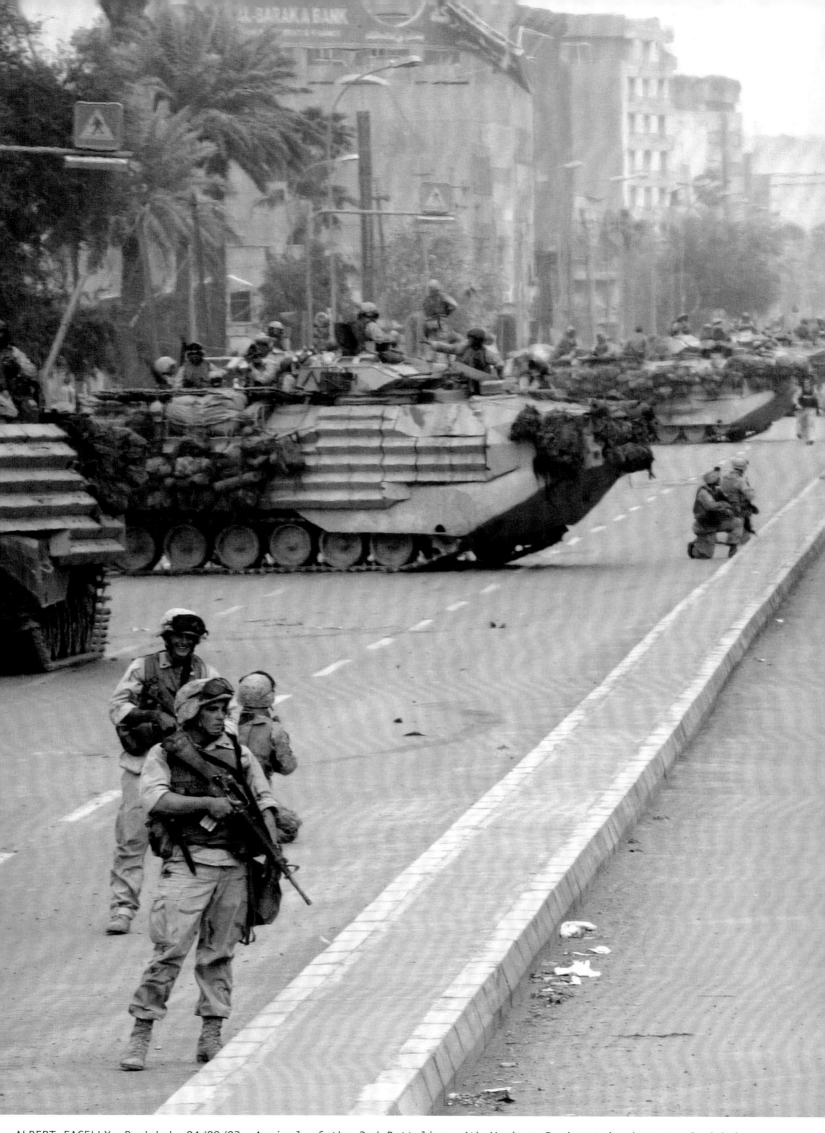

ALBERT FACELLY: Baghdad, 04/09/03. Arrival of the 3rd Battalion, 4th Marines Regiment in downtown Baghdad.

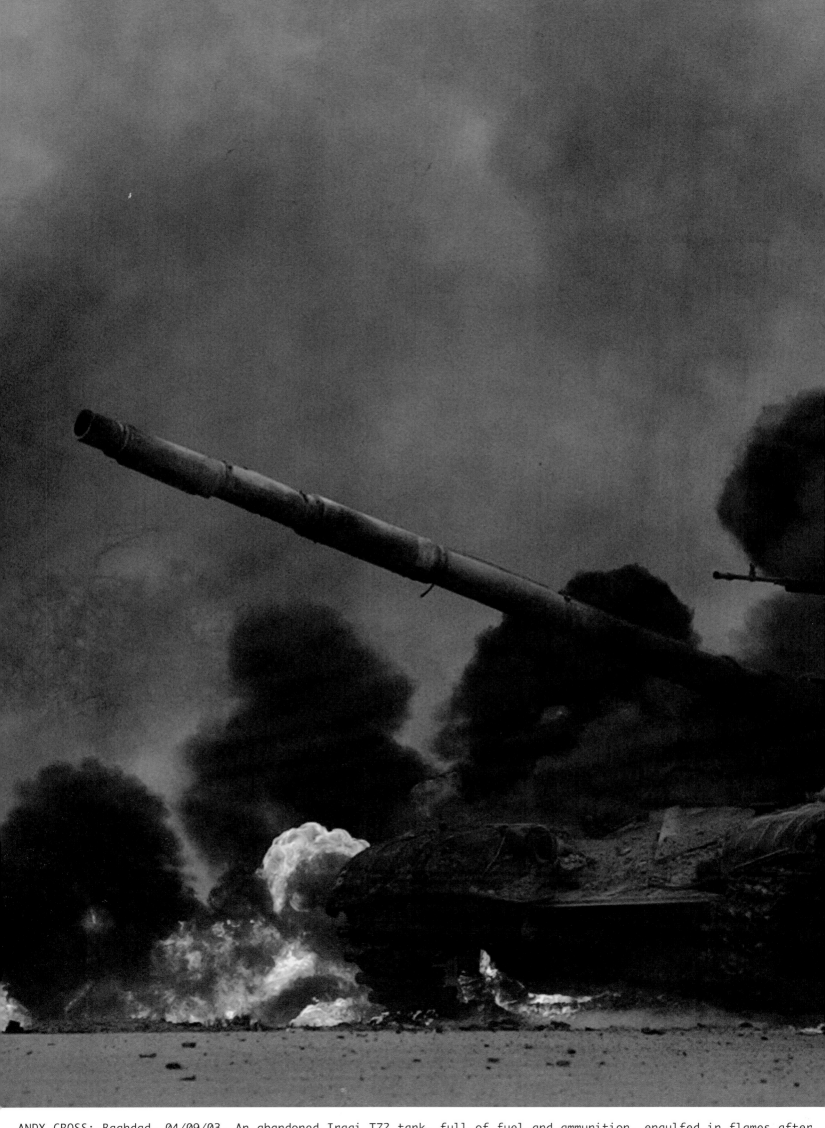

ANDY CROSS: Baghdad, 04/09/03. An abandoned Iraqi T72 tank, full of fuel and ammunition, engulfed in flames after

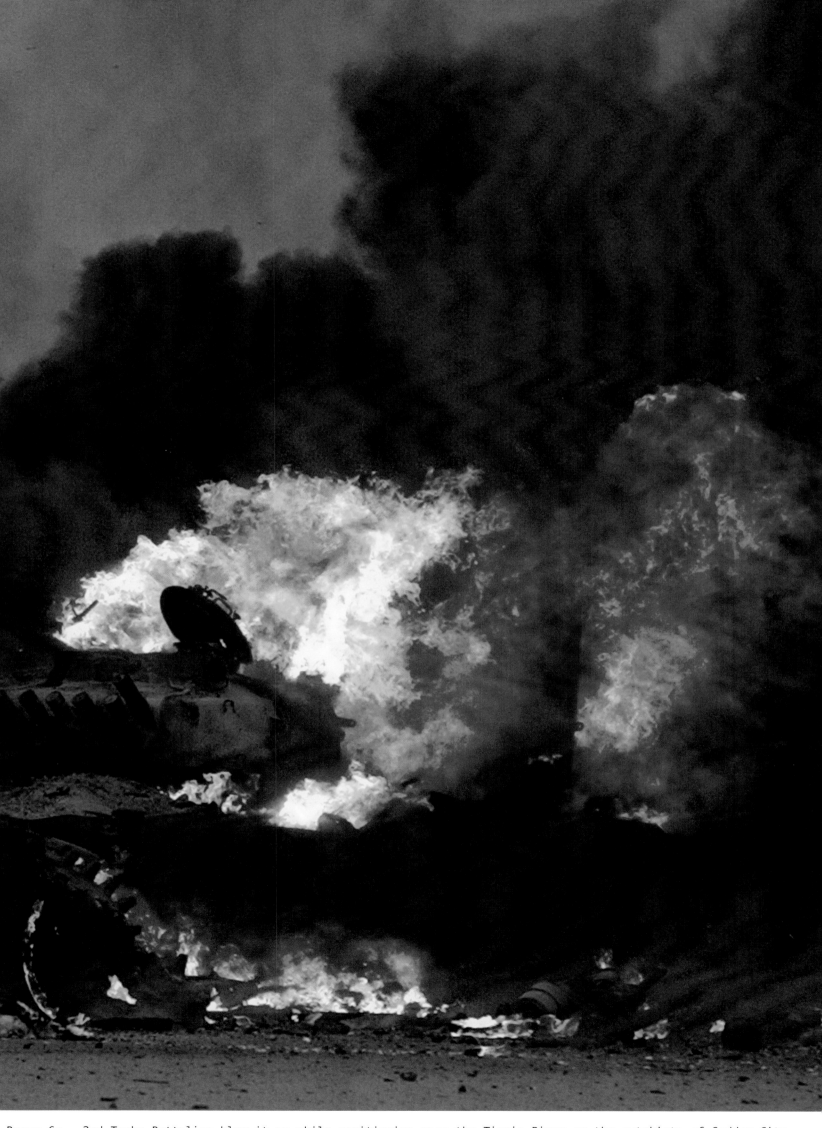

Bravo Co., 2nd Tanks Battalion blew it up while positioning near the Tigris River on the outskirts of Saddam City.

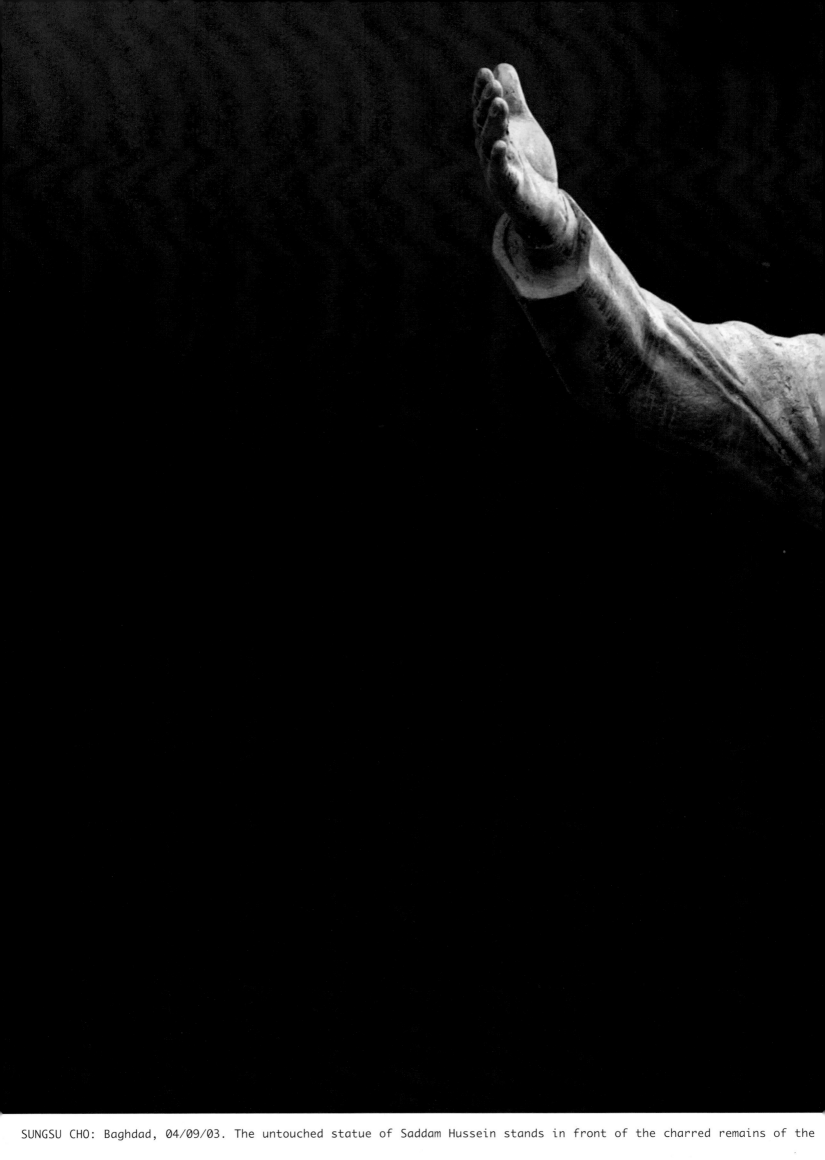

SUNGSU CHO: Baghdad, 04/09/03. The untouched statue of Saddam Hussein stands in front of the charred remains of the

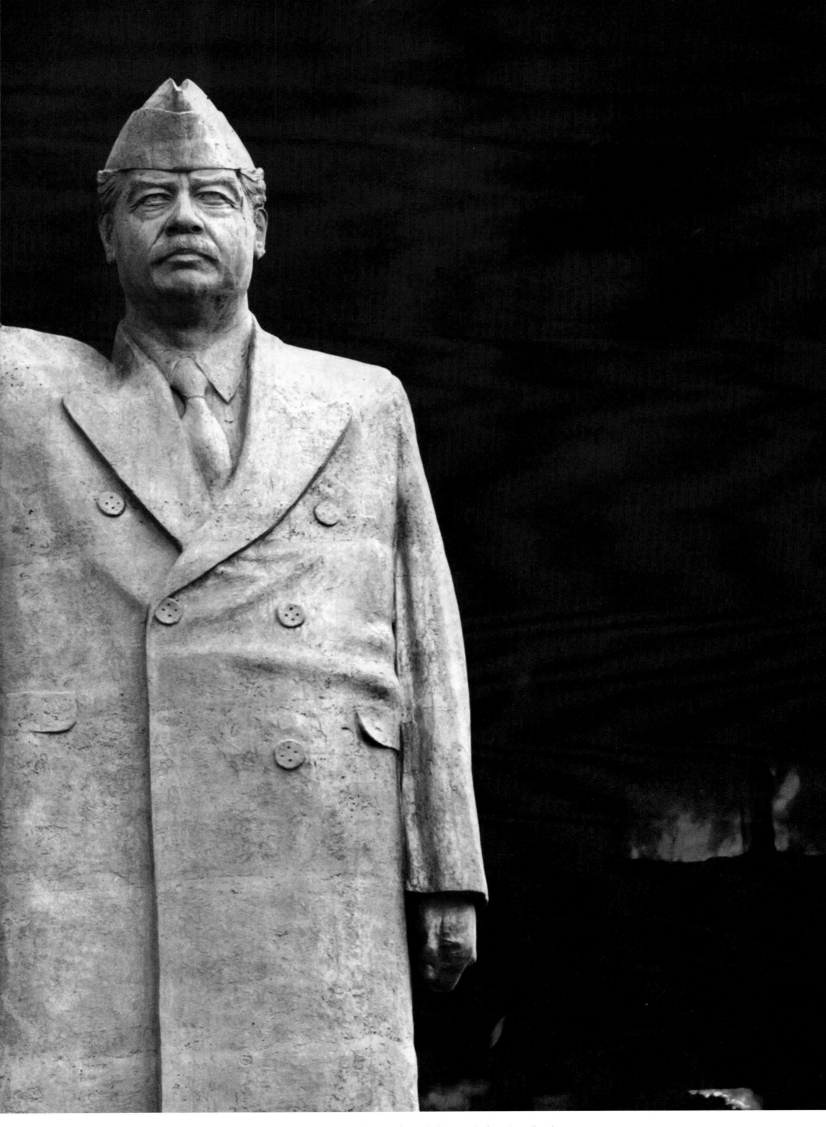

Iraqi Olympic Committee headquarters after it was burned and looted in Bagdhad.

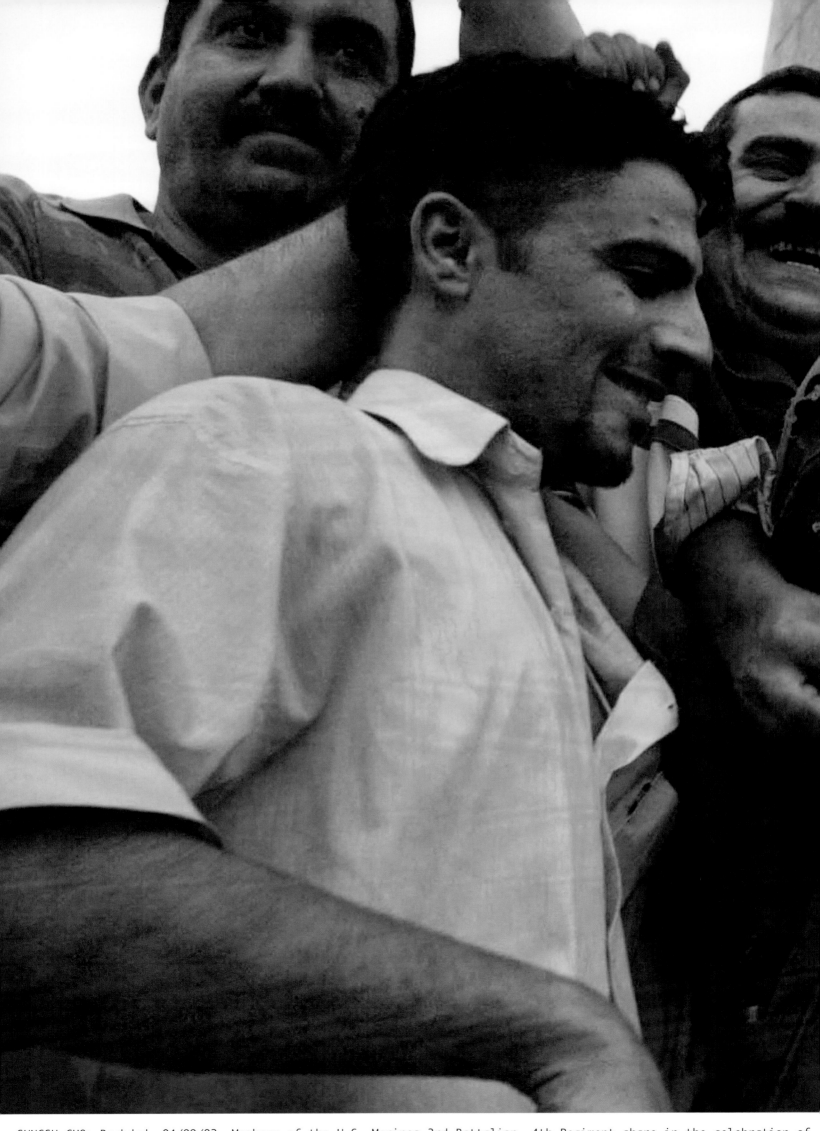

SUNGSU CHO: Baghdad, 04/09/03. Members of the U.S. Marines 3rd Battalion, 4th Regiment share in the celebration of

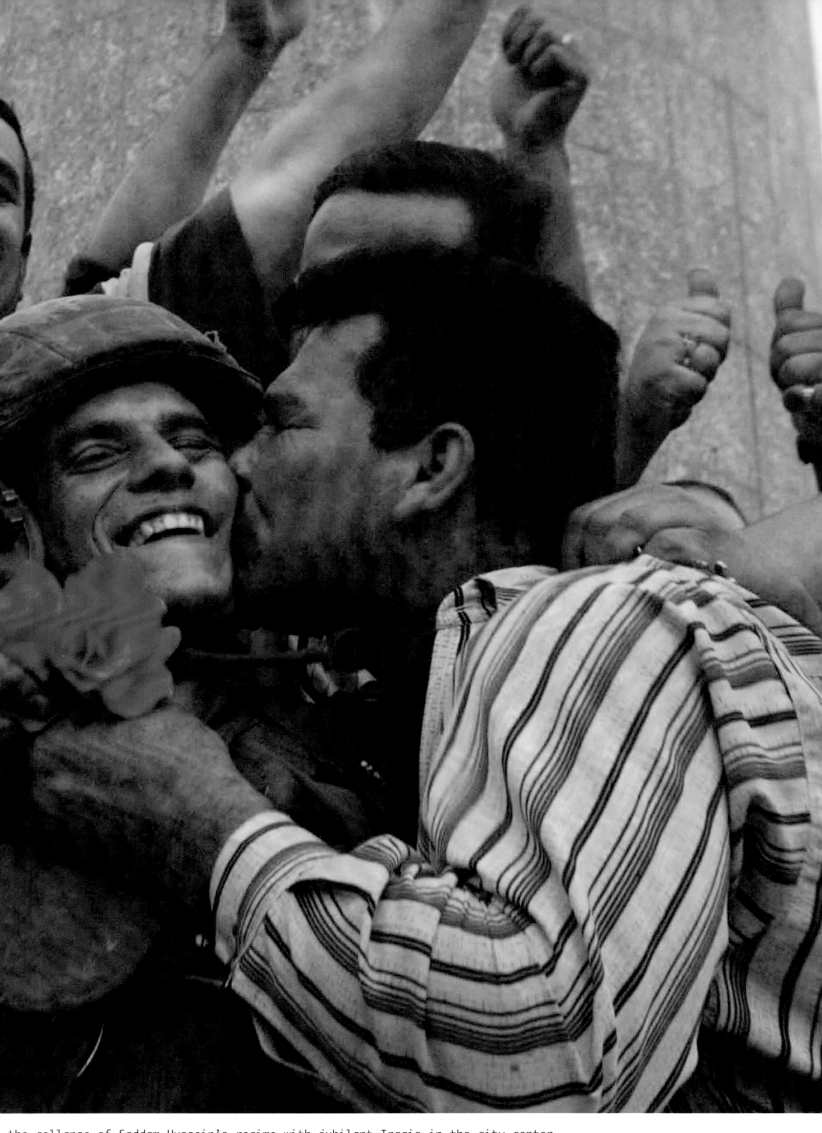

the collapse of Saddam Hussein's regime with jubilant Iraqis in the city center.

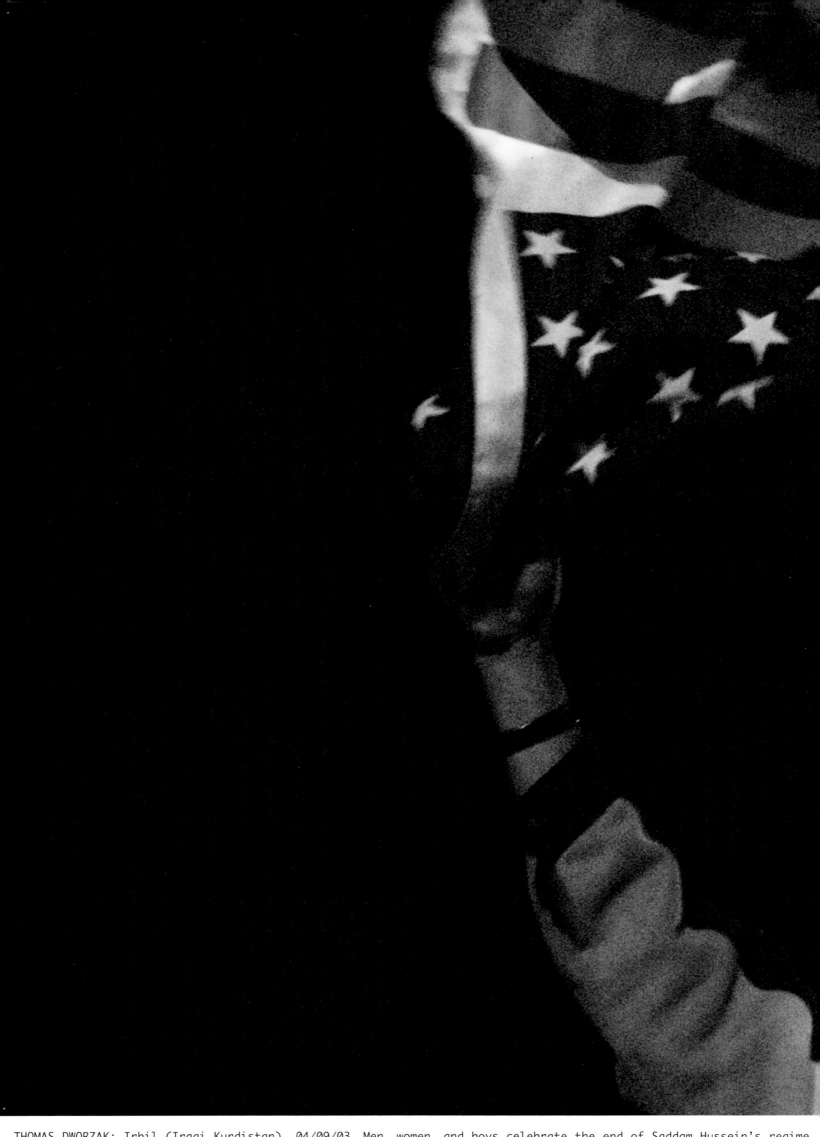

THOMAS DWORZAK: Irbil (Iraqi Kurdistan), 04/09/03. Men, women, and boys celebrate the end of Saddam Hussein's regime

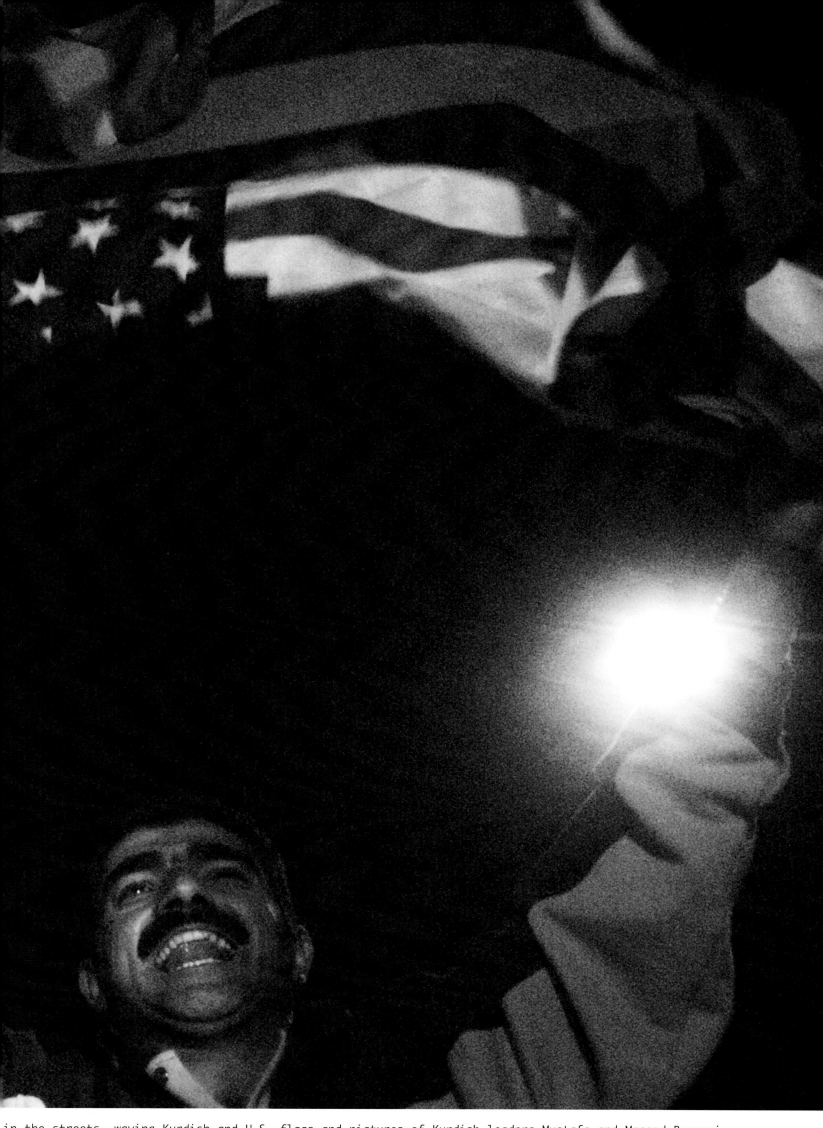

in the streets, waving Kurdish and U.S. flags and pictures of Kurdish leaders Mustafa and Masood Barzani.

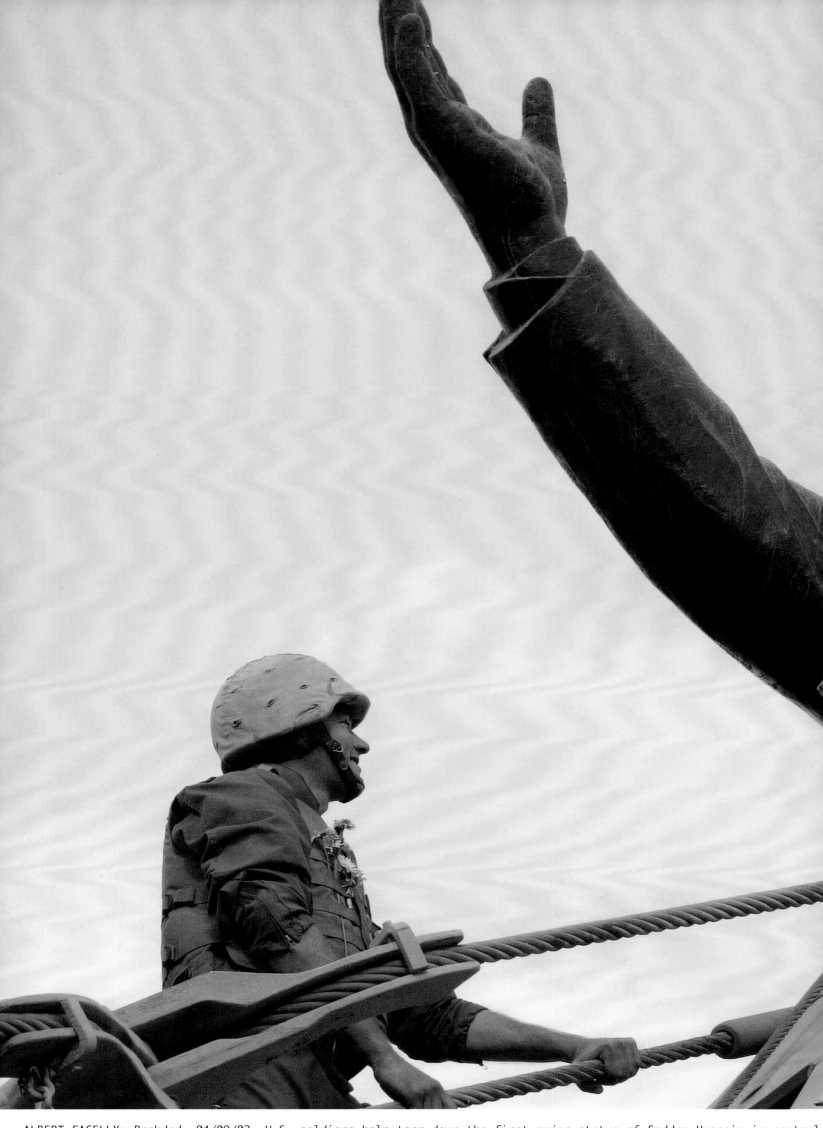

ALBERT FACELLY: Baghdad, 04/09/03. U.S. soldiers help tear down the first major statue of Saddam Hussein in central

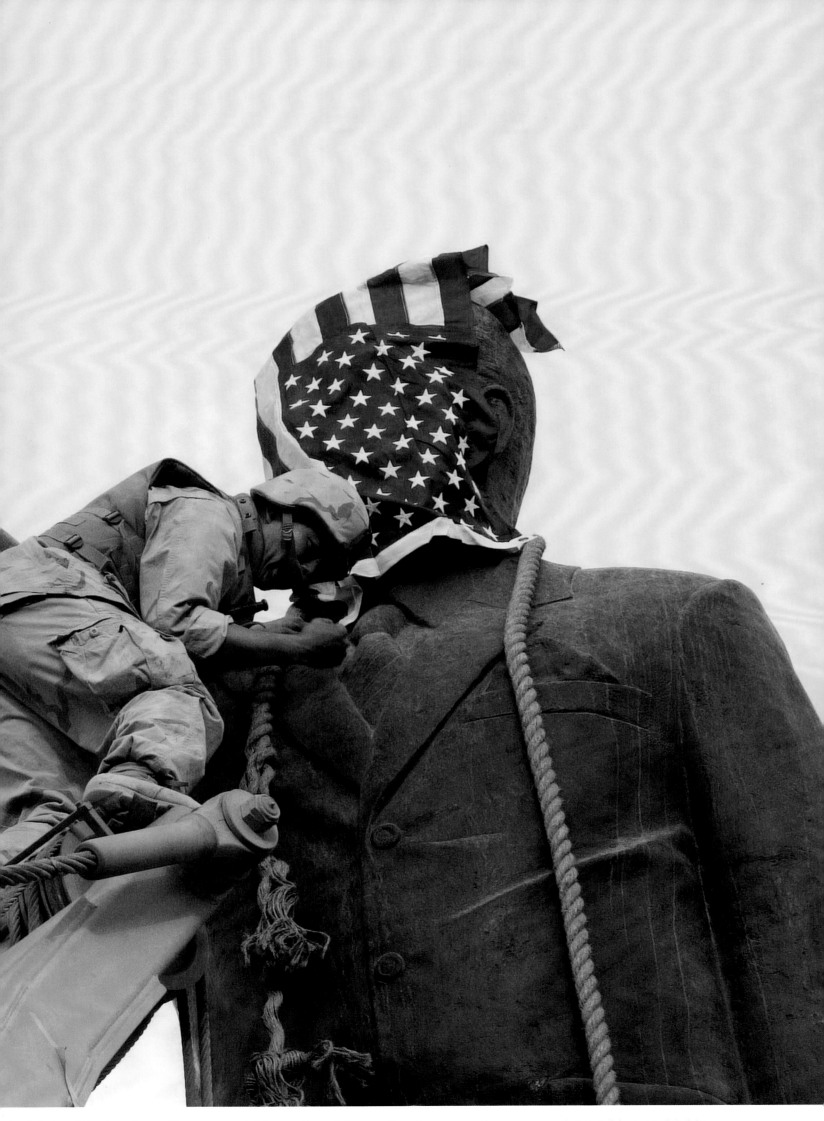

Baghdad; this American flag was quickly replaced by an Iraqi one as the scene unfolded live worldwide.

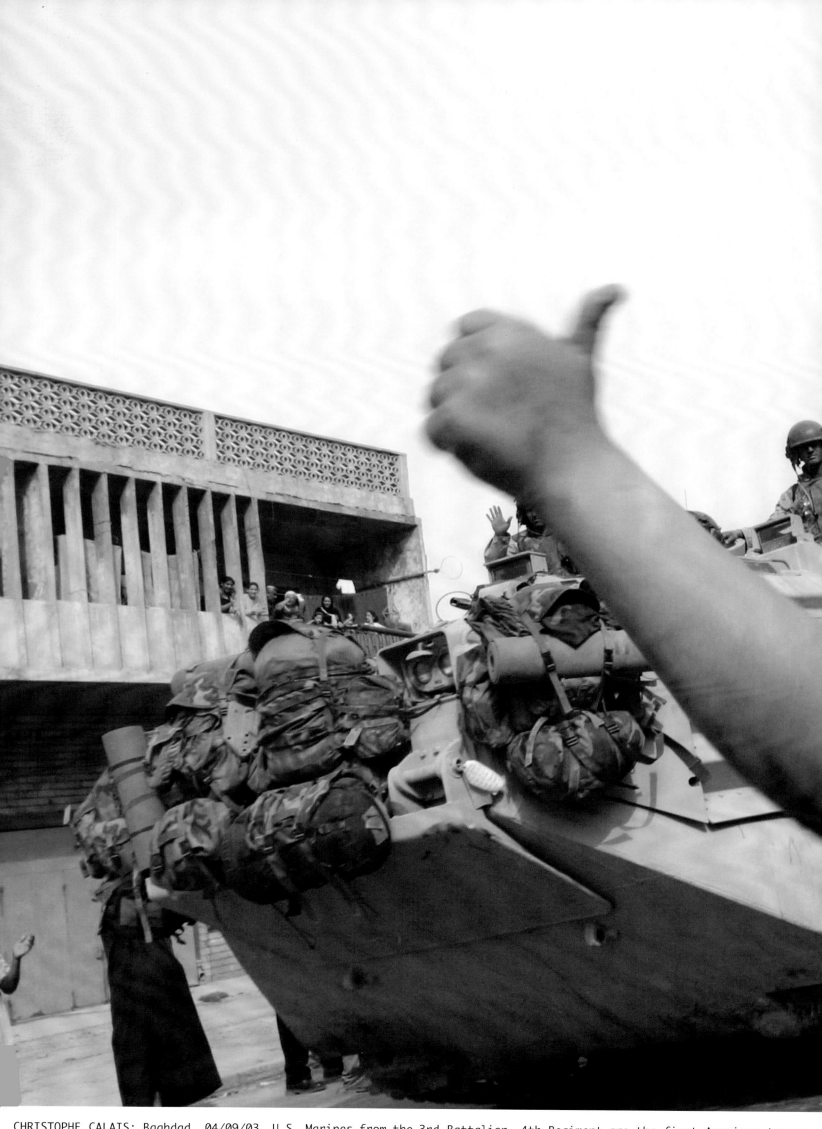

CHRISTOPHE CALAIS: Baghdad, 04/09/03. U.S. Marines from the 3rd Battalion, 4th Regiment are the first American troops

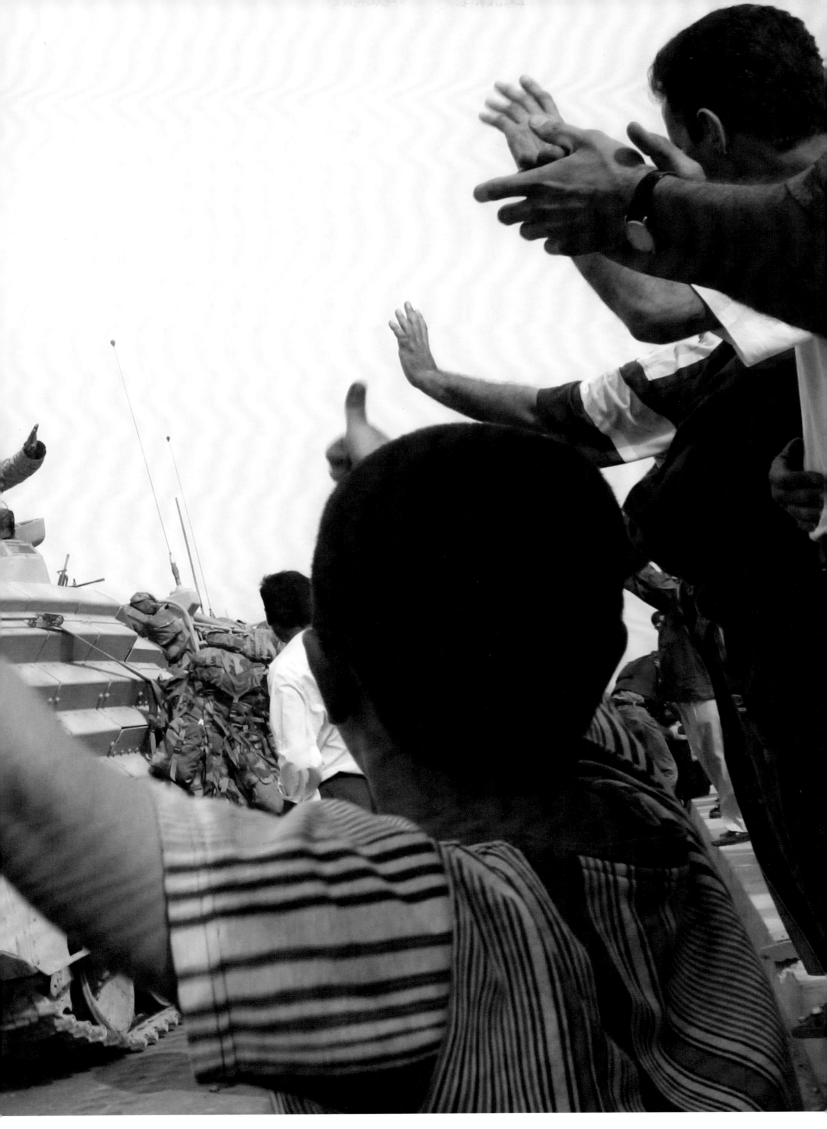

to reach the center of Baghdad, and are welcomed by a cheering crowd.

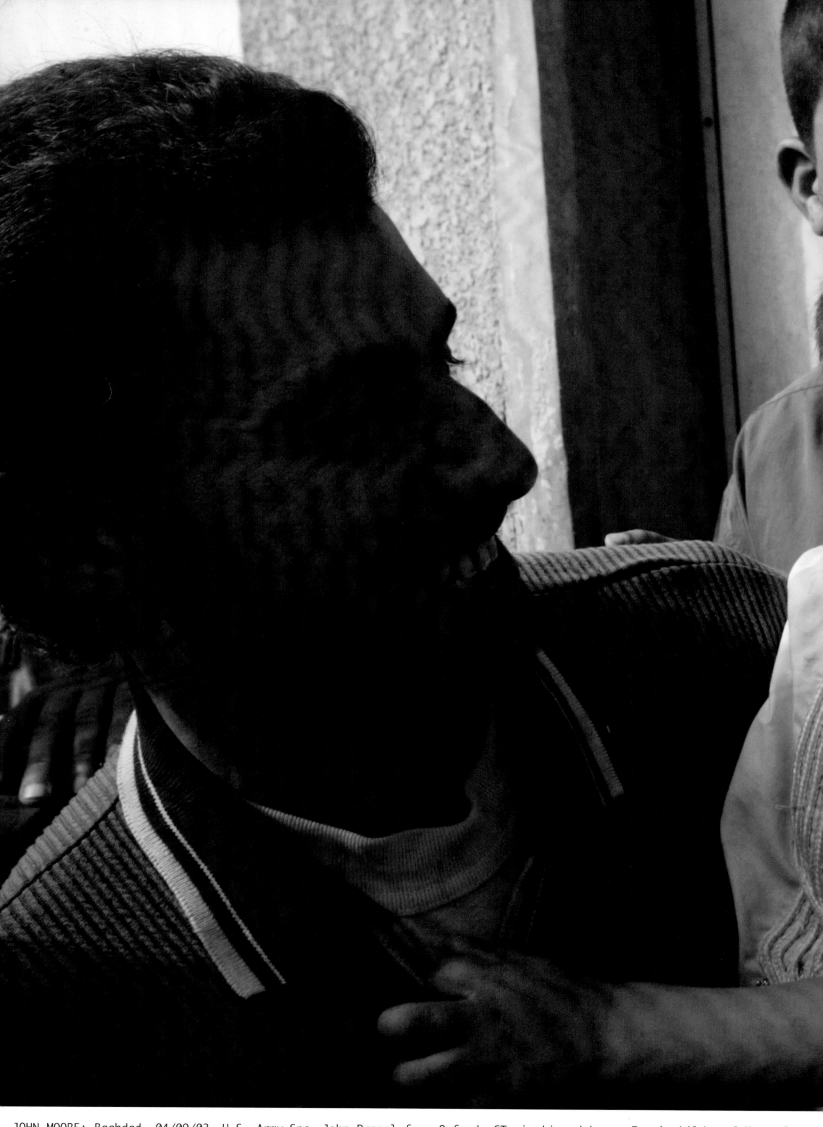

JOHN MOORE: Baghdad, 04/09/03. U.S. Army Spc. John Dresel from Oxford, CT, is kissed by an Iraqi child; soldiers from

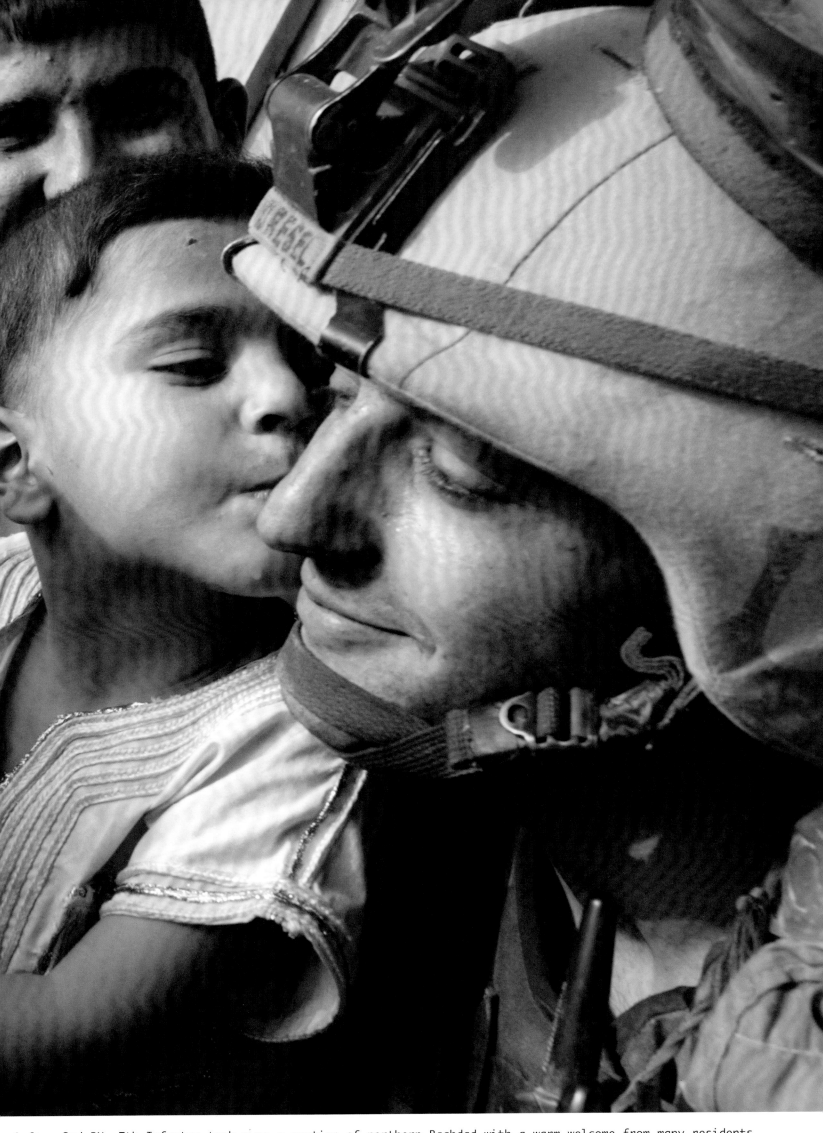

A Co., 3rd BN, 7th Infantry took over a section of northern Baghdad with a warm welcome from many residents.

April 9–April 13, 2003 "We are taking it back now"

April 9 (day 5 of the battle for Baghdad). They cut off the head of the president and rode it through the center of Baghdad. This happened right outside my hotel, the Palestine, where a crowd formed around the decapitated statue of Saddam in Firdos Square. I couldn't believe it. Less than two hours earlier I had been pleading with every American soldier I encountered in the chaos in the surrounding streets to come and protect the international media at the hotel. We figured it was the least they could do after killing three of us the day before.

At about 4:30 P.M., thirty U.S. vehicles, tanks, personnel carriers, and armed jeeps rolled in between our hotel and the Sheraton across the street. It was a sound not unlike a large helicopter, clattering up from my balcony window. I raced around the room, looking for everything I needed to head out again. My sweat-filled flak jacket and a camera would do for now. I flicked off the generator switch and ran down eight flights of stairs and out into the square to see Iraqis finally able to show their hatred of Saddam. More than twenty years of suppression had come to an end.

Once the U.S. soldiers had run through the hotel checking for snipers, they turned their attention to making their presence final by pulling down the main Saddam statue in the capital. Only one hundred yards from live television feeds to the rest of the world, dozens of Iraqis were already heartily chipping away at the base of the statue with large sledgehammers. Cue the U.S. Marine Corps. After tying a rope around its neck, a U.S. armored recovery vehicle came to the aid of locals trying to get rid of a larger-than-life Saddam that had cast a long shadow over this famous Baghdad square for years. Just for fun, the Marines tied an American flag around the face of Saddam in a personal gesture.

Finally, after a few attempts, the statue creaked like an old ship leaving the harbor. As it toppled, it seemed to hang in midair for seconds, as hundreds of people pushed foward to grab or throw stones at it in celebration of the death of their dictator. The crowd made way for a final pull of the statue to the ground. No sooner had it hit earth than hundreds of jubilant Iraqis rushed it, jumping on its head. It's a scene I've witnessed in other capitals falling in wartime. Soon the head will be off, and after some determined metal pounding, it will be dragged through the streets and ridden on in celebration.

April 10 (day 6). After a jubilant day yesterday, the evidence of sudden freedom's chaos could clearly be seen, as the headless statue of Saddam Hussein lay on the ground in the morning sun surrounded by U.S. troops. With no law and order in the city, many buildings are being looted of every stick of furniture before being set alight. A horse and cart overflows with two fridges, about a dozen computer monitors, and hard drives from the Ministry of Trade. As the upstairs offices were ransacked, thousands of sheets of paper fell like snow, as the horse cart slowly trotted off through the city unnoticed among the cars, vans, and even a fork-lift loaded with loot. Pedestrians helped themselves to the parked cars on the side of the road. I told my driver to keep the car doors locked and the engine running as we got out and raced around the streets on foot, quickening our pace as one group began to point to my watch. I got it on my last visit to Baghdad in September—a TAG Heuer given to the Iraqi Navy divers by Saddam. I took it off and moved down the street to a bank being opened by great popular demand and a little help from a large truck. As the doors were pulled off, hundreds of would-be looters rushed in and were disappointed to find that the bank managers weren't foolish enough to leave any money behind. But they still managed to take everything that wasn't nailed down, including the bank counter. Anarchy had broken out in what was yesterday a tightly controlled city under one of history's most repressive regimes.

Clearly, the act of removing the statue of Saddam had an immediate effect on the population. Order was nowhere to be found. A young teenager at home with his mother was shot in the face as he tried to protect his family home from looters. A man dragged from his car and shot in the back lay bleeding while U.S. soldiers failed to save him before he drowned in his own blood. With many hospitals now looted, patients were dying in their beds, victims of the continuing battle. Pockets of fighting remained around the city, stretching the U.S. forces to their limits while they wait for more troops to help secure more of the city and to bring about some form of law and order to normal Baghdadis. This civil unrest will not do the U.S. any good in popularity polls with Iraqi citizens.

April 12 (day 8). The People's Palace, they called it, and today the people arrived to collect their things. "This belongs to me, habibi," says a grinning, toothless old man wearing a Gha'ttra on his head and struggling to drag one of Saddam's chandeliers behind him. This palace was one of the first things to be hit during the bombing campaign. What damage the bomb made to its luxurious grounds was no match for what the people are doing. Little old ladies wrestled to drag strips of gold-colored tin from the doors. After clutching at her treasure and examining it carefully in disbelief, one spat on it and threw it to the ground, realizing it was worthless. "He's cheap, it's tin, not gold," she shouted to everyone at the top of her lungs. Then she smiled at me and giggled, running off into the darkened palace entrance filled with clouds of smoke.

I worked my way through the maze of destruction floor by floor, and finally arrived on the fourth and final floor of the palace. There was a man who seemed peaceful and happy, sitting on the window ledge, smiling as he enjoyed the view from one of the bedrooms. A Kalashnikov rifle rested at his side as the light streamed in on his face. "Welcome, mister," he said, as I slowly approached, taking pictures. "My boy is getting married in one month, so we all came down here and took a roomful of furniture for his new home. It belongs to us, and we are taking it back now."

—Seamus Conlan

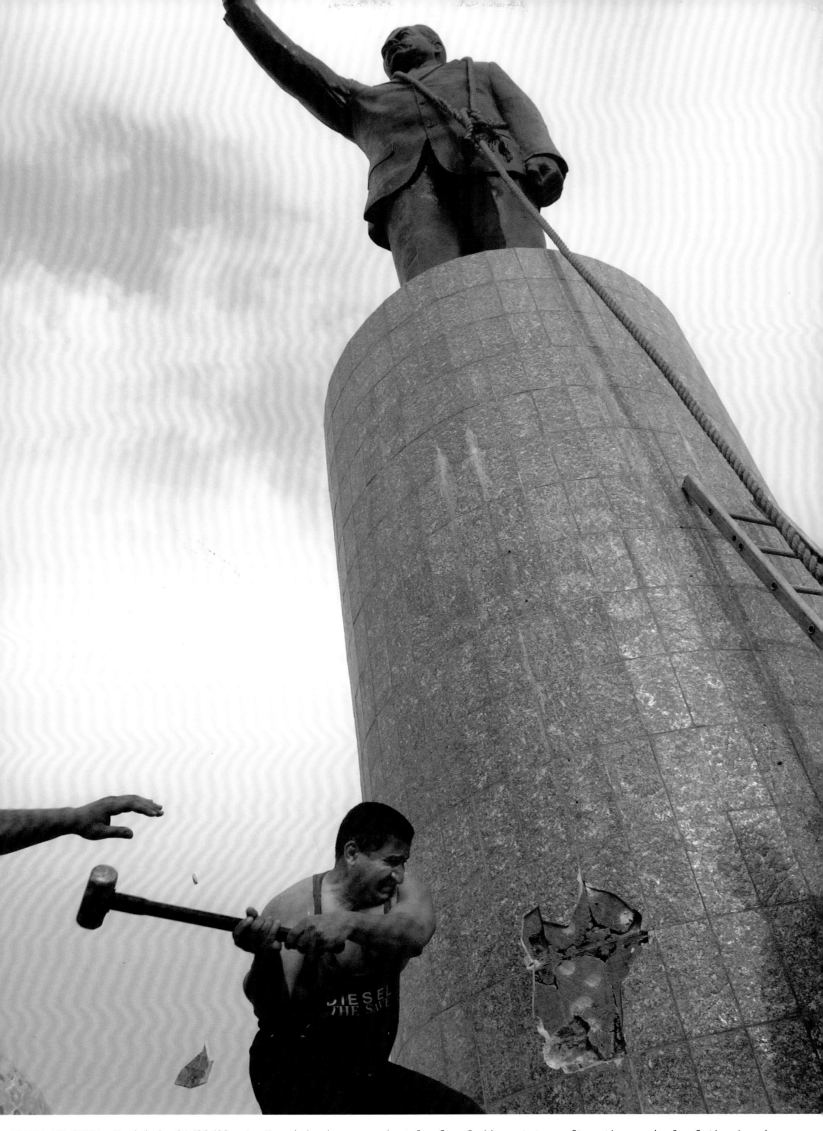

ILKKA UIMONEN: Baghdad, 04/09/03. An Iraqi bashes a pedastal of a Saddam statue after the arrival of the Americans.

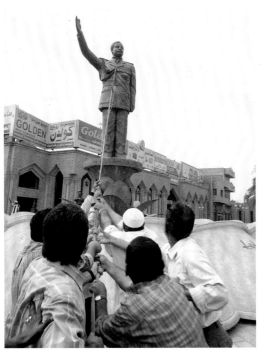

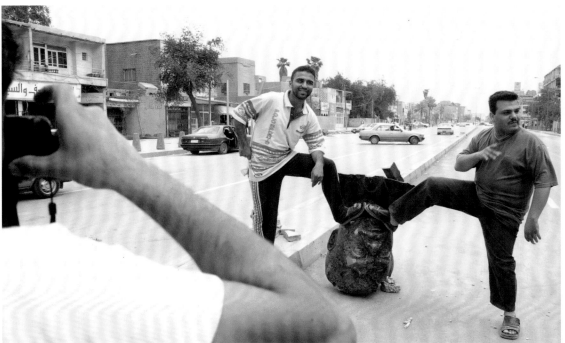

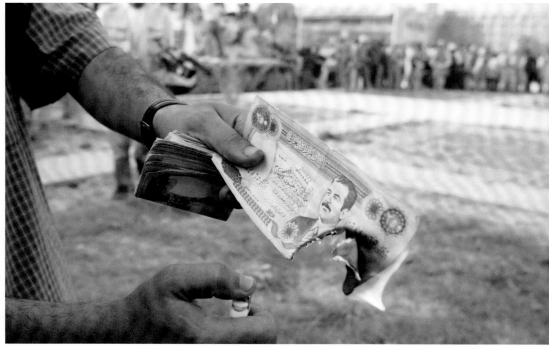

clockwise from upper left: JIM LO SCALZO, downtown Baghdad, 04/12/03; PAOLO PELLEGRIN, Basra, 04/03/03; JEROME SESSINI, Baghdad, 04/09/03; PATRICK ROBERT, Baghdad, 04/09/03; JAMES HILL, outskirts of Baghdad, 04/05/03; JIM LO SCALZO, downtown Baghdad, 04/10/03.

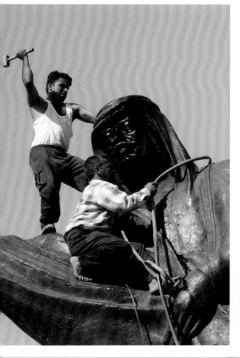
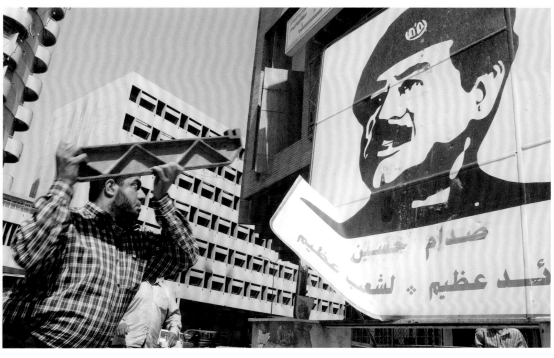
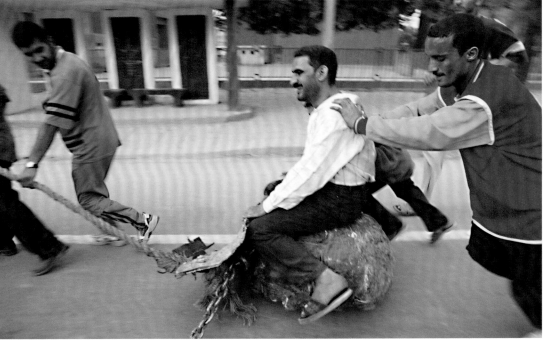
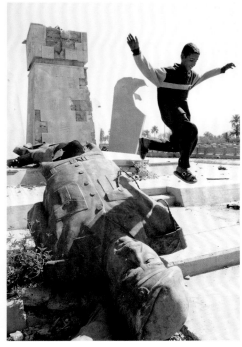

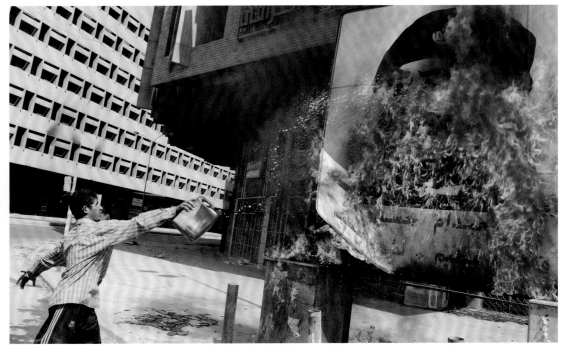

clockwise from upper left: PATRICK BARTH, Kirkuk, 04/10/03; SPENCER PLATT, Baghdad, 04/14/03; OLEG NIKISHIN, Baghdad, 04/14/03; SPENCER PLATT, Baghdad, 04/14/03 (burning sign reads "Saddam Hussein is a great leader for a great people"); YANNIS BEHRAKIS, Basra, 04/09/03; PATRICK ROBERT, Baghdad, 04/09/03.

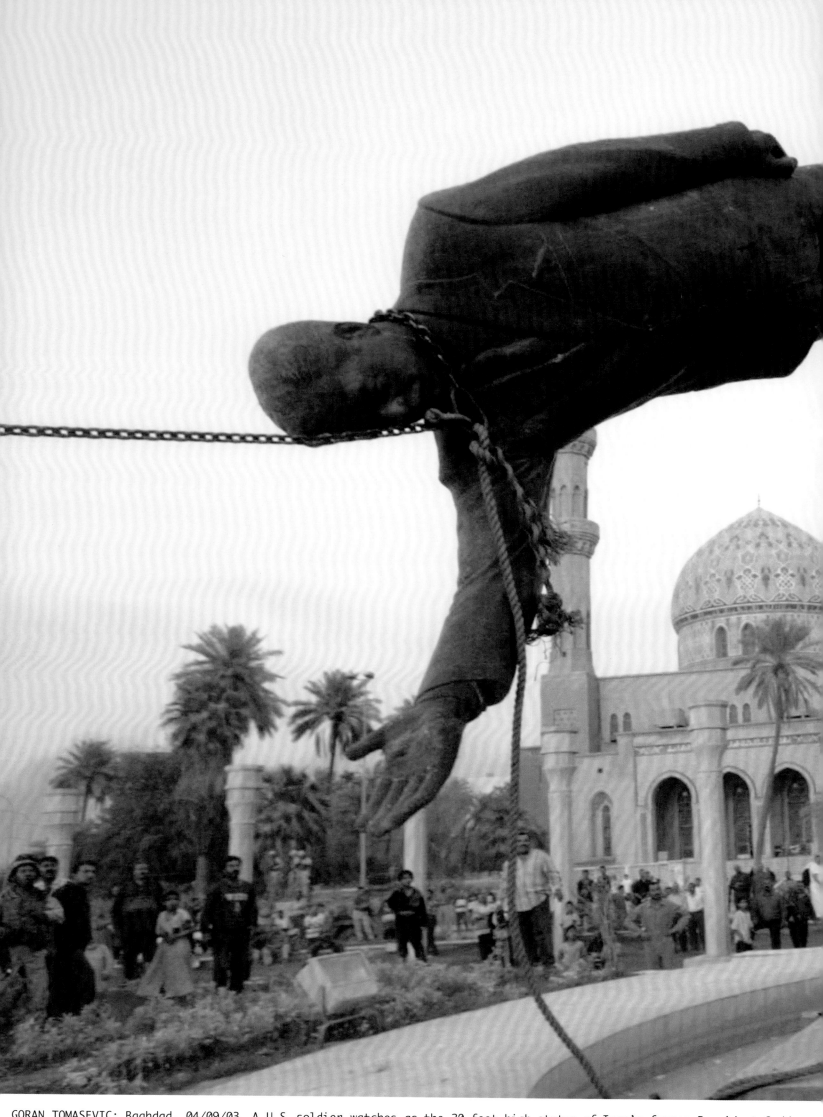

GORAN TOMASEVIC: Baghdad, 04/09/03. A U.S. soldier watches as the 20-foot-high statue of Iraq's former President Saddam

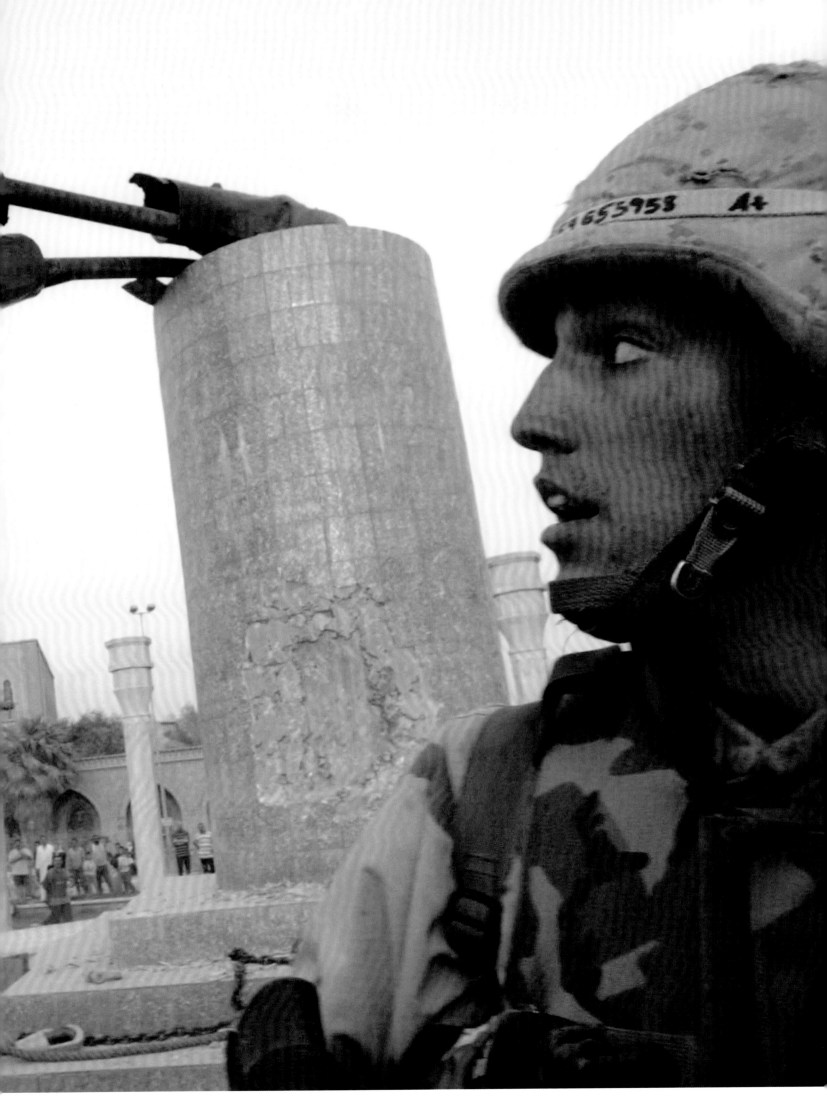

Hussein finally falls. Iraqis danced on it in contempt for the man who ruled them with an iron grip for 24 years.

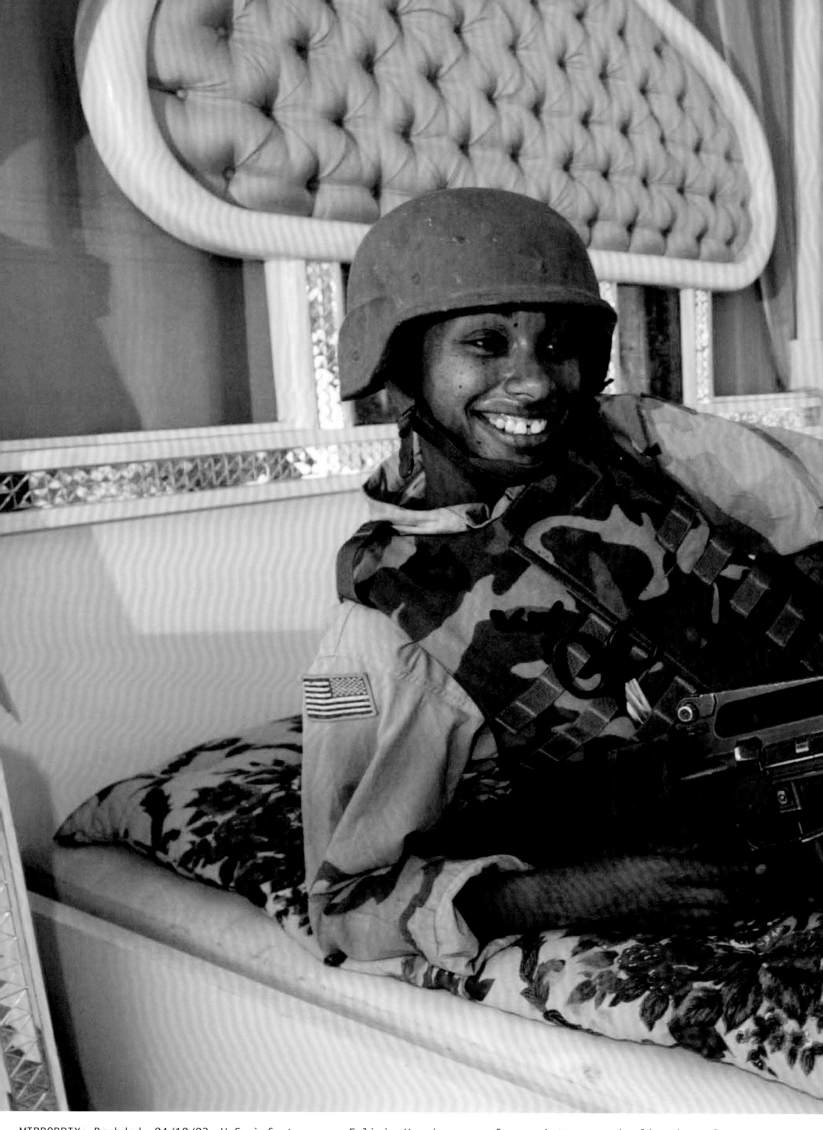

MIRRORPIX: Baghdad, 04/10/03. U.S. infantrywoman Felicia Harris poses for a picture as she lies in a four-poster bed

t the palace of Uday, the playboy son of Saddam Hussein.

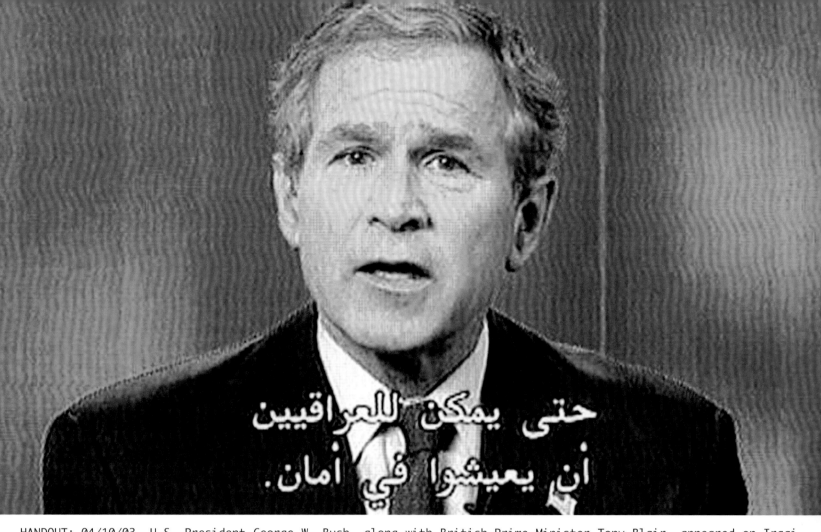

حتى يمكن للعراقيين
ان يعيشوا في أمان.

HANDOUT: 04/10/03. U.S. President George W. Bush, along with British Prime Minister Tony Blair, appeared on Iraqi television. The address was beamed into Iraq by a new Arabic TV network produced by the U.S. and U.K. governments called Nahwa Al-Hurrieh, or "Towards Freedom."

THOMAS DWORZAK: Kirkuk, 04/10/03. Thousands of Kurdish Peshmerga forces entered the city during widespread looting and celebration and took over former government buildings the day after the fall of Baghdad.

>Too much has happened the last couple of days but my head is as heavy as a lead boulder. I still can't bring myself to sleep upstairs, not that anything too serious happened after the other night, but I rather sleep under as many walls and roofs as possible...fist size shrapnel gets thru the first wall, but might be stopped by the next. So the million dollar question is of course "what the fuck happened?" Fedayeen (Syrian/Lebanese/Iraqi) were somewhere in the area.

>>It has become a swear word, dirty filthy and always followed by a barrage of verbal abuse. Syrian, Lebanese, and of course Iraqi sickos who are stupid enough to believe the Jennah-under-martyrs-feet rubbish. They want to die in the name of Allah, so what do they do? Do they stand in front of "kafeer infidel aggressor"? No, they don't because they are chicken shit. They go hide in civilian districts to shoot a single useless mortar shell or a couple of Kalashnikov shots which bounce uselessly off the armored vehicles. But the answer they get to that single shot is a hell of mortars or whatever on all the houses in the area from where the shot came. This has been happening all over Baghdad, and in many places people were not as lucky as we have been here in our block.

>>Sometimes you didn't even know that those creepy fucks have moved into your street for the night. All over Baghdad you see the black cloth with the names of people killed during these things. It is even worse when the Americans decide to go into full battle mode on these Fedayeen, right there between the houses. I have seen what has happened in Jamia and Adhamiya districts. One woman was too afraid to go out of her house hours after the attack because she had body pieces of one of these Fedayeen on her lawn.

>>Now whenever Fedayeen are seen they are being chased away. Sometimes with rocks and stones if not guns. If you have them in your neighborhood, you will not be able to sleep peacefully. The stupid fucks: for some reason they don't understand that if they want to die, they should do it alone and not take a whole block down with them.

>As if the crazy loonies from Syria are not enough, Iraqis are doing quite some damage themselves. Looters. How to explain this? Does anyone believe those who go on TV and say no-not-us, must-be-from-abroad (they mean Kuwaitis, but they are scared to say it) explains all the looting that has been going on? How much can we blame on "the systematic destruction of Iraq by foreigners" and how much on the Iraqis themselves? I heard the following on TV, don't know who said it: "If Ghengis Khan turned the Tigris blue from the ink of the manuscripts thrown in it, today the sky has been turned black by the smoke rising from the burning books." Try to rationalize that—you will fail. The same crowd who jumped up and down shouting "long live saddam" now shouts in front of the cameras "thank you Mr. Bush" while carrying whatever they could steal. Thank you indeed. This is not the people reclaiming what is theirs; these are criminal elements on the loose.

>>So how clean are the hands of the U.S. forces? Can they say "well we couldn't do anything" and be let off the hook? Hell no. If I open the doors for you and watch you steal, am I not an accomplice? They did open doors. Not to freedom, but to chaos while they kept what they wanted closed. They decided to turn and look the other way. And systematically didn't show up with their tanks until all was gone and there was nothing left.

>>We sealed ourselves away. There is nothing a voice calling for restraint can do in front of a mob. Oh, and thanks for the tank in front of the National Museum. And the couple of soldiers on it lounging in the sun while the looting goes on from the back door.

>Since we're talking about looting, Do you know who was the biggest smuggler in recent years? Arshad, Saddam's personal guard for a very long time. He even tried once to get the head of one of the winged minotaurs in Nineveh out of the country some years ago, but it turned to a fiasco and he had to get back to the smaller things. A Tikriti officer offered G. 70 pieces from the National Museum a couple of days after the reported looting; he and his other Tikriti friends had 150 pieces plus more from a later period. (They turned out to be not the real thing but copies, at least that is what the Americans told G. when he showed them photos of the stolen pieces, but that is another story.)

>>A ten minute walk from the National Museum, the Saddam Arts Center is showing now white stains on its walls instead of the collection of modern art it used to have. Some of the paintings were not stolen, they were slashed or shot. Now that is a nice picure for you: hate a painting? Go shoot it. Strange thing. There are places where if you are seen with a weapon these days and shoot it, you end up dead, but it seems that if you are shooting paintings or blowing up vaults, no one minds the weapons. The worst is of course that idiot Al-Zubaidi and his so-called Civil Administration. Did you see on TV those police cars and police men he supposedly got to work? I saw them on TV too, that is about the only place I have seen them. People in districts with a strong social fabric took over the police stations themselves and were stopping and arresting the criminals themselves. Police...don't make me laugh. Too depressing.

>I see Raed and G. every couple of days (G. in one of his impossible and crazy adventures ended up working in a Guard unit). I am just glad to see them again. The American presence and Iraqi government makes us argue until we are too tired to talk. Usually Raed ends up calling me and G. "pragmatic pigs" with no principles; he wants to put a sign on my forehead: "Beware! Pragma-pig." He talks of invading forces and foolish loonies (me) who believe that the U.S. will help us build a democracy. But what we all agree on is that if the Americans pull out now, we will be eaten by the crazy mullahs and imams. G. has decided this might be a good time to sell our souls to the (U.S.) Devil. :: salam pax [+] :: 04/17/03.

SUNGSU CHO: Baghdad, 04/09/03. Looting on the streets of Baghdad as the U.S. Marines 3rd Battalion, 4th Regiment

rolls tanks through the city with little resistance.

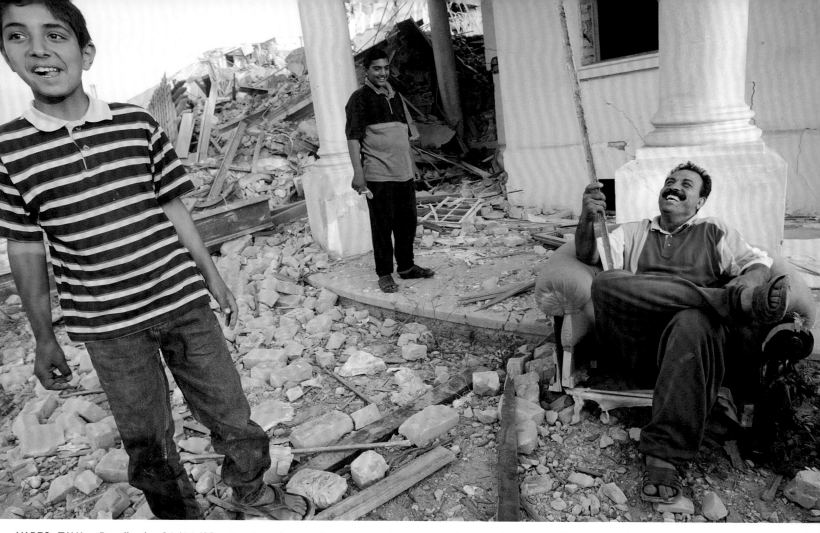

MARIO TAMA: Bagdhad, 04/14/03. An Iraqi man laughs as he pretends to sit in Saddam Hussein's chair while others look on in the rubble of a bombed-out building at the Al-Salam presidential palace.

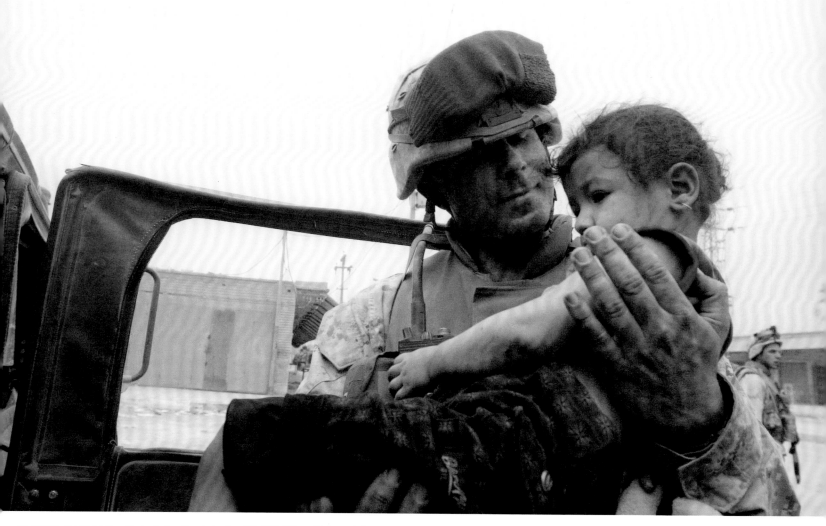

ALBERT FACELLY: Outside Baghdad, 04/07/03. First Lieutenant Paul B. Keener of the Marines 3rd Battalion, 4th Regiment holds an Iraqi girl who was wounded during the fighting for a key bridge leading into the capital.

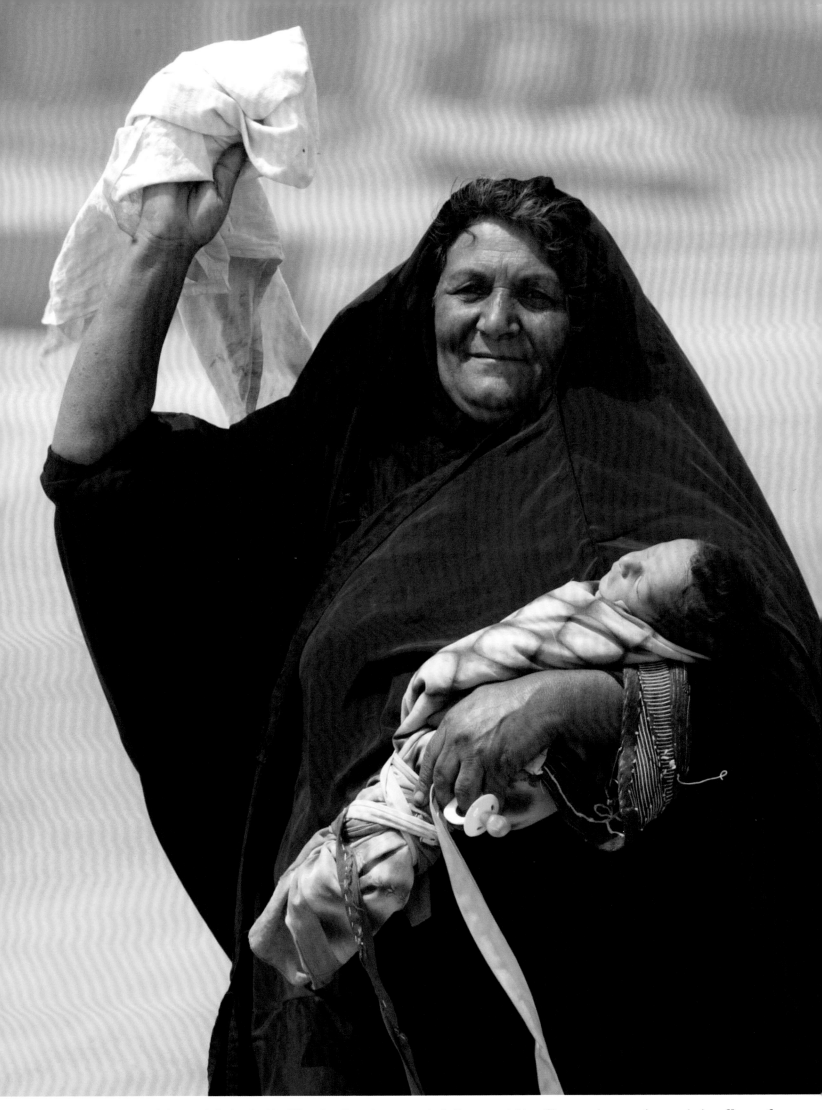

LAURENT REBOURS: Outside Baghdad, 04/05/03. An Iraqi woman holding a white flag and carrying a baby flees from Baghdad, 10 kilometers away, on the main road out of the capital.

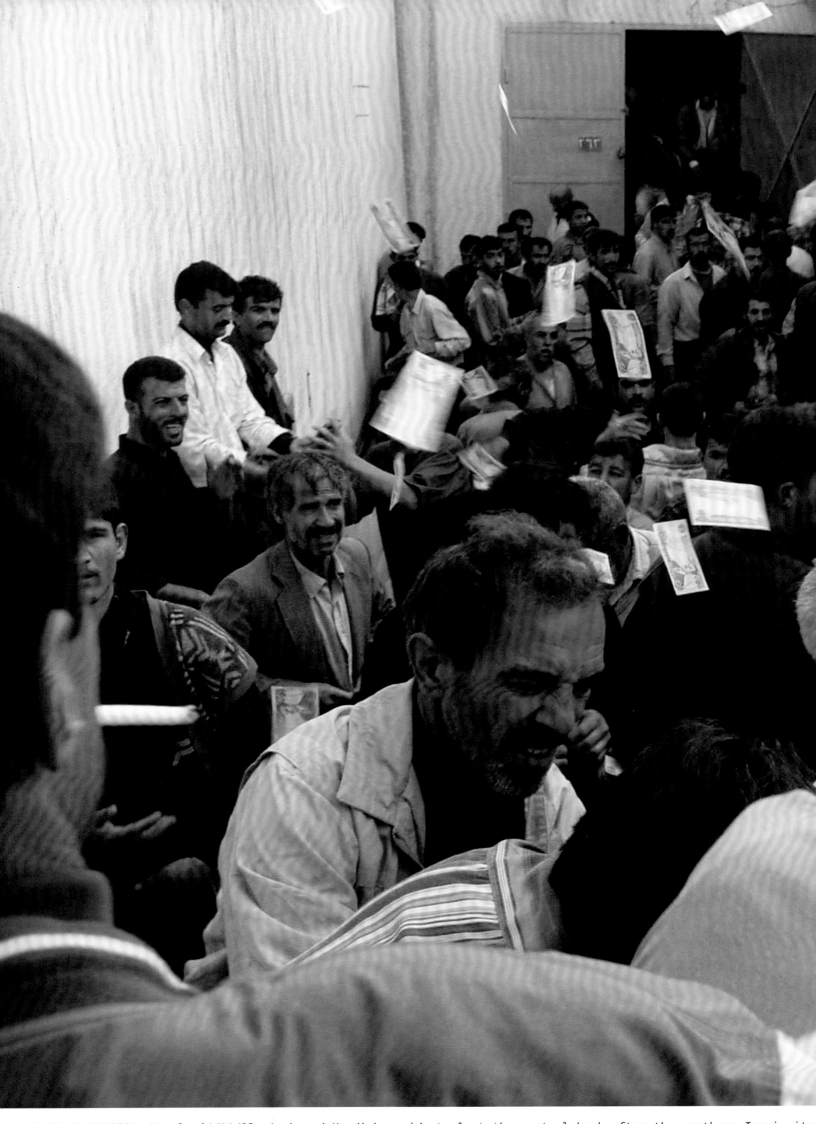

ASHLEY GILBERTSON: Mosul, 04/11/03. Arab and Kurdish residents loot the central bank after the northern Iraqi city

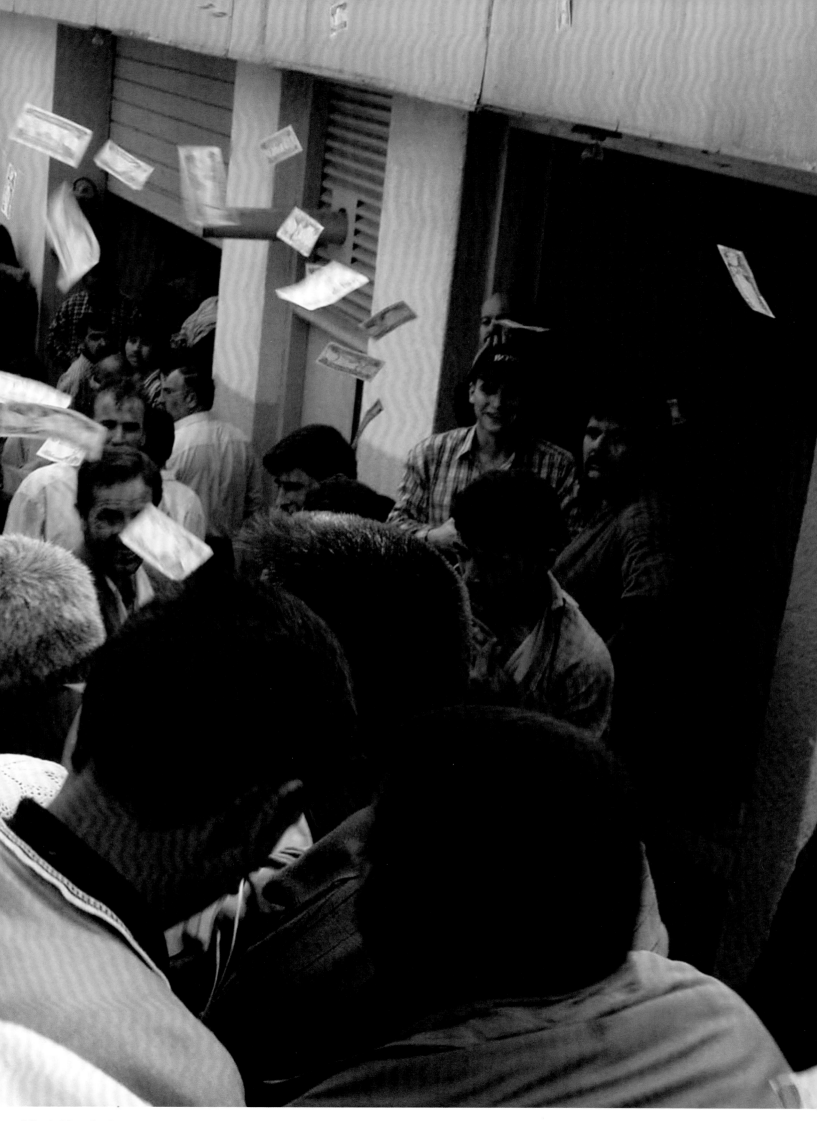

unofficially fell. Later, Kurdish and then American forces moved in to restore order in Iraq's third largest city.

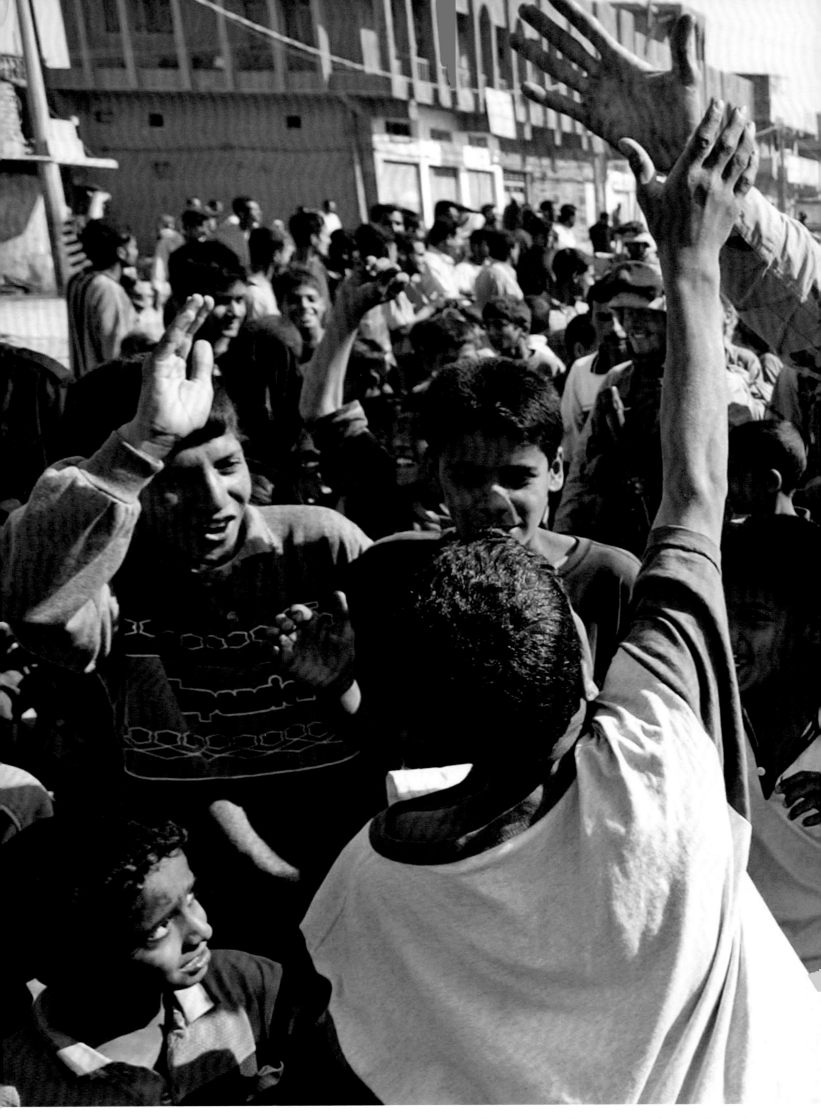

OLEG POPOV: Saddam City, 04/11/03. Iraqi boys cheer a U.S. Marine from Charlie Company, 1st Marine Division, as the

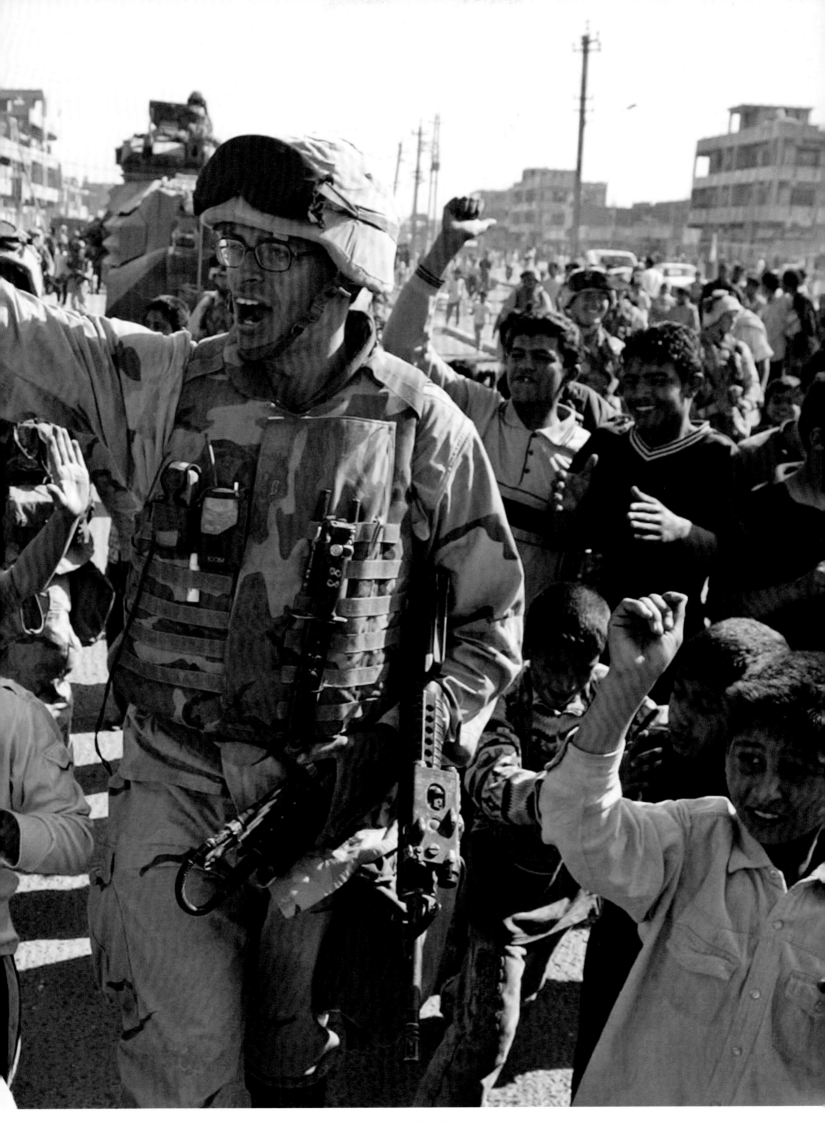

unit patrols Saddam City, the poorest part of the Iraqi capital.

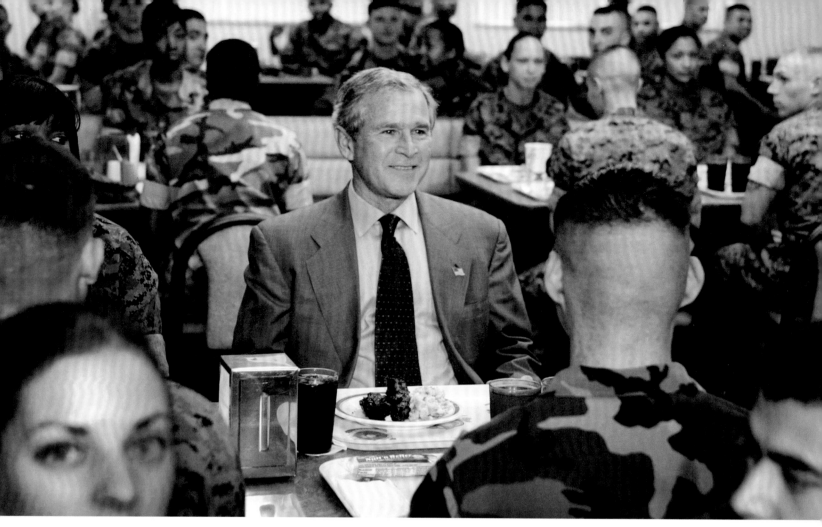

LARRY DOWNING: Camp Lejeune, NC, 04/03/03. President Bush at lunch while spending an afternoon in private visits with family members of Marines killed in the war against Iraq.

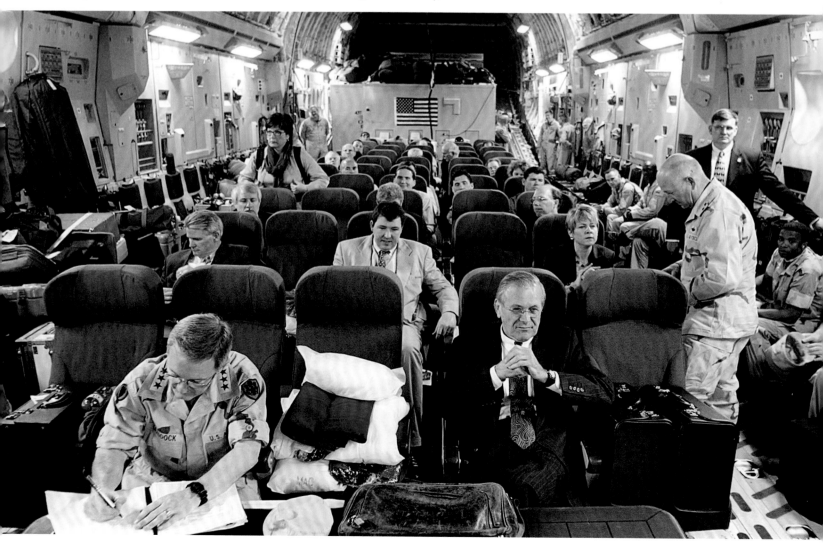

LUKE FRAZZA/POOL: Prince Sultan Air Base, Saudi Arabia, 04/29/03. U.S. Secretary of Defense Donald Rumsfeld departs in a C-17 with his staff and 14 members of the press following his visit with coalition troops.

>On BBC World for the last 15 minutes: the view from the Palestine Hotel. U.S. Marine M1 Abrams, LVTP-7s, and Hummers pouring onto the roundabout, reporters like flies buzzing around them.
>>UPDATE: No cheering crowds as yet (this is the upmarket section of town), lots of the terminally curious. Within sight is the hotel where Baghdad Bob used to give his briefings.
>>UPDATE: Crowd now ripping off the plaque from the statue...that's all they can reach.
>>UPDATE: Sign just displayed by crowd appears to read "GO HOME HUMAN SHIELDS, YOU U.S. WANKERS." Stop reading and go see the BBC webcam for yourself. Posted By Alan E Brain at 08:49 AM (TCP).

>The BBC is now showing Iraqis fastening a large noose around the huge statue's neck in the park, and they're about to do to him what was done to Stalin's statues in Moscow.
>>UPDATE: as this other post said, people are also really wailing away at the plinth with sledgehammers. Sure, the USMC could take it down with one shot from an Abrams, but it's important Iraqis be given a chance to do this for themselves. One works till exhaustion, then another takes over.
>>I was at the Kill when die Mauer (the Berlin Wall) came down, and still have my hammer and chisel. I know how they feel. GOOD ON YOU, BLOKES!
>>UPDATE: To complete the archetype, an M-88 recovery vehicle has now pulled up to give them the final help they need. CBS Webcam view.
>>UPDATE: The rope broke, but that's not going to save him: the Iraqis are now attaching a chain from the M-88 to his neck. The M-88 recovery vehicle is used to "recover" tanks by pulling them out of combat using those chains, so a mere statue should be no problem. Technical superiority.
>>UPDATE: Combat still raging; a large building opposite the Palestine hotel is now burning and under fire. The crowds taking down the statue are oblivious to the fact that there's a battle going on. The M-88 has just raised its recovery boom.
>>UPDATE: The statue now has an execution hood on it...a U.S. Flag. Nah, they've taken it off, letting the Iraqis get a good look at him as he goes down. Now there's an Iraqi flag, and the crowd continues to grow as word gets out.
>>UPDATE: He's down...and the crowd goes WILD! Posted By Alan E Brain at 09:53 AM (TCP).

>LIBERATION.
>>Baghdad has fallen.
>>They're dancing in the streets.
Posted by LT Smash at 10:43 PM 04/09/03.

>"We shall never forget what the coalition has done for our people. A free Iraq shall be a living monument to our people's friendship with its liberators." —Hojat al-Isalm Abdel Majid al-Khol (WSJ)

Washington Post: POWs found. The two Apache crewmen: Chief Warrant Officer David S. Williams, 30; and Chief Warrant Officer Ronald D. Young, 26; and troops of the 507th: Spc. Edgar Adan Hernandez, 21, Mission, Texas; Spc. Joseph Neal Hudson, 23, Alamogordo, New Mexico; Spc. Shoshana N. Johnson, 30, El Paso, Texas; Pfc. Patrick Wayne Miller, 23, Walter, Kansas; Sgt. James J. Riley, 31, Pennsauken, New Jersey. (via K-Lo in The Corner).

>Desert Bloom.
>>In the birthplace of Abraham, Iraqis met to plan their future.
>>After Friday prayers, a large group of men protested the U.S. military presence. No one was arrested, tortured, or executed afterwards.
>>Yesterday, Iraqi police arrested Saddam's Finance Minister and turned him over to Coalition forces.
>>Shiite pilgrims made their way to Karbala. For the first time in many years, no one stopped them.
>>Today, Iraqi Christians are celebrating Easter.
>>Pushing up through the rubble, a free nation is rising.
Posted by LT Smash at 11:47 AM 04/20/03.

>One sure sign that things are winding down: I no longer have to carry 30+ pounds of gear with me everywhere I go.
>>You know that feeling you get, when you think you left your wallet at home?
>>Well, imagine how it feels when you have to lug a bunch of heavy stuff around for a couple of months, and one day you just leave it all behind.
>>Feels like I'm floating when I walk.
Posted by LT Smash at 12:33 PM 04/25/03.

>Hey, the war's pretty much over. I'll be coming home soon, right?
>>I wish.
>>The Navy ordered a couple of carriers back, and the Air Force has left Turkey. But here on the ground, we're still building up forces.
>>Not sure how much longer the buildup will continue (and couldn't say if I did know), but it's obvious that we won't start drawing down for several more months.
>>I can't even think about how long I'm going to be here. I figure I'm not even to the halfway point yet.
>>I'm sure that back home, you're already starting to lose interest. You'll be thinking about summer vacations and the latest must-see movie.
>>Meanwhile, I'll still be here, trying to keep the sand out of my keyboard.
>>Don't worry about us. Get on with your lives. That's what we want you to do.
>>We've got the situation covered over here.
Posted by LT Smash at 05:41 PM 04/15/03

>Good Friday. The following have given their lives to liberate Iraq:

United States of America
 Army Pvt. Johnny Brown, 21, Troy, Ala., vehicle accident
 Army Spc. Thomas Arthur Foley III, 23, Dresden, Tenn., grenade accident
 Army Pfc. Joseph P. Mayek, 20, Rock Springs, Wyo., weapons accident
 Marine Cpl. Armando Ariel Gonzalez, 25, Hialeah, Fla., vehicle accident
 Army Spc. Richard A. Goward, 32, Midland, Mich., vehicle accident
 Army Spc. Gil Mercado, 25, Paterson, N.J., weapons accident
 Marine Cpl. Jesus A. Gonzalez, 22, Indio, Calif., combat
 Marine Staff Sgt. Riayan A. Tejeda, 26, New York, N.Y., combat
 Marine Gunnery Sgt. Jeff Bohr, 39, San Clemente, Calif., combat
 Army Sgt. 1st Class John W. Marshall, 50, Los Angeles, combat
 Army Cpl. Henry L. Brown, 22, Natchez, Miss. combat
 Marine Pfc. Juan Guadalupe Garza, 20, Temperance, Mich., combat
 Army Sgt. 1st Class John W. Marshall, 50, Los Angeles, combat
 Army Pfc. Jason M. Meyer, 23, Swartz Creek, Mich., combat
 Air Force Staff Sgt. Scott D. Sather, 29, Clio, Mich., combat
 Army Staff Sgt. Robert A. Stever, 36, Pendleton, Ore., combat
 Marine Lance Cpl. Andrew Julian Aviles, 18, Palm Beach, Fla., combat
 Army Staff Sgt. Lincoln Hollinsaid, 27, Malden, Ill., combat
 Army 2nd Lt. Jeffrey J. Kaylor, 24, Clifton, Va., combat
 Marine Cpl. Jesus Martin Antonio Medellin, 21, Fort Worth, Texas, combat
 Army Pfc. Anthony S. Miller, 19, San Antonio, combat
 Army Spc. George A. Mitchell, 35, Rawlings, Md., combat
 Army Pfc. Gregory P. Huxley Jr., 19, Forestport, N.Y., combat
 Army Pvt. Kelley S. Prewitt, 24, Alabama, combat
 Army Sgt. Stevon Booker, 34, Apollo, Pa., combat
 Army Spc. Larry K. Brown, 22, of Jackson, Miss., combat
 Marine 1st Sgt. Edward Smith, 38, Vista., Calif., combat
 Army Capt. Tristan N. Aitken, 31, State College, Pa., combat
 Army Pfc. Wilfred D. Bellard, 20, Lake Charles, La., vehicle accident
 Army Spc. Daniel Francis J. Cunningham, 33, Lewiston, Maine, vehicle accident
 Marine Capt. Travis Ford, 30, Oceanside, Calif., helicopter crash
 Marine Cpl. Bernard G. Gooden, 22, Mount Vernon, N.Y., combat
 Army Pvt. Devon D. Jones, 19, San Diego, vehicle accident
 Marine 1st Lt. Brian M. McPhillips, 25, Pembroke, Mass., combat
 Marine Sgt. Duane R. Rios, 25, Hammond, Ind., combat.
 Marine Capt. Benjamin Sammis, 29, Rehoboth, Mass., helicopter crash
 Army Sgt. 1st Class Paul R. Smith, 33, of Tampa, Fla., combat
 Marine Pfc. Chad E. Bales, 20, Coahoma, Texas, non-hostile accident
 Army Sgt. Wilbert Davis, 40, Hinesville, Ga., vehicle accident
 Marine Cpl. Mark A. Evnin, 21, South Burlington, Vt., combat
 Army Capt. Edward J. Korn, 31, Savannah, Ga., combat
 Army Staff Sgt. Nino D. Livaudais, 23, Ogden, Utah, combat
 Army Spc. Ryan P. Long, 21, Seaford, Del., combat
 Army Spc. Donald S. Oaks Jr., 20, Harborcreek, Pa., combat
 Army Sgt. 1st Class Randy Rehn, 36, Longmont, Colo., combat
 Army Capt. Russell B. Rippetoe, 27, Arvada, Colo., combat
 Army Sgt. Todd J. Robbins, 33, Hart, Mich., combat
 Marine Cpl. Erik H. Silva, 22, Chula Vista, Calif., combat
 Army Capt. James F. Adamouski, 29, Springfield, Va., helicopter crash
 Marine Lance Cpl. Brian E. Anderson, 26, Durham, N.C., non-hostile accident
 Army Spc. Mathew Boule, 22, Dracut, Mass., helicopter crash
 Army Master Sgt. George A. Fernandez, 36, El Paso, Texas
 Marine Pfc. Christian D. Gurtner, 19, Ohio City, Ohio, weapons accident
 Army Chief Warrant Officer Erik Halvorsen, 40, Bennington, Vt., helicopter crash.
 Army Chief Warrant Officer Scott Jamar, 32, Granbury, Texas, helicopter crash
 Army Sgt. Michael Pedersen, 26, Flint, Mich., helicopter crash
 Army Chief Warrant Officer Eric A. Smith, 42, Rochester, N.Y., helicopter crash
 Navy Lt. Nathan D. White, 30, Mesa, Ariz., F/A-18C Hornet lost over Iraq
 Army Sgt. Jacob L. Butler, 24, Wellsville, Kan., combat
 Marine Lance Cpl. Joseph B. Maglione, 22, Lansdale, Pa., weapons accident
 Army Spc. Brandon Rowe, 20, Roscoe, Ill., combat
 Army Spc. William A. Jeffries, 39, Evansville, Ind., illness
 Marine Capt. Aaron J. Contreras, 31, Sherwood, Ore., helicopter crash
 Marine Sgt. Michael V. Lalush, 23, Troutville, Va., helicopter crash
 Marine Sgt. Brian McGinnis, 23, St. Georges, Del., helicopter crash
 Marine Staff Sgt. James Cawley, 41, Layton, Utah, combat
 Army Cpl. Michael Curtin, 23, Howell, N.J., suicide attack
 Army Pfc. Diego Fernando Rincon, 19, Conyers, Ga., suicide attack
 Army Pfc. Michael Russell Creighton Weldon, 20, Palm Bay, Fla., suicide attack
 Marine Lance Cpl. William W. White, 24, New York, vehicle accident
 Army Sgt. Eugene Williams, 24, Highland, N.Y., suicide attack
 Marine Sgt. Fernando Padilla-Ramirez, 26, San Luis, Ariz., combat
 Army Sgt. Roderic A. Solomon , 32, Fayetteville, N.C., vehicle accident
 Marine Gunnery Sgt. Joseph Menusa, 33, Tracy, Calif., combat
 Marine Lance Cpl. Jesus A. Suarez Del Solar, 20, Escondido, Calif., combat
 Marine Maj. Kevin G. Nave, 36, White Lake Township, Mich., vehicle accident
 Navy Corpsman Michael Vann Johnson Jr., 25, Little Rock, Ark., combat
 Marine Pfc. Francisco A. Martinez Flores, 21, Los Angeles, combat
 Marine Staff Sgt. Donald C. May, Jr., 31, Richmond, Va., combat
 Marine Lance Cpl. Patrick T. O'Day, 20, Santa Rosa, Calif., combat
 Marine Cpl. Robert M. Rodriguez, 21, New York, combat
 Air Force Maj. Gregory Stone, 40, Boise, Idaho, grenade attack
 Marine Cpl. Evan James, 20, La Harpe, Ill., drowned in canal
 Marine Sgt. Bradley S. Korthaus, 29, Davenport, Iowa, drowned in canal
 Army Spc. Gregory P. Sanders, 19, Hobart, Ind., combat
 Army Spc. Jamaal R. Addison, 22, Roswell, Ga., combat
 Marine Sgt. Michael E. Bitz, 31, Ventura, Calif., combat
 Marine Lance Cpl. Brian Rory Buesing, 20, Cedar Key, Fla., combat
 Army Sgt. George Edward Buggs, 31, Barnwell, S.C., combat
 Marine Pfc. Tamario D. Burkett, 21, Buffalo, N.Y., combat
 Army 1st Sgt. Robert J. Dowdy, 38, Cleveland, combat
 Army Pvt. Ruben Estrella-Soto, 18, El Paso, Texas, combat
 Marine Lance Cpl. David K. Fribley, 26, Fort Myers, Fla., combat
 Marine Cpl. Jose A. Garibay, 21, Costa Mesa, Calif., combat
 Marine Cpl. Jorge A. Gonzalez, 20, Los Angeles, combat
 Army Pfc. Howard Johnson II, 21, Mobile, Ala., combat
 Marine Staff Sgt. Phillip A. Jordan, 42, Enfield, Conn., combat
 Army Spc. James Kiehl, 22, Comfort, Texas, combat
 Army Chief Warrant Officer Johnny Villareal Mata, 35, Pecos, Texas, combat
 Marine Lance Cpl. Patrick R. Nixon, 21, Gallatin, Tenn., combat
 Army Pfc. Lori Piestewa, 22, Tuba City, Ariz., combat
 Marine 2nd Lt. Frederick E. Pokorney Jr., 31, Tonopah, Nev., combat
 Marine Sgt. Brendon Reiss, 23, Casper, Wyo., combat
 Marine Cpl. Randal Kent Rosacker, 21, San Diego, combat
 Army Pvt. Brandon Sloan, 19, Bedford Heights, Ohio, combat
 Marine Lance Cpl. Thomas J. Slocum, 22, Thornton, Colo., combat
 Army Sgt. Donald Walters, 33, Kansas City, Mo., combat
 Marine Lance Cpl. Michael J. Williams, 31, Yuma, Ariz., combat
 Marine Pfc. Tamario D. Burkett, 21, Buffalo, N.Y., combat
 Marine Lance Cpl. Donald John Cline, 21, Sparks, Nev., combat
 Marine Pvt. Jonathan L. Gifford, 30, Decatur, Ill., combat
 Marine Pvt. Nolen R. Hutchings, 19, Boiling Springs, S.C., combat
 Navy Lt. Thomas Mullen Adams, 27, La Mesa, Calif., helicopter collision
 Marine Lance Cpl. Eric J. Orlowski, 26, Buffalo, N.Y., machine gun accident
 Army Capt. Christopher Scott Seifert, 27, Easton, Pa., grenade attack
 Army Reserve Spc. Brandon S. Tobler, 19, Portland, Ore., vehicle accident
 Marine Maj. Jay Thomas Aubin, 36, Waterville, Maine, helicopter crash
 Marine Capt. Ryan Anthony Beaupre, 30, St. Anne, Ill., helicopter crash
 Marine 2nd Lt. Therrel S. Childers, 30, Harrison County, Miss., combat
 Marine Lance Cpl. Jose Gutierrez, 28, Los Angeles, combat
 Marine Cpl. Brian Matthew Kennedy, 25, Houston, helicopter crash
 Marine Staff Sgt. Kendall Damon Waters-Bey, 29, Baltimore, helicopter crash
 Marine Lance Cpl. Thomas A. Blair, 24, Broken Arrow, Okla., combat
 Marine Sgt. Nicolas M. Hodson, 22, Smithville, Mo., vehicle accident

United Kingdom
 Fusilier Kelan John Turrington, combat
 Lance Cpl. Ian Malone, Dublin, Ireland, combat
 Piper Christopher Muzvuru, combat
 Lance Cpl. Karl Shearer, killed in accident involving light armored vehicle
 Staff Sgt. Chris Muir, Romsey, England, killed while disposing of explosives
 Marine Christopher R. Maddison, combat
 Lance Cpl. Shaun Andrew Brierley, road accident
 Lance Cpl. Matty Hull, combat; friendly fire
 Cpl. Stephen John Allbutt, Stoke-on-Trent, England, tank hit by friendly fire
 Trooper David Jeffrey Clarke, Littleworth, England, tank hit by friendly fire
 Sgt. Steven Mark Roberts, Bradford, England, combat
 Lance Cpl. Barry Stephen, Perth, Scotland, combat
 Sapper Luke Allsopp, London, combat
 Staff Sgt. Simon Cullingworth, Essex, England, combat
 Flight Lt. Kevin Barry Main, jet shot down by friendly fire
 Flight Lt. David Rhys Williams, jet shot down by friendly fire
 Lt. Philip Green, helicopter collision
 Lt. Marc Lawrence, helicopter collision
 Lt. Antony King, Helston, England, helicopter collision
 Lt. Philip West, Budock Water, England, helicopter collision
 Lt. James Williams, Falmouth, England, helicopter collision
 Lt. Andrew Wilson, helicopter collision
 Color Sgt. John Cecil, Plymouth, England, helicopter crash
 Lance Bombardier Llewelyn Karl Evans, Llandudno, Wales, helicopter crash
 Capt. Philip Stuart Guy, helicopter crash
 Marine Sholto Hedenskog, helicopter crash
 Sgt. Les Hehir, Poole, England, helicopter crash
 Operator Mechanic Second Class Ian Seymour, helicopter crash
 Warrant Officer Second Class Mark Stratford, helicopter crash
 Maj. Jason Ward, helicopter crash

>"As He died to make men holy, let us die to make men free" – The Battle Hymn of the Republic. Posted by LT Smash at 11:34 AM 04/18/03.

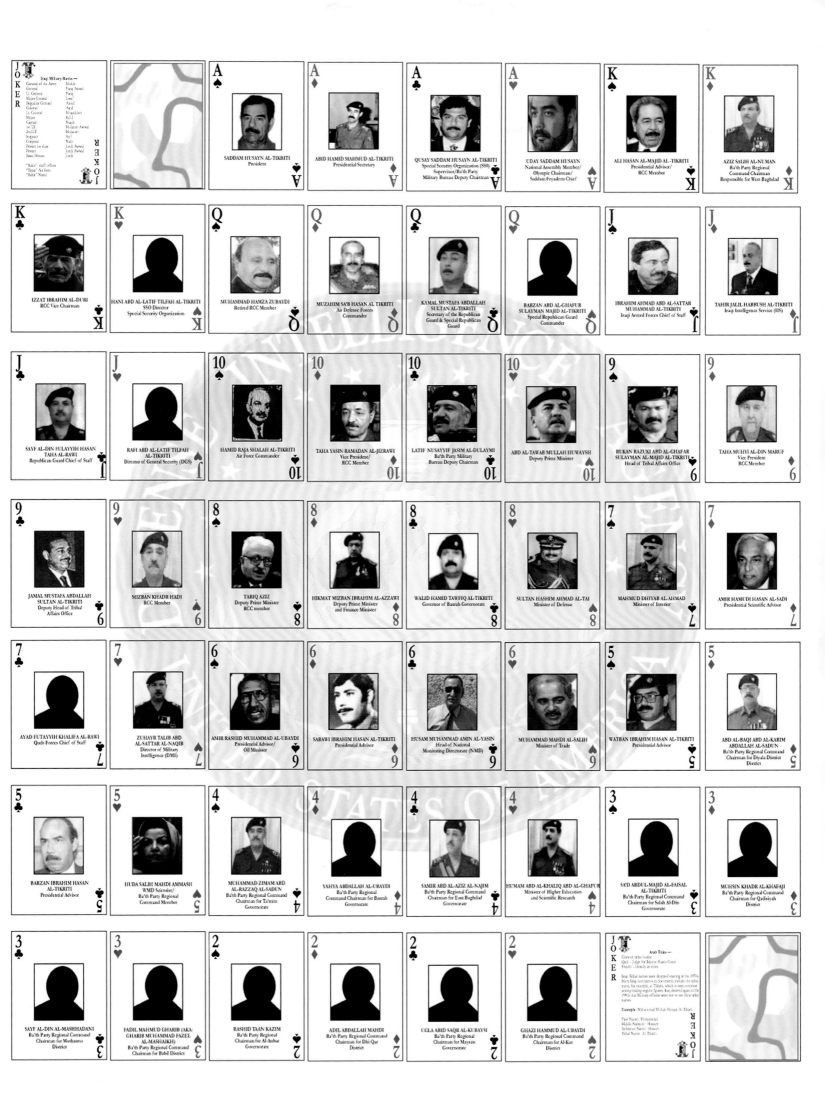

HANDOUT: 04/11/03. U.S. Dept. of Defense delivers Iraq's deposed president and his inner circle into the hands of American troops—as a deck of 55 playing cards, each depicting a leading Iraqi the U.S. wants killed or captured.

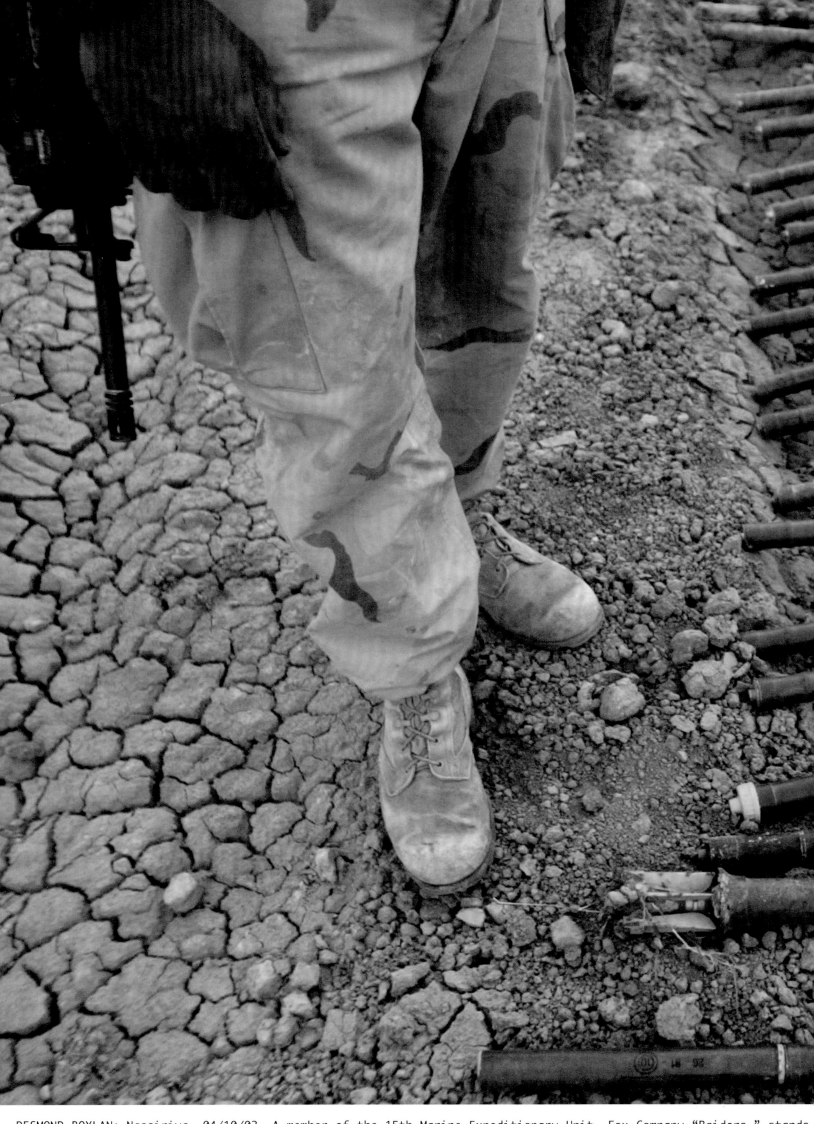

DESMOND BOYLAN: Nassiriya, 04/10/03. A member of the 15th Marine Expeditionary Unit, Fox Company "Raiders," stands

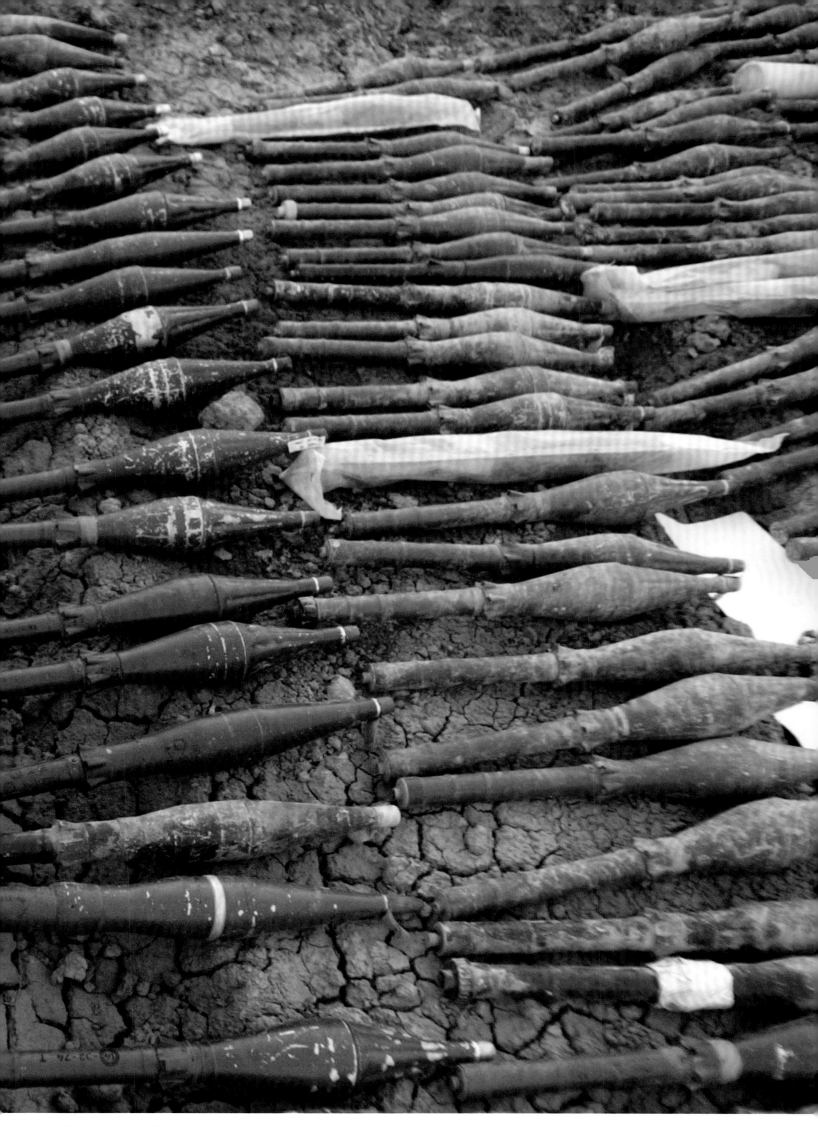

beside RPG ammunition found in schools, warehouses, banks, and private houses in neighborhoods all over the city.

TIMOTHY FADEK: Baghdad, 04/10/03. The charred remains of an Iraqi civilian in his car, where he was shot by the U.S.

rmy as they entered western Baghdad five days ago.

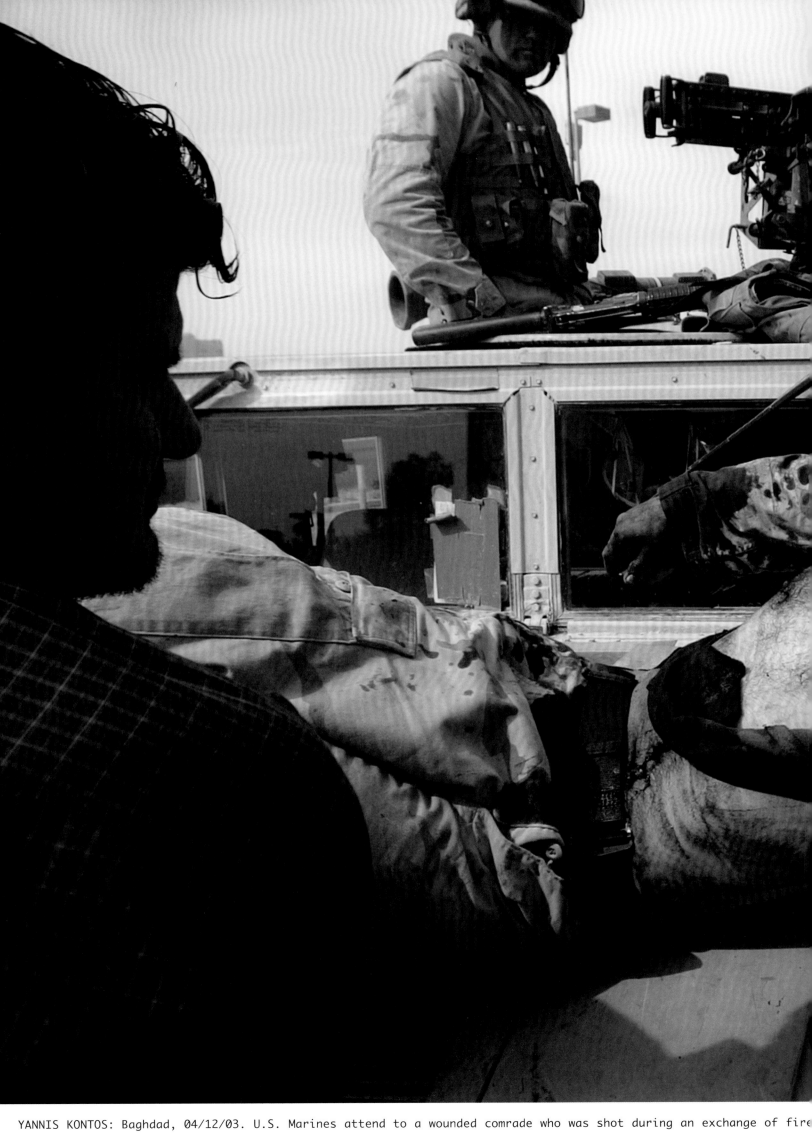

YANNIS KONTOS: Baghdad, 04/12/03. U.S. Marines attend to a wounded comrade who was shot during an exchange of fire

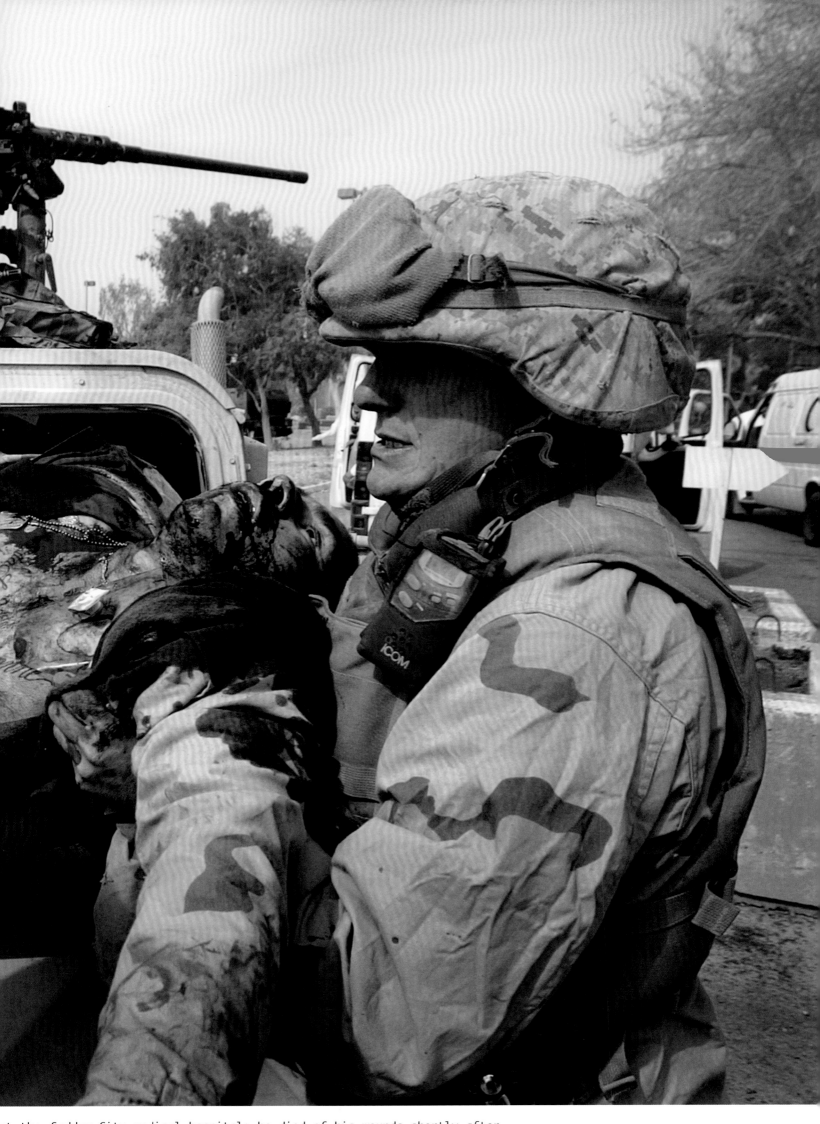

at the Saddam City medical hospital; he died of his wounds shortly after.

FRANCESCO ZIZOLA: Mosul, 04/12/03. At the main hospital dozens of wounded, mostly Arab patients, are brought in; this

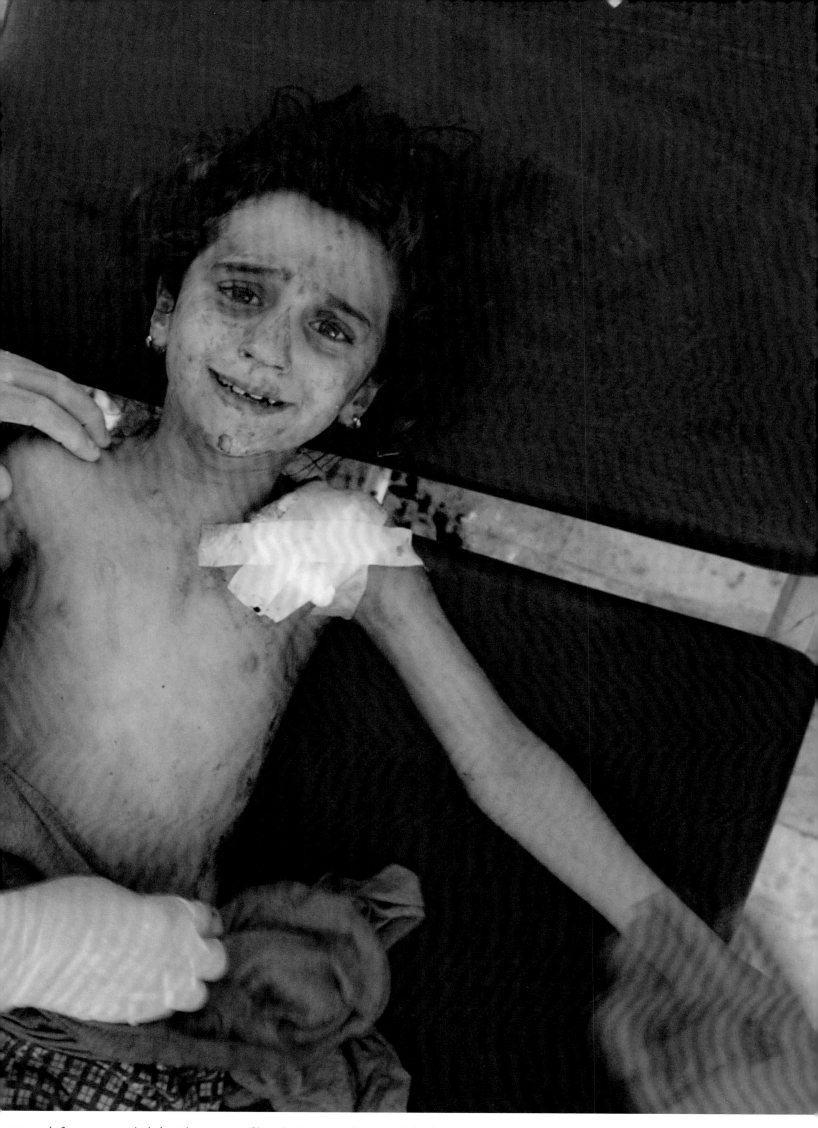

young girl was wounded in the cross fire between U.S. special forces and the Iraqi Army.

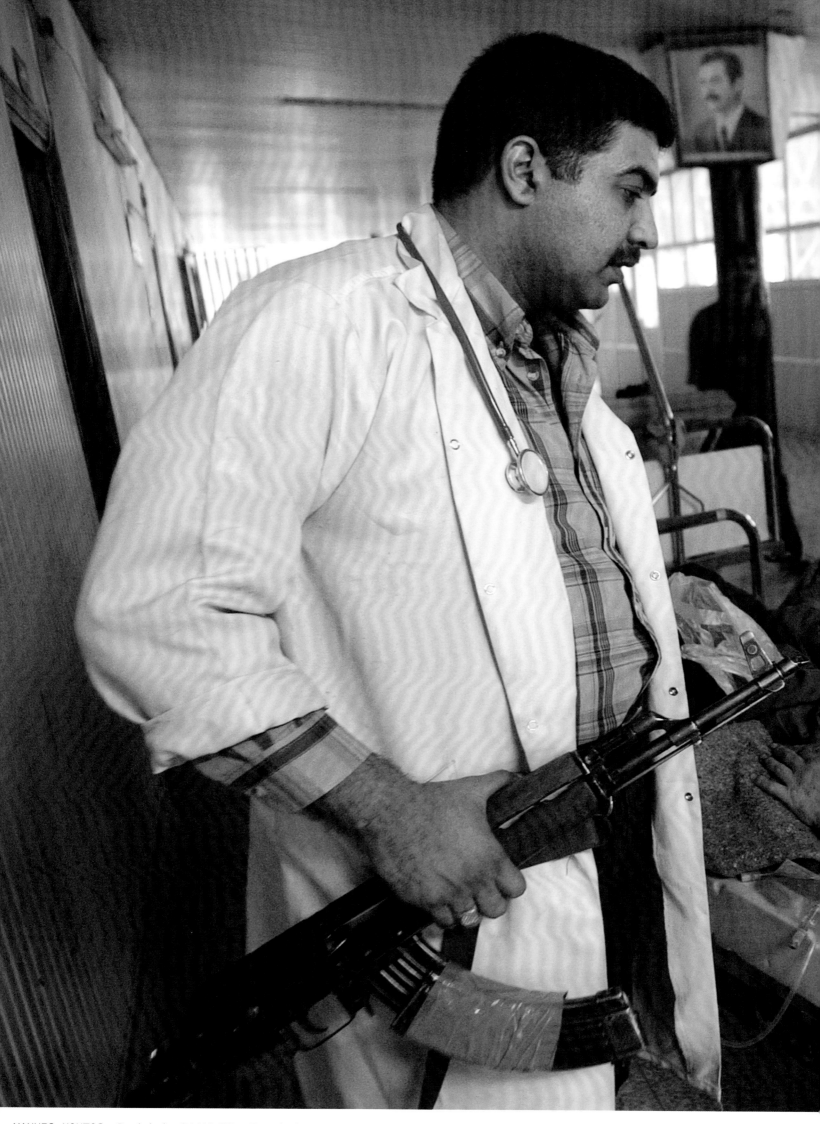

YANNIS KONTOS: Baghdad, 04/12/03. Iraqi doctors use guns to defend Al-Karh hospital and its patients from looters.

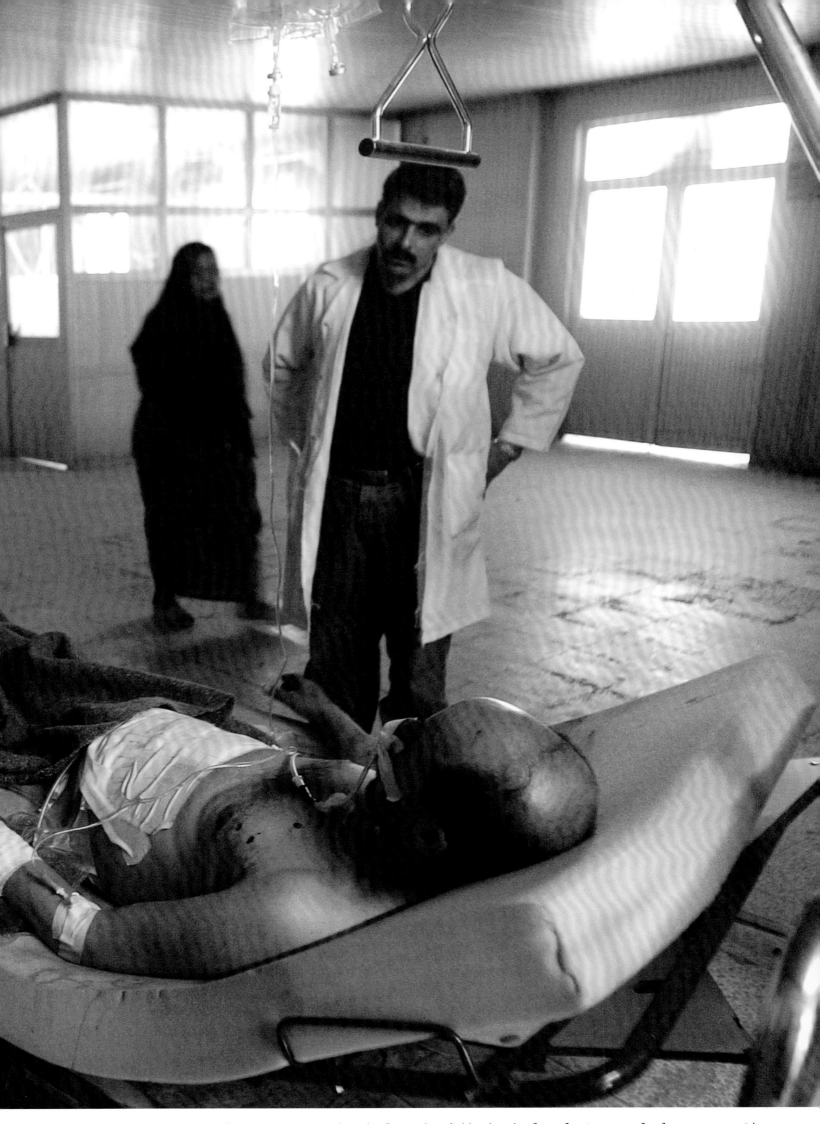

Iraqis are taking it upon themselves to protect hospitals and neighborhoods from looters as lawlessness continues.

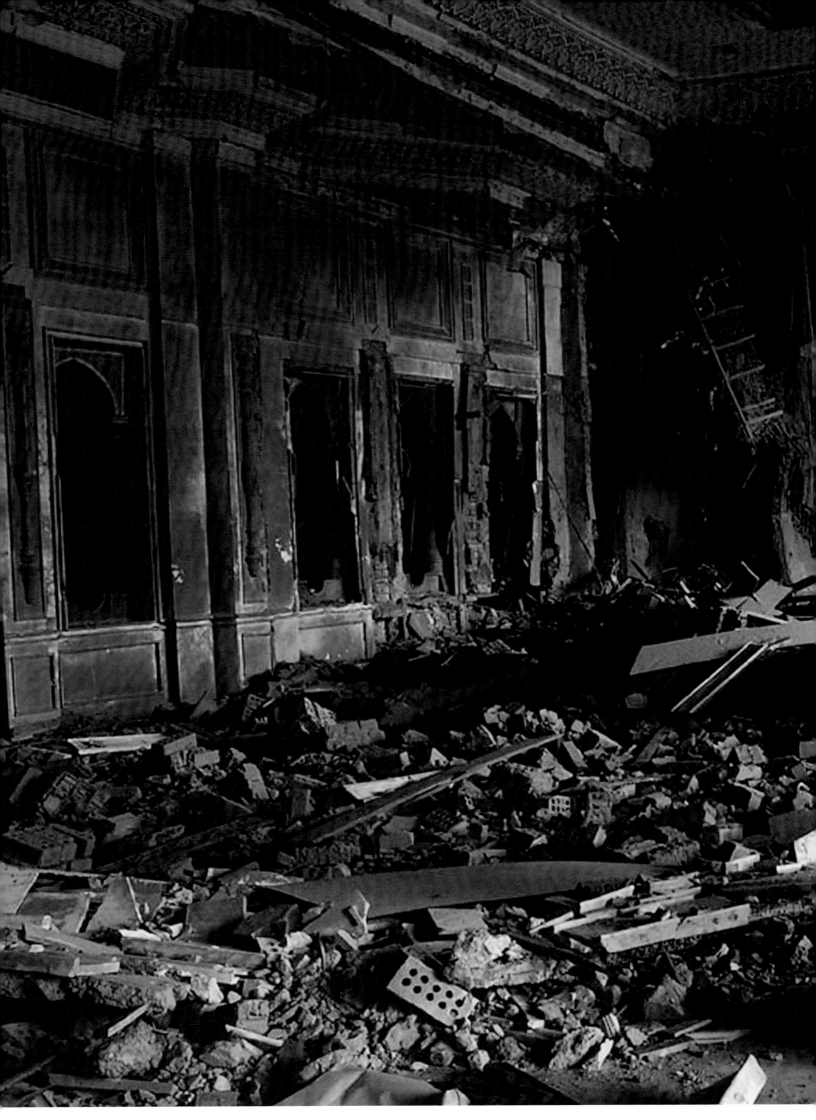

FRANCO TAZETTI: Baghdad, 04/12/03. Iraqi citizens can now see for themselves Saddam's presidential palaces—or what

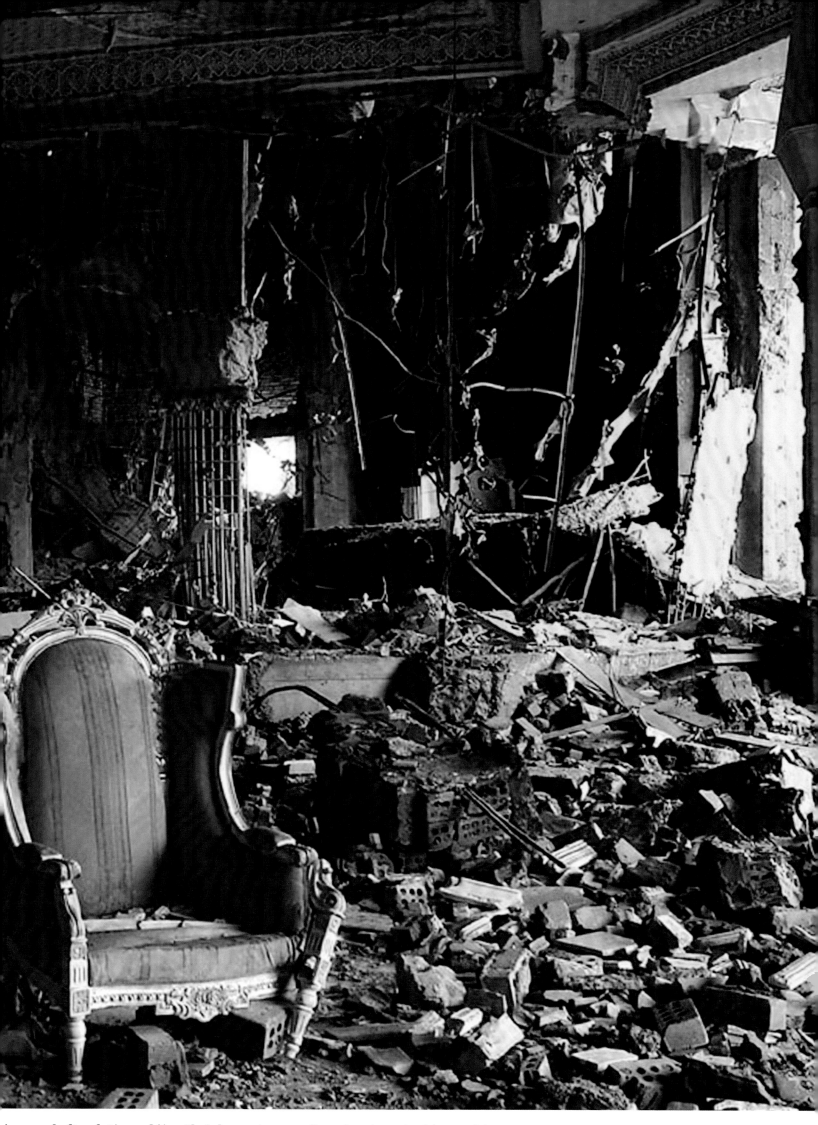

is now left of them, like Al-Salam, above, after American bombing raids.

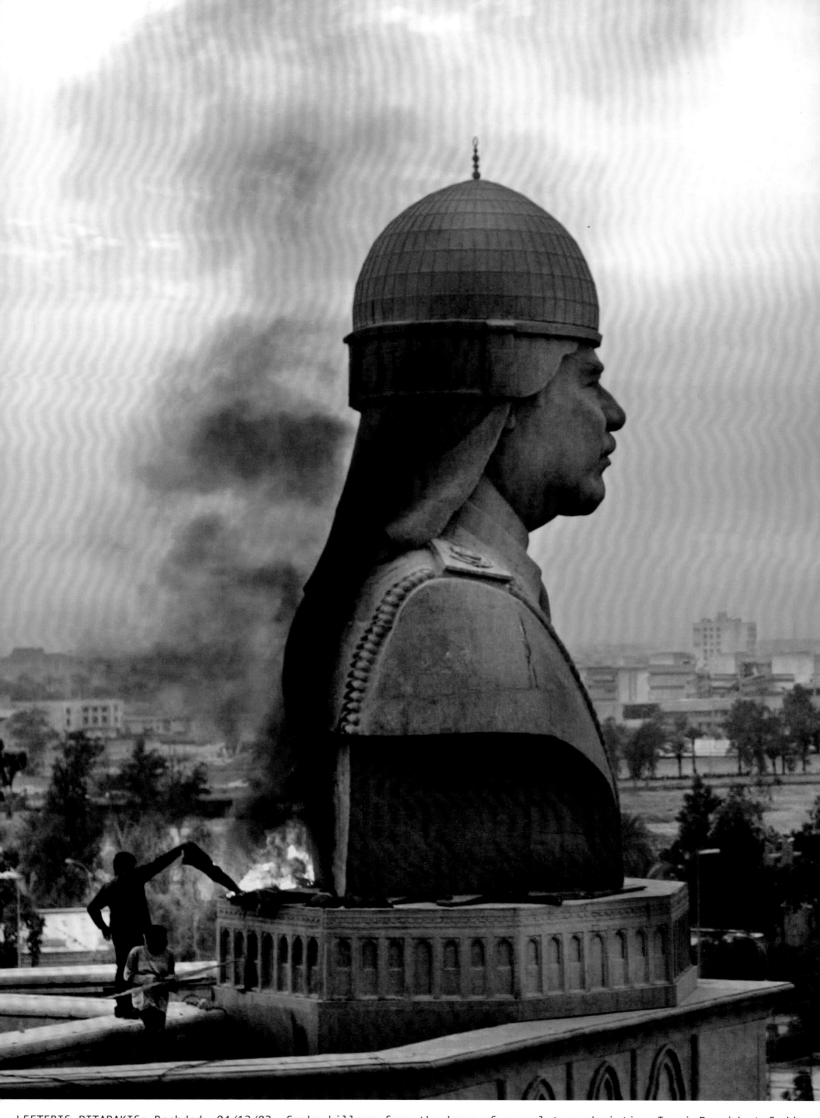

LEFTERIS PITARAKIS: Baghdad, 04/13/03. Smoke billows from the base of a sculpture depicting Iraqi President Saddam

Hussein after looters set it on fire atop the roof of his Al-Salam presidential palace.

BACK HOME

Two weeks after leaving Iraq, here I sit on the balcony of a friend's house under California-blue skies and a fresh, cool ocean breeze that can reach the condominium a block from the beach I temporarily reside in. Such a difference from the flat, brownish, hazy skies dissected by thick columns of black smoke billowing over mud-colored buildings and dusty brown streets lined with completely brown palm trees, trash, flowing sewage, and crowds of Iraqi people, who appear joyous as they wave and give a thumbs up while a column of Marine vehicles rumbles past.

The peaceful sounds of birds chirping in the green-leafed trees I hear now were then the sounds of sporadic gunfire, loud, unexplained explosions, the jovial multi-toned horns of Iraqi trucks and buses, and the constant crunching sound of broken glass and debris under my boots.

My hands typing on the keyboard of this laptop are somewhat clean with a normal skin tone, unlike the blistered hands and cracked fingertips that frantically hacked out a photo caption on a computer keyboard two weeks ago. The socks on my feet, propped up on the other chair on this balcony, don't have the powerful, nose-numbing odor that Marines and embedded journalists subjected each other to when boots were removed at sack time.

If I unconsciously desire to run my hand through my hair during a momentary pause while writing this essay, I can. Two weeks earlier, hair that wasn't matted to my scalp could be shaped and bent like wire. Here, a clean glass of bottled water sits beside me as I type. There, it was two dirty, plastic backpacking water bottles containing an unintentional mixture of two-day-old cocoa powder, day-old lemon-lime beverage base, and "fresh" apple cider drink powder. The dispenser nozzles would turn into a watering hole for dozens of flies if I didn't swat at them every few seconds.

I no longer crave the ecstasy of slowly dragging a "moist towelette" across my face, packed in every "meal ready-to-eat" (MRE), in a futile effort to remove the dirt, sweat, and complete exhaustion. I've just about forgotten where I would travel in my mind to escape the reality of muscle spasms in my back, the intense and constant vibration penetrating every cell in my body, and being one breath away from a screaming panic attack from not being able to move while riding for endless hours in a Marine Amphibious Assault Vehicle.

While being interviewed on a local live radio talk show three nights ago, callers to the show claimed we embedded journalists were controlled, and that we were only taken to places that the military wanted us to see. Three weeks ago in Baghdad, we'd simply hop on any patrol we wanted to go on. The same callers questioned our objectivity when becoming close to the Marines in our unit. Four weeks earlier, I was sending back a photo of an elderly Iraqi woman lying dead in a pool of blood after being shot in the head by Marines in our company who mistook her for a rooftop sniper. Days after that, I'm having a conversation with a twenty-one-year-old Marine in our squad about girlfriends, eating cold watermelon, and what bar we're going to when we get back.

Twelve years ago journalists were not able to witness the Gulf War from the perspective of the frontline troops—and stories went untold. Two months ago they were, and the historic record of the war in Iraq is immense.

—Hayne Palmour
North Carolina, May 2003

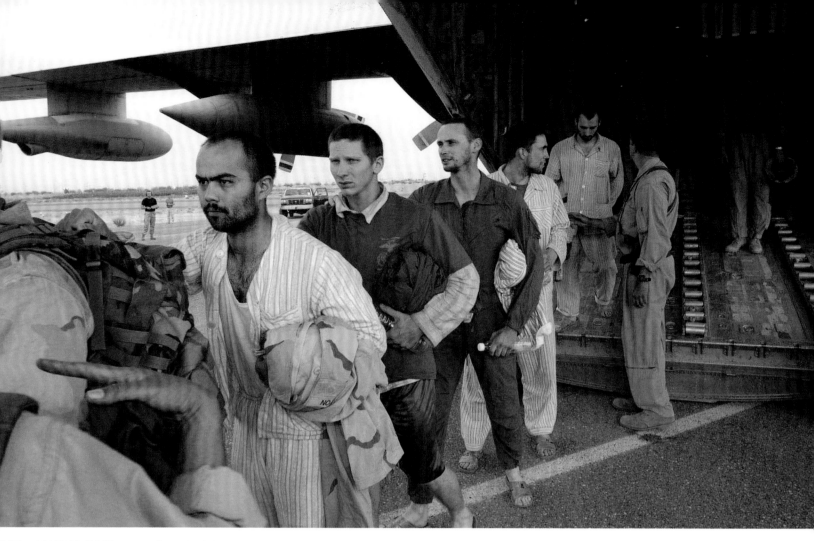

SGT. ARLEDGE/POOL: Kuwait, 04/13/03. Seven rescued U.S. POWs walk to an ambulance following their flight from Iraq.

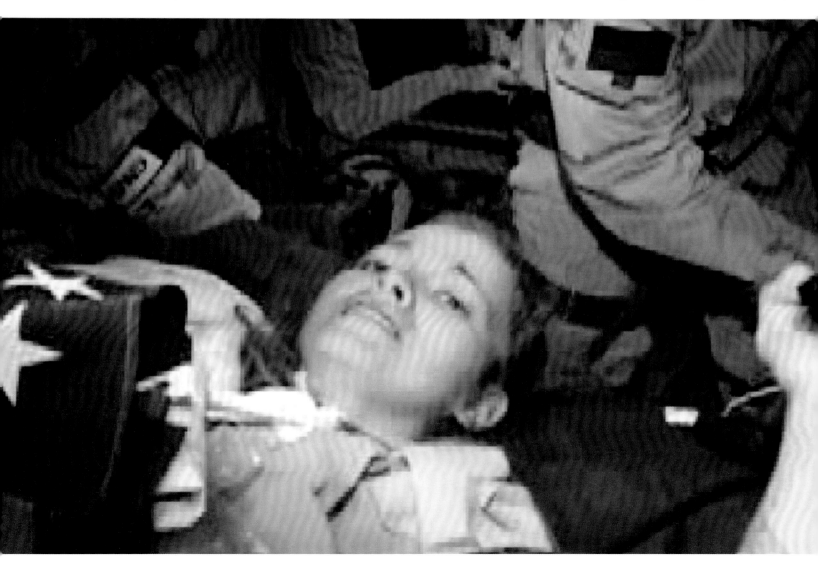

CENTCOM HANDOUT: Qatar, 04/02/03. A video of U.S. PFC Jessica Lynch shown at a media briefing at Camp As Sayliyah.

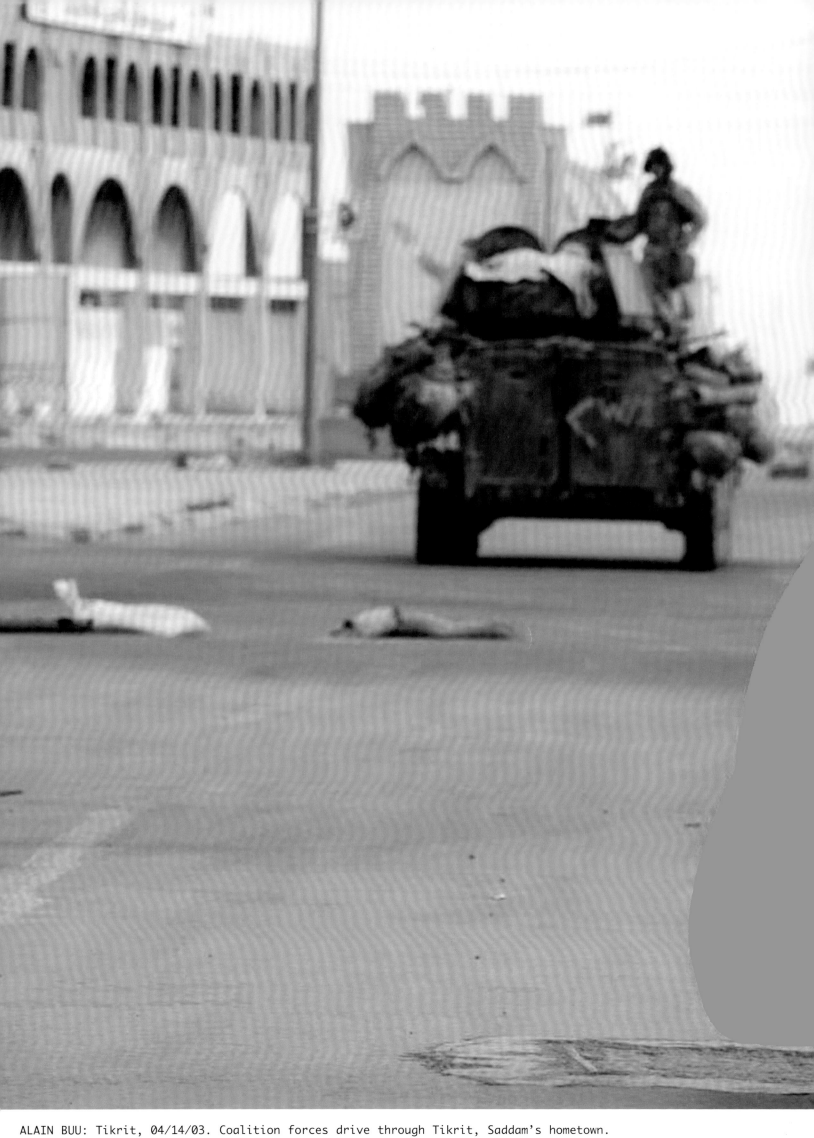

ALAIN BUU: Tikrit, 04/14/03. Coalition forces drive through Tikrit, Saddam's hometown.

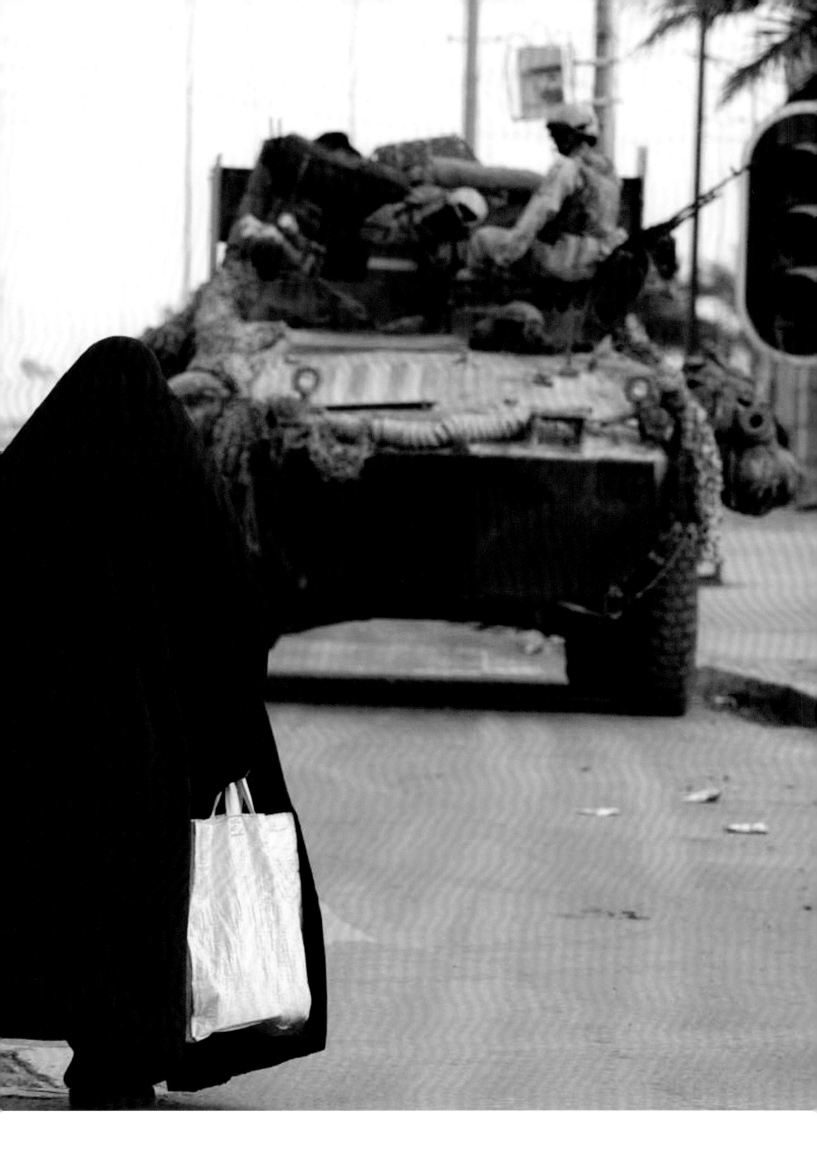

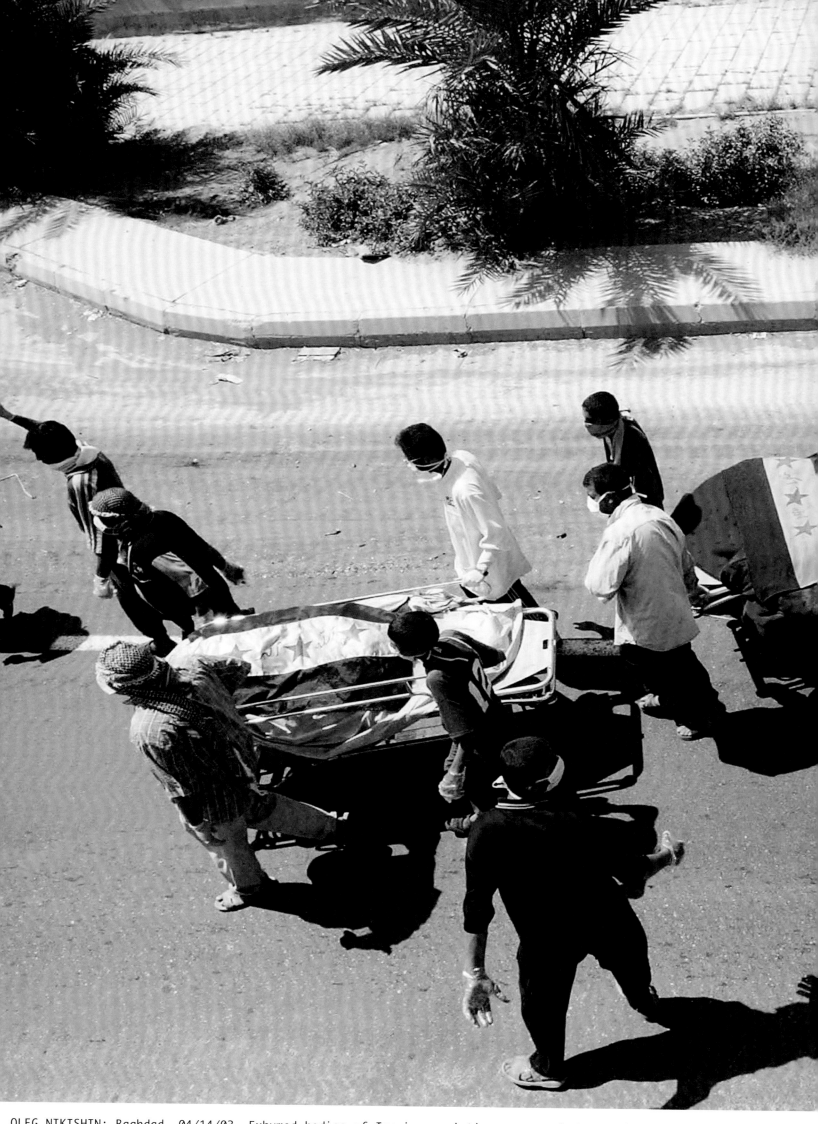

OLEG NIKISHIN: Baghdad, 04/14/03. Exhumed bodies of Iraqi war victims are carried away from temporary graves on a

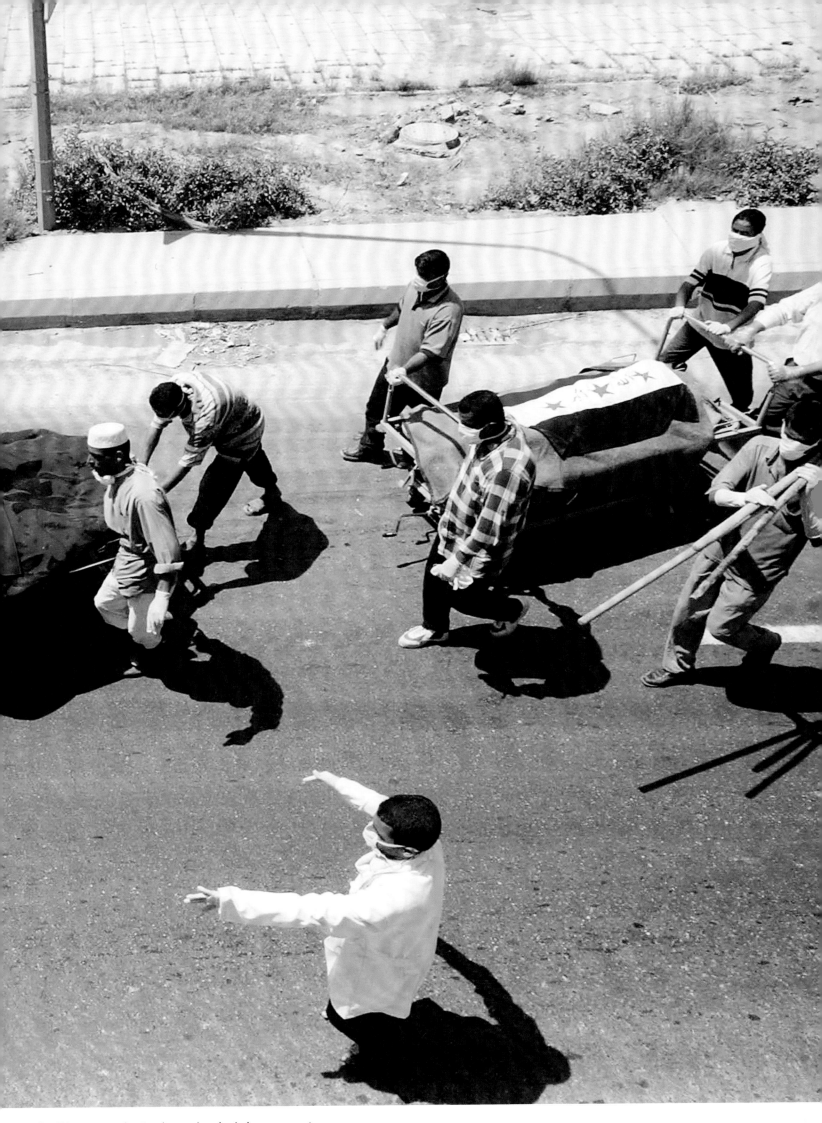

hospital's grounds to be reburied in a cemetery.

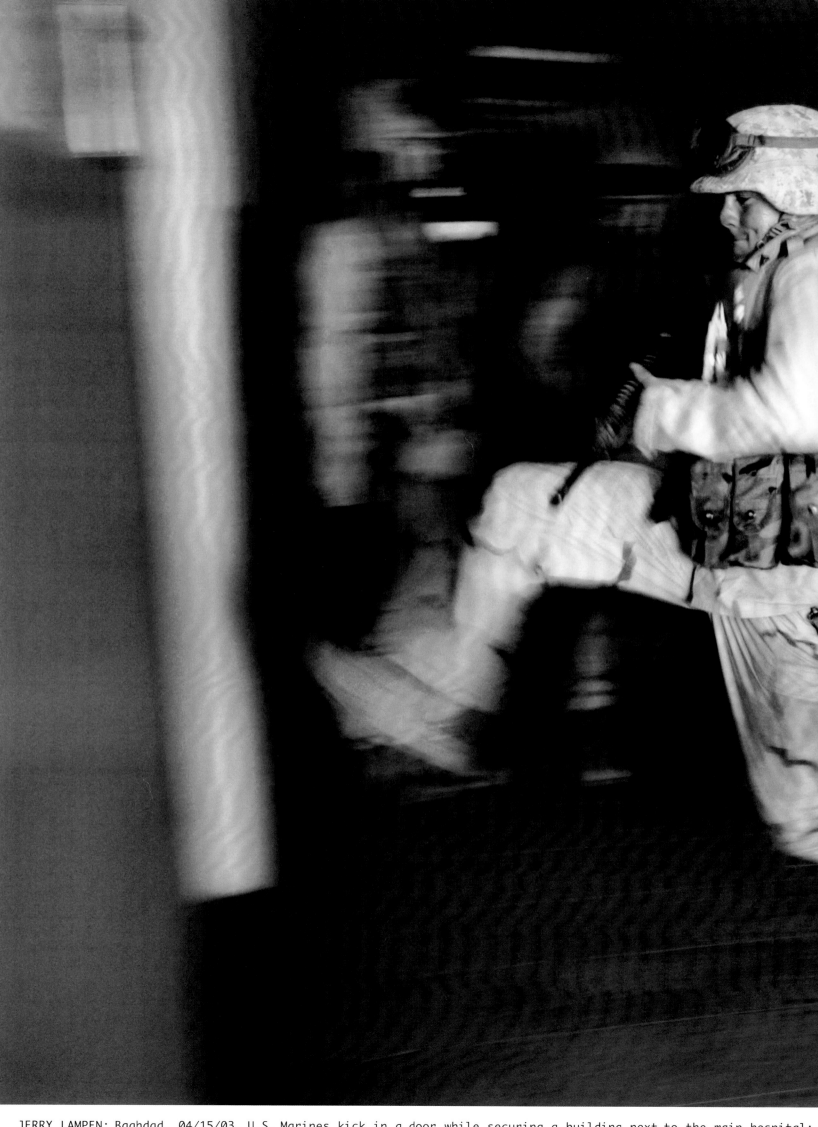

JERRY LAMPEN: Baghdad, 04/15/03. U.S. Marines kick in a door while securing a building next to the main hospital;

the building is to be used as a temporary Iraqi police headquarters.

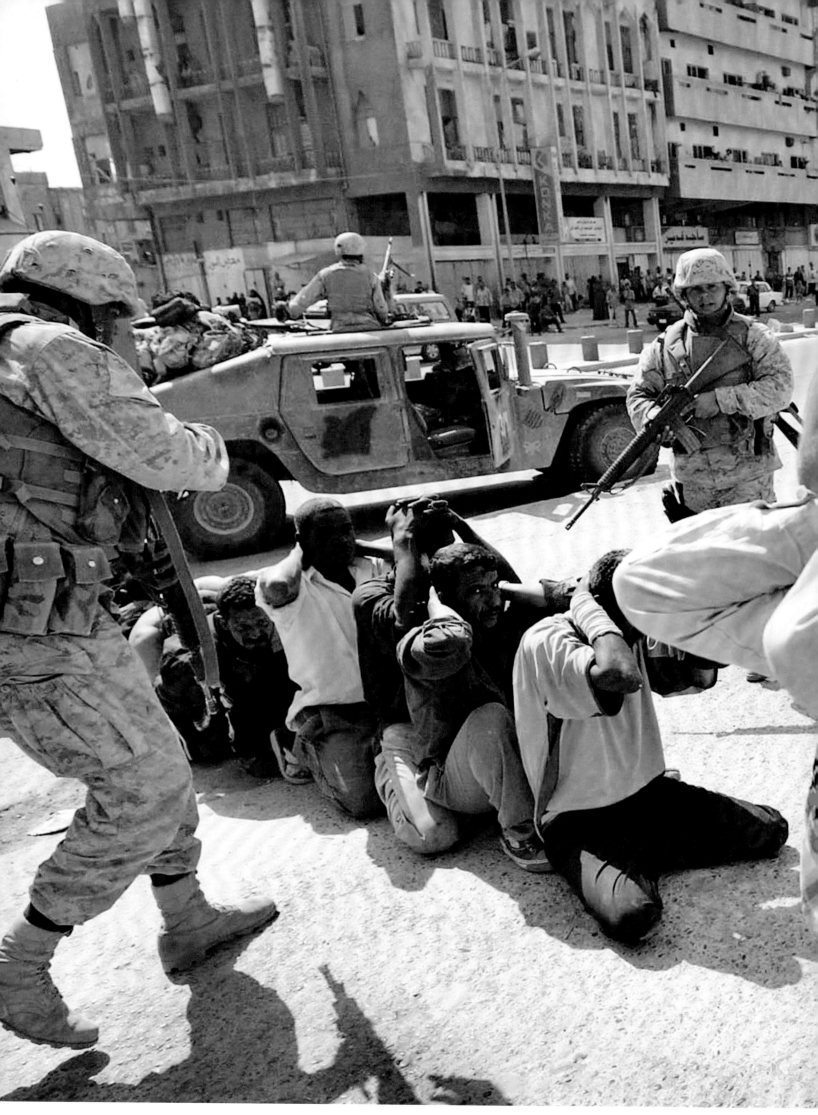

DAVID GUTTENFELDER: Baghdad, 04/14/03. U.S. soldiers arrest a group of men, accusing them of driving a vehicle with

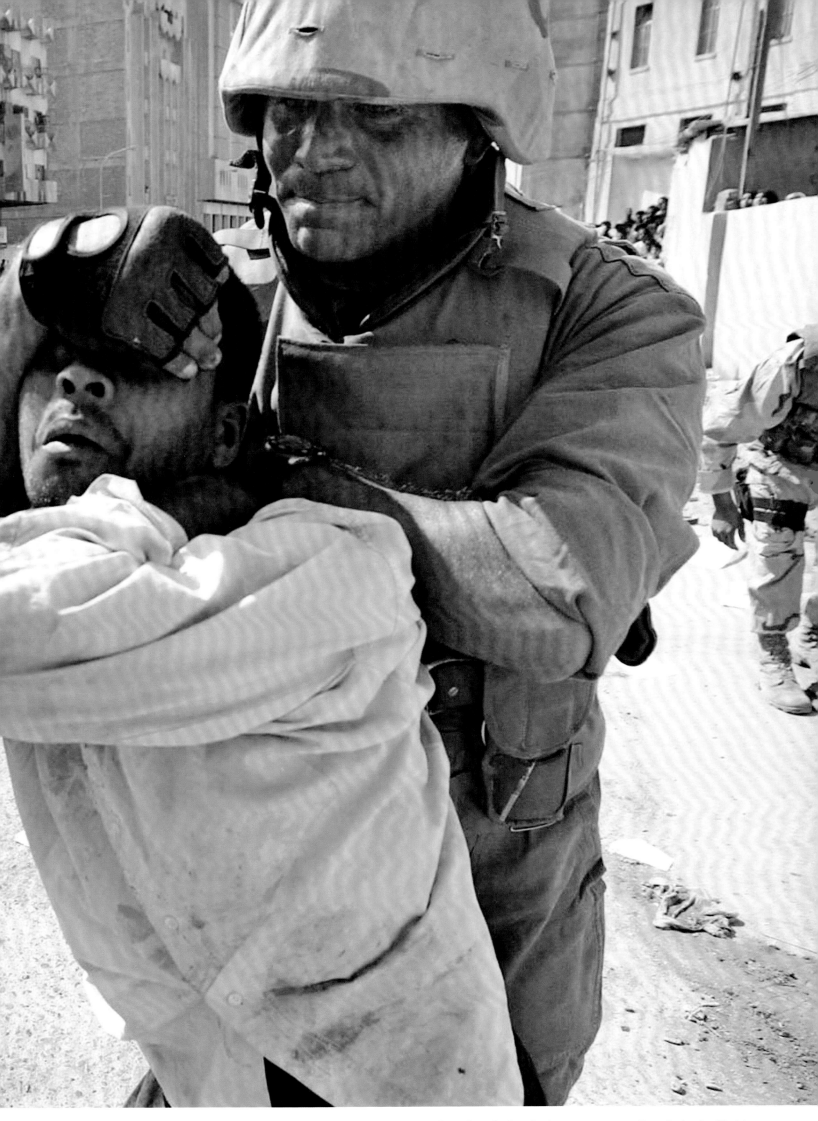

weapons and attempting to ambush American troops; soldiers and locals claimed they were non-Iraqi Arab fighters.

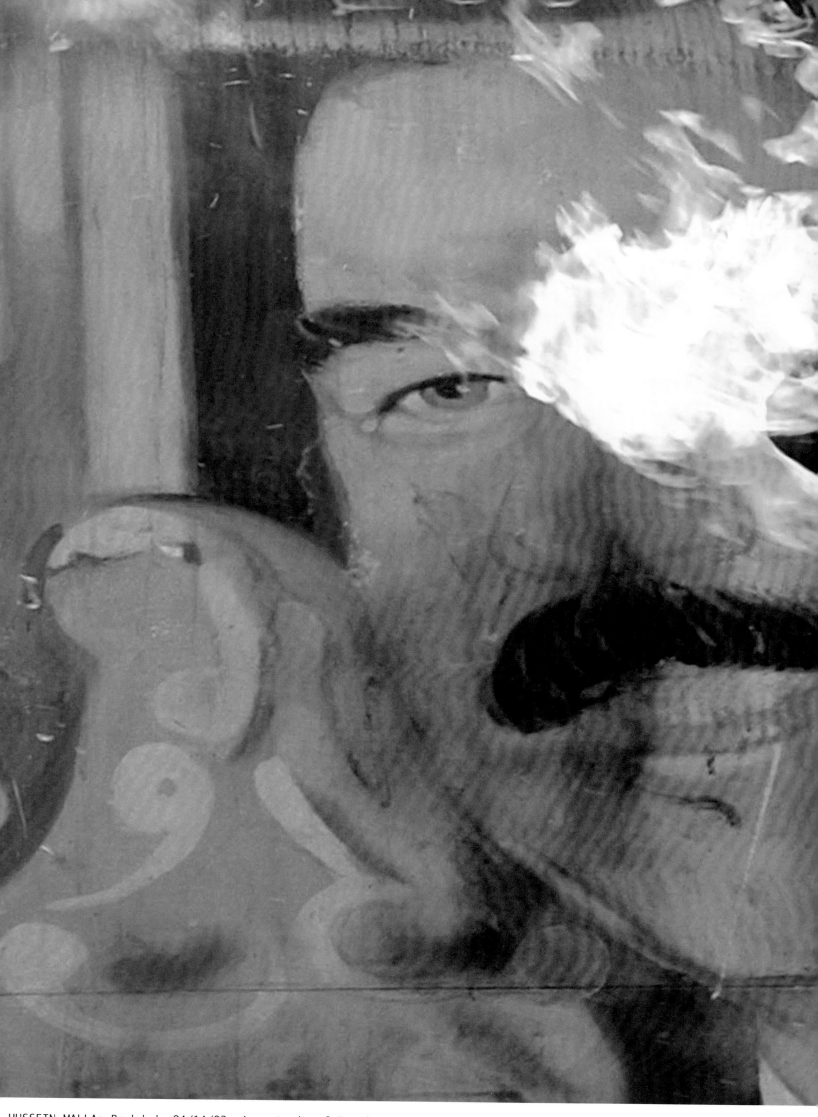

HUSSEIN MALLA: Baghdad, 04/14/03. A portrait of Iraqi President Saddam Hussein, set alight by Iraqis, burns in front

of the Iraqi Ministry of Information in the Al-Salehiya area.

>People are talking about boycotting celebrities who spoke out against the war.

>>You can count me out. I don't look to celebrities to tell me how to think.

>>I make my own decisions. I volunteered to serve in the military. I worked hard to earn my officer's commission. I swore an oath to protect and defend the Constitution of the United States. That includes the First Amendment.

>>Celebrities, like all Americans, enjoy the freedom of speech. I enjoy the freedom to not listen to what they have to say. Until they run for public office, their opinions hold no more weight with me than that of my garbage man.

>>Heard that Susan Sarandon and Tim Robbins have taken some heat for speaking out.

>>I think they are fine actors. I loved *Bull Durham*—it's a classic in my book. If Susan and Tim want to take advantage of their celebrity status to express negative opinions about my Commander-in-Chief, that's their prerogative. I happen to disagree with their point of view.

>>Hey, I have people I call friends who have similar points of view to Susan and Tim. Some of them may have attended war protests, for all I know. We disagree, but they're still my friends. I'm not going to stop returning their calls just because of their political opinions.

>>So why should I boycott actors, or musicians, just because they oppose what I'm doing? I think there's room in our democratic society for dissent, as long as it is respectful.

>>So go ahead, boycott celebrities if it makes you happy. This American respectfully declines to participate. But that's OK, I'll continue to defend your freedom, just like I defend those celebrities.

>>Whether they want me to or not.

>>Posted by LT Smash at 04:28 PM, 04/22/03.

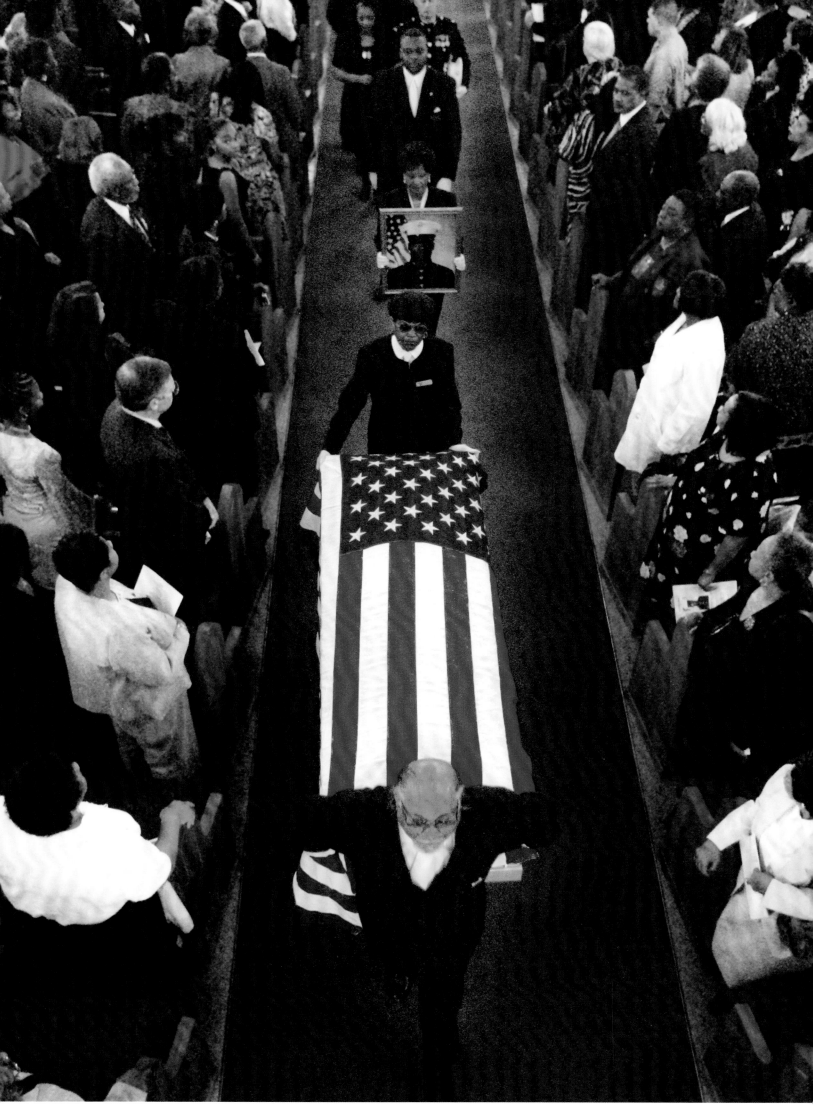

ELLEN OZIER: Durham, NC, 04/15/03. The casket of Marine Lance Cpl. Brian Anderson carried out following his memorial service.

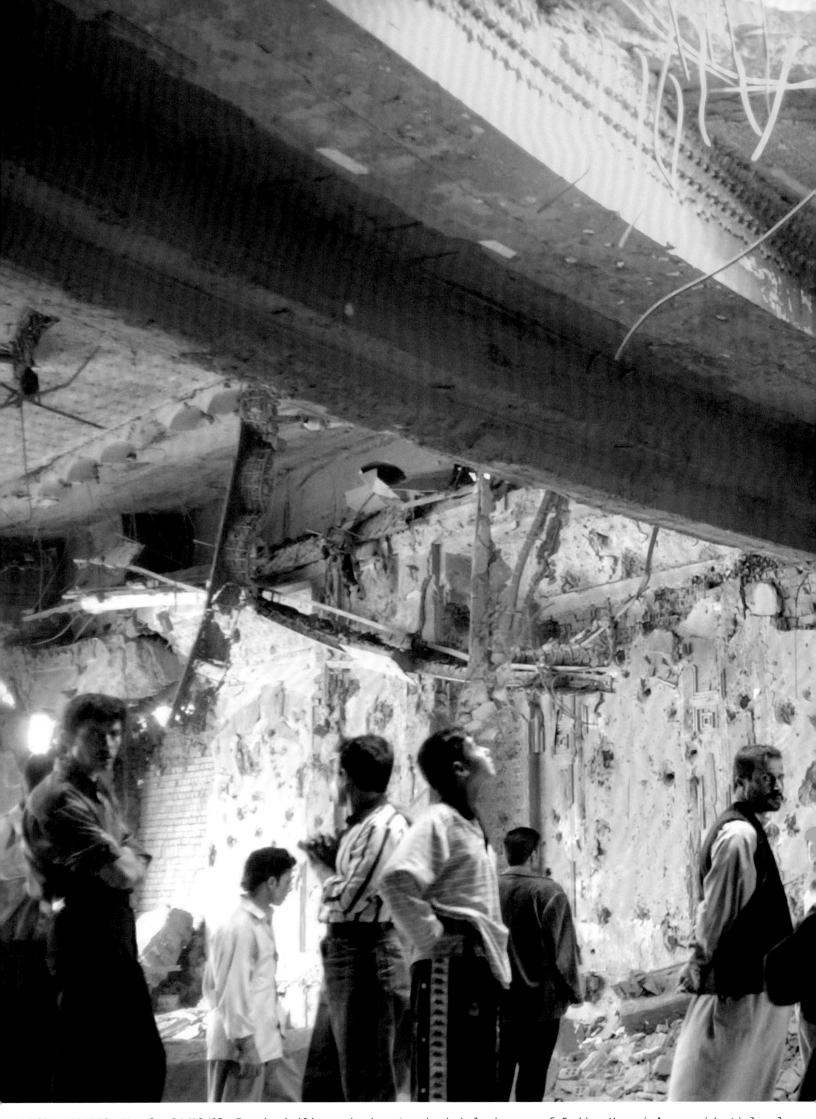

LYNSEY ADDARIO: Mosul, 04/19/03. Iraqi civilians check out a bomb hole in one of Saddam Hussein's presidential palaces

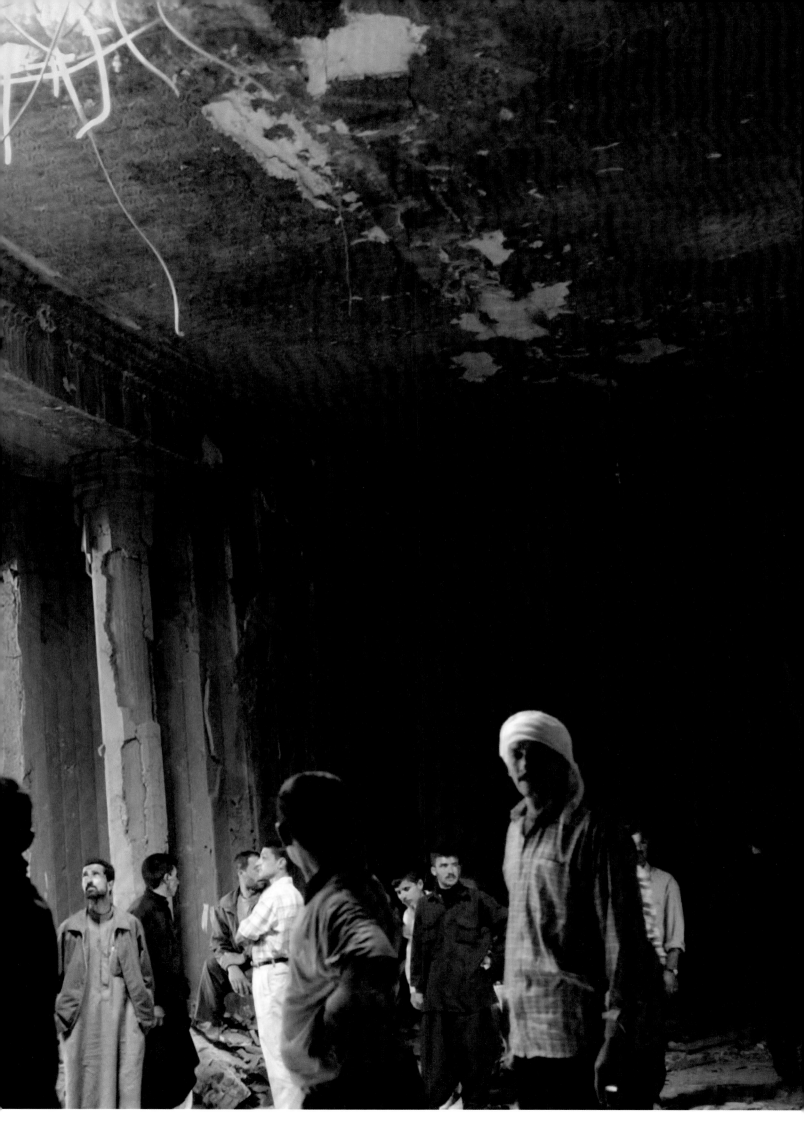

in this northern Iraqi city.

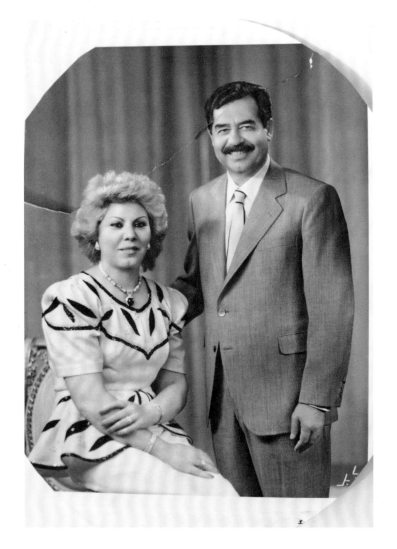
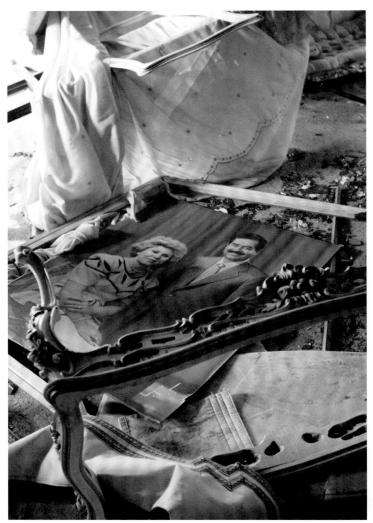
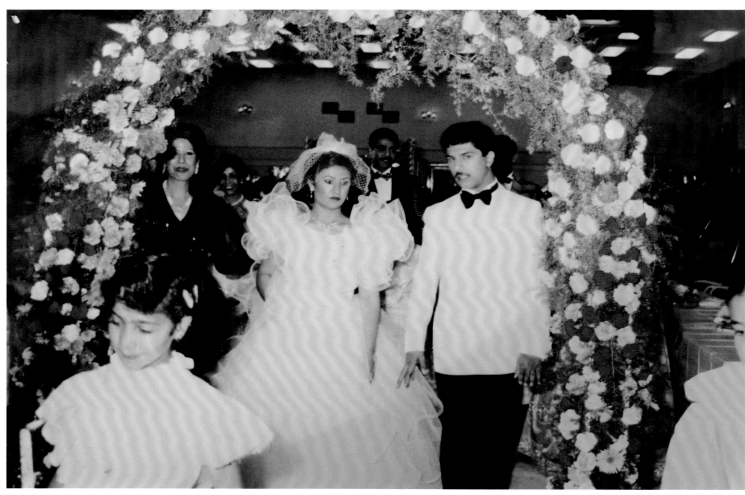

all images FREDERIC LAFARGUE, Tikrit, 04/16/03; clockwise from upper left: A picture of Saddam Hussein and his first wife, found in one of his private mansions in Al Oujeh; a smashed photograph of Saddam and his wife, Sadja; a picture of Qusay, one of Saddam Hussein's sons, during his wedding, found in Al Oujeh.

LAFARGUE, Tikrit, 04/15/03; clockwise from upper left: A picture of Uday, one of Saddam Hussein's sons, with his little sister and his mother, found in the Al Oujeh complex; Saddam with his cousin Ali Hassan al-Majid, ("Chemical Ali") found in Al Oujeh; according to a servant, this document is a present from the Iraqi people to Saddam.

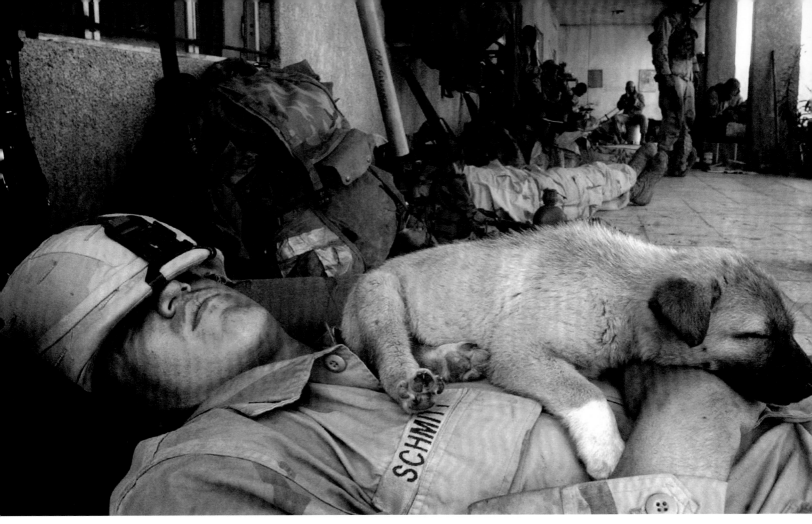

HAYNE PALMOUR: Baghdad, 04/16/03. Marine Cpl. Gunnar Schmitt, 23, from Janesville, WI, and new mascot "Willie" take a nap in the abandoned building where the Marines 3/1 has been living; "Willie" is one of many strays there.

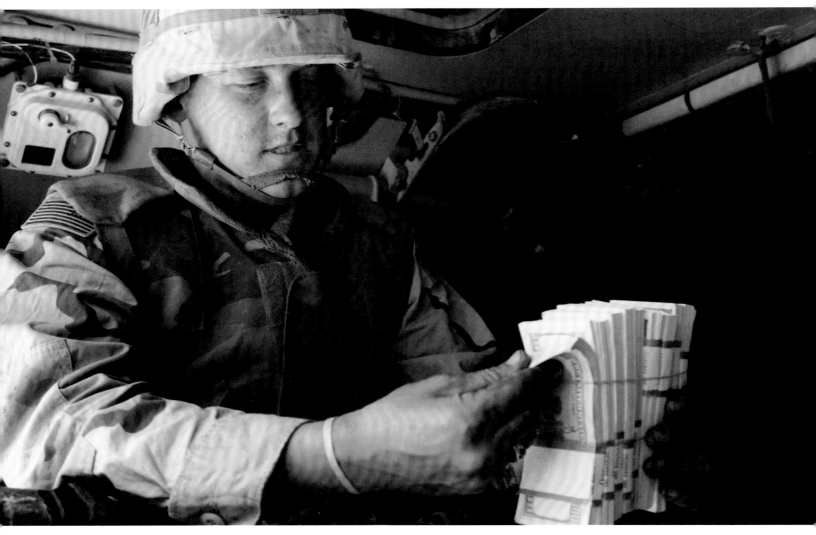

OLEG NIKISHIN: Baghdad, 04/17/03. A U.S. Marine checks fresh greenbacks in front of a bank; troops arrested thieves at a branch of the Al Rasheed Bank and removed $4 million in U.S. dollars for safekeeping.

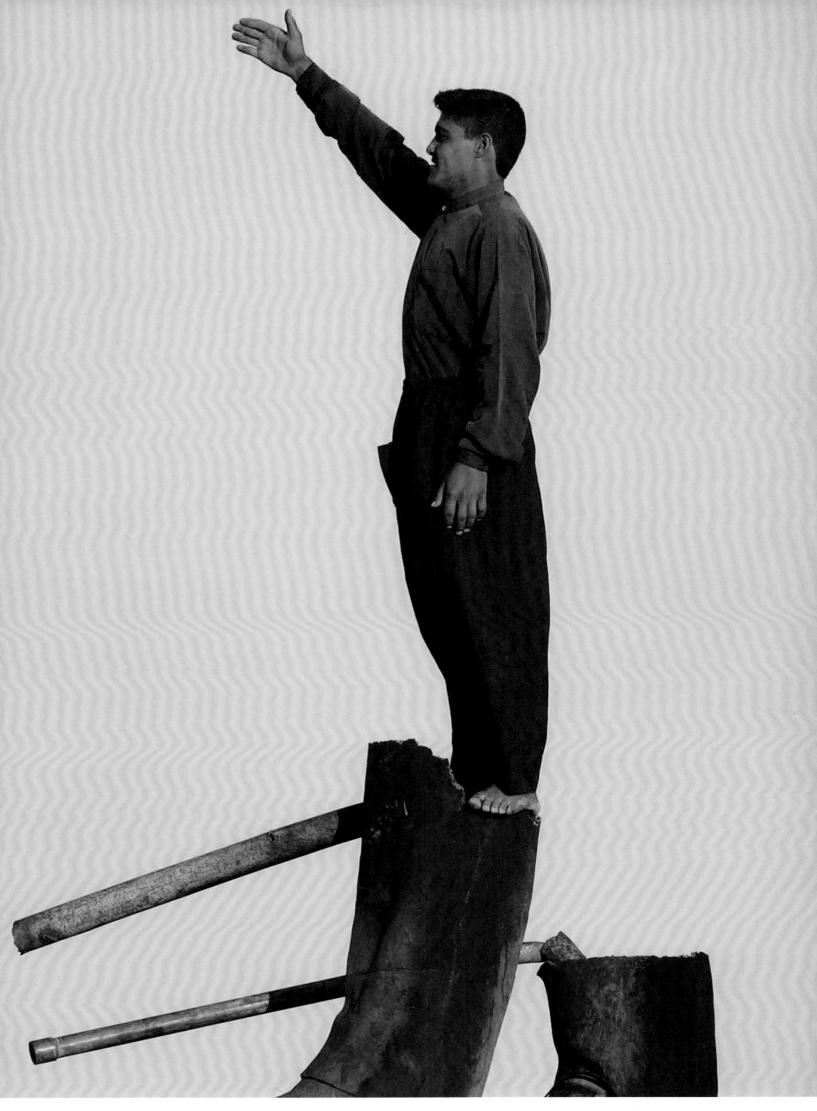

CHRIS ISON/POOL: Al Qurna, 04/15/03. An Iraqi man mimics the pose of a Saddam statue where it once stood.

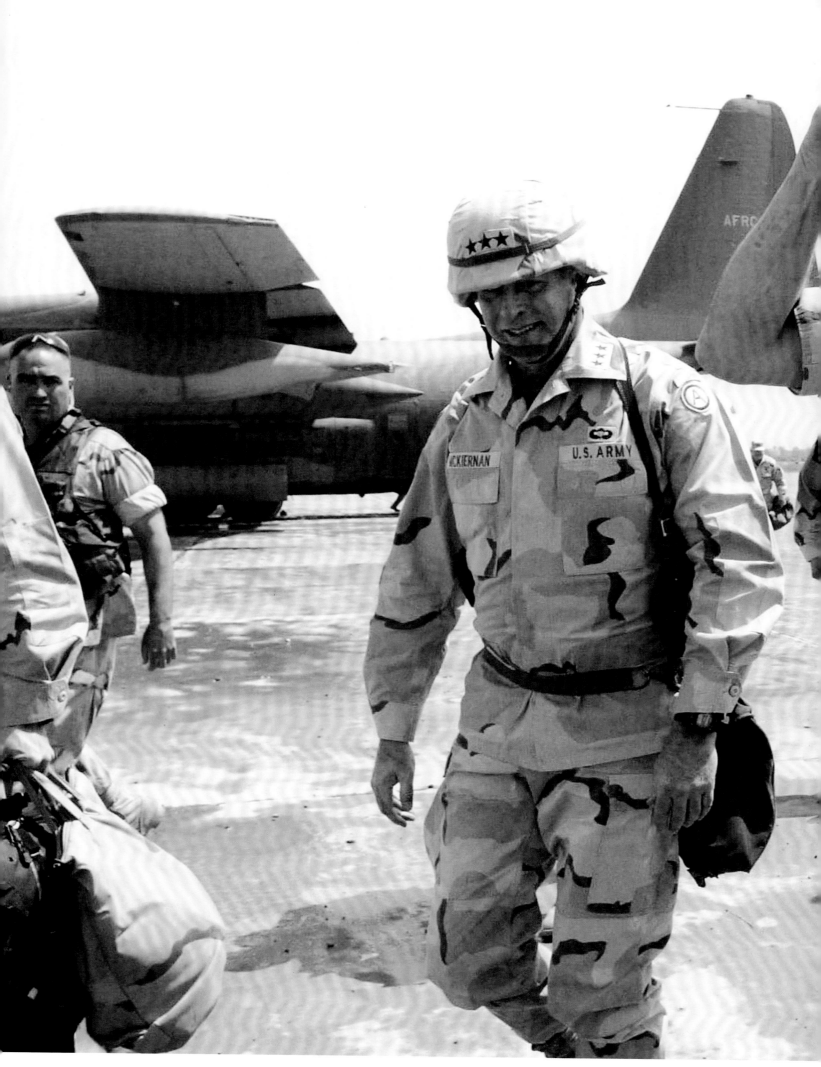

KAREN BALLARD/POOL: Baghdad, 04/16/03. U.S. Gen. Tommy Franks pumps his fist on arrival at the newly renamed Baghdad Intl.

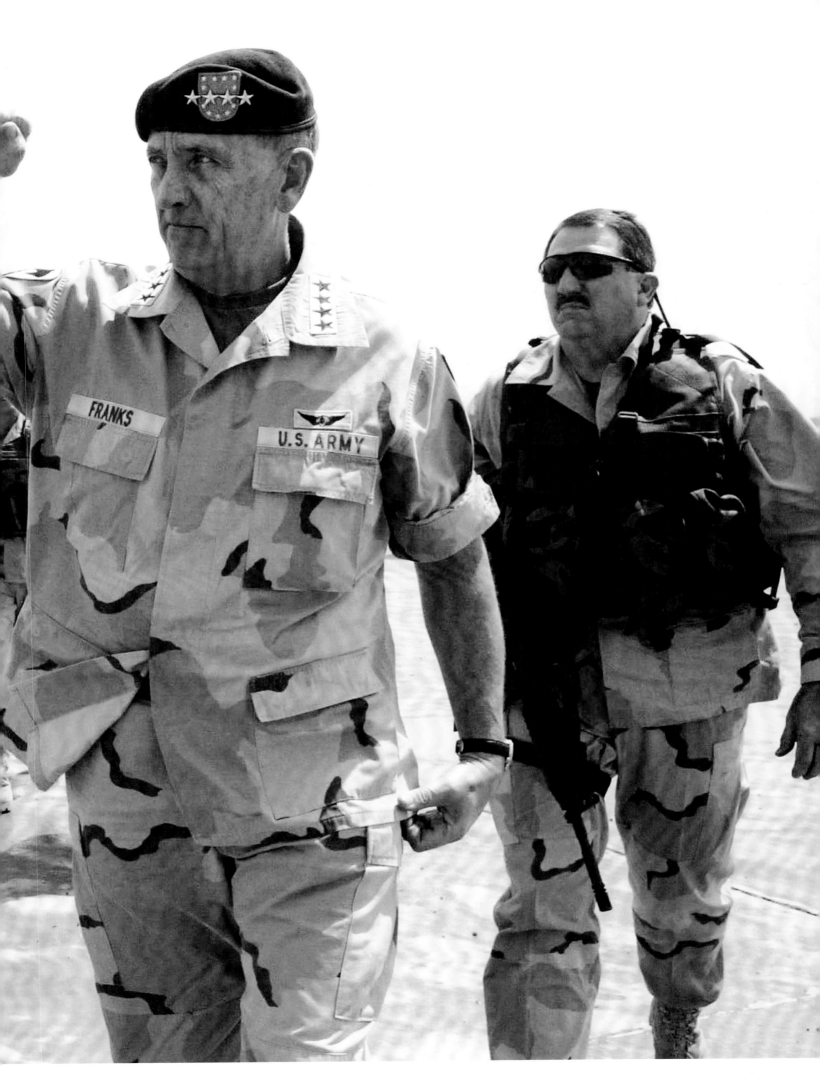

Airport; the four-star general, who directed the coalition invasion of Iraq, flew in to meet with field commanders.

FRANCESCO ZIZOLA: Tikrit, 04/14/03. By late afternoon, U.S. troops, having entered Saddam's hometown and feared last

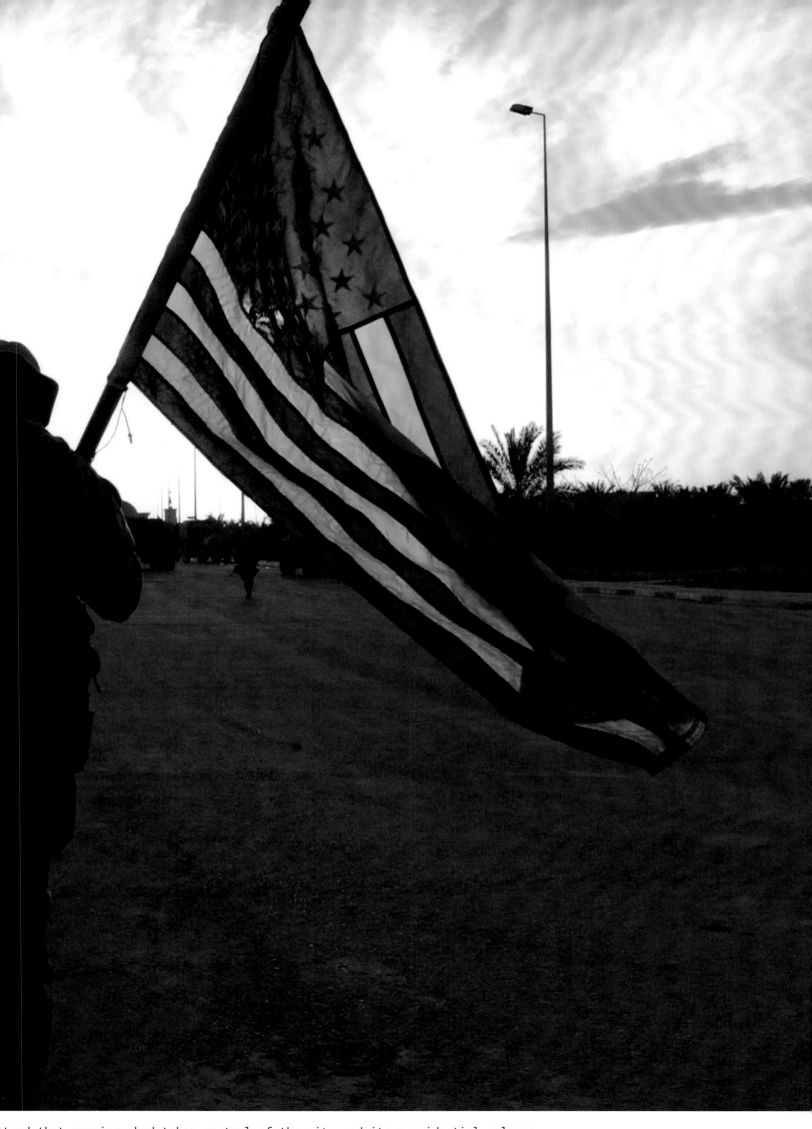

stand that morning, had taken control of the city and its presidential palaces.

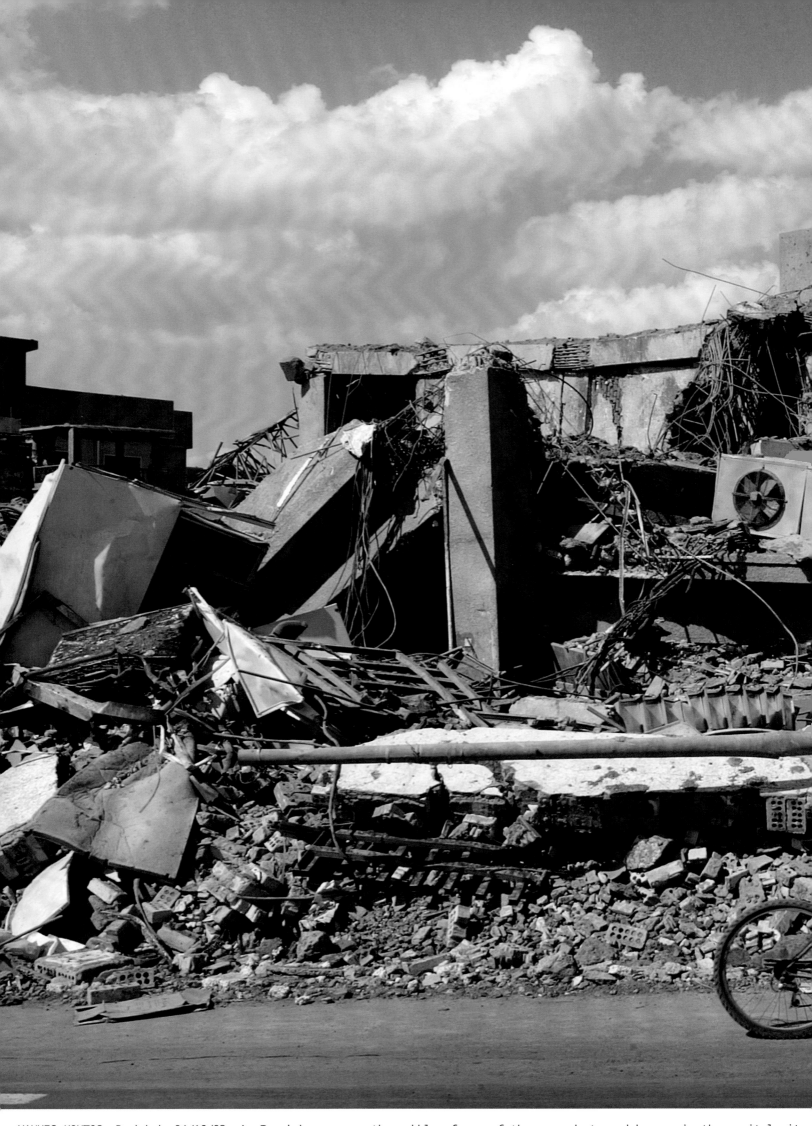

YANNIS KONTOS: Baghdad, 04/18/03. An Iraqi boy passes the rubble of one of the many destroyed houses in the capital city.

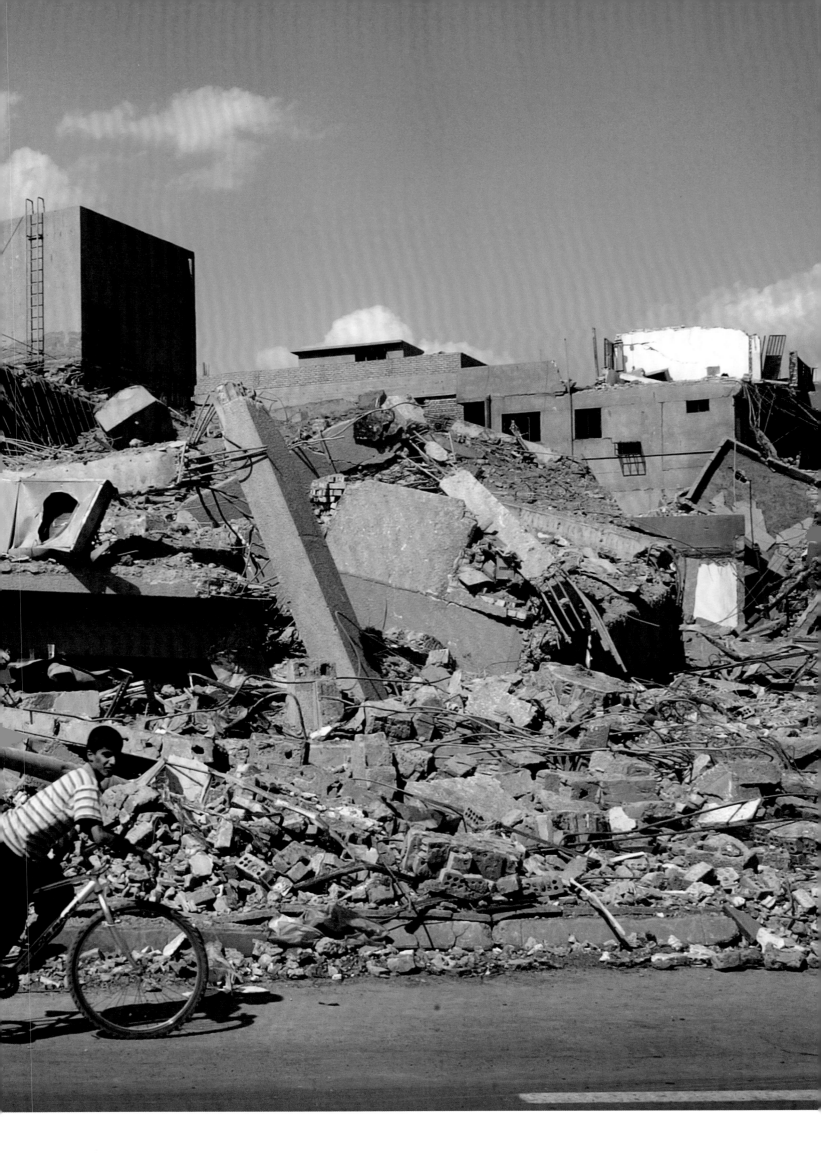

HEATHCLIFF O'MALLEY: Baghdad, 04/15/03. Remnants of priceless sculptures litter the looted Iraqi National Museum.

The only government building secured by U.S. forces at the fall of Baghdad was the oil ministry.

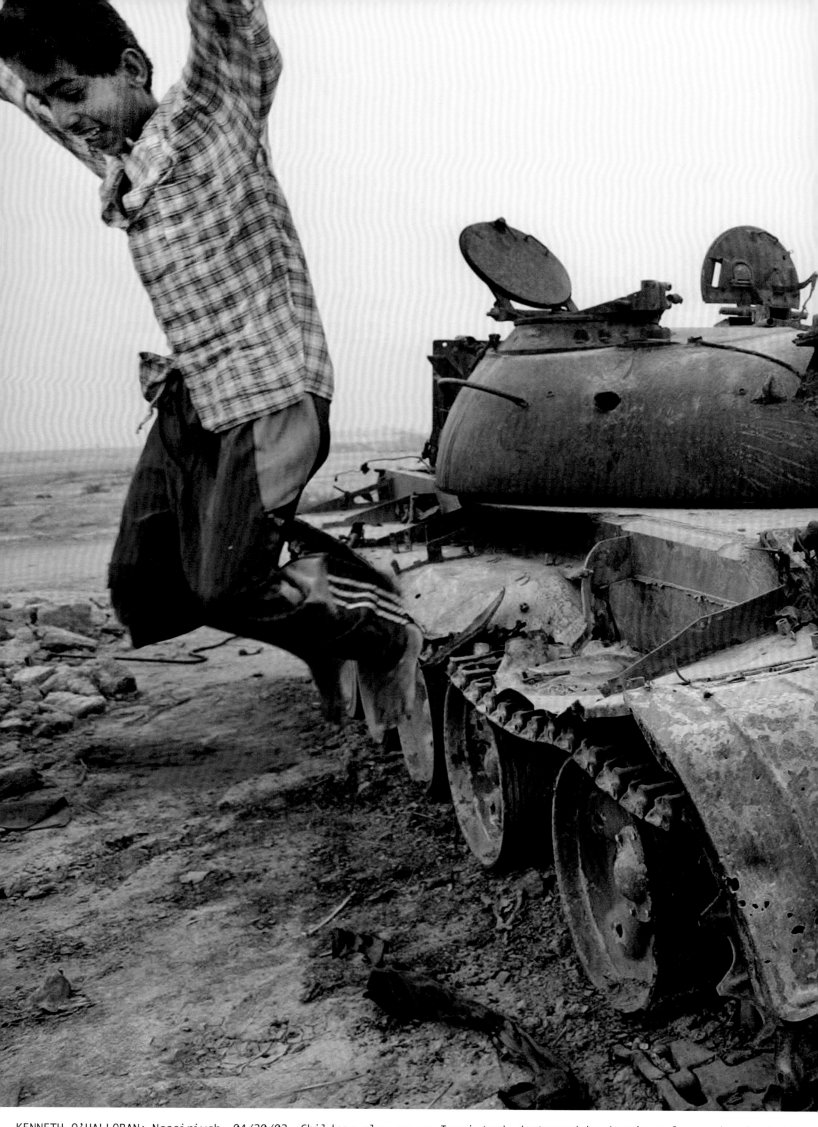

KENNETH O'HALLORAN: Nassiriyah, 04/20/03. Children play on an Iraqi tank destroyed by American forces in the battle

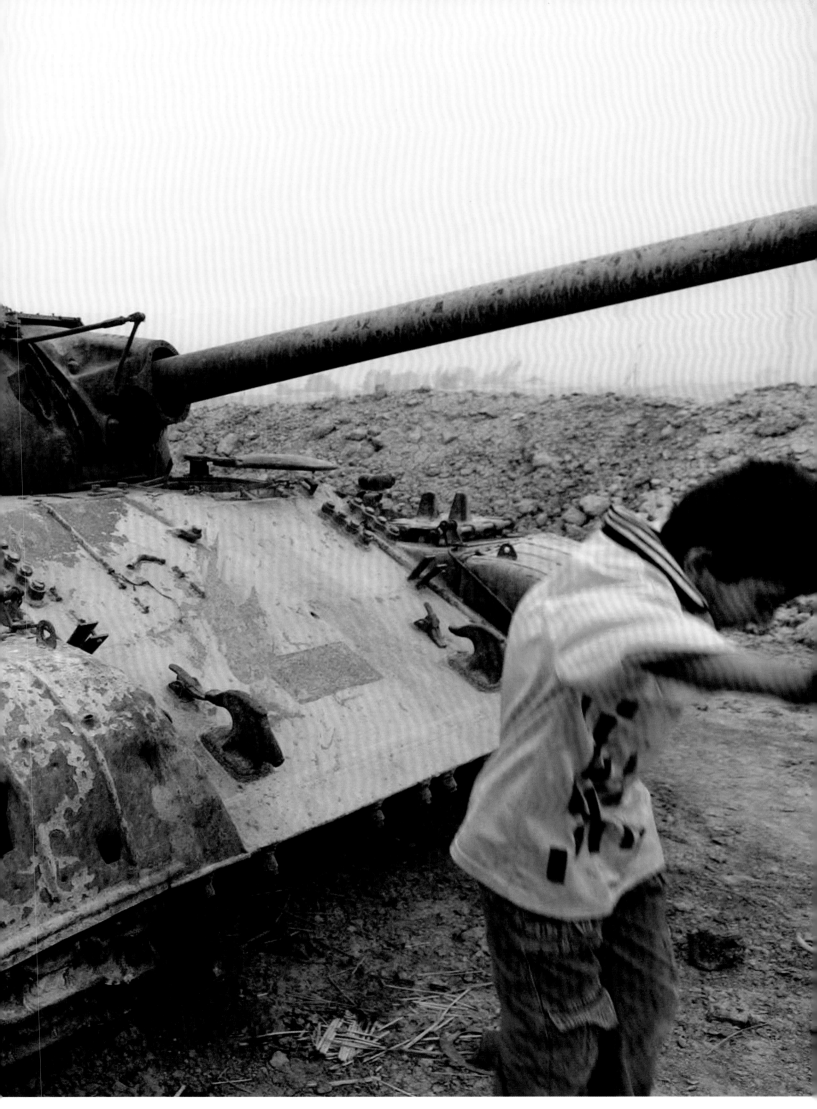

for Nassiriyah.

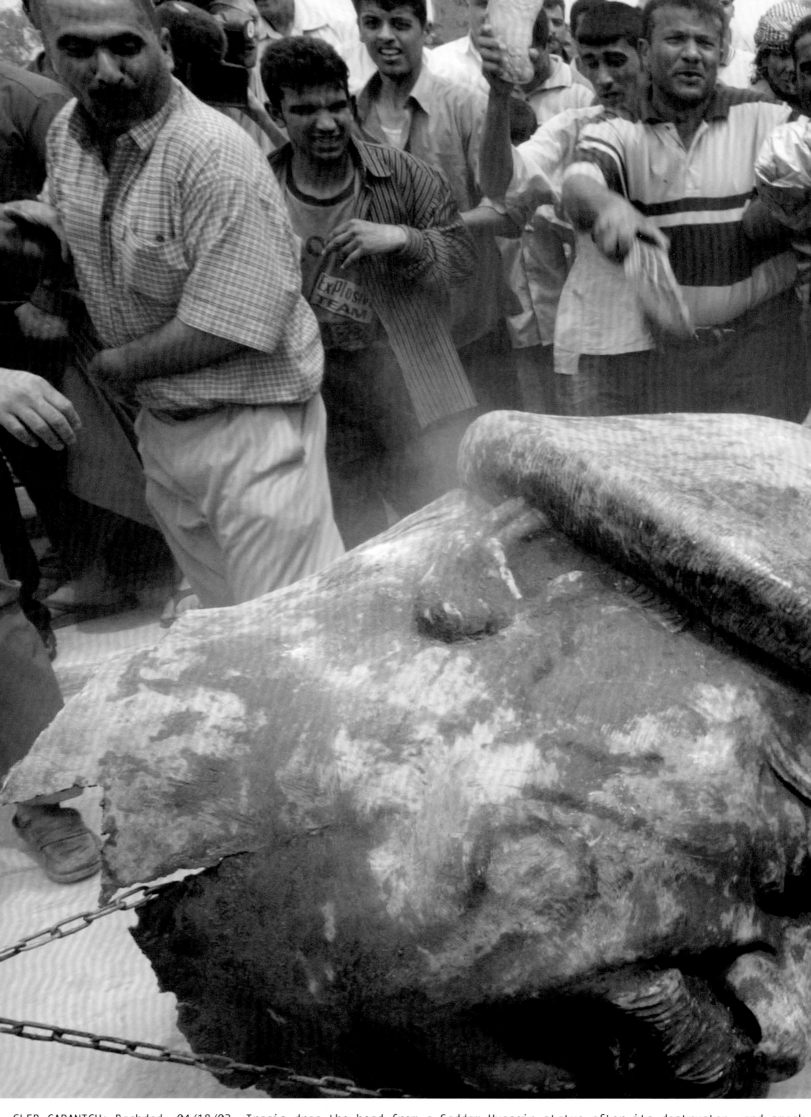

GLEB GARANICH: Baghdad, 04/18/03. Iraqis drag the head from a Saddam Hussein statue after its destructon, and smack

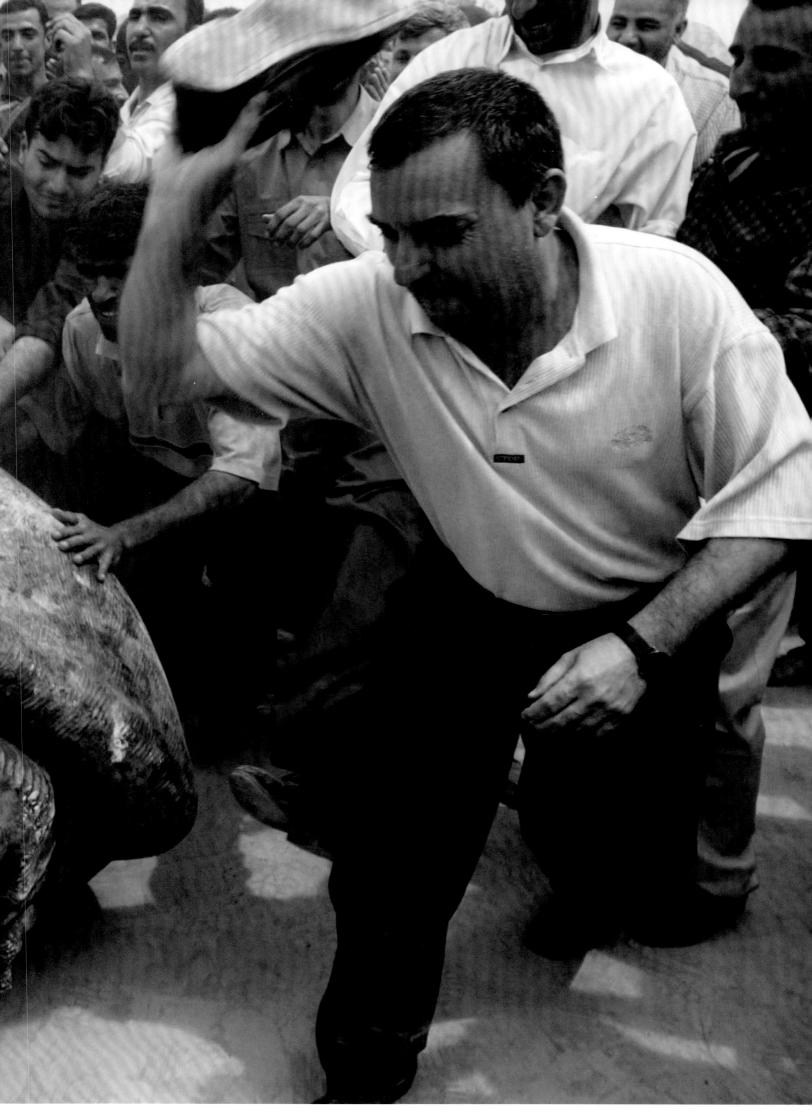

it with their sandals, a Middle Eastern symbol of humiliation.

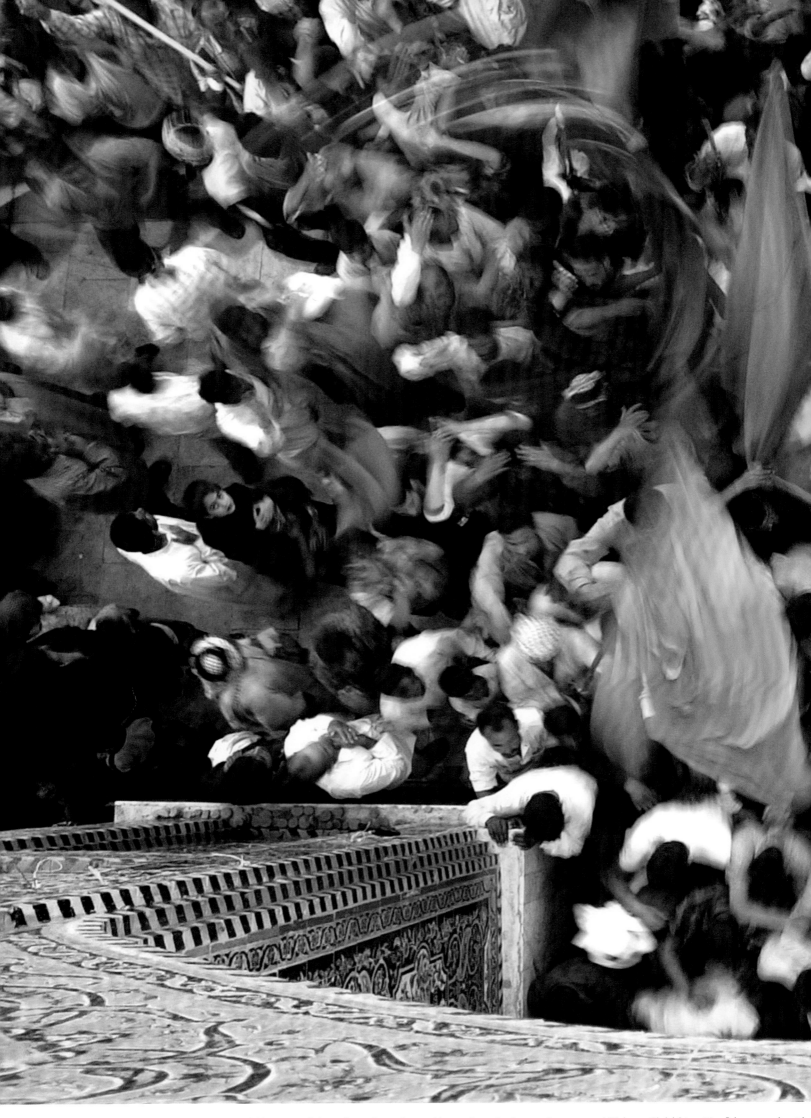

MATT MOYER: Karbala, 04/22/03. Shi'ite Muslims leaving Imam Hussein shrine. Over a million Shi'ite Muslims made the

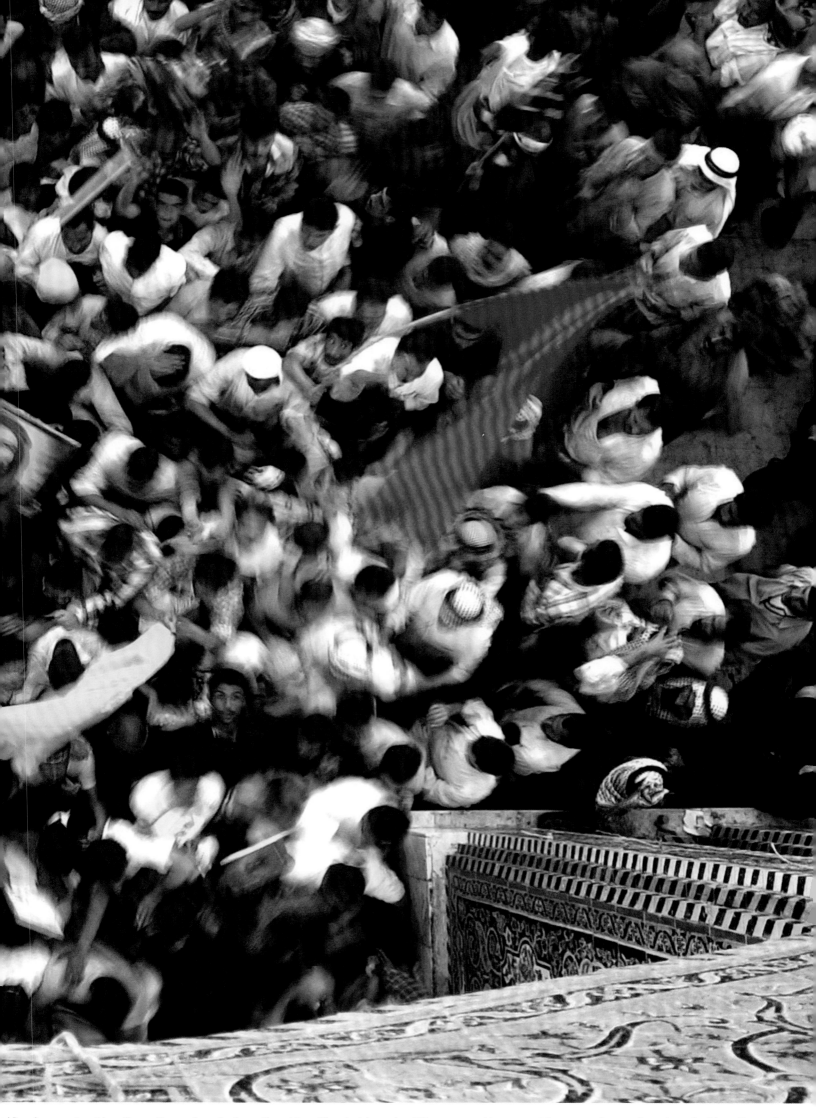

pilgrimage to the Imam Hussein shrine for the first time in 36 years; the practice was banned under Saddam Hussein.

YANNIS KONTOS: Baghdad, 04/8/03. An Iraqi boy pauses as he passes a destroyed building; several buildings across the

Iraqi capital were set on fire after looters made off with furniture, carpets, and television sets.

JIM LO SCALZO: Downtown Baghdad, 04/11/03. Two young Iraqis walk through the streets with an Iraqi flag.

WITNESS IRAQ
A WAR JOURNAL FEBRUARY–APRIL 2003

© 2003 powerHouse Cultural Entertainment, Inc.
Photographs and texts © 2003 the following:

AP/Wide World Photos: Jean-Marc Bouju, Jerome Delay, Luke Frazza, David Guttenfelder, Itsuo Inouye, Julie Jacobson, Paul Jarvis/Ministry of Defence/Pool, Hussein Malla, John Mills, John Moore (and text), Lefteris Pitarakis, Laura Rauch, Laurent Rebours; **Aurora**: Ashley Gilbertson, Bruno Stevens/Cosmos, Franco Tazetti/Cosmos; **Corbis Images**: Lynsey Addario/SABA, Mark Avery/Orange County Register, Karen Ballard/Sygma, Christophe Calais/In Visu, Oliver Coret, Brooks Kraft, David Leeson/Dallas Morning News, Patrick Robert, Jerome Sessini/In Visu; **Gamma**: Gilles Bassignac, Alain Buu, Sungsu Cho, Department of Defense/Pool, Steve Hebert/Fayetteville Observer, Frederic Lafargue, Hayne Palmour/NC Times (and text), Laurent Van der Stockt; **Getty Images**: Karen Ballard/Pool, Peter Barth, James Hill, Chris Hondros, Mirrorpix, Scott Nelson, Oleg Nikishin, Spencer Platt, Joe Raedle, Mario Tama; **Magnum Photos**: Thomas Dworzak, Paolo Pellegrin, Ilkka Uimonen, Francesco Zizola; **Polaris**: Hyoung Chang/Denver Post, Andy Cross/Denver Post, Timothy Fadek, Yannis Kontos; **Reuters**: Peter Andrews, Sgt. Arledge/Pool, Yannis Behrakis, Desmond Boyland, Gleb Garanich, Chris Ison, Faleh Kheiber, Jerry Lampen, Ministry of Defence/Pool, Ellen Ozier, Giles Penfold/Pool, Oleg Popov, Damir Sagolj, Goran Tomasevic, U.S. Central Command (handout); **Sipa Press**: Albert Facelly, Olivier Jobard, Kenneth O'Halloran; **US News & World Report**: Jim Lo Scalzo; **World Picture News**: Seamus Conlan (and text), Matt Moyer, Heathcliff O'Malley. **Unaffiliated**: Seamus Murphy.

Published in the United States by powerHouse Books, a division of powerHouse Cultural Entertainment, Inc.
180 Varick Street, Suite 1302, New York, NY 10014-5448, telephone 212 604 9074, fax 212 366 5247
e-mail: info@powerHouseBooks.com web site: www.powerHouseBooks.com

First edition, 2003

Library of Congress Cataloging-in-Publication Data:

Witness Iraq / edited by Marcel Saba.-- 1st ed.
 p. cm.
 ISBN 1-57687-200-9
 1. Iraq War, 2003--Pictorial works. I. Saba, Marcel, 1960-
 DS79.762 .W58 2003
 956.7044'3--dc21

 2003010773

Hardcover ISBN 1-57687-200-9
Printing by Meridian, East Greenwich, Rhode Island
Binding by Bindtech, Nashville, Tennessee
Images suplied for this book were shot digitally and transmitted via satellite phones.

I would like to thank all the photojournalists, whether represented in this book or not, who put themselves at great personal risk to bear witness to this conflict. I would also like to thank the agencies and organizations who support them, among them AP, Aurora, Contact Press, Corbis, Getty, Gamma, Magnum, Polaris, Reuters, Sipa, and World Picture News. A special thanks is also due to the individuals in those organizations, which includes James Danziger, Sue Brisk, Michael Schulmann, JP Pappis, Kelly Price, Nancy Glowinski, David Laidler, April Jenkins, Cindy Gin, Jeffrey Smith, James McGrath, Sabine Baumgartner, Patrick Whelan, Sandy Ciric, Rosa Disalvo, Vin Alabiso, Ken Dale, Yvette Reyes, Brad Khunes, James Wood, Mete Zihnioglu, James Price, and Tara Farrell. I would also like to thank Katy Howe and Matthew Naythons. I would especially like to thank my family, most of all, my wife Jean, whose support and love for me has never wavered, and to my three girls Christine, Caroline, and Kitty for their love and their curiosity about this project. From powerHouse Books, I want to thank Daniel Power, Craig Cohen, Sara Rosen, Kristian Orozco, Kiki Bauer, Heidi Thorsen, Meg Handler, and Daniel Buckley for their incredibly hard work and amazing talent; they work miracles. Also, Danny Frank, Wendy Jordan, and all the wonderful artisans at Meridian Printing for a superb job, and Steven I. Weiss for surfing the web for blogs and related posts. I would very much like to thank Yolanda Cuomo for her hospitality and for all the wonderful things I learned from her. I would also like to thank her staff, Associate Designer Kristi Norgaard and Natalia Yamrom.　　—MS, NYC 05/20/03

A complete catalog of powerHouse Books and Limited Editions is available upon request; please call, write, or visit our web site.

10 9 8 7 6 5 4 3 2 1

Printed and bound in the United States of America

BOOK DESIGN BY YOLANDA CUOMO, NYC